Refigured Painting

Refigured Painting

Refigured Painting
The German Image 1960-88

Edited by
Thomas Krens, Michael Govan,
Joseph Thompson

Prestel

in association with Solomon R. Guggenheim Museum, New York

This book is published in conjunction with the exhibition
Refigured Painting: The German Image 1960-88 held at The
Toledo Museum of Art, Toledo, Ohio (October 30, 1988-
January 8, 1989); Solomon R. Guggenheim Museum, New York
(February 11-April 23, 1989); Williams College Museum
of Art, Williamstown, Massachusetts (February 11-March 26,
1989); Kunstmuseum Düsseldorf (May-July 1989);
Schirn Kunsthalle, Frankfurt (September-November 1989)

The exhibition is organized by the Solomon R. Guggenheim Museum, New York
and the Williams College Museum of Art, Williamstown, Massachusetts

The essays by Heinrich Klotz and Jürgen Schilling were
translated from the German by John William Gabriel, Worpswede.
The essay by Hans Albert Peters was translated by Stephen Reader, Dusseldorf

Front cover: Sigmar Polke, *Tischrücken* (Seance), 1981 (cat. no. 117, detail),
Collection Dr. Rainer Speck, Cologne

Frontispiece: K. H. Hödicke, *Stilleben mit spanischer Puppe I: Hommage à Velázquez*
(Still Life with Spanish Doll I: Homage to Velázquez), 1963
Courtesy Galerie Gmyrek, Dusseldorf

Prestel-Verlag
Mandlstrasse 26
D-8000 Munich 40
Federal Republic of Germany

Soft cover edition not available to the trade

Distributed in continental Europe and Japan by Prestel-Verlag,
Verlegerdienst München GmbH & Co KG, Gutenbergstrasse 1,
D-8031 Gilching, Federal Republic of Germany

Distributed in the USA and Canada by te Neues Publishing Company,
15 East 76th Street, New York, NY 10021, USA

Distributed in the United Kingdom, Ireland and all other countries
by Thames & Hudson Limited, 30-34 Bloomsbury Street,
London WC1B 3QP, England

Library of Congress Cataloging-in-Publication Data

Refigured painting.
Exhibition organized by the Solomon R. Guggenheim
Museum and the Williams College Museum of Art.
Bibliography: p. 252
1. Figurative painting, German—Exhibitions.
2. Painting, Modern—20th century—Germany (West)—Exhibitions.
I. Krens, Thomas. II. Govan, Michael. III. Thompson, Joseph, 1958-.
IV. Solomon R. Guggenheim Museum. V. Williams College. Museum of Art.
ND568.5.F54R44 1989 759.3'074 89-1700
Composition by Fertigsatz GmbH, Munich
Color separations by Repro Dörfel, Munich
Printed by Karl Wenschow-Franzis Druck GmbH, Munich
Bound by R. Oldenbourg, Heimstetten

Printed in the Federal Republic of Germany

ISBN 3-7913-0866-1

Contents

Acknowledgments

8

Foreword

11

Thomas Krens

German Painting: Paradox and Paradigm
in Late Twentieth-Century Art

12

Joseph Thompson

Blasphemy on Our Side: Fates of the Figure
in Postwar German Painting

23

Michael Govan

Meditations on A = B: Romanticism and Representation
in New German Painting

35

Jürgen Schilling

Metaphors: Positions in Contemporary German Painting

47

Heinrich Klotz

Abstraction and Fiction

51

Hans Albert Peters

Double Exposure – The Golden Shot?
By one who set out to unlearn fear

57

Catalogue

with Alphabetical List of Artists in the Exhibition

65-245

Documentation

List of Works

246

Biographies, Selected Exhibitions
and Selected Bibliographies

252

General Bibliography

286

Photographic Credits

290

Lenders to the Exhibition

ACT Collection, London
Galerie Hans Barlach, Hamburg and Cologne
Galerie Beaumont, Luxembourg
Reinhard Becker, Monheim
Hans E. Berg, Herten
Mary Boone & Michael Werner Gallery
Galerie Buchmann, Basel
Anthony d'Offay Gallery, London
Deutsches Architekturmuseum, Frankfurt
Kamram T. Diba
Gerald S. Elliott, Chicago
Rainer Fetting
First Bank System, Inc.
Fröhlich Collection, Stuttgart
Fundació Caixa de Pensions
Garnatz Collection
Joshua Gessel Collection
Galerie Gmyrek, Dusseldorf
Wally Goodman, San Francisco
Galerie Grässlin-Ehrhardt, Frankfurt
F. C. Gundlach
Harvard University Art Muscums (Busch-Reisinger Museum)
Galerie Max Hetzler, Cologne
Jule Kewenig
Martin Kippenberger
Kleihues Collection
Uli Knecht, Stuttgart
Karin Koberling
Dieter Krieg
Kunstmuseum Düsseldorf
Thomas Lange
Raymond J. Learsy
Galerie Lelong, Zurich
Los Angeles County Museum of Art

L. A. Louver Gallery, Venice, California
Paul Maenz, Cologne
Galerie Paul Maenz, Cologne
Susan and Lewis Manilow
Marx Collection
Meister Collection, Braunschweig
Metro Pictures, New York
Earl Millard
The Montreal Museum of Fine Arts
Munson-Williams-Proctor Institute Museum of Art, Utica, New York
Neue Galerie – Sammlung Ludwig, Aachen
Galerie Neumann, Dusseldorf
Reinhard Onnasch, Berlin
Piepenbrock Collection, Osnabrück
Peter Pohl, Berlin
Raab Galerie, Berlin and London
M. Riklis, New York
Rotthof Collection, Dusseldorf
Saatchi Collection, London
Salomé
Schmidt-Drenhaus Collection, Cologne
Schürmann Collection
Galerie Folker Skulima, Berlin
Sonnabend Gallery, New York
Dr. Rainer Speck, Cologne
Galerie Springer, Berlin
Monika Sprüth Galerie, Cologne
Stober Collection, Berlin
Dr. Eleonore and Dr. Michael Stoffel
Monika Verhoeven, Cologne
Voswinkel Collection, Dusseldorf
Galerie Moderne Kunst Dietmar Werle, Cologne
Wurlitzer Collection
Donald Young Gallery, Chicago

Acknowledgments

Refigured Painting: The German Image 1960-88, having evolved through many different stages and forms, reaches fulfillment as an international project involving forty-one artists and over 180 paintings, a signal achievement that would have remained no more than an intriguing concept had it not been for the imagination, skill and energy of the numerous individuals who have contributed to the organization and presentation of this exhibition and to the making of its catalogue. It hardly seems possible to express to them the thanks they deserve.

In 1984, on first visiting Germany to investigate the possibility of mounting this show, I met three people who from then on unfailingly provided essential support for the project. My esteemed colleagues Hans Albert Peters, Director of the Kunstmuseum Düsseldorf, Heinrich Klotz, Director of the Deutsches Architekturmuseum in Frankfurt, and Jürgen Schilling, the respected freelance curator, were all most willing to share their insights. In pointing me in the direction of relevant galleries and museums, they facilitated the organizing of this enterprise to a degree greater than I can describe. I am honored and grateful that Drs. Peters, Klotz and Schilling agreed to write about recent German painting for this exhibition.

It is particularly gratifying, moreover, that *Refigured Painting* will be shown at two venues in Germany — at the Kunstmuseum Düsseldorf, directed by Dr. Peters, and at the Schirn Kunsthalle in Frankfurt, directed by Christoph Vitali, whose moral and financial support has been vital to the success of our plans. I must add, however, that this success is due in no small measure to the energies of Roger Mandle, former Director of The Toledo Museum of Art, now Deputy Director of the National Gallery of Art, Washington, D.C. Under his guidance, the Toledo Museum's early commitment to the exhibition made its present scope and scale possible. And I would like to cite Stephen High, now Director of the Portland Art Center, for some important formulations back in 1984 about the purposes and principles of this project.

I am especially indebted, of course, to the artists themselves, many of whom worked unstintingly with us to achieve the best possible selection of their work. Among those who made generous commitments of time and effort I wish to single out Georg Baselitz, Eugen Schönebeck, Anselm Kiefer, Gerhard Richter, Markus Lüpertz, K. H. Hödicke, Bernd Koberling, Norbert Tadeusz, Michael Buthe, Dieter Krieg and Christa Näher, as well as Hermann Albert, Rainer Fetting, Dieter Hacker, Friedemann Hahn, Thomas Hartmann, Konrad Klapheck, Thomas Lange and C. O. Paeffgen. Detlev Gretenkort, assistant to Georg Baselitz, offered timely help.

Refigured Painting could never have been realized without the financial contributions of its funders. I am indebted, first of all, to the Federal Republic of Germany for its generous support, and in particular to Dr. Bartold C. Witte and Paul von Mahlzahn of the Auswartiges Amt of the Federal Republic, who were instrumental in arranging that support. Lufthansa German Airlines and its President, Heinz Ruhnau, merit our special gratitude — the organization for its extraordinary financial and logistical support, the man for his sustaining belief that the worlds of business and the visual arts can creatively connect. Nicolas V. Iljine, Manager of Public Relations International for Lufthansa German Airlines, arranged and coordinated extensive transportation sevices in conjunction with this exhibition. His enthusiastic interest in the event throughout its long development has been a continuously important source of encouragement. For faithful backing and trust at a time when both were very much needed, I am particularly grateful to the Deutsche Bank and to Dr. Herbert Zapp, member of the Board of Managing Directors, and his colleague Michael Rassmann, Executive Vice President and General Manager. The Cultural Society of Frankfurt has our warmest thanks for generously providing funds crucial to the project's well-being.

Without the collaboration and encouragement of private collectors and museums any exhibition of this scale would be impossible to realize. Among officials of the museums and public institutions who have contributed to this presentation I would like to thank the following: Dr. Edgar Peters Bowron, Director of the Harvard University Art Museums; Dr. Siegfried Gohr, Director of the Museum Ludwig, Cologne; Earl A. Powell, Director of the Los Angeles County Museum of Art; Pierre Théberge, Chief Curator of the Montreal Museum of Fine Arts; and Dr. Paul D. Schweitzer, Director of the Munson-Williams-Proctor Institute of Art, Utica, New York.

In addition, I am happy to acknowledge the generosity of several individuals who, having opened their magnificent collections for public viewing (collections matching the scope and quality of those of many museums), agreed to lend key works from their holdings to *Refigured Painting*: Dr. Erich Marx, Charles Saatchi and Peter Ludwig, not to mention their respective curators Heiner Bastian, Julia Ernst and Dr. Wolfgang Becker. I would like to attest as well to the thoughtful consideration of other collectors who have had the courage and foresight to commit themselves philosophically and financially to much of the art in this exhibition. Their consent to share their works with us has been crucial to the project's fruition. My thanks go to all of the collectors who spent valuable time with us, including Drs. Michael and Eleonore Stoffel, Dr. Rainer Speck, Raymond J. Learsy, Joseph Fröhlich, Dr. and Mrs. Georg Böckmann, Dr. Hans H. Stober, Reinhard Onnasch, F. C. Gundlach and Eberhard Garnatz.

In organizing this exhibition we have worked with many dealers. My thanks to all of them, especially Michael Werner, Wolfgang Gmyrek and Erika Templin, Paul Maenz, Marian Goodman, Ingrid Raab, Max Hetzler, Dietmar Werle, Ileana

Sonnabend and Antonio Homem, Janelle Reiring, Monika Sprüth, Hans Barlach, Bärbel Grässlin-Eberhardt, Rudolf Springer, Anthony and Anne d'Offay, Silvia Menzel, Jule and Michael Kewenig, Elisabeth Kübler and Pablo Stähli; and to gallery staff members Anne Blümel, James Hofmaier, David Goldsmith, Claudia Bäz, Gitta Lutze and Madeleine Ferretti for futher help.

The patience, skill and determination necessary to produce a catalogue such as the one accompanying *Refigured Painting* were abundantly evident on the part of the staff of Prestel-Verlag in Munich, whose grace under pressure was as unfailing as their editorial expertise. They were models of kindness and efficiency throughout the invigorating, sometimes hectic process of producing this book. In Munich and New York Jonathan Aaron applied his considerable organizational, editorial and critical skills to the catalogue at the moment they were most needed and valued.

I am very grateful as well to Rod Faulds, Director of the Williams College Museum of Art, for his cooperation, and to Sally Shafto and Kathryn Potts, of the same museum, for their scholarship and organizational skill in producing the catalogue's bibliographies and biographies, and to their colleagues Hanne Booth and Deborah Leveton. These individuals and the entire staff of the Williams College Museum of Art worked with serene efficiency throughout the organizing of this exhibition, from its earliest moments to its completion.

The staff of the Solomon R. Guggenheim Museum suddenly found itself faced with this project well after its launching and responded to the unexpected with constant resourcefulness, ingenuity and good cheer. My particular thanks go to Susan Hapgood, Curatorial Coordinator, for masterfully overseeing the project; to Kathleen Hill McGee, Associate Registrar, for her skillful coordination of shipping arrangements; to Carol Fuerstein, Editor, for her invaluable editorial advice; to Diana Murphy, Assistant Editor; to Mimi Poser, Officer for Development and Public Affairs; to Ann Kraft, Executive Associate; and to Jill Snyder, Administrative Coordinator; to Linda Gering, Special Events Associate; and to Holly Evarts, Public Affairs Associate. My thanks, additionally, to Scott Wixon, Operations Manager, David Veater, Assistant Preparator, Myro Riznyk, Building Manager, and Elizabeth Estabrook, Assistant Conservator, for taking on the extraordinary installation responsibilities this exhibition imposed; and Bethany Oberlander, Patricia de Alvear, Barbara Larsen and Maxine Levy, assistants and interns who willingly helped with the day-to-day processes of keeping the project on track. Thanks, too, to Tom Sansone, architectural consultant, and to Germano Celant, new Curator of Contemporary Art at the Guggenheim, for their advice at key times. In addition, I would like to acknowledge Hans-Ewald Schneider and Reiner Rupsch of Hasenkamp for their professionalism and cooperation.

The staff of The Toledo Museum of Art — including Robert Phillips, Interim Deputy Director, Steve Frushour, Assistant Curator of Exhibitions, Pat Whitesides, Registrar, and Steve Nowak, Assistant Registrar, whose cooperation and efficiency were so important — deserve special recognition for helping to make this exhibition a reality.

Michael Govan and Joseph Thompson join me in expressing deepest appreciation to all who have had a hand in bringing to light *Refigured Painting: The German Image 1960-88*.

Thomas Krens, Director
The Solomon R. Guggenheim Foundation

Foreword

In 1984 at Williams College, we were discussing the remarkable phenomenon of the growth of the museum industry in Europe and the United States, and its relation to the recent explosion of the market for contemporary art that occurred by the end of the last decade. In the context of our inquiry, the recent rise of contemporary German painting to international prominence prompted us to consider in turn the velocity with which art-making attitudes, as reflected in the art market and art criticism, change. If, our logic went at the time, German painting was a primary topic of current popular and critical attention, then it was quite likely that it would no longer be so by the time a comprehensive presentation in an institutional setting could be made. The voracity with which the public consumed new art led us to speculate that the current phenomenon would become history at a comparable pace. Correlatively and perhaps paradoxically, a museum might well find itself in the unusual position of presenting as historical and resolved what ordinary logic would still understand as contemporary and vital.

Exhibited conspicuously in the early 1980s in Kassel at *Documenta,* at the Venice Biennale and in exhibitions in London and Berlin, the new German painting seemed to us a particularly significant context in which to pursue our investigation. From an American perspective, we were increasingly interested by the extent to which this painting seemed to reject the discoveries and criteria of late modernism as manifested in Abstract Expressionist painting, then in Pop, Minimal, Conceptual and Performance Art. After the systematic reduction of the process of painting to its most basic elements, and in light of a concurrent critical analysis that recalled Marcel Duchamp's implication that painting had played itself out like a board game, the return of narrative, figurative, even decorative, painting suggested a sort of reverse — or perverse — radicality. Touted as the harbinger of stylistic pluralism, as the end of an academicized modernism and the start of a popular post-

modernism, the new German painting, in the face of an increasingly international exchange of information, often engaged a subject matter that reflected and referred to a specifically national consciousness of history.

The apparent anomalousness of German painting was one of the considerations that led us to undertake a systematic review and evaluation. During the course of numerous visits to studios, warehouses and galleries in Germany, Great Britain and the United States, we discovered a greater diversity of approach in the art than had been publicized. It ranged from the obviously Neo-Expressionistic strategies of Fetting to the highly personal and sexually charged imagery of Salomé, from the cool distancing tactics of Gerhard Richter to works within an essentially conceptual register by Rosemarie Trockel and Walter Dahn, who seem drawn to painting almost against their wills. Nevertheless, we were led to conclude that the most central — and most problematic — consideration of postwar German painting was figuration. *Imagery* had catapulted the new German painting into prominence.

Refigured Painting establishes the location for the intersecting of a number of considerations, including the purported end of modernism, the psychological and political relevance of Germany's recent past, the increasing popularization and distribution of culture worldwide, and the reopening of the difficult and sometimes forbidding realms of subjectivity and self-expression. The work of these forty-one artists — most notably Georg Baselitz, K. H. Hödicke, Anselm Kiefer, Markus Lüpertz, A. R. Penck, Sigmar Polke and Gerhard Richter — comprises a map with which to navigate some of the pressing aesthetic and cultural issues of our time.

Thomas Krens
Michael Govan
Joseph Thompson

German Painting: Paradox and Paradigm in Late Twentieth-Century Art

Thomas Krens

Sigmar Polke's Paganini *1982*

The ostensible subject of Polke's painting is Nicoló Paganini (1782-1840), the foremost violinist of his time, a spectacular virtuoso who revolutionized the theory and practice of concert performance of the violin. From 1828 to 1834 Paganini marched through Europe, conquering audiences in the great cities from Prague to London, amassing a fortune he would soon squander attempting to start a gambling casino in Paris. The striking nature of his musical accomplishment is suggested by contemporary reports. Upon hearing Paganini in Weimar, Goethe was impressed: "I can find no base for this column of flame and cloud. I can only say that I was aware of some meteoric sounds, which I have not yet succeeded in interpreting"[1] Paganini's opening night in Paris in 1831 was a tumultuous success, and the reports were ecstatic: "It was divine, a diabolic enthusiasm . . . the people have all gone mad," wrote one journalist.[2] Exclaimed another, borrowing from Mme. de Sévigné, ". . . the most surprising, the most wonderful, the most miraculous, the most triumphant, the most bewildering, the most incredible, the most amazing, the most impossible, the most unexpected thing that ever happened."[3]

Paganini was both a bravura performer and a wily showman — a "star" in the modern sense of the term. His appeal had a touch of the lurid about it. No doubt the result of his promo-tional self-mythologizing, rumor had it he had made a pact with the devil. By no other means, went the story, could he have acquired the physical dexterity and creative ingenuity that made such complete control over a musical instrument possible. "You will notice," one journalist wrote, "that I have to have recourse to the devil himself to give you an idea of what Paganini is like, to explain to you what I felt when I heard him and what I felt afterwards, and to convey to you the excitement which robbed me of my sleep that night and gave me St. Vitus's dance. And yet I can never succeed"[4]

Polke's painting evokes the Mephistophelian theme that even today comes to mind when the virtuoso's name is mentioned, a theme that in the painting metamorphoses into a number of visual contexts and formulations as in a dissonant visual version of musical theme and variation. If the work can be said to contain or refer to a dramatic situation, we might conclude that Paganini, whose pillowed head marks the virtual center point of the canvas, is being serenaded by the entity or power with which he made his legendary pact. Whether on his death bed or merely dreaming, Paganini seems to be enjoying himself; his raised hands suggest he is keeping time with the music, perhaps even directing the grotesque performer beside him. Paganini here is an emblem for the idea of the artist who traffics with strange powers, a person who controls those powers but whose destiny may be ruled by them.

There are three primary constellations of imagery in the painting: first, the mythology of the Faustian pact; second, the

1 de Saussine, Renée. *Paganini*, Marjorie Laurie, trans. (London, 1953): II.

2 *New Grove Dictionary of Music and Musicians*, vol. I (New York, 1982):88.

3 de Saussine: 161.

4 Ibid.

legend of virtuosity embodied in the hand of the maestro; and third, the burden of historical consciousness, reflected in the painting's ironic and obsessive engagement of the swastika, which pardoxically simultaneously stresses and deflects a connection between German art of the present and the terrible events that mark that country's historical and cultural past.

The swastika is central to the painting's agitated, purposeful sense of play, a motif both hidden and overt which challenges the viewer to a game of textual hide-and-seek, indeed, to a sort of metaphysical treasure hunt. A symbol common to Christian and Hindu iconography, as well as to that of the Buddhist, Mayan and Navaho, it is generally taken to represent strength and prosperity. (The Sanskrit svastikah = "conducive to well-being" or good luck.) For our time, of course, a considerable irony lies in the fact that this primordial symbol of beneficent power was turned by the Nazis into a quintessential sign of moral and physical evil. The network of reference in the painting is omnipresent and complex, ranging from the blatant swastika outlined in the lower right corner to the much smaller one in Paganini's water glass, or in the flame of his bedside candle, or stamped on the figures in the lower left. The symbol marks the eyes of Paganini himself and those of a barely visible torso to the right of the death's-head juggler. It hangs from Paganini's bedsheet, moves in a purple stream between his upraised hands, it swarms at the top of the plinth/door shape that decisively divides the picture in two.

In using the symbol and thus evoking a set of dire associations, Polke may be suggesting that which seems benign and restorative in one period has the capacity to change, even to the point of maleficence, in another. And if such power is inherently unstable, then what about the power of art and the artist's own experience and use of that power? The contradictory implicatons of the symbol lead to the contradictory nature of the artist, whom the Romantics sometimes saw as a brilliant overreacher, someone enviably but often dangerously in touch with the Sublime.

Creation involves the knowledge of destruction, of death itself. To create, the artist must be open to all possibilities, including the possible loss of self and soul. Such is the significance of the traditional notion, virtually a cliché, of the artist's diabolical bargain — Faust's with Mephistopheles, to begin with, but also Paganini's with the devil. The risk measures the daring of the quest and the value of the dreamt-of reward.

Paradigm

Figurative painting was the critical issue that introduced the 1980s. As the decade began, the modernist paradigm, in retreat since the 1960s, appeared to have been finished off in America by the Conceptual and Minimal strategies of the 1960s and 70s. The international center-stage was now being claimed by an aggressive European representationalism that displayed all the superficial characteristics of historicizing mimeticism that modernism was thought to have laid to rest decades ago. The critical controversy that exploded around this new work generated a succession of critical repartees that had audiences on both sides of the Atlantic eagerly awaiting the latest developments. In Europe the discussion was framed by curators and critics on several levels simultaneously: in terms of aesthetic values; as a revolt against an American cultural hegemony of the postwar era; and, perhaps more sensationally, in Germany

in terms of the propriety of an art with a national identity, one that engaged and exorcised the demons associated with fascism and Nazi domination.

On a broader critical plane, at issue was nothing less than the shape and direction of the epistemological structure that informed both art-making and the role of art criticism. While the death of painting had been predicted since the birth of photography in the mid-nineteenth century, no one, to paraphrase Douglas Crimp's observation, had been entirely willing to execute the death warrant. The phenomenological potential of paint and canvas proved to be resilient enough to sustain the detailed inquiries of abstraction, Surrealism, Minimalism, Conceptual Art and various fertile cross-combinations within the boundaries of the modernist enterprise well into the postwar era. But with reductivist and perceptual strategies dominating the 1960s, painting's terminal condition finally seemed impossible to avoid. Even under the protective wing of a postmodern pluralism, the vitality of painting was difficult to sustain. If the outcome of the modernist endeavor was the exhaustion to the point of extinction of the formal possibilities for artistic expression, painting was the principal casualty.

The devalorization of modernism had nevertheless created a condition that was alternately seen, in the late 1970s, as the end of art or the herald of a new postmodernism free from the tyranny of the modernist hegemony and available to a new language of critical reference. The closure suggested by Minimalist and Conceptual Art at the end of the 1960s was forestalled by various recombinative strategies in the 1970s, but none with the power to establish that new frame of reference. What was lacking was a convincing coda and interpretive framework based on an interplay between a vital and authentic contemporary art, on the one hand, and a criticism that provided a theoretical location for it, on the other. The poststructuralist literary discourse in the 1970s had established the imminency of such a development, but its promise had so far been unable to deliver a viable mediation between its theoretical potential and the various manifestations in the practical world of contemporary art. Thomas Lawson's description of the dilemma that artists faced at the end of the 1970s and beginning of the 1980s effectively captures the characteristics of the situation of art-making adrift from an effective critical context.

> [Artists] can continue to believe in the traditional institutions of culture, most conveniently identified with easel painting, and in effect register a blind contentment with the ways things are. They can dabble in "pluralism," that last holdout of an exhausted modernism, choosing from an assortment of attractive labels — Narrative Art, Pattern and Decoration, New Image, New Wave, Naive Nouveau, Energism — the style most suited to their own, self-referential purposes. Or, more frankly engaged in exploiting the last manneristic twitches of modernism, they can resuscitate the idea of abstract painting. Or, taking a more critical stance, they can invest their faith in the subversive potential of those radical manifestations of modern art labeled Miminalism and Conceptualism. But what if these, too, appear hopelessly compromised, mired in the predictability of their conventions, subject to an academicism or a sentimentality every bit as regressive as that adhering to the idea of Fine Art?[1]

1 Lawson, Thomas. "Last Exit: 'Painting.'" *Artforum* (October 1981): 40.

One of the unique features of the German assault on the international art consciousness in the early 1980s was that it created an opportunity for the critical debate to unfold and to compete with its own ironies — the most obvious of which was the appearance of an obsolete convention and a decadent style aspiring to describe a radical definition of the avant-garde. Another was the scale and dimension of the German situation. The claims being made for the new German painting, particularly for an art that indulged figurative convention, as "the true home for radical art today,"[2] to use Donald Kuspit's words, depended on a sophisticated manifestation with an authenticity and presence that was confirmed by its own accumulated history — which is what the new German painting possessed. In other words, the special circumstances of a postmodern paradigmatic shift required an engagement between an authentic art and a credible critical reference. But as long as the dominating critical reference placed conditions before an art that denied it a priori a meaningful context, most practical strategies, in Lawson's words again, would "appear hopelessly compromised, mired in the predictability of their conventions, subject to an academicism or a sentimentality every bit as regressive as that adhering to the idea of Fine Art,"[3] in short, a prisoner of its own self-consciousness.

The new German painting was important precisely because if it were to be "the true home for radical art," as its advocates claimed, it could do so only if a new-modern paradigm, with a critical language and frame of reference grounded in a historical relevance, were able emerge to describe it. The crucial precondition for the new paradigm would be the resolution of the dilemma posed by the exhaustion of modernism, on the one hand, and the need to have the art of the present confirmed in the same terms as the art of the past, on the other. The new German painting used history and presence to challenge the structure of contemporary art-history. It was finally the demands of this critical adjustment that placed the issue of figurative painting in such sharp relief.

If modernism was originally rooted in artistic intuition, its development had been accompanied by the evolution of an acute critical consciousness vis-à-vis the nature of art that was expressed in a history of art formulated in strict and demanding terms, and it had come to enjoy existence dominated by its explicit history. The exhaustion of the modernist enterprise in art was predicated on the *inherent and finite* possibilities for formal expression, not on the *inherent and infinite* abilities of a discourse to provide a rationalization. The exhaustion of modernism did not erase the need for a critical structure to provide a historical rationale that had come to be expected from the formalist critique. The problem was essentially an art-historical one, but dependent on the spontaneous appearance of a mode of expression worthy of engagement, an art with the power to establish its presence in advance of and independent from its critical framework. It was the unusual combination of

the history of the new German figurative painting, its claim to authenticity, the passionate if sometimes misdirected advocacy that it inspired, its obvious historicizing and its ability to manifest a dominant presence that forced the confrontation between the painting and its critical framework, with implications for a profound epistemological shift.

Phenomenon

Although German figurative painting swept the international scene at the end of the 1970s and in the early 1980s, one of its distinctive features, in fact the foundation of its success, was a history in practice that went back to the 1950s. By virtue of its lateral and chronological reach, the new German painting enjoyed a reputation for authenticity exempting it from the ontological anxiety that came with various postmodern "strategies" trapped in the highly self-conscious context of art-making in New York in the 1970s. Figurative painting had been the medium of artists like Georg Baselitz, Markus Lüpertz, K. H. Hödicke and Bernd Koberling for almost two decades, and the work of Konrad Klapheck, Gerhard Richter and Sigmar Polke featured figurative elements for even longer. Figurative painting was contained within Germany for most of the 1960s and 1970s, largely unknown to an international audience, but nevertheless informed by, and placed in opposition to, the attitudes of the international avant-garde. Abstract Expressionism, introduced to Berlin in 1958 in an exhibition at the Hochschule der Künste, corroborated *Art Informel* and led to the entrenchment of *Tachisme* in Germany, it provoked a resistance based in a strong tradition of German realism going back to the early part of the century. Berlin provided the context for various new kinds of figurative and representational art known for example as Critical Realism, Dramatic Realism, a term that was first used to describe the work of Baselitz and Schönebeck in the early 1960s or Richter's and Polke's ironic Capitalist Realism. Baselitz and Schönebeck produced the *Pandämonium* manifesto in 1961, but not until 1966 and the exhibition of the large painting *The Great Friends* at the Galerie Springer, was Baselitz recognized as a progenitor of bold contrarian ideas. Lüpertz, Hödicke, Koberling and twelve other younger artists working in figurative or realist modes established the Galerie Grossgörschen 35 in 1964, which took its place in a vigorous and adventurous gallery structure that provided the backdrop for exhibitions of American Pop Art, Fluxus events, Beuys performances, the German group ZERO and other Minimal and constructivist manifestations.

Despite the richness of the German context in Berlin and Dusseldorf, it was not until the end of the 1970s that the international profile of German figurative painting began to change — rapidly and dramatically. In 1979 Rudi Fuchs presented Baselitz's recent work abroad at the Van Abbemuseum in Eindhoven, an exhibition called *Ugly Realism* appeared at the Institute of Contemporary Art in London, and Nicholas Serota organized a show of Lüpertz's still-life paintings for Whitechapel and an exhibition of Baselitz sculpture with Max Beckmann paintings the following year. The summer of 1980 saw the pivotal exhibition of work by Baselitz and Anselm Kiefer in the German pavilion at the Biennale in Venice and the

2 Kuspit, Donald B. "Flak from the 'Radicals': The American Case Against Current German Painting." In *Expressions: New Art from Germany — Baselitz, Immendorff, Kiefer, Lüpertz, Penck*, exh. cat., St. Louis Art Museum (St. Louis and Munich, 1983): 55.

3 Lawson: 40.

60/80 survey of European art at the Stedelijk in Amsterdam, organized also by Fuchs. Inspired by the interests of Serota and Norman Rosenthal, and through them the German curator Christos Joachimides, London continued to play a leading role in stimulating international interest in new figurative painting. Paul Maenz introduced the Mühlheimer Freiheit to the art world at his gallery in Cologne, and exhibitions of this group were followed up the next year in Sweden and Freiburg. The first major international museum success for this "new" art came in 1981 with the exhibition entitled *A New Spirit in Painting* organized by Joachimides, Rosenthal and Serota for the Royal Academy; eleven German painters dominated the cast of thirty-eight artists from six countries selected for the exhibition. A major show of recent German art took place in 1981 in Paris at the Musée d'Art Moderne de la Ville de Paris. In 1982 *Documenta 7* was dominated by German artists, and Joachimides and Rosenthal struck again with *Zeitgeist* at the Martin-Gropius-Bau in Berlin. Of the forty-five artists shown in Berlin, twenty-two were German, and but for Beuys, all of them primarily painters. With the *Expressions: New Art from Germany* exhibition of the work of Baselitz, Jörg Immendorff, A. R. Penck, Lüpertz and Kiefer at the Saint Louis Art Museum in 1983, followed by *Origen y visión: Nueva pintura alemana* at the Palacio Velázquez in Madrid in 1984, the meteoric rise of German figurative painting to international prominence was established as an indisputable if nevertheless controversial fact.

Despite, or, perhaps more accurately, because of its prominence on the international scene, the new German figurative art was "fiercely opposed right from the start," as Kuspit described it in his accounting of the critical debate that unfolded in its wake.[4] The strength of the reaction to the work is important, for the controversy reflects the conditions that described both the art and the criticism of the time, and the conditions were the pretext for the controversy. Its timing was crucial. In the broadest possible sense, the popular success of German figurative painting intersected with the crisis prompted by the subsidence of the power of the modernist paradigm. Had the critical framework for contemporary art not been under attack at the very time that this mode of representational picture-making appeared in force on the international scene (not as a new manifestation as much as a discovery or rediscovery in an expanded context of what was heretofore regarded as a regional or backward art), it is unlikely that either critics or artists would have felt as vulnerable to the challenge that figurative painting presented at the beginning of the 1980s. In short, the rapid rise to prominence of the new German art crystallized issues that lay at the foundation of contemporary artistic and critical discourse. The question of the validity of figurative modes of expression at the end of the twentieth century could not be considered outside the province of critical inquiry; German figurative painting was the territory for debate. The rules of engagement were less specific, involving, as they did, a discussion whose range was perhaps as important as its various conclusions, for its tenor and stridency contributed in no small way to the stature and significance of the new figurative work.

4 Kuspit, "Flak from the 'Radicals'": 43.

I.

The principal contestants in the international critical debate were Kuspit and Benjamin Buchloh, the former by virtue of his persistent attention to the topic, the latter on the strength of a penetrating Marxist critique. Kuspit and Buchloh demand particular attention because they both understood the implications of an exhausted modernism and its central importance to art historical discourse. While Kuspit appeared to be the enthusiast and Buchloh the cynic in their writing on German painting, in reality their positions were reversed. In the face of the modernist collapse, Buchloh argues idealistically for an open-ended conception of the dialectic. Pointing to examples in the history of art in the twentieth century, he claims that the current exhaustion of an inherently subversive modernist attitude was a recurring event. In a true Hegelian sense, therefore, the posssibility of a continuous series of oppositions was theoretically limitless. His concept of art is not bounded by the finite conventions of a material world. It is predicated on the notion of intuitive challenge as a necessary condition of existence. Kuspit, on the other hand, also saw the end of modernism and believes we inhabit a world of limited artistic conventions. His longing for tangible objectness cannot accommodate the dilemma posed by an immaterial concept of radicality. Kuspit cannot disguise his nostalgia for painting as a primal act of making, though his despondency is obscured by the enthusiasm of his attack.

Buchloh's polemic is based on an insightful, if selective, Marxist reading of history that is systematically organized to attack the obvious and superficial characteristics demonstrated by an oeuvre that threatened the adversarial stance that a radical art had traditionally maintained against the cultural status quo. The Marxist model sees the function of aesthetic production as exclusively subversive, committed to perpetual opposition to activities or attitudes that support the existing power structure. Notions of aesthetic hierarchy, historical value or artistic mastery, to the degree they contribute to or support a prevailing cultural enterprise, are regarded as forms of an elitist exercise of authoritarian power. The new German painting, in Buchloh's view, internalizes these characteristics and practices, generating a "climate of authoritarianism" that is disguised by an ineffectual assortment of competing postmodern ideas.

> If the current debate does not place these phenomena in historical context, if it does not see through the eagerness with which we are assured from all sides that the avantgarde has completed its mission and has been accorded a position of comfort within a pluralism of meanings and aesthetic masquerades, then it will become complicit in the creation of a climate of desperation and passivity. The ideology of postmodernism seems to forget the subtle and manifest political oppression which is necessary to save the existing power structure.

Buchloh builds his argument on three points. First, by challenging what he regards as the misconceptions and misrepresentations of the true substance of historical modernism, he offers a reading of art history that differs significantly from the established canon. His point is that the modernist paradigm has been subject to periodic breakdowns throughout the history of its development, and the latest episode of exhaustion, by implication, may be nothing more than a temporary recidiv-

ism. Loss of historical momentum, he argues, is usually met by a panic that supports itself with a call for a return to traditional values of craft and representation. Citing examples from the early part of the twentieth century, he argues that "their own academicization and the actual exhaustion of the historical significance of their work" prompted artists like Pablo Picasso, André Derain, Carlo Carrà and Gino Severini to call for "a return of traditional values" that resulted in a "stubborn refusal to recognize the epistemological consequences of their own work." Therefore, the present cannot justify a "retrograde contemporary" art whose newness "consists precisely in [its] current historical availability, not in any actual innovation of artistic practice."

On a second front, he attacks aesthetic justifications for the new German painting by demonstrating that the prevailing critical perspective relies on "critical clichés" and "manufactured visions," on an obsolete critical language of "false naiveté and bloated trivialities which forms the terminology of the new subjectivity." With particular emphasis he attacks both the painters and their early supporters:

> The mock avant-garde of contemporary European painters now benefits from the ignorance and arrogance of a racket of cultural parvenus who perceive it as their mission to reaffirm the politics of rigid conservatism through cultural legitimation.

Finally, he condemns "the specter of derivativeness hover-[ing] over every contemporary attempt to resurrect figuration, representation, and traditional modes of production." He dismisses the attempt by German painters in particular "to re-establish forlorn aesthetic positions" and immediately situates them in "historical secondariness … [the] primary function of [which] … is the confirmation of the hieratics of ideological domination."

The strength of Buchloh's critique stems from his recognition that the new German painting was more than a rudderless exploration in the context of devalorized postmodern conditions, but rather represented nothing less than a frontal assault on the nature of contemporary discourse.

> This appearance of a unified pictorial representation, homogeneous in mode, material, and style, is treacherous, supplying as it does aesthetic pleasure as false consciousness, or vice versa. If the modernist work provides the viewer with perceptual clues to all its material, procedural, formal, and ideological qualities as part of its modernist program, which therefore gives the viewer an experience of increased presence and autonomy of the self, then the historicist work pretends to a successful resolution of the modernist dilemma of aesthetic self-negation, particularization, and restriction to detail.5

The proponents of the new figurative painting can also be identified on levels of critical language and argument that closely approximate those of their opponents, although with a fundamentally different purpose. Together these opposing views offer a discursive countervalence that neatly balances the discussion, and presents a picture of the rhetorical range and territory of the critical debate that came to surround new German figurative art once it appeared on the international scene.

For example, in response not to Buchloh's article, which did not appear until 1981, but rather to the near universal condemnation in the German art press of the Kiefer and Baselitz exhibition at the 1980 Venice Biennale, Bazon Brock offered a defense of the new German painting. This was based on an original reading of the historical relationship between tradition and the avant-garde that is in fact a synthesis of a Marxist analysis, but turned upside down by what Brock describes as a fundamentally German tendency to treat purely intellectual designs as actual realities. This tendency "to read philosophy and artistic works as if they were down-to-earth operating manuals for the translation of ideas and imaginary constructs into reality," is a function, he claims, of a historical "lack of tradition and control that had to result from a rejection of the new." In other words, it emanates from an absence of a viable avant-garde, which he claims never really existed in Germany. Brock's analysis identifies a functional flaw in the German national psyche — he argues that Germans are by temperament not inclined to engage in an effective political dialectic. His criticism is not a critique of a discourse as much as it is a challenge to a historical condition of political inaction. He seeks to place in a political context the negative response to the work of new German figurative painters who dared to confront an establishment (that of the modernist paradigm) that rejects any reference to or discussion of the most difficult aspects of Germany's past. Brock would argue, like Hegel and Buchloh, that a capacity for political opposition is missing from the German character; he accepts the radicality of the new German painting in terms of an unromantic reading of modernism that shows it inherently dependent on a condition of specific restriction, one of a "clearly defined and historically unique period." Modernism, therefore, "is an attempt to understand artistic problems as exclusively immanent, for example, as purely formal problems. But, he continues,

> … if one asks why the artists of a given period deal as they do with formal problems, one cannot help but pose questions other than those about formal problems. Nobody has yet succeeded in seeing art works purely in terms of formal problems.6

In other words, since traditional formalist notions of modernism are irrelevant to the situation, by revealing that irrelevance the new German painters are practicing a politically challenging art.

Brock and Buchloh speak back and forth at one another, rather than to one another. They both see subversion or opposition as the essential social function for the act of aesthetic production, but they each place the implications of this perception at the service of diametrically opposed positions. For Buchloh the German painters, by indulging in bourgeois conventions, have abandoned radical notions. For Brock indulging in bourgeois conventions is the radical mechanism for exposing a mentality of repression.

5 Buchloh, Benjamin H. D. "Figures of Authority, Ciphers of Regression: Notes on the Return of Representation in European Painting." *October* 16 (1981): 120.

6 Brock, Bazon. "The End of the Avant-Garde? And So the End of Tradition. Notes on the Present 'Kulturkampf' in West Germany." *Artforum* (June 1981): 63.

2.

A second level of support for the new German painting was provided by a cast of European curators, critics and exhibition organizers responsible for the initial presentation of the new German art to an international, as compared to a specifically German, audience. As its early champions had it, the new German painting was nothing less than catharsis, redemption and salvation — and the return of the Romantic spirit of Richard Wagner and Caspar David Friedrich to overthrow the American hegemony of the postwar years. For a brief time at the end of the 1970s and the beginning of the 1980s the new figurative work was promoted to an international audience with the fever of a religious awakening. In Kiefer's work Fuchs found the painter as "guardian angel carrying the palette in blessing over the world."[7] Joachimides wrote nostalgically of "studios... full of paint pots again," of artists finding a "new consciousness" of the "oldest form of their art," and invoked the vision of an earlier era by recalling German art as "a gash of fire... governed by an expressive vision and by a feeling for the world marked by Romanticism."[8] For Norman Rosenthal the art was "a therapeutic activity, a means towards a better, more optimistic form of life."[9] Wolfgang Max Faust saw the new German painting as a heroic mediation, an inspired intervention between "Star Wars and unemployment, the terror of the mass media and the ecological crisis, the exploitation of the Third World and ... a quest for new identities."[10]

If the early advocacy of the new German figurative art involved more passion than critique, it was predicated on three basic elements — nostalgia and longing for a past power, authenticity and the reification of the radicality of painting — and operated in terms of the following process: The power of painting as the primal artistic act was rediscovered and then presented as the only vital and indispensable means of free artistic expression; references to the specifics of the German political and social situation were invoked to establish its authenticity; and once established as authentic, the phenomenon of German figurative painting was validated as the most radical recent development in a discourse that had until now been unable to produce a radical mediation of the modernist/postmodernist incongruity. In other words, through a post-modern inversion, the traditional means become the most radical. The degree to which these basic points had already been systematically built upon in setting up a coordinated and legitimate critical structure for the new painting was not really considered in this kind of inquiry, which was generally more exposition than analysis. Much of the writing that accompanied the early exhibitions and reviews of German figurative painting indulged in romantic and hyperbolic claims for the primacy of painting (part of what Buchloh scornfully refers to as "critical

clichés" and "manufactured visions" in support of the new art) that ultimately cannot be defended as helping to establish a substantive critical basis for this work. Yet these claims are important to note because they situate the phenomenon of figurative art at the center of a popular fascination, which is one of the primary factors that lends presence to the occurrence of German figurative painting. But when Fuchs writes that

> Painting is salvation. It represents freedom of thought which is triumphant expression The painter is a guardian angel carrying the palette in blessing over the world;[11]

or when Kuspit declares that

> [German art] is clearly an art about the power of paint to create a perverse poetry — the power of paint to conjure images that overpower and force the spectator to look beyond his ordinary perception and everyday fantasies. It is about the power that paint, used with raw force, has in and of itself on a purely material level. It is about the power... that painting, which is all too regularly declared to be on its last legs, can still have — even when one uses it in a culturally predictable way. The Germans show that painting is still of value for an understanding of the complexity of the concept of art;[12]

or when Faust claims that only through painting can an attitude toward society which he calls "productively anarchic" be expressed;[13] or when Hilton Kramer sees painterly expressionism as a salvation for a contemporary malaise because it is

> a medium of discovery and exploration. It exults in painting's physical properties, which it looks to as a means of generating images and stirring the emotions. Above all, it has a hearty appetite for the metaphysical and the mysterious;[14]

art criticism is on the verge of surrendering to an entirely uncritical bias. While enthusiasm and promotional excess are unavoidable in the advocacy of a problematic art, and indeed play a role in establishing a presence for that art, when aesthetic passion and a longing to recapture lost worlds replaces a critical incisiveness as the principal criterion in the evaluation of an art, the vitality and relevance of this criticism are jeopardized.

If this second level of commentary was promotional and demonstrated faith in traditional modes of art-making, a correlative counterpoint was the glib descriptive syntax developed in reaction to the exuberance and uncritical hubris with which the new painting was initially presented to an international audience. It is tempting to compare the advocates at this level of commentary with their counterparts in the opposition. William Feaver, a critic who seems to have a special problem with Rosenthal's presentations of the new painting in London and Berlin, criticizes the *Zeitgeist* exhibition with the flair of a pop movie reviewer; claiming, in a language and tone more suggestive of Tom Wolfe than Leo Steinberg, that the success of new German painting was essentially facile and counterfeit, driven more by market concerns than by any innovative conceptual considerations.

7 Fuchs, R. H. *Anselm Kiefer* (Venice, 1980): 62.

8 Joachimides, Christos. "A Gash of Fire Across the World." In *German Art in the 20th Century 1905-1985*, exh. cat., Christos Joachimides, Norman Rosenthal and Wieland Schmied, eds., Royal Academy of Arts, London (Munich, 1985): 12.

9 Rosenthal, Norman. "A Will to Art in the 20th Century." In ibid.: 13.

10 Faust, Wolfgang Max. "'Du hast keine Chance. Nutze sie!' With It and Against It: Tendencies in Recent German Art." *Artforum* (September 1981): 33.

11 Fuchs: 62.

12 Kuspit, Donald. "Acts of Aggression, German Painting Today, Part I." *Art in America* (September 1982): 144.

13 Faust: 36.

14 Kramer, Hilton. "Signs of Passion." In *Zeitgeist*, exh. cat. Martin-Gropius-Bau, Berlin (New York, 1983): 16.

This triumph was celebrated with a feast of ersatz expression-ism. Speedway paintings with so many stylistic quotes per square foot, trenchant paints with bombs, crucifixions and soft swastikas for kicks, flip paintings with characters seemingly derived from Dr. Seuss leaping about at random, all showed how certain trends are fast becoming endemic. Output is all important here. The art world market is being fed with Georg Baselitz and Rainer Fetting and A. R. Penck and K. H. Hödicke at a reckless pace. By keeping up the pressure, the dealers are deciding the issue.[15]

In a response to the Royal Academy's *A New Spirit in Painting* exhibition, Feaver saw the Germans as "poised to take-off world wide" and sardonically observed,

Theirs is an opportunistic *zeitgeist*. . . . They paint big because that's the way to command attention, seem convincing and (most important) get sufficient wall space and coverage. Lebensraum it used to be called. By dint of repetition, notions are made assured.[16]

3.

The advocates of the new German painting were on firmer ground when they sought legitimization for the work in histori-cal terms, as the expression of an authentic contemporary voice raised on behalf of a suspended cultural identity. These themes were the focal point of the third level of commentary, this one grounded in more parochial aesthetic and traditional art-his-torical terminology and generally accepting the viability of fig-urative painting while debating many of its specific details, characteristics and points of reference and inspiration as they appear in the work of individual artists. This level of criticism is ineluctably drawn to the notion of historical reference, par-ticularly to the Nazi past, and to historical allegory, as it be-comes an implement for cultivating narrative mythologies, a practice valorized, of course, by the dominant presence of Joseph Beuys. Inevitably this line of analysis led to the conclu-sion that the new German painting was radical precisely be-cause it *depended* on contact with Germany's political situa-tion and, just as important, on a connection to German art of an earlier era. Through this interaction two primary objectives were achieved: authenticity, and through authenticity, rele-vancy. This relevancy, it should be noted, depended in turn on the notion of a basically perverse postmodern radicality that reversed the traditional superficial or syntactical characteristics of a conventional and revolutionary art. By demonstrating that this art conscientiously engaged a forbidden history, on a metaphoric, allegorical and technical level simultaneously, these critics claimed that the artists were both radical in a formal sense, since they stood up to the modernist paradigm, and courageous in a humanistic sense, for forcing an encounter with Germany's past. The obvious equation to historical specificity refers to history as subject and art as catharsis. Every commentary devotes at least a paragraph or two to recapitulating history. Germany, deceived by Hitler, seduced and dominated by fascism, and destroyed during the War,

spent the first two postwar decades accommodating to a di-vided country and capital, rebuilding its economy, and follow-ing the lead of its former enemies in matters of finance and culture. Its authentic voice was stifled by amnesia, guilt and the good common sense that committed it to maximizing its post-war assets whatever the long-term costs. Thus we have Rosen-thal affirming

The artists of the post-war period who perhaps best represent the German spirit are those who, taking the fullest cognizance of the horrors of this century, incorporate with both irony and respect a reverence for the healing powers of the artist and the resonant cultural tradition of Europe;[17]

and Siegfried Gohr stating

In Nazi Germany . . . modern art and artists were defamed and driven out of the country, destroying even that small freedom to produce art independent of the official line which had been so laboriously achieved since 1880. This is a problem that, though it has been discussed by influential commentators on the history of German art has up to now been treated in only very general terms;[18]

or Faust remarking

After the Second World War, as a result of barbarian Nazi policy, Germany had almost no vanguard art, and turned to one international stream after another for nourishment. France, then the United States and the revival of past phases of the international pre-war avant-gardes became the fixed points around which West German art revolved. . . . To put it bluntly, the art that rapidly established itself in West Germany after the war reflected the power structures of resurgent capitalism.[19]

In one form or another, the authenticity of the relation be-tween the historical and artistic situations in Germany was the central issue on which rested critical support for the new fig-urative painting. This view placed specifically *non art-histori-cal* history at the center of an art-historical rationalization by suggesting that in a postmodern world formalist, quasiscien-tific exploration of the signifying potential of a medium is replaced by an authentic engagement of personal and historical reality.

Gohr, for one, took pains to anticipate the formalist critique by directly challenging what he felt were the most obvious criticisms of the new German painting, which were that it stood accused on two points: as a relapse into representation-alism in reaction to the dominations of Abstract Expressionism and *Art Informel;* and as a return to expressionism. But he further controlled the context for his own criticism by exempt-ing German art from the standards that modernism had im-posed and relying on its special history.

. . . German art cannot be adequately outlined in terms of those categories and stylistic developments which in earlier centuries proved so useful when applied to Italian and, later, to French art. If we agree that historical situations affect art, then these situations must be used to judge it.[20]

15 Feaver, William. "Dispirit of the Times." *Art News* (February 1983): 83.

16 Feaver, William. "A 'New Spirit' — Or Just a Tired Ghost? *"Art News* (May 1981): 115.

17 Rosenthal. "A Will to Art in the Twentieth Century." In *German Art in the 20th Century*: 20.

18 Gohr, Siegfried. "The Difficulties of German Painting With Its Own Tradi-tion." *In Expressions: New Art from Germany*: 30.

19 Faust: 33.

20 Gohr: 30.

If the German art-historians developed the most conventional defenses of German figurative painting, they did so from perhaps the most difficult position. As art historians they were sensitive to the demands of critical inquiry and the criteria defining internationally "important" art during the 1960s and 1970s. On the other hand, a vital and internationally significant German art of any formal structure created possibilities for historical exegesis that were impossible to ignore. As a result, the question of authenticity became a critical fulcrum, by means of which other issues could be raised. The establishment of authenticity performed three functions: it legitimized a concern with historical research, the kind of art history that was born in Germany; it encouraged a discussion that focussed on the alignment of social values, another preoccupation of traditional art-historical inquiry; and third, it opened the door to a contemporary discourse that had been missing from German culture for more than a half century.

4.

A fourth critique operates principally from a philosophical and theoretical plateau. It appears to be the most disinterested and in many ways the most skeptical, not specifically of the phenomenon of new German figurative art, but generally of the kind of response it represented to the collapse of the modernist paradigm. These critiques argue against the notion of an effective postmodernism in general terms, citing the inherent contradictions between non-innovative syntactical maneuvers and the formalist notions of a radical opposition upon which conceptions of art history in the twentieth century are essentially built. Crimp, in one of the better examples of the genre, builds a model of the end of painting on the contrast between painting as "a high art, a universal art, a liberal art, ... an art through which we can achieve transcendence and catharsis," and painting as opposition to "the myths of high art ... [and] contingent upon the real, historical world." Crimp's purpose is to discredit "the myth of man and the ideology of humanism which it supports" because these are "notions that sustain the dominant bourgeois culture."[21] In an analysis based on a comparison between the paintings of Frank Stella and Daniel Buren, Crimp sees various postmodern strategies as increasingly hysterical holding-actions against the inevitable death of painting: "only a miracle can prevent it from coming to an end."[22]

Craig Owens, arguing from a similar perspective, contends that various poststructuralist strategies, and by extension various postmodern figurative strategies, cannot be absorbed by art history without "a total transformation of art history itself."[23] Since art history collaborates with power (Buchloh and Crimp) in the legitimization and perpetuation of the predominance of Western culture's enshrinement of humanistic thought, art history would never allow a reduction of its own powers of authority by embracing attitudes that question and perhaps invalidate the history upon which that authority is based. Owens's synthesis of elements of the poststructuralist discourse of Michel Foucault dates his critique, but reflects nevertheless a level of argument against the new figurative painting based on elements of sophisticated philosophical and historical discursive thinking, including a historical Marxism without the overtly political polemics, and on an analysis of paradigmatic structures of modernism, postmodernism, art history, art-making and structuralism, to recognize the more authoritative themes. This commentary tends to move toward the critical ground-zero upon which the major epistemological positions are staked out, the domain where the question of the radicality of German figurative art was the most pressing issue.

Certainly the most sustained defense of German painting takes place in Kuspit's writing. Kuspit's principal antagonist is Buchloh, and by extension, other formalist critics who cannot accept either a devitalized art or a figurative challenge to the modernist paradigm. Kuspit claims that their arguments are predicated on an analytical strategy that fails to recognize its own vested interest in perpetuating an "ineffectual, directionless criticism – a criticality that no longer really knows its own goals." This argument claims that the formalist conception of history is flawed because it refuses to acknowledge its complicity in perpetuating a version of a power structure upon which their own authority is based.

> ... these critics are not sufficiently self critical to see their own approaches as conventional and traditional to the point of being obsolete, which is why they may be unable to see the critical point of the new German painting. These critics above all intend to deny its vanguard character, because to acknowledge its radicality would mean for them to deny their own. They have an unwittingly ahistorical and thus subtly irrelevant conception of avant-garde radicality. They refuse to see themselves as traditionalists loyal to the old cause of Modernism, for then they would have to see themselves, rather than the Germans, as decadent. Unwilling to re-examine the concept of avant-garde intention, they regard the new German painting as a simulated vanguardism, succeeding only in its deception because it looks "different" at the moment.[24]

Kuspit has attempted to turn the modernist critique against its disciples without acknowledging the inherent irony of his own position; while he recognizes the exhaustion of the formalist invention, he refuses to abandon the fundamental modernist notion of dialectical opposition. He attacks Buchloh in particular, but also the positions represented by Crimp and by Owens, with the passion of a born-again modernist. Kuspit closed his case by maintaining that the urgency of the art had been met by an urgent critique, and that by 1981 "neither theoretical nor art historical comprehensiveness was at stake."[25] Seven years later, however, the implications of his claim for an "innovative framework" for German figurative art are still unclear.

There finally is a level of intense interplay among commentators like Kuspit, Buchloh and Brock that specifically sought to place the new German painting in a definitive context. More disinterested but no less relevant theoretical positions were engaged by Crimp, Owens and others not mentioned here, to

21 Crimp, Douglas. "The End of Painting." *October* 16 (1981): 75.

22 Ibid.: 83.

23 Owens, Craig. "Representation, Appropriation, and Power." *Art in America* (May 1982): 9.

24 Kuspit, "Acts of Aggression": 142.

25 Kuspit, "Flak from the 'Radicals'": 540.

raise the level of the debate. Kuspit's call for greater detail in dealing with the art has been sustained by art-historical analysis by Gohr and others in numerous exhibition catalogues and art journals, with the best reflections demonstrated in the monographs on Kiefer, Richter and Polke that have accompanied recent retrospectives of their work in the United States, Germany and France.

Passionate advocacy of an art that is no longer regarded as "new" has of course abated, but the questions raised by the phenomenon of German figurative painting at the beginning of the decade have not been satisfactorily resolved. The art world has inexorably moved on. But the impact of the work and the scale of the debate still open themselves to discursive analysis, particularly as the high practitioners moved toward the hallowed category of "modern masters." The review above of major critical positions posed by German figurative art in the early 1980s demonstrates that for all the differences, for all the polemical, rhetorical flourish that the various positions displayed, for all the differing perspectives and attitudes upon which the multiple arguments were based, and after irrelevant conclusions are discounted, only two possible positions can describe the interplay. Either the new German figurative art could be seen as a decadent, derivative and repetitive enterprise that ignored the fundamental lessons of modernism and brazenly indulged the conventions of a bourgeois art for its recognizable and marketable historical referents — or it was a logical extension of the modernist discourse in a context altered by the exhaustion of critical language.

If it were to prove true that the "new" painting demanded that entirely new and possibly fictive frames of reference be established to explain it, a new critical language, sensitive enough to the discursive possibilities of reading history in a postmodern context, but authoritative enough to satisfy the expectations generated by the rigorous modernist critique, would have to be developed. As both Crimp and Owens have pointed out, however, an effective postmodern art-critical discourse could maintain its vitality only at the expense of an established canon upon which its authority as a critical language could be based. At the heart of the paradox was the problem that Owens described as the basic incompatibility between modern and postmodern notions: "...the post-structuralist critique could not possibly be absorbed by art history without a significant reduction in its polemical force, or without a total transformation of art history itself."[26]

If the critique has indeed been absorbed by art history, the "total transformation" has never been recorded. Far from censuring subjective meanings derived from a poststructuralist critique that demands that reading itself be acknowledged as part of the interpretive act, contemporary art-history has developed into an industry that seems to thrive on it. The question of the power of its polemical force is another matter. Postmodernist attitudes have unquestionably placed the notion of a dialectical determinism in jeopardy. Whether art history still needs to depend on the authority of such visions clearly remains to be seen.

In the face of this paradox, however, the options suggested by the square-off between German figurative art and the criti-

cal reaction to it seem to be hopelessly obsolete. A logical explanation is a perception of the interplay that steps outside the either/or context of the confrontation between contemporary art and contemporary art-history and sees them as partners in a historic enterprise. This synthesis acknowledges the implications not only of a devalorized modernism, but of a concurrent reduction of the power and impact of the art-historical enterprise. Specifically with regard to painting, it is predicated in equal parts on the systematic marketing of the art object in contemporary society, on a fundamental perception that the range of formalist art-making strategies is restricted and finite, and on a skeptical commitment to the act of painting as play, suggested by Richter's description of painting as "pure idiocy."

It would be a mistake to understand the interplay between contemporary art and art criticism as essentially a succession of exchanges among disparate practices of esoteric discourse — the material and textual modes of demonstrating attitudes of abstraction and representation. High art, as it is brought to our attention with increasing insistence, is mediated by a market. And markets, we are learning, facilitate the distribution of information as well as of goods and services and the objects of material culture. When the dynamics of the exchange between art and criticism are understood as part of a triangular constellation that includes the market, and not a bipolar relationship based on the contest and exchange between art and its critical/historical frame of reference, the complexity of the emergence and international presence of the new German painting takes on additional dimensions.

The fact is that the phenomenal success of the new German painting was based on its market performance, the collective votes of confidence that were cast by exhibition organizers, gallerists, museum directors, collectors and the ever-increasing art-consuming general public. Artists have always wanted 1) to make history and 2) to make money. The contemporary appetite for art has upset the modernist axis that chose to emphasize the former and ignore the latter.

Traditionally, when new art emerged to challenge the status quo, it sought a critical justification that could make it either more or less appealing to collectors and dealers. When artists, dealers, curators or collectors spoke about quality, they also meant art history, which suggests that enduring quality required a determinant historical frame of reference against which it could be measured. Art was made to be seen and sold, but that was secondary. The subordinate function of the market was to distribute the object. In a contemporary context, however, the object information, historical worth and practical value are all more or less linked together on equal terms. This alliance depends on a controlled disequilibrium. The art continues its attempt to be challenging and remain beyond the reach of conventional aesthetics (but not far enough out to prevent it from being bought, sold, performed, analyzed or discussed); the criticism seeks to locate it by expanding the frame of reference in a historically coherent direction (which means both forward and backward because the multifaceted information function of art includes the ability to present historical reference to its audience in a contemporary context); and the market places value relative to the degree to which the art and its criticism continue to authenticate the magnitude of the achievement.

26 Owens: 9.

This new world, which really is not so new, is a world where information is imparted by both the artist and by the reader; where prime formal strategies are recognized as finite; where the velocity and scope of the markets emphasize the value of the object as a transmitter of historical information rather than of historical significance; where the art object must adjust to a less exalted status without surrendering its subversive potential; where the modernist historical code must give way to a less imperious standard without abandoning its mediative and interpretive function. In a world such as this, an epistemological shift has already occurred. The special significance of the German figurative art of the last thirty years may therefore reside not in the range of formal invention it was able to articulate, but in the obvious lack of such abilities. It is an art that has successfully operated in a postmodern situation, content to carry the potential for subversive and inventive activity without having to flaunt it as its primary reason for being.

That the modernist enterprise, inextricably tied to the history of the history of art, was based on a finite set of formal propositions has become more than a hypothesis — it is the very condition of the contemporary environment to which artists and critics have been forced to adjust. Three decades ago, with prophetic clarity, George Kubler envisioned the postmodern situation with a profound insight about the limits of the modernist enterprise. Kubler pointed out that the traditional position of art history, that of the discovery and systematic chronological and stylistic categorization of works of art, will no longer be relevant once the archeological process of discovering and recording is more or less complete.

> The historical study of art in systematic principles is about two thousand years old if we include Vitruvius and Pliny. This accumulated knowledge now far surpasses the ability of any individuals to encompass its detail. It is unlikely that many major artists remain to be discovered. Each generation of course continues to reevaluate those positions of the past which bear upon present concerns, but the process does not uncover towering new figures in the familiar categories so much as it reveals unfamiliar types of artistic effort, each with its own new biographical roster.[27]

The implication of Kubler's observations is that while the facts of art history are more or less completely known up to the present, interpretations of that information will continue to depend upon the uses that contemporary society will find for them. Similarly

> Radical innovations may perhaps not continue to appear with the frequency we have come to expect in the past century. It is possibly true that the potentialities of form and meaning in human society have all been sketched out at one time and place or another, in more or less complete projections.... Were this hypothesis to be verified, it would radically affect our conception of the history of art. Instead of occupying an expanding universe of forms, which is the contemporary artist's happy but premature assumption, we would be seen to inhabit a finite world of limited possibilities, still largely unexplored, yet open to adventure and discovery, like the polar wastes long before their human settlement.

Should the ratio between discovered positions and undiscovered ones in human affairs greatly favor the former, then the relation of the future to the past would radically alter. Instead of regarding the past as a microscopic annex to a future of astronomical magnitudes, we would have to envisage a future with limited room for change, and these of types to which the past already yields the key. The history of things would then assume an importance now assigned only to the strategy of profitable inventions.[28]

Kubler's brilliance was to see that a perception of the boundaries of formal invention did not necessarily invalidate the enterprise, but simply indicated a shift in strategic assumptions. Rather than obsess itself with a strategy of invention, he suggests that art has a history to mine, that the excavation of expressive potential performs the salubrious function of communicating with the past.

If the art object has become a commodity, and if the depreciation of radical innovation appears to have diminished the historical relevance of painting, the expansion of the historical frame encourages sustenance of the engagement. German painting no longer displays the radical presence it commanded in 1982. It has been moderated from all sides. The urgency regarding its relationship to the avant-garde, though still unresolved, is no longer a concern. The artists have been provoked into more complicated positions. A second and third generation of figurative painters have emerged to challenge the conventions and attitudes of the original group, but hardly with the passion of a frontal attack. The work of painters such as Norbert Tadeusz, Christa Näher and Michael Buthe, who missed the glare of the spotlight ten years ago, now offer other dimensions to the discourse. The rediscovery of the complex attitudes of Polke and Richter testify to the final irrelevance of historical categorization.

The critical context for new German painting is then not only demystified, but the political and social atmosphere in which the art was made in the first place and provided its authenticity, recedes in significance as well. The situation is now interesting because of its complexity and at times beguiling virtuosity within the restricted and artificial frame of the medium of painting. The viewer may watch and admire whatever information can be retrieved from the obscure surface, "pure idiocy" so artfully displayed; the viewer may excavate from that same surface a rationale for a new political or social project; or, as Gerhard Richter says, "One can look away."[29] The artist's engagement of the medium with determination, or with luck, may result in a sufficiently significant intervention in the field to stir the genius of authenticity, of criticism, of history. Within the context of the medium of history is established the history of the medium — against which finally the personal history is painted. Just as Jasper Johns no longer paints against art history in any modernist sense, Georg Baselitz paints only against himself and against his earlier paintings, against his earlier authenticity. The important thing is to paint long enough to have a history.

27 Kubler, George. *The Shape of Time* (New Haven and London, 1962): 123.

28 Ibid.: 125.

29 Dietrich, Dorothea. "Gerhard Richter: An Interview," *The Print Collector's Newsletter* (September-October 1985): 130.

Blasphemy on Our Side
Fates of the Figure in Postwar German Painting

Joseph Thompson

While I was painting the sewing machine in my simply furnished apartment in Versailles, it dawned on me that the picture had become something more than the image of a modest home appliance. In the feminine lines of the sewing machine's body, in the shimmering knobs, thread guides and needle, I recognized Lilo again, with whom I had just broken off in a fight. A part of our troubles had made their way into the picture, which came to be known to —me and I promised then to tell no one — as The Offended Bride. — KONRAD KLAPHECK

Since 1955, Konrad Klapheck has created a precise system of *maschinenbilder* in which intensely seen, intensely remembered appliances are painted in hieratic isolation. Appearing in 1955-57, at the height of all-over, abstractionist painting, and before Pop Art had found its American, one-off, disposable imagery, Klapheck's works should be read neither as simple reactions to international abstract tendencies, nor as ironic statements about a materialistic world. Rather, his images are portraits and landscapes projected through careful renderings of beautiful machines to which Klapheck bestows monumental presence. Klapheck's implements leap free from the canvas with the wholistic pictorial logic of medieval icons and the visual punch of modern advertisements. The effect, finally, is that of the intensity and magical focus projected from a child's gaze, and, tellingly, when Klapheck speaks of his work, his explanations are interwoven with stories of his childhood and personal past. Psychological association, and the distancing of common objects into alienated objects of special meaning, relate Klapheck to both the Surrealist and Neue Sachlichkeit movements of the pre-War period. André Breton said of his work that, "Towards the machine Klapheck acts like a magician hiding none of his methods..."

Insofar as Klapheck's hard-edged precision and prosaic subject matter stand in formal opposition to the lyrical evocations of the *Informel*, his work also exists as a continuation of a figurative mode which had been cut off by the war and then subsumed in the non-objective vocabulary of the postwar years. *The Offended Bride* (cat. no. 2) is thinly painted, with sharp Ingresque lines, little material presence, and, despite its precise draftsmanship, almost no illusionistic volume. The image remains abstract and is representational only in the sense that a map or a mechanical drawing is representational; and rather than present a pictorial organization in which the whole painting surface is given 'as a single undifferentiated field of interest',[1] Klapheck's imagery unfolds in the sinister configuration of the needle bale, in the tipped-over spool of thread, in the modestly gesturing nude who appears in the shape of a brand-name medallion, and finally in the careful rearrangement of the power switch, which places the toggle slit in a much more anatomically suggestive position than it occupies in the actual sewing machine on which Klapheck modeled this one.

I am always allowing myself to be seduced into painting unbelievably beautiful pictures.
DIETER HACKER

Painting is not justifiable in itself, and I find painting for the sake of painting totally boring.
HELMUT MIDDENDORF

Pictures must be made according to a recipe. The painting must be done without any engagement, just as one would break stones or paint facades. The making process is not an artistic act.
GERHARD RICHTER

The means of painting is color on canvas, Oswald.
MARKUS LÜPERTZ

the work by everything that it is not — nonperformance art, *non-immatériel* and non-site-specific, the works can be hung on almost any large wall; nonindustrial, the mark of the human hand is almost everywhere evident; and non-high-tech, the work is entirely lacking in state-of-the-art, high-technology production values.

The dominant conventionality of *Refigured Painting* is all the more remarkable in view of the Federal Republic of Germany's prominent role in the international avant-garde of the past three decades.[2] Germany, after all, was the home site and

1 Steinberg, Leo. "Other Criteria," in *Other Criteria: Confrontations with 20th Century Art* (London: 1972): 79.

2 From this point on, geopolitically precise nomenclature will give way to a looser, more metaphorical Germany, neither East nor West particularly. There are good reasons for nonspecification. A simple listing of the places of birth and formal education of the artists included in this exhibition, for example, makes a very good showing for the East, and more particularly for Saxony. If sourcing and homeland argue for such vagaries of language, however, then the market, political alignment and art-historical convention urge one to mean the FRG, from which this exhibition is, of course, drawn.

1. Introduction

Although drawn from an epoch of art-making as diverse in media and technique as any in the history of art, *Refigured Painting: The German Image 1960-88* nevertheless settles into distinctly conventional bounds. Indeed, it is tempting to place the entire production under a giant negative sign, cataloging

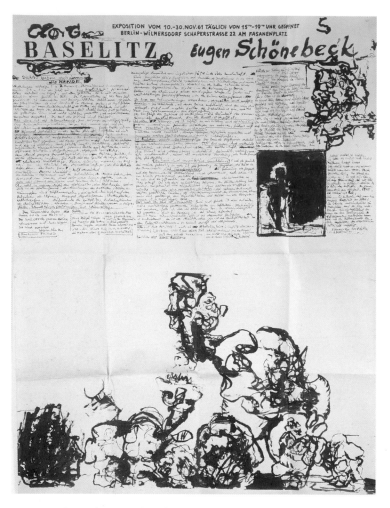

Georg Baselitz and Eugen Schönebeck, *Pandämonium I.* 1961

principal object of Joseph Beuys's vast social sculpture project, a *Gesamtwerk* which occupies perhaps the primary position in European art of the postwar twentieth century. Beyond Beuys, the entire idiom of performance-based and nonobject art was developed as early and has been taken as far in Germany as anywhere else. In 1962, for example, the Städtisches Museum in Wiesbaden was the site of the first Fluxus manifestation, the *Festum Fluxorum*, and the internationalist currents of that movement, represented by George Maciunas, Robert Filliou, Dick Higgins, Emmett Williams, Allan Kaprow, George Brecht, Toshi Ichiyanagi, Giuseppe Chiari, Milan Knizak and Willem de Ridder, among many others, always flowed through Germany, where Maciunas earned the United States Air Force paycheck he used to subsidize the promotion and organization of the loose-knit group. Moreover Nam June Paik, Wolf Vostell and Ben Patterson had a strong presence in Cologne, and it was at Darmstadt in 1959 that La Monte Young was introduced to the work of John Cage.[3]

While Fluxus was spreading through Germany and across Europe, Japan and the United States, the SPUR group in Munich — Dieter Kunzelmann, Lothar Fischer, Heimrad Prem and H. P. Zimmer — was engaged in a highly charged, socially

motivated art that earned them their arrest and conviction for blasphemy and abuse of religion. And in Berlin on November 10, 1961 — one day after the arrest of the SPUR antagonists and three months after the construction of the Berlin Wall — Georg Baselitz and Eugen Schönebeck staged *Pandämonium*, a small exhibitory event in a decrepit Berlin-Wilmersdorf attic studio rented specially for the occasion.

Publicized by a combination poster/manifesto which the artists pasted up in Berlin and mailed to critics all across Europe, *Pandämonium* provoked a negligible public reaction. Schönebeck recalls that the single written response was by the critic Heinz Ohff, and the visitation "averaged about one or two people per day, which was surprisingly many, because we were not known, and the manifestoes only lasted a day or two around the city."[4] The original manifesto itself was an intensely rendered and worked-over sheet six feet high by four feet wide filled with tight-handed, scratchy, Artaudesque text by Baselitz and closely interwoven sketches by both artists, all of it passionately aggressive and contradictory in tone and subject.

> No truck with those who can't wrap art up in a smell. I have no kind word to say to the amiable. They have proceeded by art historical accretion, they have ruled neat lines under things, they have practised mystification with all the passion of a collector....
> We have blasphemy on our side! They have escaped their sickbeds. Their simplifying methods have swept them on to the crest of the waves. The ice beneath the foggy maze is broken. They are all frozen stiff — those who believe in fertility, those who believe in it — those who deny their pens and those who revere them. Fiery furrows in the ice, flowerlike crystals, crisscross icicles, starry sky torn open. Frozen nudes with encrusted skin — trail of spilt blood. The amiable are washed up, deposited as sediment....[5]

The *Pandämonium* exhibition employed an image vocabulary which was to be of central importance to German figurative painting of the next twenty-five years. But it is the manifestation itself of that imagery — its almost unnoticed realization in a space outside the international avant-garde and society at large — which most concerns us here. The figures of Schönebeck, for example, most poignantly realized in his drawings of 1961-63, emerge from a web of lines and pointillistic marks which derive directly from the *Tachiste* and *Art Informel* environment of the Hochschule für Bildende Künste in Berlin, the academy in which Schönebeck had enrolled after moving from the DDR in 1955.[6] We might note in particular the bottom section of the first *Pandämonium*, and the loose, "allover" technique of figure 4, which dates from 1961, the period just prior to the appearance of stand-alone figures. The abrupt, stubborn brushwork which centrifuges out from a seemingly random zone on the page recalls the dense, frag-

3 See Emmett Williams's firsthand account, "St. George and the Fluxus Dragon." In *Aufbrüche: Manifeste, Manifestationen, Positionen in der bildenden Kunst zu Beginn der 60er Jahre in Berlin, Düsseldorf und München*, exh. cat., Städtische Kunsthalle Düsseldorf (Cologne, 1984): 19-39.

4 Discussion with Eugen Schönebeck, December 20, 1988, at Galerie Silvia Menzel, West Berlin.

5 From *Erste Pandämonium* (Berlin, November 1961), as translated in *Aufbrüche*: 171.

6 Hann Trier and Fred Thieler, two of the leading exponents of *Tachisme* and *Informel*, were professors at the Berlin Hochschule für Bildende Kunst from 1957 to 1980 and 1959 to 1981, respectively.

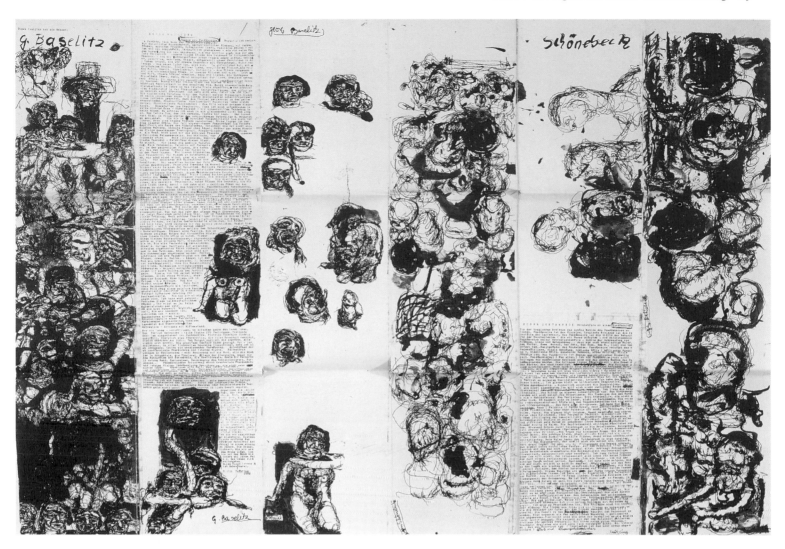

Georg Baselitz and Eugen Schönebeck, *Pandämonium II.* 1963

mentary "wound paintings" of Jean Fautrier and Wols, and the aggressive marking techniques of Chaim Soutine, to whom Schönebeck looked as an alternative model to the "dogma of *Informel.*[7]" Out of these pictorial openings — which can be considered as metaphorical passages from an essentially 1950s *Informel* space — began to emerge, by 1962, an array of figural creatures, elephant-headed, amputated, congenitally deformed, with eyes and extremities seemingly pressed back into body and bone by the slashing brushwork itself.

We see very clearly in these early works the moment at which Schönebeck, together with Baselitz, assumed an unequivocal, provocative position counter to the then dominant mode of abstraction. Schönebeck's troubling body-stumps arise to challenge all those amiable critics and artists who, as noted in the *Pandämonium* manifesto, "have proceeded by art historical accretion, have ruled neat lines under things, and have practised mystification with all the passion of a collector." Against the Ecole de Paris and against the rational world of the *burgerliche* "Economic Miracle" — whose most glittering moment, we should recall, was showcased in the early 1960s in the heavily underwritten economic oasis of West Ber-

lin — Schönebeck posited a personal vision much more closely tied to Goya's than to Trier's, a world from the gut in which monsters arise from the sleep of reason. Like scenes from Lautréamont's *Songs of Maldoror,* the stunted, ruinous themes of Schönebeck proclaim an alternate and desperate *Menschenbild,* an inhabited pictorial space which vaunts the little mutant horrors repressed in the *Wirtschaftswunder* but alive outside of it. This was a vision very precisely and consciously alien to the mainstream of formalism, the figural bodies occupying a pictorial territory in which the marking structure of *Informel* was literally denied, an outsider's space which Schönebeck also articulates in this statement about his relationship to Baselitz in the early 60s

> Our relationship at that time consisted in shaking each other up to raise our energy levels. We put ourselves into extreme situations; we cultivated an extreme antibourgeois attitude. We wanted to provoke. We wanted to stand out. Because we were outsiders and no one took any notice of us. There was definitely something adolescent about it.[8]

Schönebeck's defective humanoids and Baselitz's monumentally perverse antiheroes not only established a pandemoniac

7 Discussion with Schönebeck, December 20, 1988.

8 Quoted by Faust, Wolfgang Max. In "Die exemplarische Biographie des Eugen Schönebeck." *Wolkenkratzer* 2 (1987): 66.

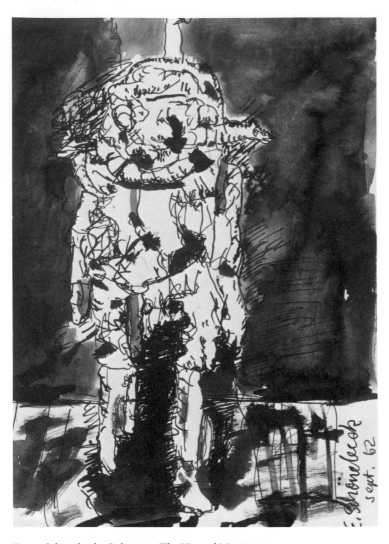

Eugen Schönebeck, *Gehängter* (The Hanged Man). 1962

world far removed from the amiable dogma of "allover" abstraction, but it also carried the artists themselves outside the law. Specifically, the Schönebeck/Baselitz program, "blasphemy on its side," drew the attention of the public prosecutor in a 1963 exhibition at the gallery of Michael Werner and Benjamin Katz, when Baselitz's *Big Night Down the Drain* was confiscated because of its magnificently aggrandized phallic motif. It was in the act of figuration, then — an ironic, anti-illusionistic act of image making — that Schönebeck and Baselitz discovered a mode of artistic operation which closely corresponded to their self-images as radical antibourgeois *provocateurs*.

In the Germany of the early 1960s other important, extra-painterly positions were established. In Dusseldorf, Otto Piene, Günther Uecker and Heinz Mack (under the group name ZERO) brought forth a cool, conceptually based response to the highly wrought, international style of abstraction represented by the Abstract Expressionists and their European counterparts working in the *Informel* and *Tachiste* styles. Using light and kinetic sculpture, focussing on minimalistic forms and restricted color choice, ZERO meant to establish a sort of aesthetic tabula rasa, where art could be mixed with radiant light and motion at the onset of a new and hopeful age. The browns and dark gray greens of *Informel* were thus rejected for

pure white, and Utopian, continental-scaled productions of light and movement were planned.

Also in Dusseldorf Konrad Fischer-Lueg teamed up with Gerhard Richter and later Sigmar Polke to advance what they called Capitalist Realism, in which the consumerist reality of a materially refined and sophisticated Western world was both emulated and questioned in a variety of techniques that included performances as well as painting. While Fischer-Lueg would soon become Konrad Fischer the successful gallerist, and while Richter and Polke developed into formally inventive painters of major standing (represented in this exhibition and discussed further below), it is important for the present argument to note that their work had, at a critical early moment, a strong extra-painterly component as closely tied to politicosocial commentary as it was to formal inquiry.

It is clear, then, that within the media-rich, nontraditional context of the post-1960 international art-scene, and particularly within the context of Germany itself, *Refigured Painting*, as an assemblage of objects, appears distinctly circumscribed. The exhibition is composed almost entirely of four-square paintings, pigment on canvas on stretcher. Closely demarcated by format, the exhibition is restricted by forms as well: In almost none of the paintings do representation and narrative impulse yield to pure abstraction, and in almost every work recognizable figural elements are situated within a discrete pictorial space. Across the exhibition, conventional format and pictorial structure recall established painterly traditions, and the critical and marketing nomenclature associated with the work — Neo-Expressionism, Neo-Fauvism, Die neuen Wilden — seconds the idea that recent German art continues where other historical painting movements left off. The exhibition reads as counterpoint, and sometimes as reaction, to the main lines of the international avant-garde.

One might further point out that the sheer square-footage of ambitious, well-painted canvas produced from the Rhine to the Schnee during the past three decades is an astonishing phenomenon in the recent history of art, parallels for which one might find in mid-nineteenth-century France during the age of the great Salons, when national identity was also at stake, when history-invoking scale was an important criterion, and when every stroke of the brush was licked by tradition and guided by craft, much as it is again in Germany today. Other parallels might be found in Paris during the 1910s and 20s, or New York in the 1940s and 50s, when important movements in painting quickly coalesced into professional, quasi-institutionalized coalitions of surprising organization and control. This is to say that the combined aesthetic project represented by *Refigured Painting* has all the characteristics of what once would have been called an academy, but which in the twentieth century is better described structurally as a nexus of cultural, social, political and economic interests giving rise to a vibrant scene — a scene in which independent positions are created, taught and widely followed, constituencies are formed, and markets sustained.[9]

9 For a measure of the substantial importance of real art academies in postwar Germany see Rattenmeyer, Volker. "Kunstakademien: Ihre Bedeutung für die Kunstentwicklung in der Bundesrepublik am Beispiel von Karlsruhe und Düsseldorf." In *Kunst in der Bundesrepublik Deutschland, 1945-1985*, exh. cat., Nationalgalerie Berlin (Berlin, 1985); 646-54.

2. *Figur Politik*

The most penetrating critique linking new German painting to past styles, and, ultimately, to past ideologies, is Benjamin H. D. Buchloh's "Figures of Authority, Ciphers of Regression."[10] Buchloh equates figurative tendencies in German art to fascism. His observations, always trenchant, are worth quoting from at length.

> The reference to expressionism in contemporary West German art is the natural move to make at a time when the myth of cultural identity is to be established specifically against the dominance of American art during the entire period of reconstruction. Since the Second World·War, expressionism, the German intuition of early twentieth-century modern painting, has received increasing esteem. It had of course lacked just this esteem in the post-World War I period, prior to its eventual suppression under fascism. But during the early sixties skyrocketing prices indicated that expressionism had achieved the status of a national treasure, the best of the pre-Fascist heritage of German culture. As opposed to the political radicalism of Berlin dada, expressionism presented an avant-garde position acceptable to the newly reconstituted upper middle class, and it thus became the key object for historical study, collection and speculation. The apolitical humanitarian stance of the expressionist artists, their devotion to spiritual regeneration, their critique of technology, and their romanticization of exotic and primal experience perfectly accorded with the desire for an art that would provide spiritual salvation from the daily experience of alienation resulting from the dynamic reconstruction of postwar capitalism.[11]

Buchloh asks whether there is a causal connection "by which growing political oppression necessarily and irreversibly generates traditional representation." With a sense of trepidation he wonders whether "the brutal increase of restrictions in socioeconomic and political life unavoidably result in the bleak anonymity and passivity of the compulsively mimetic modes that we witness, for example, in European painting of the mid-1920s and early 1930s."[12] Buchloh's attack on figurative painting as retrograde and politically suspect rigorously formulates a critique that runs beneath the surface of much of the analysis (particularly American) of German figurative painting. The politics of figuration reaches its other extreme in Donald Kuspit's 1983 riposte to Buchloh's attack (which Kuspit termed "a Marxist blitzkrieg"), in "Flak from the 'Radicals': The American Case Against Current German Painting."[13] In that article, Kuspit resorts to drastic critical gymnastics in order to situate new German expressionism as "the true home for radical art today." Along the way he generalizes and hyperbolizes the work into the great cure for the German problem, for which abstraction is no more than a placebo.

> The new German painters perform an extraordinary service for the German people. They lay to rest the ghosts — profound as only the monstrous can be — of German style, culture, and

Eugen Schönebeck, *Untitled.* 1961

history, so that the people can be authentically new.... They can now identify themselves without first being identified as the "strange Others." They can be freed of a past identity by artistically reliving it. The new German painting naturalizes a de-natured abstract notion of "being German," without first forcing a new German nature upon us.... to see these pictures is to be confronted with the special necessity and special freedom of the Germanic today. Indeed, it is the same necessity and freedom that constitutes us all, for we are all increasingly possessed by an abstract past that we must transcend. Above all, we are increasingly possessed by the demonic power of abstraction. It makes us forget our potential for naturalness, which, for all its uncertainty, is more of a clue to our future than the certainty our abstract knowledge gives us. The new German painters want to recover this apparently specious naturalness because they regard it as the only alternative to an abstractness that has made us hollow.[14]

Polemically spirited, both positions leave us at sea with respect to the paintings and painters themselves, grouping ideologically that which defies categorization and avoiding completely the visual issues of what these pictures actually look like. Even if one acknowledges its history-seeking features, an extraordinary aspect of *Refigured Painting*, for example, is the intensity with which its imagery resists established relation-

10 Buchloh, Benjamin H. D. "Figures of Authority, Ciphers of Regression: Notes on the Return of Representation in European Painting." *October* 16 (1981): 39-68).

11 Ibid.

12 Ibid.

13 In *Expressions: New Art from Germany — Baselitz, Immendorff, Kiefer, Lüpertz, Penck*, exh. cat., Saint Louis Art Museum (Saint Louis and Munich, 1983): 43-55.

14 Ibid.: 46.

ships of figure to ground. Scanning the show, one comes face to face with an astonishing abundance of free-floating figural signs: strong shapes which systematically avoid the grounding properties of perspectival lines; laconic, mechanico-serial icons overlaid onto visually unrelated fields; formulaic Pop Art motifs transcribed into rich, painterly "significant forms"; cartoonish characters and art-world caricatures; unfettered stick people suspended on the canvas like algebraic signs in a state of permanent disequivalence; and angular, aggressively colored silhouettes dispersed across the pictorial field with fluid, full-arm strokes of the brush. All lushly painted, and without doubt figural, the dominant images of this exhibition nevertheless remain unhinged from ground, drifting fragments of narrative intent.

Indeed, the most compelling forms within this show systematically isolate themselves from the material, compositional and brushstroke-based concordance with ground that has been a fundamental assumption of both figurative and nonfigurative painting throughout the twentieth century.[15] Figures and forms are repeatedly rendered with a straightforward, stubborn simplicity verging on the banal. Images consistently emerge with the direct force of advertising art. Pictorial structures are almost without exception precisely construed. Figure to ground relationships, however, often remain ambivalent, defined neither by composition nor by the organizing stroke of the brush. Whether it is Schönebeck's *The Hanged Man*, in which the human figure is physically maligned and stunted as if by the act of painting itself, the actual body parts losing out to a fury of painterly jabs; or whether it is Norbert Tadeusz's 1963 *Woman on a Bed*, in which the supine nude is tipped forward into vertical contact with the picture surface (in this case, an American surface, or more precisely the Californian surface of Richard Diebenkorn and David Park, whom Tadeusz much admires), so that she neither sleeps nor stands, her bed becoming neither solid nor void; or whether it is Markus Lüpertz's *Ratman*, in which the main actors swirl in an aqueous, gravity-free space; or whether it is Georg Herold's *Egypt* (cat. no. 168), in which the entire Sahara is summed up with the lapidary gesture of two thin brushstokes making delicate triangles, brief signs for great pyramids; or whether, finally, it is Anselm Kiefer's *Ways of Worldly Wisdom: Arminius's Battle* (cat. no. 177), the vast papered plane of the picture ground becoming a physical equivalent for segmented cultural *Heimat*, which is then punctured by an array of high-Germanic hero portraits, the faces and deep forest spatially eliding into a cul-

tural memory landscape — in each instance, the major figural elements find their place neither within illusionist pictorial space, nor within the physical matrix of the work's materiality. Neither window nor billboard, the pictorial structures offer their figural elements neither an illusionistic envelope of space, nor a flat surface on which they can sit like bits of informational appliqué.

Time and again in recent German painting we see the fates of the figure launched with little regard for the unity of a pictorial entity; with some consistency, however, these works remain allusive in a way that is more coherent than not, alluding in particular to the communicative prospect of the figure on ground, though there is no consensus at all across the exhibition as to what is to be done with the figure, how it is to be presented in its decisive moment, how and upon what it is to be grounded. Many options are pursued, few of them following the primary concern of modernist painting, the formal prerequisite which, while endlessly deferred, is ultimately self-referential — the pure stroke of the brush, the overall material complex, the submersion of the figure in the playful enterprise of formal manipulation. This nostalgia of form which characterizes modernist painting in its purist state, the endless self-reference which is modernism's most fulsome and pleasing moment, is generally absent from *Refigured Painting*.[16] In this context, it is important to note that there was no Clement Greenberg for German figurative art, no clear critical voice to articulate and bundle its primary desire. Nor was there a Frank Stella or Jasper Johns, or any other maker of objects who set such an unequivocal path with respect to the phenomenological requirements of post-1950s German painting, that it could become anything like Pop Art or Mimimalism. Instead refigured painting exists as a series of varied responses — sometimes grouped in philosophical and geographical nodes — to the particular German situation in the decade following the end of World War II.

It is therefore important to recognize that as much as the figure — as a symbol for illusionistic, representational, anti-conceptual, antiabstractionist art, as the marker of a retrograde position, or as the harbinger of postmodernist possibilities — is discussed and debated, figure *qua* figure is not at all the issue in recent German painting. What is at issue throughout this exhibition is the specific means by which oil on canvas might communicate meaning in a period poised between the petro-chemical and information ages, and in a country that is forced to struggle, perhaps forever, as a postwar nation. The breadth and diversity of the exhibition further reveal how, in Germany between 1960 and 1988, painting cannot be understood as a genre — as a unified field of aesthetic activity. Recent German figurative painting breaks down into a field much more complex than that of nonsculpture, nonperformance or nonconcept art. While German figurative painting of the past three decades is a matter of image making that advances recognizable, representational shapes within varying types of narrative structure, the nature of figuration in post-

15 For a discussion of the history of figuration in twentieth-century art, see Kertess, Klauss. "The Other Tradition." In *The Figurative Fifties: New York Figurative Expressionism*, exh. cat., Newport Harbor Art Museum and Pennsylvania Academy of Fine Arts, (Newport Harbor, 1988): 17-24. Kertess traces the influence of the figurative styles of Henri Matisse, Pierre Bonnard and Edouard Vuillard on Alex Katz, Jane Freilicher, Larry Rivers and Fairfield Porter. He also finds important links between the American figurative painters of the 1940s and 50s to Max Weber and Max Beckmann (shown by Alfred H. Barr, Jr. at The Museum of Modern Art, New York, in 1931), and to an earlier generation of Americans, including Milton Avery and Marsden Hartley. The Kertess article establishes a continuity of style and form specifically denied to the German figurative painters by World War II, to whom Baselitz referred as a "fatherless generation."

16 Lyotard, Jean François. *The Postmodern Condition: A Report on Knowledge*, vol. 10, *Theory & History of Literature*. Geoff Bennington and Brian Massumi, trans. (Minneapolis, 1984): especially 79-82.

1950s German painting nevertheless remains more important and problematic than a simple dialectic between representation and abstraction, illusionism and critical practice or romanticism and analytical progress. To understand the means and motives of German figurative painting from 1960 to 1988 is to understand it quite specifically as a postwar or — even more precisely as a post-1950s — phenomenon.

3. Figuration and Postwar Germany

In postwar German painting of the 1940s and 50s, political and cultural ideology materialized in the painted figure. Progressive, obviously postfascist positions were associated with international modernism, which was in turn linked to specific forms of abstract painterly expressiveness and, more generally, to a certain agitated physicality of pigment on ground.[17] A kind of postwar cultural vertigo translated into a sweeping acceptance of abstractionist tendencies, and the result was an abundance of dense, paint-strewn canvases loaded down with pigment and the seeming gestures of freedom. And within this cultural construct, the narrative consequence of "objective" painting was subsumed in the material truth of pigment on ground.

In 1945 the critic Werner Haftmann asked "whether or not in view of the completeness of the collapse and devastation, the deeper mutuality of the creative forces had also been destroyed," and Alfred Hentzen wrote that the German situation in 1945 could not be compared to 1919, because the soul-destroying cultural policies of National Socialism had left behind a tabula rasa. It was impossible to take up where on had left off in 1933.[18] Willi Baumeister's diary from October 20, 1945, reads

> The year 1945 did not bring with it the kind of general artistic rebirth that took place in 1919. The energy of creative individuals was impaired by years of systematic humbug and intimidation. The young had seen no real contemporary art. Klee and Kandinsky had died abroad; Schlemmer had died in Germany; Kirchner had shot himself in Switzerland....[19]

The issue facing postwar artists, as laid out by Haftmann, Hentzen and Baumeister, was how to recover from a near total break with the national cultural heritage and a near total loss of international cultural legitimacy. What ensued in the postwar vacuum was a remarkable debate about the place of the figure in postwar painting, a debate in which the figure, im-

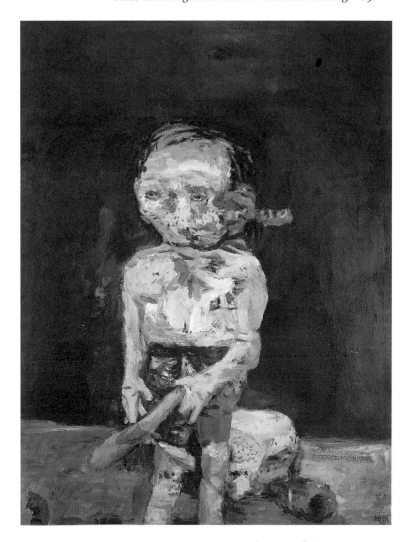

Georg Baselitz, *Die große Nacht im Eimer* (Big Night Down the Drain). 1962-63

bued with the representational bias of a retrograde, Hitler-tainted program, arose from the canvas as a sort of place marker of the immediate past, while abstraction or, more precisely, nonfiguration, blessed by the absence of the figure, represented the future.

Within the debate about objective versus nonobjective painting, nonfiguration came to be understood as incorporating the free gesture, the spirit of internationalism and finally the political symbolism of a reconstructed world. As Dieter Honisch has formulated it

> The artists realized that people no longer wanted to live in bombed ruins but in new buildings. They began either to renovate what was left standing in our towns and cities or to clear away [the rubble] and reconstruct. The first way was easier inasmuch as they could keep to the old blueprints and ground plans without, however, really knowing whether or not the old materials were able to carry the load. The second way was more difficult.[20]

It is important, however, to distinguish here between the meaning of the debate about figuration — and especially the meaning of the term "figuration" — with the actual articula-

17 The term figurations is often associated with the human form, shapes on the canvas looking more or less like people. Figurative painting is also often used as a catchword for images containing pictorial narrative-painting that is not nonobjective, but rather painting has the capacity to represent recognizable scenes from the world around us. Against these broad associations, there exists a much narrower and more technical meaning for figuration which concerns the visually distinct appearance of shapes against a flat ground. Thus, completely abstract paintings, painting populated by no one, telling no recognizable story, can still have "figures" which may be pointed to with a finger. This essay uses the term in all its various meanings, with the precise usage given explicitly, or made clear by context.

18 Quoted by Trier, Eduard. In *Kunst in der Bundesrepublik Deutschland*: 10.

19 *Baumeister* (Cologne, 1971): 189.

20 "Auf der Suche nach der eigenen Identität." In *Kunst in der Bundesrepublik Deutschland*: 17.

tion of the figure itself in paint.[21] As Siegfried Gohr has pointed out, the terms of debate were often more polarized than was apparent in the painting itself. "Nearly every large general exhibition gave rise to a quarrel about ideology. The argument, however, could not be resolved, since it rested on humanistic debates about the human image. If one looks closely at the apparently opposing trends, an odd and unexpected harmony becomes apparent...."[22] This prospective harmony was noted by some observers even in the heat of the moment. The Viennese art historian Gotthard Jedlicka, for example, closed the famous "Darmstadt Debate" of July 1950 with the observation that, "Figurative and abstract art had to and indeed could exist side by side. For figurative painting today contains much that is abstract."[23]

The issue, as Jedlicka suggested, was thus never so much whether or not to paint figurative objects, although the figure was always important as a symbolic point of discussion. Within the debate about objective painting the figure represented nonabstraction, but from 1945 to 1955, abstraction became conflated with the obvious recognition of the painting surface itself, and with the materiality of paint on ground heavily handled. Therefore, figuration and nonobjective painting were not, in practice, mutually exclusive, and indeed a strong tradition of figurative painting developed under the protective cover of the material truth of paint on canvas. In the representational works of Carl Hofer and Werner Heldt, as well as in the *Informel* surfaces of Emil Schumacher, figural and objective elements — which for now might be broadly defined as any referential element within the pictorial field having the capacity to narrate meaning beyond pure form — were almost always articulated by more than contour, more than line and local color, and more than modeling and conventional perspectival formulae. While the figure was indicated by all these techniques, it was also established three-dimensionally, in the very rising of pigment from the canvas surface.

Perhaps the most telling example of the conflation of figurative and nonobjective painterly strategies is found in the work of Baumeister himself, who became the leading German proponent of abstract painting in the postwar years, and yet whose work reveals a continuing interest in the tension between flat abstraction and allegorical figuration, a tension played out in a literal loading of the canvas surface with material presence. The figural participants in Baumeister's *Atlantis,* for example, are built up in thick brushstrokes against a thin blue aquatic background. Embodied in paint, the highly abstracted fish and rocks and trident-bearing gods become a pure augmentation upon the surface, a clear example of the figurative elision into pure materiality which characterizes much of postwar German painting. One might even say that impasto, as a material presence, had become a matter of aesthetic, quasipolitical convention, and it was indeed materiality — thick painting — rather than nonfiguration that distinguishes the German painting production of the postwar years.

There were of course other nonobjective conventions operating, even in the work of Germany's most accomplished postwar painters — artists of the quality of Fritz Winter, Werner Heldt or Baumeister. The French models provided by *Informel* and *Tachisme* — Jean Dubuffet, Nicolas de Staël and Pierre Soulages — were vital for the approach they offered to the overall canvas surface. American Abstract Expressionism was also quoted and emulated.[24] Color choice owed much to German Expressionist experiments of the first three decades of the century, and in the Verist work of Ehmsen and Radziwill, potentially powerful depictions of urban destruction yielded to the familiar tropes of Surrealism: Elision of form, exaggeration of shape and radical juxtaposition of disparate objects were used like a screen to separate the actual German situation from its painted image. In the face of the dominant forms of international modernism, in other words, the capacity to create a unique imagery, matched to the unique conditions of physical and cultural depletion, was simply not present in the decade following Germany's surrender.

The West German novelist and draftsman Günther Grass has provided a first-hand recollection and analysis of the issues surrounding postwar German painting in a speech delivered from his chair as president of the Akademie der Künste in Berlin on May 6, 1985, the fortieth anniversary of Nazi Germany's capitulation. In a passage that merits full quotation, Grass places his own experience as a yong German painter in the context of Germany's postwar situation:

> When I moved to Berlin as a young sculptor in January 1953, the arts were in some danger of drifting into vapidity. In literature, the familiar sound of whispering grass was winning all the prizes, and authors like Wolfgang Köppen and Arno Schmidt were left out in the cold; in visual art Modernism was very much to the fore, but only on condition that it presented itself in an abstract form. All that unpleasantness was safely behind us, and the less that was seen of it the better. Ciphers, yes. Ornaments, by all means. Materials and structures galore. Pure form. Just nothing too explicit, that was all: nothing that might hurt. There was no Dix, no Kirchner, no Beckmann, to force the remembered horror back into the picture.
>
> The controversy in the early 1950s between the "objective" painter Carl Hofer and the apologist of the "nonobjective," Will Grohmann, extended into the ranks of the Künstlerbund. This was no ordinary artistic dispute. It was about the perception or nonperception of reality, as seen in a country that was defeated and divided, that had genocide on its conscience, and that, in spite or because of this, was busily engaged in repressing — or, as I say, making nonobjective — all that might evoke the past and act as a drag on its headlong retreat into the future.
>
> There came into being a strange, composite avant-garde: the avant-garde of streamlined technical progress, dedicated to

21 The most recent attempt to document the postwar situation was the exhibition and catalogue *Kunst in der Bundesrepublik Deutschland, 1945-1985,* Nationalgalerie, Berlin, 1985. The catalogue is extremely thorough, and unlike the Royal Academy of Arts, London, exhibition *German Art in the 20th Century, Painting and Sculpture, 1905-1985,* which took place in the same year, takes a broad documentary and sociological approach, rather than a hierarchical and selective point of view.

22 Gohr. "Art in the Post-War Period." In *Kunst in der Bundesrepublik Deutschland:* 466.

23 As reported in *Die Zeit* (August 3, 1950): 5; quoted in *Kunst in der Bundesrepublik Deutschland:* 474.

24 Which, it is interesting to note, the Guggenheim Museum was responsible for bringing to Germany with the traveling exhibition *An exhibition of paintings from the Solomon R. Guggenheim Museum, New York* in 1958.

economic growth, and the avant-garde of the large-format, reality-masking canvas. Very soon, the walls of executive suites all over the country — everywhere that a Beckmann triptych might have broken the bank — were hung with pompously titled specimens of vapidity, perfectly adapted to the architecture and the *Zeitgeist* of reconstruction.

Meanwhile, over in the German Democratic Republic, there was a "Socialist Realism" that depicted anything but reality. And so, in spite of antithetical labels, an all-German consensus was taking shape: the nonobjective carried all before it. On both sides of the border, anyone who put things as they really were into his pictures, anyone who rubbed himself up against reality, was ruled out of court. It was Will Grohmann, not Carl Hofer, who had the last word. It may seem curious today, but then it was a fact of life: in internal politics the power structures of a sovereign State were being reestablished, and at the same time, for external consumption, an uncritical avant-garde, all of whose conflicts were formal ones, was presented as evidence of the new Germany's modernity and openness to the world.[25]

A unique painterly response to the German situation not forthcoming, available aesthetic models would be taken from the shelf as ready formal links between postwar Germany and mainline international modernism. As Grass suggests, the lack of serious critical introspection is implicit in the very terms of the aesthetic debate that did occur, those terms focussing on the figure and the narrow issue of whether it should or should not be included in painted imagery, rather than how figurative imagery might be given a new and reconsidered context.[26] Given the international priority of form, the real task for the Germans was the creation of expository structures powerful enough to undertake the reconstruction of a legitimate German culture — a job requiring narrative tools capable of developing themes of drastic personal and national loss — all within the language of form laid down by the central tenets of modernism. The easiest way to speak of those issues was to reduce them to simple distinctions based on the use of recognizable figures, though the reality of postwar German painting is far more complex.

Figures themselves, when they made their appearance, were often painted in a manner that drew heavily on imported styles. Thus the linkages to the sanctified territory of modernism were more often than not clearly apparent even in the most illusionistic of postwar painting. Theodor Adorno, who also participated in the "Darmstadt Debate," made use of early twentieth-century formalist arguments as a means of establishing the postwar German nations' continuity with the world, in the face of dominating international abstractionist tendencies.

I would go further and say that even the elements of abstract painting have their origin in history and contain within themselves, in a sublimated way, these same elements of the histori-

cal world. In any truly distinguished radical painting, there would be the same multiple levels of meaning as in a traditional work.[27]

Adorno ascribes basic elements of history to the basic elements of abstract art. In Adorno's formulation, abstract painting contains history. This theory parallels that of the New York critic Clement Greenberg, who placed the abstract, two-dimensional canvas surface at the apex of a logical development of art. The idea of an ineluctable material progress in painting, leaning always towards a self-referential two-dimensionality, joined with the political and economic emergence of the United States, investing abstract painting, and the aesthetics of reductionist modernism, with profound political meaning.[28]

America's position of strength in both the aesthetic and geopolitical worlds had come to ensure that the aesthetic and symbolic mode of painting was linked absolutely to the physical and dimensional coordinates of the canvas itself. Indeed, by 1950 the eminent material value of the picture plane was already the most universally accepted assumption of international modernism. In a seminal 1953 text on American Abstract Expressionism, for example, William Seitz could write

Whatever its source, the space which ultimately appears on canvas is conditioned, perhaps first of all, by the medium of painting and by its internal tradition. Since Cézanne it has been a tradition which insisted that space be reconciled with the physical reality of the painted surface.... Of all the structural criteria which provide a bond between the individualism of modern painters, their creation of this "translucent" relational surface, the picture plane, is the most important. So fundamental is it, so taken for granted, that it usually remains on the periphery of discussion.[29]

25 Text reprinted in *Die Zeit* (May 10, 1985): 20-21.

26 Siegfried Gohr, director of the Ludwig Museum, Cologne, has thus observed "... the following conclusion can be drawn: 'Abstraction' and 'Realism' were not what they were alleged to be; both were rather styles, marked by literary-humanistic trends, which pursued certain ideas, but did not introduce a revival of German art. And therein lies the cause of the weakness of a large proportion of post-war art in Germany." "Art in the Post-War Period." In *German Art in the 20th Century, Painting and Sculpture, 1905-1985*, exh. cat., Christos M. Joachimides, Norman Rosenthal and Wieland Schmied, eds., Royal Academy of Arts, London (Munich, 1985): 466.

27 Quoted in the documentation from the "Darmstadt Debate," published in Evers, Hans Gerhard. *Erstes Darmstädter Gespräch, Das Menschenbild in unserer Zeit* (Darmstadt, 1950): 194. Other participants in the discussion of July 15-17, 1950, were Willi Baumeister, Johannes Itten, Hans Hildebrandt, Hans Sedlmayr, Wilhelm Hausenstein and Ottomar Domnick. See also Angela Schneider's cogent and well illustrated essay, "Wege zur Abstraktion: Ausstellungen bei Ottomar Domnick und die Gruppe 'Zen.'" In *Kunst in der Bundesrepublik Deutschland*: 88-105.

28 The battle over figuration is well documented and often discussed in the literature. See particularly Gohr, Siegfried. "Art in the Post-War Period." In *German Art in the 20th Century*. An outstanding documentary source is the chronology compiled for the catalogue of the exhibition *Kunst in der Bundesrepublik Deutschland*, in effect a month by month accounting of contemporary German art and art politics drawn from important primary and secondary sources, with an accompanying bibliography. This catalogue also offers the best compilation extant of essays about postwar German art. It begins a project which still calls for more work, namely a systematic account of the position of international abstraction in the art of the 1940s and 50s. For a systematic analysis of the specific political meanings of abstraction, and in particular American Abstract Expressionism, see Guilbaut, Serge. *How New York Stole the Idea of Modern Art: Abstract Expressionism, Freedom and the Cold War*, Arthur Goldhammer, trans. (Chicago and London, 1983). And finally, for a personal account of the effects of this battle on an insider during the 1960s and 70s, see Hans Albert Peters' essay in this catalogue.

29 Seitz, William C. *Abstract Expressionist Painting in America*. Ph. D. dissertation (Princeton University, 1953). The Seitz text became an underground classic for the Abstract Expressionist generation of the 1950s, and is an important historical source for the ideas that motivated the most important paintings of its time. The major themes of the Seitz text therefore form a pertinent context for the discussion of the post-1950s developments represented in this exhibition. The meaning of the representational vignettes and illusionistic overlays that appear throughout this exhibition is made clearer, for example, in view of Seitz's 1953 assessment that "For a painter

It was of course from precisely this surface — the aesthetic plane established by the medium of painting and by its internal tradition — that Nazi Germany had segregated itself with absolute finitude in 1937. Fascist realism, even in its various modernist forms, never permitted the human figure, or any other figurative element, to be overwhelmed by the ideas and styles and painterly techniques of Cubism, Futurism, Vorticism or any other of the major movements of the twentieth century.[30] Instead, a different set of conventions ruled — conventions for drawing heads, for articulating muscle and machinery, for presenting perspectival systems, all of which converged around state-sanctioned tropes of *ein Deutsches Land und ein Deutsches Volk*.

A post-Nazi German art, therefore, would have to reattain the modernist ground, a ground upon which each stroke of the brush sat up or soaked in but at any rate never dissipated invisibly into narrative imagery. The expressive distance between form and an optically verifiable world had to be unequivocally reasserted in order to establish a clear position counter to that of National Socialism, which was itself defined almost exclusively through condemnation, led by the most determined art critic of the twentieth century, Hitler himself.

> Among the pictures submitted I have observed a number of works which actually lead one to assume that certain people's eyes show them things differently from the way they really are.... I do not want to enter into an argument as to whether or not these people actually do see and perceive things in this way, but in the name of the German people I wish to prohibit such unfortunates, who clearly suffer from defective vision, for trying to foist the products of the faulty observation on to their fellow men as though they were realities, or indeed from dishing them up as "art." No, there are only two possibilities. Either these so-called "artists" really do see things in this way and so believe in what they are representing — if so one would have to investigate whether their eye defects have arisen by mechanical means or through heredity; in the former case these unfortunate people are profoundly to be pitied; in the latter it would be a matter of great concern for the Reich Ministry of the Interior, which would then have to consider ways of putting a stop to the further transmission of such appalling defects of vision — or perhaps, on the other hand, they themselves do not believe in the reality of such impressions, but have other reasons for inflicting the humbug on the nation, in which case it would constitute an offense falling within the area of the criminal law....[31]

Within this frame of reference it becomes absolutely clear why figures, when they emerged on canvas, had to appear fully

conjoined with the material requisites of a loaded, expressive brush. Thick paint and "allover" designs signaled "material truth," and honesty to form signified *Modernismus ex-fascismus*. Typical of the postwar period is the group that called itself, quite tellingly, the Junger Westen — the Young Western — whose members painted in more or less derivative styles ranging from Action Painting to warmed-over Surrealism. Few of their number will be readily recalled: Gustav Deppe, Emil Kieß, Thomas Grochowiak, Ernst Hermanns, Emil Schumacher, Heinrich Siepmann, Herbert Berke, Hans Werdehausen.

Even in the work of the best of the postwar generation, the representational impulse is checked by "material truth." Thus, whether it is the ghostly faces in Hofer's streetscapes, emerging from the dark bomb-strewn scenes of postwar urban Germany, or the angular and saturated "figures" of Ernst Wilhelm Nay, carrying both the marking structure of Ernst-Ludwig Kirchner and the color work of Vasily Kandinsky into the rarified matrix of the *Informel*, or whether it is the paintings of the exiled Wols, which appear as painterly wounds erupting from beneath the cool surface of *Tachisme* — in each of these cases, at the exact moment the artist turns toward psychological or political or social issues of the recent past, toward the national horror of genocide, the aesthetic debacle of the state dismantlement of "degenerate art," or the personal crime of silent participation — at each of these moments the ground accedes to the figure, and at the same time the figurative image concedes to the demand for a material presence upon the surface. In seeking the hallowed ground of an obvious modernism, the work becomes caught up in what Leo Steinberg criticizes as "the single criterion for important progressive art."

In Steinberg's analysis of the formalist imperative, this criterion

> ...remains a kind of design technology subject to one compulsive direction: the treatment of "the whole surface as a single undifferentiated field of interest." The goal is to merge figure with ground, integrate shape and field, eliminate foreground-background discontinuities; to restrict pattern to those elements that suggest a symbiotic relationship of image and frame; to collapse painting and drawing in a single gesture, and equate design and process; in short, to achieve the synthesis of all separable elements of painting....[32]

The expressive reference of modernist formalism, given as the physical and stylized handling of paint upon the surface, was meant to transport figuration beyond the realist, nineteenth-century Munich-based program of the Nazis and onto the sanctified ground of international modernism. The cosmopolitan gesture of the dense and angular brushmark, together with the focus upon the figure as a concrete formal unit superimposed upon a two-dimensional grounding system, effectively linked postwar German painting to both the dominant movements in international art and to the prewar tradition of *Die Brücke* and *Der Blaue Reiter*. It did not establish, however, at the level of the construction of a painting — the level of aesthetic modes and motifs that create essential phenom-

to ignore the plane is to dissociate himself from tradition in formation; it is as if an artist living in the second decade of the quattrocentro had chosen to abandon linear perspective or the analytical depiction of muscles.... The desire to assert the picture plane has been one of the foremost formal determinants leading to the dissolution of traditional three-dimensional bulk and the materialization of empty volume. To preserve the picture plane is to flatten, dissolve, or fragment solid bodies, and to fill void."

30 For a visual documentation of Hitlerite taste, see *Die "Kunststadt" München 1937: Nationalsozialismus und "Entartete Kunst,"* (Munich, 1987).

31 The full text of Hitler's inauguration speech for the newly opened Haus der Deutschen Kunst is included in the guide to the exhibition, *Entartete Kunst.* (Munich, 1937) and quoted in part by Bussmann, Georg. In *German Art in the 20th Century*: 122.

32 Steinberg, Leo. "Other Criteria." In *Other Criteria: Confrontations with Twentieth-Century Art* (London, 1972): 79.

enological models and reveal epistemological motives — a system for the kind of introspection and critique appropriate to this particular moment in the cultural and political history of Germany. To do so would require the derailing of form and figure, a refiguring of painting. It would require, in short, the superimposition of two systems of expression, one at the level of form and "material truth," and the other at the level where stories are told.

To summarize, then: in German figurative painting of the postwar decade, cultural politics ensured that the narrative work of the brushmark had at least to be offset, if not fully subjugated, by the mark's formal value. Indeed, perhaps no other instance in modern art-history presents such a clear example of the power and professional authority of the modernist formal idiom as does the postwar period in Germany. If there existed in Germany a set of strong motivations to construct unique pictorial environments that could accommodate, in paint, the human issues of massive destruction and loss of cultural standing, then there were equally powerful forces at work in the international aesthetic arena that held those impulses at bay.

By the mid-1950s, however, those forces had begun to give way to fundamental changes in Germany itself. Germany's "Economic Miracle" was well underway by then. If by, 1950, Germany's GNP had recovered to prewar levels, per capita income had almost doubled between 1950 and 1955 as consumer items, cars and major appliances flowed off the production lines with ever-increasing speed.[33] The year 1955, which marked the dissolution of the Allied High Commission, and therefore the Federal Republic of Germany's first year of sovereignty, also saw the presentation of the first *Documenta* exhibition in Kassel. The show was a large-scale historical survey, clearly positioning Germany within the international arena of twentieth-century art and bringing into sharp focus issues of the German national character in aesthetic develop-

ment.[34] The work of Kassel Academy professor Fritz Winter, for example, who had studied with Kandinsky and Oskar Schlemmer, and who continued to paint in an abstracting, so-called "Energy Image" style after the war, was displayed in a comparative relationship with that of Picasso, just as in 1959 the paintings of Nay would represent the German position against the Ecole de Paris.[35]

As Germany recovered physically from the war, painters of the first generation presented in *Refigured Painting* were just turning twenty. Hofer and Baumeister, principal polemicists, respectively, for figuration and nonobjective painting during the postwar decade, both died in 1955. In that same year, Konrad Klapheck painted his first machine painting (cat. no. 1) in a thin, mechanical-illustrative style, and Schönebeck arrived in West Berlin from East Germany. Having experienced the war only as young children, they faced a completely different set of issues with respect to the nation's moral standing than the generation of painters led by Schumacher, Baumeister and Hofer. The response of this generation of artists to the postwar situation manifested itself specifically at the level of pictorial structure.

Historical context allows us to understand why the tradition of recent German painting presented in this exhibition is really less about figuration versus abstraction than about an altered mode of painting, one in which the modernist company of mark and narrative form necessarily part ways. The separation between the specific mark of the brush and the figurative image itself, which had begun already in the mid- and late-1950s with the work of Klapheck, Antes, Schönebeck and Baselitz (to mention four artists represented in this exhibition) and Horst Janssen, Paul Wunderlich, Helmut Sturm and Walter Störher (to mention four who are not) opened a broad and fertile field between formal manipulation and figurative representation, the painterly possibilities for which have been thoroughly cultivated from that time forward.

33 For a discussion of the "Economic Miracle," see Ardagh, John. *Germany and the Germans: An Anatomy of Society Today* (New York, 1987): especially 12-15.

34 See Trier, Eduard. "Historistische Perspektiven — Eine Chronik der retrospektiven Ausstellungen." In *Jahresring* 56/57 (Stuttgart, 1956): 340-348.

35 The effects of *Documenta* on the German art scene are widely debated. Against various charges that the *Documenta* exhibitions' essential role has been that of a promoter of a) German art b) American art or c) the art market in general, Manfred Schneckenburger argues that it is more a register of the moment than a market-maker or national booster, though the latter functions are not fully discounted. He points out, for example, that while the major themes of the 1955, 1959 and 1964 exhibitions were abstraction and "evocative rather than representational" art, it was in fact the resurgence of representation during the early and mid-1960s that would lead to Germany's strength in the international art-world. This development was reflected, rather than projected, in the next three *Documenta* exhibitions. See Schneckenburger's "Ein deutsches Ausstellungswunder und die deutsche Kunst." In *Kunst in der Bundesrepublik Deutschland*: 683-87. For other interpretations of the *Documenta* event, see Grasskamp, Walter. "Modell documenta oder wie Kunstgeschichte gemacht wird." *Kunstforum International* (March 1982) and Celant, Germano. "Eine visuelle Maschine, Kunstinstallation und ihre modernen Archtypen. In *Documenta 7*, exh. cat. (Kassel, 1982).

Meditations on A=B
Romanticism and Representation in New German Painting

Michael Govan

I. On Baselitz

According to the art critic Clement Greenberg

> Representation, or illustration, as such does not abate the uniqueness of pictorial art; what does do so are the associations of the things represented. All recognizable entities (including pictures themselves) exist in three-dimensional space, and the barest suggestion of a recognizable entity suffices to call up associations of that kind of space. The fragmentary silhouette of a human figure, or of a teacup, will do so, and by doing so alienate pictorial space from the two-dimensionality which is the guarantee of painting's independence as an art.[1]

Looking back from the perspective of the 1960s on developments in painting immediately following World War II, Greenberg, champion of American Abstract Expressionism, outlined a clear paradigm for "Modernist Painting."[2] He identified Modernism with what he called a "self-critical tendency that began with the philosopher Immanuel Kant...

> the use of the characteristic methods of a discipline to criticize the discipline itself — not in order to subvert it, but to entrench it more firmly in its area of competence.... The task of self-criticism became to eliminate from the effects of each art any and every effect that might conceivably be borrowed from or by the medium of any other art. Thereby each art would be rendered "pure," and in its "purity" find the guarantee of its standards of quality as well as of its independence. "Purity" meant self-definition, and the enterprise of self-criticism in the arts became one of self-definition with a vengeance.[3]

Kant had launched the era of Modernism, concludes Greenberg, "because he was the first to criticize the means itself of criticism"; and if "Enlightenment criticized from the outside... Modernism criticizes from the inside, through the procedures themselves of that which is being criticized." Kant's philosophy, implies Greenberg, is important for art because it establishes the model of "self-criticism," of a view inward.

The implications of the development of Greenberg's Modernism for painting, with regard to figuration and abstraction, were clear; figuration destroyed the purity of painting because it was bound, as representation, to things outside itself rather than focussing internally on its own mechanism.

Much has been written about how the rise of American art — of Abstract Expressionism in particular — and the shift of the world's art capital from Paris to New York, reflected America's unprecedented political, economic and military power in the wake of World War II. Serge Guilbaut's 1983 study, *How New York Stole the Idea of Modern Art*, meticu-

Georg Baselitz, *Erster P. D. Fuß: Der Fuß* (First P. D. Foot: The Foot). 1963

lously documents this phenomenon. Guilbaut's analysis of the influential critical rhetoric of Greenberg and Harold Rosenberg in particular reveals the construction of a simple ideological equation between American Abstract Expressionist painting and the liberty, freedom and truth that America held dear and vowed to promote and protect around the globe.

Guilbaut builds a persuasive explanation as to why *abstraction* — "centered on the person of Jackson Pollock — superceded other forms of art and took upon itself the positive role of representing liberal American culture, which emerged victorious from the 1948 presidential elections."[4]

As propaganda Hitler had deployed a realistic style of art that he said would be characterized by truth of presentation without any of the distortion characteristic of modern German Expressionism, dubbed by him "degenerate art." Thus

1 Greenberg, Clement. "Modernist Painting." *Art and Literature* 4 (1965)
2 Ibid.
3 Ibid.

4 Guilbaut, Serge. *How New York Stole the Idea of Modern Art: Abstract Expressionism, Freedom and the Cold War*, Arthur Goldhammer, trans. (Chicago and London, 1983): 195.

The search for a new style that would avoid the trap of illustration was therefore at the heart of the avant-garde's concerns. The new manner of painting emphasized the individual aspect of creation but at the same time laid bare the process, the mechanics of painting, and the difficulty, not to say impossibility, of describing the world.[5]

In an effort to dismantle the propagandistic power of the image, "truth" would be sought in the internal mechanics of the medium, revealing the deception of representation or figuration.

Abstraction in general played an important role in Germany after World War II, whose consequences represented a traumatic rupture in the cultural, ideological and physical fabric of Germany. "A consciousness of guilt was added to the material distress, and shame was heaped on the feeling of defeat," writes Wieland Schmied.

> German artists in particular regarded the language of abstraction as a moral force which was internationally binding as well as promoting international friendship. Post-war Germany above all yearned for internationality, it yearned to be accepted once again into the fold of nations and to be recognized as an equal partner. If one had to be German the desire was to be international.[6]

After the war, figurative painting in Germany was associated on one hand with Hitler's Reich, and on the other with the Socialist Realist propaganda of the Soviet Union and Eastern half of a divided Germany. West German artists adopted an international abstraction, known primarily through its manifestation in the French *Art Informel* and *Tachisme,* but epitomized theoretically by the critical rhetoric of the victorious Americans; not surprisingly, German collectors acquired primarily American art.

If, as Schmied claims, "Post-war Germany above all yearned for internationality," recent exhibitions of German art, including this one, have made it clear that the German internationalism of the late 1940s, 50s and 60s has given way to a complex set of reassessments of a *national* identity. The sense of responsibility for the horrors and atrocities of Hitler's Germany, as well as a genuine optimism about the cause of internationalism, contributed to the German appropriation of an international style of abstraction.[7] After the War, in the wake of Hitler's masterful and painfully effective use of image, figure and myth,[8] any recovery of individual independence and freedom was possible only through the visual autonomy of the language of abstraction. Yet even as early as the late 1950s and early 60s, sculptor Joseph Beuys in particular, and then, significantly, painters — first Georg Baselitz, followed by Markus Lüpertz, K. H. Hödicke and A. R. Penck in an aggressively expressive mode on one hand, and Gerhard Richter, Sigmar Polke and Anselm Kiefer in a more discursive and theoretical mode on the other — began to dismantle the simple equation of abstraction and freedom.

Hans-Jürgen Syberberg's 1976 *Our Hitler — A Film from Germany* unearthed the taboos of recent German history much as Kiefer's paintings and Baselitz's sculptures did in the Venice Biennale of 1980. "That our history is in everything of necessity our most important heritage, both for good and evil," says Syberberg, "is the fate laid upon us at birth, and something that we can only work our way through with an active effort."[9] The German problem is essentially one of its past. If we can speak about a cultural or national unconscious, we may be tempted, quite understandably, to speak about Germany's. The end of World War II and secondly, but equally significantly, the division of East from West Germany, constitute in the abstract a psychical trauma of the subject as nation — pictured in Jörg Immendorff's *Naht* (*Seam*) (cat. no. 30), the broken skin, the wound in the shape of the Brandenburg Gate, in the Star of Germany.

Georges Bataille outlined a model of the "social superstructure" in psychological terms of a dualism of *homogeneous* and *heterogeneous* traits. The *homogeneous* Bataille relates to the "productive system" and the interest in conserving the highest levels of *homogeneity* in society to serve the efficiency of capitalist production. *Heterogeneous* elements are defined not in chaos but as diverse, subversive, perverse and sacred elements *in relation to* a general mass *homogeneity. Heterogeneous* elements introduce considerations of taboo, religion, magic, violence, excess, delirium and madness. *Heterogeneity* is linked with the subjective and to "nonexplainable difference." "*In summary,*" writes Bataille, "compared to everyday life, *heterogeneous* existence can be represented as something *other,* as *incommensurate,* by charging these words with the *positive* value they have in *affective* experience."[10] Bataille identifies *the unconscious* as an aspect of the *heterogeneous* in the *exclusion* or censorship of "*heterogeneous* elements from the *homogeneous* realm of consciousness." As we know from Freud, the trauma held in the unconscious is bound to return, for example in the construction of images that is the "dreamwork." If the appropriation of abstraction in Germany after the War is an act of censorship of images and figures is general in their inherent relationship to things past, then that past is bound to return in figuration.

The return of the figure against the ground of abstraction is perhaps most dramatically played out in the work of Baselitz. Baselitz's vehement insistence on the notion of "motifs" — schematic figures imbedded in a mass of abbreviated brushwork moving out to the edges of the canvas — defines the terms of a conflict between figure and ground. Baselitz, and Eugen Schönebeck, in the early 1960s transgressed the academic, dogmatic, even propagandistic stasis of *Tachisme* and *Informel* and international abstraction not by simplification of form (as exemplified in the reduction toward a mystical nothing of the ZERO group), but by a manneristic "addition to excess" — not far from Bataille's theory of heterogeneity and excess. The *Pan-*

5 Ibid.: 197.

6 *German Art in the 20th Century, Painting and Sculpture 1905-1985,* exh. cat., Christos Joachimides, Norman Rosenthal and Wieland Schmied, eds. Royal Academy of Arts, London (Munich, 1985): 56.

7 See for example the essay by Hans Albert Peters in this catalogue.

8 Bussmann, Georg. "Degenerate Art." In *German Art in the 20th Century*: 116.

9 Quoted in Corrigan, Timothy. *New German Film: The Displaced Image* (Austin, Texas, 1983): 108.

10 Bataille, Georges. "The Psychological Structure of Fascism." In *Georges Bataille: Visions of Excess, Selected Writings 1927-1939,* Allan Stoekel, ed. (Minneapolis, 1985): 143.

dämonium manifesto of 1961, which bears comparison to Bataille's texts, is filled with anger fuelled by memories, with the "sacrifice of flesh," boiling past the boundaries of programmatic aesthetic and political capitalism. The "Pacifying meditation, starting with the contemplation of the little toe" of *Pandämonium* recalls Bataille's meditation "The Big Toe" which asserts that "Human life entails, in fact, the rage of seeing oneself as a back and forth movement from refuse to the ideal, and from the ideal to refuse — a rage that is easily directed against an organ as *base* as the foot,"[11] which in turn recalls Baselitz's series of foot paintings of 1963. Baselitz himself develops a theory of baseness.

"Degenerate art" returns in Baselitz's work not as progressive, but as psychotic, repressed and unfinished — as frustration and overflow (Baselitz's *Big Night Down the Drain*, 1963). The provincialism and isolation of Baselitz's and Schönebeck's home region of Saxony in what is now East Germany (also home of Wagner) haunts the rational confidence of a comfortable internationalism promoted in West Germany, as the private and incommunicable sabotages the concept of the common language, and as the burden of representation invades the sanctity of abstraction.

The division of East and West Germany is demonstrated in Baselitz's painting in the simultaneous but dislocated presence on a two-dimensional surface of the *abstraction* of the capitalist West and the *figuration* both of the progressive communist East and, importantly, of Germany's past. Through the reappearance of the figure, the canvas becomes memory's screen on which the forgotten invades the present, breaks back to arrest and displace the smug comfort of a living present.

The figurative painting in this exhibition owes a great deal to the abstraction that preceded it, in terms of its scale, shape and technique of paint application. It is precisely in the midst of abstraction that the figure appears, not necessarily only as an affront to abstraction, but in an attempt to regenerate its painterly innovations in a vital context. New figurative painting may have itself faced exhaustion of innovation by 1980, yet in its betrayal of abstraction, Baselitz's and Schönebeck's radical figuration, ironically, returned what was in the 1960s a depleted Modernist painting to the task of what Greenberg defined as "self-criticism." Along with Lüpertz and Hödicke, also from the East (Lüpertz is from Bohemia), Baselitz and Schönebeck demonstrated that the vulnerability of a language of international abstraction lay precisely in the provincialism and difference, the heterogeneity, it censored. If memory is a subjective action in the present alternately repressing a past and finding a past (at times in disguise), and if memory is played out, as Freud says, in dreams, in images, then it makes sense particularly in Germany that figurative painting, the ghost of "degenerate art," would return.

Greenberg made a fundamental mistake in his characterization of Kant. He set up an external (international) and closed *system* of "self-criticism," which concluded in the so-called death of painting, a structural and legible syntax that he felt avoided "representation." But the realm of "self-criticism" opened by Kant primarily was not one of a discipline criticizing

its own conventions of representation, but a criticism of the human *perceiving self* — that by nature receives and formulates representations internally and externally. Kant's self is in isolation, but that isolation may be better reflected in provincialism than in internationalism. The explosive growth of recent German painting raises the issue, not merely of figuration (representation) or abstraction, but also of the common mechanism of self-representation that each entails.

II. On Penck

One of the stick figures in Penck's system-picture *Ein mögliches System (A = Ich)* (A Possible System, [A = I]) holds up with one arm a sign that reads "A = A"; with two other arms the figure presents a picture of a group of stick figures holding hands and standing on a mound or a globe. A small stick-figure on the far left points to the sign; another appears to dance beneath the picture. In the center of the composition a number of figures is encompassed by a tall fence. Figures on the left within the fence are calm; one holds onto the fence, seemingly looking out; two others face inward, holding between them what may be a small figure. Within the fence on the right figures rendered with curved erratic marks struggle upward; one holds a large sign reading "A = A/A = Ā/A = A + Ā"; others struggle over the fence only to be slaughtered by two tall figures mechanically swinging axes; bodies of those already killed lie on the ground. On the far right another smaller figure, paralleling the pointing figure furthest to the left, points at the whole scene and holds up a sign reading "A = ICH/ICH = B" (A = I/I = B).

The signs held high look like political posters with slogans. The schematically rendered figures on this odd stage — the ground of the world here resembles the one in Penck's *Weltbild* (World Picture), 1961 — are all of the same type, though each plays a different role. The "system" is a sort of sociopolitical model encompassing a variety of personal positions or relations to the system — on the left a vision of utopia, in the center both calm and frantic reactions to captivity, on the right mechanical slaughter of those who attempt to escape confinement. One is tempted to make out the form of a swastika in the lines of the slaughterers' interlocking arms.

A roughly painted diagrammatic sign itself — a hieroglyphic mixture of writing, calculations and pictures — the painting is a communicating device that depicts attempts to communicate. Penck's work is typically characterized by this sort of sign-making or signifying. Accused more than once of being simply unfathomable, Penck's works rarely proffer a purely linguistic translation. Instead, each picture, whether didactic or decorative, elicits a reading by presenting abbreviated messages within messages within messages, and by incorporating patterns, letters, numbers, symbols and figures across an almost "allover" painterly surface of information. What is at issue in this message-sending or system-building are processes by which the self represents its own relation to the world. Cryptic and personal ("expressive"), Penck's messages — system-pictures — reflect the difficulty of modeling that relationship.

Unlike his friend Baselitz, Penck, born in Dresden, remained in the East after the Berlin Wall went up in August 1961.

11 Bataille. "The Big Toe." In ibid.: 21.

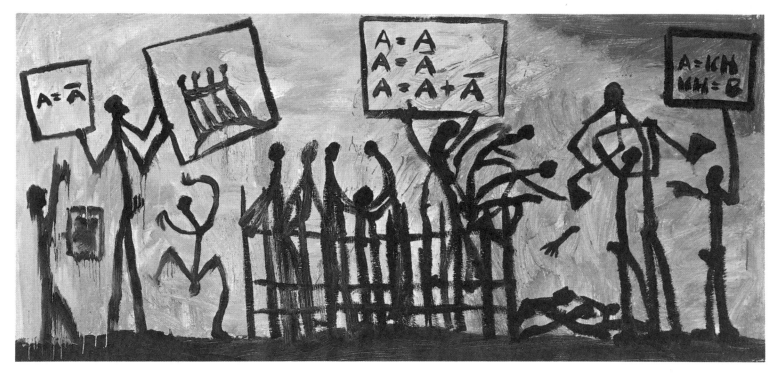

A. R. Penck, *Ein mögliches System* (A = Ich) (A Possible System [A = I]). 1965

Penck, a communist, felt his "messages" had the potential to change the world. In 1980, when he moved to the West, he judged his political optimism to have failed. Yet Penck has never felt comfortable with the capitalist West, moving, without speaking English, to London in 1982 to regain the sense of isolation and alienation he felt in the East.

Penck's interests are as diverse as the markings across the surface of his canvases. In the East, with little available information about contemporary art, Penck read whatever he could get his hands on — philosophy, literature, mathematics. His contact with art history was first through Rembrandt, then through Picasso — *the* great master and exemplar of modern art for artists in East Germany — as well as through the German Expressionist masters of his native Saxony. Penck's close study particularly of Rembrandt and Picasso discloses his specific propensity toward marking and schematization. His copies of Rembrandt drawings reveal the originals as conglomerations of single and autonomous pen marks; his copies of Picasso etchings emphasize Picasso's use of pen hatching conventions not for effects of chiaroscuro but to define differences in attitudes between figures.

Penck's appropriation of primitive marking techniques and figure types reduces the "message" to its most primary form — as immediate utterance rather than elaborated exposition. Each picture retains above all a spontaneity virtually free of conscious purpose or design. Yet expression is privileged theoretically as much as it is stylistically. The gesture is consciously displayed as self-expressive — quoting the method of Pollock: "When I am *in* my painting, I'm not aware of what I'm doing.... I try to let it come through."[12] Each picture, then, is a sort of self-production, placing the self, through representation, as an object in the context of other objects outside the self.

The reemergence generally of the painterly expressive gesture characteristic of Penck's work in particular has been seen as aesthetically and politically suspect in some of the most intelligent art criticism of the decade.[13]

> Through its repetition the physiognomy of this painterly gesture so "full of expression" becomes, in any case, an empty mechanics. There is only pure desperation in the recently reiterated claim of "energism," which betrays a secret foreboding of the instant reification that awaits such a naive notion of the liberating potential of apolitical and undialectical aesthetic practices.[14]

That Penck, who has made his political and communicative interests quite clear, has so obviously selected the most comprehensively coded form of expression — painting — choosing to emphasize its subjective possibilities, *is* suspect, as Penck himself no doubt intends.

In working out the course of perception in pattern-painting and drawing, Penck employs essentially syntactical conventions. The *conventional* nature of the activity is crucial to Penck's method, evidenced by his study of systems and contemporary information and communications theory — or cybernetics, the study of the structure, formation and legibility of messages in a general psychology of perception.

Indeed, his interest in exploring language, as well as the modern sciences of information and communications theory through a model of self-expression might be adumbrated in terms of a Romantic conception of science and poetry, such as

12 Pollock, Jackson. "My Painting." *Possibilities* (Winter 1947): 79.

13 Critics who have written eloquently against Neo-Expressionist painting include Benjamin H. D. Buchloh, Hal Foster and Craig Owens.

14 Buchloh, Benjamin H. D. "Figures of Authority, Ciphers of Regression: Notes on the Return of Representation in European Painting." *October* 16 (1981): 39-68.

that of the German Romantic poet Novalis. As Géza von Molnár writes in a recent study, *Romantic Vision, Ethical Context: Novalis and Artistic Autonomy*, which I will return to in the discussion that follows,

> With his poetic qualification of science, Novalis indicates that he understands any attempt to explain nature to be an interpretative effort for which the relationship of things to one another falls within the bounds of the self's unconditional identity with itself. Self-identity, in this sense, furnishes the ground of reference for the self's release from subjective isolation and for its potential identity with others. That potential is the unconscious premise realized in every act of communication, because communication entails the eventual possibility of a consensus for which subjective differences remain invalid. In practice, the self's unconditional identity is its identity with the communal self, not with any particular community but with the community of mankind. It is the same transcendental community to which we belong as free moral beings, only Novalis also derives from our potentially realized citizenship in it the actual possibility of language, no matter what its relative code might be. As Novalis conceives of it, language has transcendental value and therein lies not only its claim to truth but also its poetic quality.... In this sense, poets necessarily complement scientists, because poets demonstrate by their poetic use of language that the concrete observations of science derive their validity not from the object of experience but from the consensus concerning that object, which can only be obtained and verified insofar as subjective experience is also communicable.[15]

The premise that the commonality, the "consensus concerning the object," which is the basis of communication and art, must be located first in the subjective self that perceives is as relevant to a modern discovery of intertextuality as to Novalis's Romantic project. In Novalis's theory, as in Penck's, there is no possibility for communication without acknowledgment of the self at the center of all acts of perception and communication. The concept of representation, of poetic language, for example, is central to the theory. The self constantly re-produces itself in order to place itself — through its own capacity for mimetic self-representation — outside its own center in the realm of that which it is not — in otherness, in the world. A brief explication of Novalis's Romantic theory of perception and aesthetics will be helpful here in exposing the complex and still relevant philosophical foundations of Romanticism and in illuminating the specific case of Penck, creating a richer ground on which to examine this artist's documented interest in modern communication science and its relation to the process of art-making.

Novalis's theory of communication and art are worked out in detail in his study of the German philosopher Johann Gottlieb Fichte, a follower of Kant, who

> ...first questioned the self's absolute dependence as a sufficient premise for the world our intellect presents to us and comes to the conclusion that the mind is not only reactive to experience but contributes independently in certain acts of cognition he calls "synthetic judgments *a priori*."[16]

Fichte places Kant's discovery of a *subjective* self that assimilates the world by means of its own subjectivity at the basis of his theory concerning the *Wissenschaftslehre* "science of knowledge," "doctrine of science" or "science of science," which Novalis examines in his "Fichte-Studies." Following Kant, says von Molnár, Fichte, establishes his own "self-consciousness, expressed in the synthetic sentence a priori "I = I," as an act of uncontestable validity... the primary axiomatic sentence for the entire *Wissenschaftslehre*."

Recognizing the fissure that Kant opens between the subject and objects, including other subjects, Novalis in his "Fichte-Studies" is led, von Molnár continues, "directly to considerations that, far from isolating the ego in solipsist splendor, point to its absolute heritage as the ground from which interpersonal bonds may be established."[17] Beginning with the only certainty, the "I am" of self-consciousness, Fichte attempts to develop a philosophy of aesthetics and ethics that allows for self to perceive, to make contact with, something outside itself.

Fichte's elegant proof of the *Wissenschaftslehre* begins with a tautology, "A = A," that reflects the certainty of the declarative "I am" — "accepted by everyone and that without a moment's thought... perfectly certain and established." The "A = A" is "intrinsically certain," and is not the same as "A is the case" or "A exists"; rather it means "If A exists, then A exists." Fichte proposes to begin with the irrefutable, like the self-assertion that is the ideal "I am," and from it to develop a philosophy of experience, of the real.[18]

Between the "if" and "then" of "If A exists, then A exists" is a "necessary condition" that is "posited absolutely, and without any other ground" and to which Fichte assigns the term X. But does A exist? The first A of "A = A" (in the subject position) is "posited absolutely," as is the connection X, so that "given that the A in the subject position is asserted, that in the predicate is asserted absolutely; hence the above proposition [A = A] can also be expressed as follows: if A is posited *in the self*, it is thereby *posited*, or, it thereby *is*."[19]

"A" then exists for the judging self by means of X, that which is absolutely posited and thus that which can also be expressed as I = I (I am I) and "By this operation we have already arrived unnoticed at the proposition: *I am* (as the expression, not of an *Act*, to be sure, but nonetheless of a *fact*)."[20] But, further, the proposition "A = A" constitutes a judgment, an activity of the human mind.

> The self posits itself simply *because* it exists. It *posits* itself by merely existing and *exists* by merely being posited.... If the self exists only insofar as it posits itself, then it exists only *for* that which posits, and posits only for that which exists. *The self exists for the self* — but if it posits itself absolutely, as it is, then it posits itself as necessary, and is necessary for the self. *I exist only for myself; but for myself I am necessary.... To posit oneself* and *to be* are, as applied to the self, perfectly identical... "*I am absolutely, because I am*"... If the account of this Act is to be viewed as standing at the forefront of the

15 von Molnár, Géza. *Romantic Vision, Ethical Context: Novalis and Artistic Autonomy* (Minneapolis, 1987): 133.

16 Ibid.: 90.

17 Ibid.: 32.

18 Fichte, Johann Gottlieb. *Science of Knowledge ("Wissenschaftslehre") with First and Second Introductions*, Peter Heath and John Lachs, eds. and trans. (New York, 1970): 94.

19 Ibid.: 95.

20 Ibid.: 96.

Wissenschaftslehre, it will have to be expressed as follows: *The self begins by an absolute positing of its own existence.*[21]

This act of positing self absolutely, first as subject (on the left side of the equation "I = I"), then as object (on the right) — the basic act of self-consciousness — is the key of the *Wissenschaftslehre,* and in fact, according to Fichte, the key to the relationship between subject and object: "*the self* is a necessary identity of subject and object: a subject-object."[22] Bound up in the "Act" of the self's absolute positing of its own existence — the first primordial and unconditioned principle of Fichte's *Wissenschaftslehre* — is the process of representation, "not the essence of existence, but a specific determination thereof"; each determination "must pass through the medium of representation, in order to attain to empirical consciousness."[23] This representation within the self takes on the quality of mimicry, a doubling of the same self: once in expression, once in reflection; in other words, once as absolute subject, once as determined object. The self is by its very nature a *presenting-self.*

A dissertation on the *Wissenschaftslehre* is not necessary to comprehend the basic tenets of Fichte's theory. Fichte goes on to establish the second fundamental principle of the *Wissenschaftslehre,* the logical proposition "~A is not equal to A" — not derived from the statement of identity "A = A," but like that statement, posited absolutely, or rather counterposited — the principle of opposition which opens the "*category of negation.*" Positing "~A" is conditioned by positing "A" in that "Whether such an act is possible at all, depends on another act . . . is an act in relation to some other act."[24]

> But *what* that thing may or may not be, *of* which I know this, can be known to me only on the assumption that I am acquainted with A Nothing is posited to begin with, except the self; and this alone is asserted absolutely. Hence there can be an absolute opposition only to the self. But that which is opposed to the self = the *not-self* As surely as the certainty of the proposition "~A is not equal to A" is unconditionally admitted among the facts of empirical consciousness, *so surely is a not-self opposed absolutely to the self.*[25]

Of course, while it can be demonstrated that "*what was couterposited* must = the not-self."[36] Fichte says that this "category of negation" is not fully meaningful, like the first assertion "A = A," without the third fundamental principle of the *Wissenschaftslehre,* the formal process by which the category of negation can be proved and related to the posited self.

Fichte takes the act of consciousness as a basis for both self and not-self.

> Both self and not-self are alike products of original acts of the self, and consciousness itself is similarly a product of the self's first original act, its own positing of itself.[27]

The relationship between the two Fichte describes as one of "limitation."

> How can A and ~A, being and nonbeing, reality and negation, be thought together without mutual elimination and destruction? . . . We need not expect anyone to answer the question other than as follows: They will mutually *limit* one another. And if this be the right answer, the Y will be a *limiting* of each opposite by the other; and X will denote the limits.[28]

Fichte sets up a clear paradigm for the three fundamental principles of the *Wissenschaftslehre:* Thesis-Antithesis-Synthesis, a process "of combining opposites in a third thing." But through the combination, their synthesis, self and not-self are revealed as part of the same self.[29]

Thus, Fichte's self is discovered as fundamentally divisible

> . . . I would wish to express the outcome in the following formula: *In the self I oppose a divisible not-self to the divisible self.*[30]

The *Wissenschaftslehre* is finally defined not by statement, but by process: Thesis (A = A or I = I, self positing self), Antithesis (~A is not equal to A, self positing not-self) and Synthesis (self limits not-self and not-self limits self).[31]

Having set up a philosophy in pseudo-mathematical terms, Fichte allows himself a play of descriptive signs to activate the theory, one which allows, for example, in particular, the equation of A and B.

> We have unified the opposing self and not-self through the concept of divisibility we obtain the logical proposition hitherto known as the *grounding* principle: A in part = ~A, and *vice versa.* Every opposite is like its opponent in one respect, = X; and every like is opposed to its like in one respect, = X. Such a respect, = X, is called the ground
> *Demonstrated,* for
> a) Every counterposited ~A is posited counter to an A, and this A is posited. By positing of a ~A, A is both annulled and yet not annulled. Hence it is annulled only in part; and in place of the X in A, which is not annulled, we posit in ~A, not ~X, but X itself: and thus A = ~A in respect of X. Which was our first point.
> b) Everything equated (= A = B) is equal to itself, in virtue of its being posited in the self. A = A. B = B.
> Now B is posited equal to A, and thus B is not posited through A; for if it was posited thereby, it would = A and not = B. (There would not be two posits, but only one.)
> But if B is not posited through the positing of A, it to that extent = ~A; and by the equation of the two we posit neither A nor B, but an X of some sort, which = X, = A, and = B. Which was our second point. From this it is evident how the proposition A = B can be valid, though as such it contradicts the proposition A = A. X = X, A = X, B = X. Hence A = B to the extent that each = X: but A = ~B to the extent that each = ~X.[32]

"A = B" to the extent that each equals the common "X" which is the totality of the act of positing self once as subject "A," separately once as object, "~A" or the equated external object "B." Whether or not Fichte's logic is always perfectly clear, his

21 Ibid.: 98-99.
22 Ibid.: 99.
23 Ibid.: 101.
24 Ibid.: 103.
25 Ibid.: 104.
26 Ibid.: 106.
27 Ibid.: 107.

28 Ibid.: 108.
29 Ibid.: 112.
30 Ibid.: 110.
31 Ibid.: 182.
32 Ibid.: 110-111.

rigorous explication of the process by which he attempts to reach the outside from a position of subjectivity and isolation is compelling. And Penck himself is deeply sympathetic to such a process of working through subjectivity by means of a manipulation of symbols which is a mimicry of thought. In Penck's system picture, *A Possible System (A=I),* in one literal sign, "*A = Ich/Ich = B,*" Ich (I) is the common element of identity that allows either an equation of or transformation from A to B. Even the didactic texture or sense of the language of Fichte's proof is relevant to an analysis of Penck's work.

Apparently compelled by Fichte's equation of A and B, subject and object, self and not-self, under which lies their equation by the *process* of self-presentation, Novalis places emphasis on this process by introducing concepts of "representation" and "signification," which become the foundation for his analysis of Fichte. Novalis represents the primary position of the process of signification by an active substitution of a new equation of identity, "A = B," for Fichte's first equation of identity, "A = A," in von Molnár's words, "because it does not convey the problematic nature of this concept [the act of signification] with sufficient urgency.[33]

> ...subject and object are entirely different realms, yet the subject is part of the object's domain and the object part of the subject's. The relationship between subject and object is one that entails otherness and sameness simultaneously, with the immediate and obvious accent on the former. Novalis's focus is on this immediate aspect when he introduces his ideas on signs and representation in contrast to the sentence of identity, A = A, in which the dualism of its components remain almost unnoticed because of their sameness.[34]

Novalis's schema reveals the interdependence of self, world and Absolute.

> There must be a nonego in order for the Ego to posit itself as ego. Thesis, antithesis, synthesis. The action of the ego's being posited by the Ego must be accompanied by the antithesis of an independent nonego, which, in turn, requires a simultaneous relationship to a sphere that encompasses both — this sphere can be called God and Ego.[35]

"Only when we make for ourselves pictures of God," Penck states in a paradox, "can we make no pictures of God and so come closer to God." God (Absolute) and Ego (divisibly Absolute and relative) are abstractions: spheres that overlap or are separate at any particular moment in the process of perception. Novalis revels in the notion of the play of signs that activates Fichte for him, and divulges a divisible self. According to von Molnár

> Novalis questions this nomenclature because the term "Ego" is all too easily associated with the relative, empirical subject, a dangerous possibility that would result in the very solipsist nonsense romantics are so frequently accused of advocating; instead, he wishes to emphasize the difference that exists between the absolute and relative realms. In a brief but thorough examination of the meaning attached to the concept of self, he

arrives at the conclusion that the word "I" used in Fichte's manner is essentially a sign, a hieroglyph. Stated more explicitly, he implies the symbol must not be confused with the symbolized, yet a relationship between the two must, nonetheless, exist.[36]

The hieroglyphic conception of the "I" or uttered "I am" is perhaps not so far from Penck's own conception of self-expression. Penck paints the "I" literally into a hieroglyph, on the same plane as the hieroglyphic representation of the figure. Penck asserts self-presence in representing the momentary act of perception, an act always of *self*-perception and always in the process of being repeated in another painting, in another poem, in another sound. No one picture, representation, necessarily surpasses another in terms of quality. Each is but one in a series. By the speed of their execution, the repetition and revision of patterns and the systematic determination of their shape and scale, Penck, as much as any contemporary painter, rejects the conscious creation of a masterpiece. Not that the notion of genius is not wrapped up in his spontaneity, but the literalness of his act of representation leaves space open between the self-enacting process of representation and its physical remainder, the painting as object among other objects outside the self.

The theory of communication, writes Dr. Abraham Moles in 1958,

> now appears to be one the great theories of science. The concepts of *information, code, redundancy, complexity, the dialectic banal-original, foreseeability,* and *background noise* must take their places beside the quantum theory, the principles of relativity and uncertainty, and the opposition between the microscopic and macroscopic universe.[37]

Moles, in his *Information Theory and Esthetic Perception,* generalizes two essential aspects of the external world: the energetic aspect — having to do with mechanics, materials, thermodynamics, etc., "in which man as an individual plays no role at all," and the communicational aspect — returning man to the material world and relating to the "*interaction* between the individual and the rest of the world."

> ...*Behavioral sciences* are attached to this point of view... [considering] the individual as a *system* connected to the world whose evolution is determined by his *environment,* which acts on him through the messages he receives from the inert world or from other individuals, who, according to the existential thesis, remain as alien to him as the external world.[38]

Moles elevates the theory of information and communication along essentially the same lines that Fichte articulates his *Wissenschaftslehre*: both are general theories that attempt to define some channel, some conceivable means of relationship, between an alienated perceiving self and the world of objects that the self perceives.

33 von Molnár: 32.

34 Ibid.: 33.

35 Novalis, quoted in von Molnár: 36.

36 Ibid.

37 Moles, Abraham. *Information Theory and Esthetic Perception,* Joel E. Cohen, trans. (Urbana and London, 1966): 3.

38 Ibid.: 1.

"The individual receives *messages* from this environment through various channels"; messages can also be formed and *transmitted.* "*Information* must be considered as a *quantity,*" measured not by the length of the message, but by its *originality,* that is, to the extent that it is *unexpected,* and *unforseeable;*[40] "*messages* are measured by a *quantity of information* which is the originality, that is, the quantity of unpredictability (unforseeability) that they present."[41] A collection of texts ordered by increasing rates of originality might include "ABABABABABABAB..." as an example of *no information;* a logical narrative or piece of news as *information in the ordinary sense;* and a paragraph of randomly selected words as an example of *maximum word information.*[42] Penck plays with the notion of "originality" in information as it relates to "originality" in art. Originality is obviously a desirable quality in art, but in information theory is inversely related to legibility and intelligibility.

Moles draws a distinction between *semantic* and *aesthetic* information. Semantic information is that which is *intelligible,* or meaningful, but, *information* is essentially different from *meaning;* "meaning rests on a set of conventions which are a priori common to the receptor and transmitter. Thus it is not *transmitted;* potentially it preexists the message."[43] Semantic information is based on *redundancy,* which reduces originality but increases legibility. *Aesthetic* information on the other hand, is that which "determines interior states," and is not translatable into symbols as is semantic information. Yet,

> Messages with exclusively semantic or purely esthetic content are theoretical limits, dialectical extremes. Every real message has some of each. Semantic information, related to the universal aspects of the individual's mental structure, is rather easy to measure and to determine objectively; hence it is better known. On the other hand, esthetic information is randomized and specific to the receptor, since it varies according to his repertoire of knowledge, symbols, and a priori structurings, which in turn relate to his sociological background.[44]

The commonality and background that the sending of messages implies, in Novalis's sense, as von Molnár describes, is "the ground of reference for the self's release from subjective isolation and for its potential identity with others." That commonality is emphasized in Penck's so-called standard "Standart."

The entirety of Moles's explication of a theory of information is based on a Hegelian method of "rapid and incomplete synthesis" of dialectical opposites, such as: Order and Disorder, Predictable and Unpredictable, Banal and Original, Redundant and Informative, Intelligible and Novel, Simple and Complex.[45] Penck mines the substance of this discourse to retrieve a whole set of definitions, metaphors, conventions, dialectical oppositions, formulas and processes that help gener-

ate pictures. Penck plays with both the terms and the terminology of the science of information, mobilizing the theory literally and figuratively in his pattern-painting. The image of Penck playing his free-jazz at an opening of one of his exhibitions reads like Moles's suggested "methods of experimental aesthetics"; *destroying* the work by *noise.* Penck's simultaneous experimentation with painting, poetry and music can be read as an experiment in structuring multiple messages over different channels. The painting, the arrangement of symbols, figures, colors and shapes becomes a message. Individual symbols are variously recognizable and translatable, others are improvised — and transmit great originality and unpredictability if not legibility. Improvised symbols are then repeated until they take on some "meaning."

> Try out everything you can draw with a pencil or a piece of chalk: lines, dots, crosses, arrows, and whorls, but notice how all these things look, and practice imagining them. If you do this you will find that a feeling or sensation appears for each sign when you paint it, and also when you imagine it. It can also happen that with one sign some idea for doing something occurs. You will even find that the feeling you had when you imagined the sign also appears suddenly and so creates for you an experience in reality.[46]

Penck employs the conventions of painting — repeating patterns, using line both as body and as boundary — in demonstrating his theory. Penck's games with lines are games of inside and outside; as in an Escher drawing any given part of figure or canvas can alternate between its reading as background or foreground, inside or outside. Even solid figures are punctured by geometric unpainted spaces revealing outside through inside. Each message is an attempt to communicate from inside out.

A thorough examination of the relation of a structural theory of information to Penck's work is beyond the scope of this essay. Still, it is worth observing that the discipline is particularly interesting with regard to the tenets of a philosphy of Romanticism. Like Novalis's theory of Romantic poetry, Moles's theory of information attempts to identify "the individual's perception with all its uncertainties...[as] the very condition of knowledge of the world."[47]

Penck draws upon the rules and terms of an information theory in making messages, acts of self-presentation, yet he perhaps finally situates the problematic of self in relationship to world in the Romantic model of a divided self. The possible relationship between subject and object lies within the self that posits itself twice — that is doubled and therefore divisible. In the case of the artist, the presenting-self is manifest in the spontaneous activity of signification, of making signs or messages, which in Penck's case is painting. The result of that signification is a representation, now reified — a presentation outside the presenting self, available for reflection. The canvas has become — as in the canvases of Pollock — an arena for spontaneous self-production, a bounded (framed) trace in time and space of that activity. Penck's productions are not like Pol-

39 Ibid.: 3.

40 Ibid.: 20.

41 Ibid.: 54.

42 Ibid.: 21.

43 Ibid.: 197.

44 Ibid.: 132.

45 Ibid.: 208.

46 Penck, A. R. "Was ist Standart?"; quoted in Koepplin, Dieter. "Experience in Reality: The Art of A. R. Penck." *Studio: International Journal of Modern Art* 964 (1974): 116.

47 Moles: 209.

lock's wholistic representations of self, but rather testify to a divisible self. No picture is sufficient; like Novalis, he implies the symbol must not be confused with the symbolized, yet a relationship between the two must, nonetheless, exist.

The question of division and divisibility is central in Penck's work. Germany divided from its past, East divided from West, Penck divided from friends and world, all are played out in a doubled self, and in the act of signification — of expression, let's say — of making, be it painting or free-jazz. The insufficiency of painting, obviously a bounded mode of representation, self-mimicry, antithesis, is essential to the processes of synthesis, of reconciling the gap between self and a necessarily imperfect (not-self) presentation of self that typifies the inherent problematic of the activity of communication. If there is optimism in his philosophy, it is in the notion that the possibility for communication first requires acknowledgment of the problematic of communication, our own subjectivity, not by way of objective scientific analysis, but by dint of a necessarily insufficient self-presentation, an act of creativity.

III. On Beuys

"Every man is an artist," claims Beuys. "First of all, we must extend the definition of art beyond the specialist activity carried out by artists to the active mobilization of every individual's latent creativity."[48]

Beuys's aphorism echoes Novalis's conception of creativity outlined in his novel *Heinrich von Ofterdingen*,[49] whose eponymous protagonist follows the creative passage to encounter-of-reality through encounter-of-self, fundamentally bound to self-representation or self-expression, that Novalis formulates in his study of Fichte's *Wissenschaftslehre*.

While Penck resolves to incorporate the mechanisms, signs, symbols of language into painting by equating the bounded and coded process of painting with the bounded and coded process of language, Beuys before him held a certain optimism, like Novalis, about the power of language to transform. Healer, shaman, psychoanalyst, Beuys presented a piece of sculpture, a representative fragment of the artist's activity, as an object of mediation. (The object's subsequent reduction to commodity status is a result of its tangibility and tradability; yet while "traffic in relics" is deplorable in principle and often in practice, it may nevertheless sometimes serve the greater purpose of disseminating a message.)

In every case Beuys posits language alongside the object, stating his *intention* for the object, reading it in reverse. What is so radical about Beuys's procedure is not the coherence of intention and sculpture, but the distance, the void it sets up between intention and sculpture, subject and object. Beuys privileges language both at the beginning of the process — "sculpture always begins with the idea" — and at the end by its

Joseph Beuys, *Fettstuhl* (Fat Chair). 1964

interpretation through discussion. Beuys creates a space between the object and what it may signify, a space alternately filled by intention and by interpretation. The viewer's desperate attempt to resolve the confusion between the artist's stated intention and its result in sculpture is a further act of language. "My initial intention in using fat was to stimulate discussion," said Beuys.

The artist's intention is re-placed by the object, which is in turn re-placed by interpretation of the object; each step in this process is necessarily insufficient, leaving, by re-placement again, the creative activity itself of intending/making/interpreting — of reconciling the disparity between *subject* (maker or interpreter) and *object* (sculpture, but also the past, also our physical environment) — as the primary artwork. "Every man is an artist."

IV. On Polke

If Penck's work can be juxtaposed with Fichte's and Novalis's conception of the *Wissenschaftslehre* and a divided self manifest in an act of perception through self-expression, Polke's might be juxtaposed with Novalis's conception of the *höhere* (higher) *Wissenschaftslehre* and a spiritual self manifest in an act of *reception,* also through representation. Polke's *Higher Beings Command: Paint the Upper Right Corner Black* or *I STOOD BEFORE THE CANVAS AND WANTED TO PAINT A BOUQUET OF FLOWERS. THEN I RECEIVED AN ORDER FROM A HIGHER BEING: NO BOUQUET OF FLOWERS! PAINT FLAMINGOS! I WANTED TO CONTINUE PAINTING, BUT THEN I REALIZED,*

48 *Joseph Beuys: A Retrospective*, exhibition "Acoustiguide," Solomon R. Guggenheim Museum (New York, 1979).

49 This idea became the kernel of a discussion of the relationship of Beuys's work to German Romanticism in a graduate seminar led by Steve Fagin at the University of California, San Diego, Visual Arts Department. I have followed this lead through the course of the present essay.

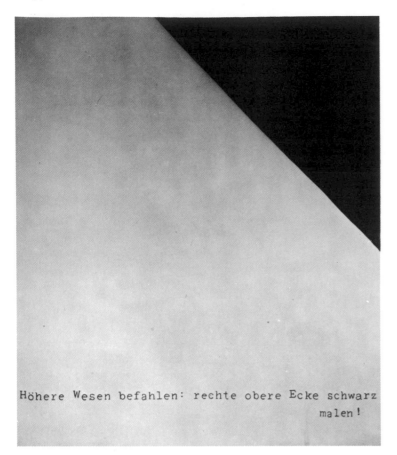

Sigmar Polke, *Höhere Wesen befahlen: rechte obere Ecke schwarz malen!*
(Higher Beings Command: Paint The Upper Right Corner Black!) 1969

THIS SHOULD BE TAKEN SERIOUSLY,[50] each "commissioned" by higher beings, "painted after a model," might be described by Novalis in terms of

> . . . certain fictions that occur to us, quite different in character from all others because they are accompanied by a feeling of necessity, even though there is no external cause for them on which we could base this feeling, as we do in all other theoretical processes of cognition. *In this state, it seems to a person as though he were engaged in a conversation and, in a miraculous manner, some unknown spiritual being caused him to evolve thoughts of the most evident truth* [author's italics]. This being must be a Higher Being because it relates to the human individual in a manner that is not possible for any being subject to the laws of the phenomenal realm comprising our world — It must be a being akin to human being because it treats the individual as a spiritual entity and summons him to exercise his freedom of agency at the highest level. This self of a higher kind is to the human being what the human being is to nature or what the wise person is to the child. The human individual longs to be like that higher self just as he seeks to make the nonego like himself.[51]

The "higher being" as Novalis terms it is, of course, the higher self related to the not-self, nonego, self-representation. Polke's method, like Penck's, is situated at the vantage point of self at center. Polke's concerns are also focussed on the massive web

of information that comprises our experience of the world, but focussed in particular on the reception and making sense of the barrage of external stimuli, of the experience of material and information. He replaces the phenomenological investigations of material of Minimal artists with phenomenological investigations of the spirit; the making-sense, a necessary activity can become a transcendental one, entailing the mechanism of representation — "certain fictions that occur to us" — as Polke demonstrates when he reads his name and discovers a narrative in the image of a supposedly Egyptian hieroglyph he has run across in a book of Egyptian art.[52]

Polke's fictional pseudoscientific *Palmology*, which functions primarily as parody and by means of verbal and visual puns, becomes a source of a great deal of his imagery. Palms (hands) are easily replaced by palms (trees).

> . . . behind so incoherent and disconnected-seeming appearances such as e. g. Palmin — Palm — Polke — Prometheus — etc. are indeed the soundest connections which brought to maturity that concept which has to be seen as the credo of my research work in natural sciences: For if you draw the necessary conclusions from such experiences: a) nothing comes of nothing, and b) everything was already once in existence, — it becomes easy to realize that everything is merely a question of connections! — And further: That a progressive science such as mine is not after any pert causalities but rather after connections.[53]

Polke covers his pictures with "Polke" dots. Through pun Polke mobilizes a rapid and effective machine of substitution. Language and image become malleable — even slippery.

A parody of the premises of a deterministic behavioral and information theory, Polke's work resonates with a distrust of structural scientific or philosophical theories of causality or structural analyses of information, semiology and art (or even now-fashionable theories of universal causal connection commonly labeled the science of Chaos, which attempts by mathematics and computer calculation to model the universe and all of its complex and previously unmodelable phenomena, for example, the growth and shape of clouds). Yet as a whole Polke's work seriously investigates the substance of the subject; that is, he questions human subjectivity as a foundation both of imagination and scientific objectivity.

Focusing in particular on the *mistranslation* he recognizes as the fundamental problematic of transmission and reception of message, Polke operates opportunistically and aggressively in the gap that is opened by mistranslation, or misprision. Perhaps the science of alchemy and the realm of paintings made from volatile or ephemeral materials are interesting to Polke because they reflect the uncertainty and fragility of all materials as they are actively perceived by a subject, and reflect the pulse, the change, the flux that is the essence of the ever-shifting envelope of our experience. Favored models of communication become telepathy, dreams and divine inspiration. The artist is better situated in a seance than in the studio.

50 *ICH STAND VOR DER LEINWAND / UND WOLLTE EINEN BLUMENSTRAUSS / MALEN. DA ERHIELT ICH VON / HÖHEREN WESEN DEN BEFEHL: KEINEN BLUMENSTRAUSS! FLAMINGOS / MALEN! ERST WOLLTE ICH WEITER / MALEN, DOCH DANN WUSSTE ICH, / DASS SIE ES ERNST MEINTEN.*

51 Novalis, quoted in von Molnár: 91-92.

52 Sigmar Polke, in Polke exhibition catalogue *Bilder, Bücher, Objekte,* Kunsthalle Tübingen, 1976. Polke's formative discovery is almost a parody of Beuys's famous story of the two formative events in his artistic career: his crash in the Crimea, and the sight of his biology professor drawing amoebas on the blackboard.

53 Ibid.

Beuys's concern with transformation of substance is deconstructed by Polke in his formulation of a theory of the receptor. If there is a human spirit or a genius, Polke discovers it in the distance, the fissure, between sender and receiver, subject and object — in the gap of mistranslation (or miscalculation: "1 + 1 = 3"). All of the philosophy and science in the world, all interpretation, is thrown back on an examination of the subjective state of being of the receptor. The artist is not a maker but a receiver, like the viewer. The image made by the artist is meaningful because the image reflects the artist's self, which, if you follow all of the semantic and causal connections that determine that state, encompasses, as Polke says, everything, and also nothing. The particular state of the receptor is determined by everything, as the lines on one's palms are determined by everything — every event bears on every configuration of materials. While the state or circumstance of the receptor is only visible through representation, it is at best imperfectly translatable. Like Fichte's divisible and doubled self, the state of the receptor-self is only made consciously accessible by its representation, its expression. Polke's interest, like Penck's, is the examination of self, but while Penck may begin with the message-sender, Polke begins with the message-receiver. The situation and context, as well as the implications, of the artist in a drug-induced trance are of central importance in Polke's work. Hallucination is the most privileged kind of image-making. Drugs are as important as prior knowledge in the construction and aesthetic and ethical realization of the body and mind of the subject as they relate in Novalis's terms to the appearance of a nonego, or higher self. One is tempted to invoke Novalis again on Polke's behalf.

> Everyone, however, is to strive to induce this experience by reaching the level of preparedness at which it can occur. The science that comes into being in this context is the *"höhere Wissenschaftslehre"* The practical part contains the self's self-education in order to become capable of receiving this impartation [from the higher self] — the theoretical part — [describes] the characteristics of a true communication.... With Fichte, the theoretical part contains the characteristics of a true conception [of objects] — the practical [part contains] the education and formation of the nonego so that it is fit to be truly affected by the self, fit to allow for true intercourse with the self — and that entails also the parallel formative process of the self's self-education. Morality, then, belongs in both worlds [that of the *"höhere Wissenschaftslehre"* and that of the *Wissenschaftslehre*]; in the latter as purpose — in the former as means — and it is the tie that links both together.[54]

Polke's spirit emerges from the crack between a prepared receiving self and a higher self revealed in an act of representation bound in an act of perception. To connect the dots of the stars to reveal a constellation, a figure, a certain fiction is to divulge that spirit.

V. On Richter

A "better possibility to approach that which cannot be grasped or understood," writes Richter, was created with *abstract* painting, "because in the most concrete form it shows 'noth-

ing.'"[55] Richter in the late 1960s, because he "did not know what to paint," began to paint canvases monochrome gray.

> Grey. Grey just has a clear-cut character, it does not unleash emotions or associations, grey is really neither visible nor invisible. Grey is, by virtue of its neutrality, so eminently suited to act as mediator, to clarify, just as illusionistically as a photograph. And it is better than any other color for clarifying "nothingness."[56]

All of Richter's painterly tactics are characterized by the neutrality and nonpresence inherent in gray. Like his simple mirrors and panes of glass, Richter's gray paintings reveal most clearly what they lack.

If Baselitz engages the East/West Germany schism in a figuration/abstraction dichotomy on the single plane of the canvas, Richter by contrast engages the conflict by juxtaposition of separate figurative and abstract canvases, acknowledging the inadequacy of both figuration or abstraction, but maintaining the exploration of this inadequacy as a valid endeavor for painting.

If Romanticism recognized the fundamental isolation of the subject and attempted to reconcile the difference between interior subject and exterior object through a creative process of self-representation, Richter's rigorous "clarification of nothingness" is a dramatization of the distance between subject and object, artist and representation (the "model" as Richter calls it). *Representation* in all of its basic inadequacy, however, remains the essential ground of possible mediation between subject and object, and subject and subject.

Gerhard Richter, *Tourist (grau)* (Tourist [Gray]). 1975

54　Novalis, quoted in von Molnár: 92.

55　Richter, Gerhard. [Statement.] In *Documenta 7*, exh. cat., vol.1 (Kassel, 1982): 84-85. (Translated from the German by Stefan Germer.)

56　Richter, Gerhard. [Statement.] In *Fundamental Painting*, exh. cat., Stedelijk Museum, Amsterdam (Amsterdam, 1975): 57.

Metaphors: Positions in Contemporary German Painting

Jürgen Schilling

In recent years the special historical situation of German art in the wake of World War II has been exhaustively discussed from various points of view.[1] Despite the decreasing prominence of national traits in the art produced during the 1960s, German art of this decade has become a focus of popular and critical interest. The period witnessed the emergence of a major development in painting by members of a new generation, protagonists of a movement that may someday figure as the last of the declining century. While American Pop Art was staking out a counterposition to the then predominant movement in the United States, Abstract Expressionism, artists in Germany began to challenge the enervated and frequently derivative abstraction prevalent during the postwar period in Central Europe. This new figuration was hotly debated, and for a long time critical consensus was negative. For over a decade the vacuum created by the devastation and defeat of Germany had been filled by a conceptual abstraction and a gestural style based on *Art Informel*; no artistic resurgence comparable to that of 1919 had occurred. In these circumstances the new painting, emotional and sensuous, oriented toward representation, often met with disapproval. Nevertheless, these painters, predecessors of the Neo-Fauves in much the same way that Jasper Johns and Robert Rauschenberg preceded the inventors of Pop, remained obstinately true to their credo, especially when they worked in such bastions of nonrepresentational art as Berlin and the Rhineland.

The point of departure of artists who rejected the ossified structures of an academically teachable spontaneity lay for the most part in their personal backgrounds. Almost all of them came from the eastern sector of divided Germany, or, as in the case of Markus Lüpertz, from Bohemia. "This reservoir is differently composed and contributes different impulses. If West German artists are basically oriented toward France and America, those from the East are more strongly influenced by memories and experiences associated with the likes of Caspar David Friedrich and Ernst Ludwig Kirchner."[2]

Dissatisfaction with the situation in West German art schools, museums and galleries took the form, with artists like Georg Baselitz and Eugen Schönebeck, of irrationally ecstatic drawings and manifestos or, as with K.H. Hödicke, Sigmar Polke and Gerhard Richter, of ironic and cynical gestures intended to make their doubts perfectly clear. "A common feature was the obsession with boundlessness combined with dark memories and existential fears."[3] Nevertheless, no common denominator existed that might have allowed these artists to develop a consistent contemporary style. For those living in Berlin, as Baselitz reports, this meant persisting in "total isolation, which is why [we] always felt the need to form a group or join with people we thought had the same or a similar approach to ours, if only as regards protest...but they weren't interested; they considered our position fascistic."[4]

It was perhaps the very isolation he describes that prompted the independent, wholly unmistakeable work produced by this generation of artists, which included, besides those already mentioned, Bernd Koberling, Dieter Krieg, A.R. Penck and Norbert Tadeusz. Tadeusz worked in a realistic style even though — or maybe because — like Jörg Immendorff and Anselm Kiefer, he came from Joseph Beuys's classroom, which was characterized by diversity of opinion and no-holds-barred debate.

Many monographs have been devoted to these artists, and their intentions cannot be discussed in any detail here. One common and central characteristic of their approach deserves emphasis however: they attach equal, if not greater, importance to the process of painting than they do to the figurative content that is so prominent a feature of their work. Though they have never relinquished such motifs as the human figure and the inanimate object as points of departure, their interpretations tend to issue in highly expressive, almost abstract imagery. Their inward vision demands expression, compels alienation from purely figurative representation.

Max Beckmann once said that artists could change the visible world in any way they wished, so long as the change was justified by force of design; and Novalis declared that romantic poetry in art consisted in alienating reality in a pleasing way, rendering the subject strange and yet at the same time somehow familiar and attractive. The properties of alienation and

1 Gohr, Siegfried. "The Difficulties of German Painting with Its Own Tradition." In *Expressions: New Art from Germany* (Munich, 1983): 27-41; Schrenk, Klaus, ed. *Aufbrüche, Manifeste, Manifestationen* (Cologne, 1984); Kneubühler, Theo. In *Malerei als Wirklichkeit*, Johannes Gachnang, ed. (Berlin, 1985); Schulz-Hoffmann, Carla. "'Nero malt' oder: 'Eine neue Apotheose der Malerei.'" In *Deutsche Kunst seit 1960: Sammlung Prinz Franz von Bayern* (Munich, 1985): 21-37; Gachnang, Johannes. "German Paintings: Manifestos of a New Self-Confidence." In *The European Iceberg*, exh. cat., Germano Celant, ed. (Toronto, 1985): 61-65; Gercken, Günther. "Figurative Painting after 1960." In *German Art in the 20th Century*, Christos M. Joachimides et al., ed. (Munich, 1985): 473-76; *Kunst in der Bundesrepublik Deutschland 1945-1985* (Berlin, 1985); Galloway, David. "Taking Stock," *Art in America* (May 1986): 29-39; Godfrey, Tony. *The New Image: Painting in the 1980s* (New York, 1986); Gachnang, Johannes. "From Continent to Continent." In *Europa/Amerika: Die Geschichte einer künstlerischen Faszination seit 1940* (Cologne, 1986): 337-42; *Brennpunkt Düsseldorf: Joseph Beuys — Die Akademie, Der allgemeine Aufbruch, 1962-1987* (Dusseldorf, 1987).

2 Joachimides, Christos M. In *Die wiedergefundene Metropole: Neue Kunst in Berlin* (Brussels and Leverkusen, 1984): 12.

3 Gercken, "Figurative Painting": 473.

4 Quoted in Gachnang, Johannes. "Ein Gespräch mit Georg Baselitz am 6. November 1975." In *Georg Baselitz: Tekeningen/Zeichnungen*, exh. cat., Groninger Museum (Groningen, 1979): 3.

distortion underlay the art of the new generation of painters who began to work in Germany in the 1960s, though the extent of their achievement apparently escaped the notice of the international public until the late 1970s. Recognition of their work came partly from the explosive emergence of the Neo-Fauves at the beginning of this decade and the critics' ensuing search for influences, and partly from the controversy touched off both in Germany and abroad by the German contribution to the 1980 Venice Biennale, where Baselitz presented a space-encompassing sculpture and Kiefer paintings and books.

The work of Baselitz and Kiefer embodies primary traits of the art of their generation, and has divided German opinion from the beginning. Their oeuvres reflect problems of German identity, problems to which Lüpertz, in cycles like *German Motifs* and the *Five Paintings on Fascism* of 1980, also addresses himself. Penck and Immendorff, in turn, have pursued approaches that, strongly colored by their political convictions, might be termed systematically didactic.

The mood of postwar Germany informed the attitudes of these artists. They accepted the obligation to face what their predecessors had avoided. The seemingly spontaneous act of painting was in fact an act of obligation; the subjects and their manner of presentation were as disciplined as they were inventive.

In Baselitz's oeuvre in particular we find a latent aggressiveness, a vehemence of attack, that has set standards for the rest. Like Penck and Richter he comes from Saxony (now in East Germany), the home of the most significant manifestation of German art at the turn of the century — Die Brücke of Dresden. One might suspect a *genius loci* at work, for many of Baselitz's paintings, and not only the more recent ones (beginning with *Dinner in Dresden* and *Brücke Choir*, both executed in 1983), suggest the influence of this Expressionist group. The artist himself, however, says that although there may be "similar elements, similar brushwork, the same brutality of paint application, this is not Expressionist, it's German."[5] At any rate, these sources, the German Primitives and the art of Edvard Munch, are certainly the same as those of Die Brücke.[6]

The German Expressionist tradition continues as well in the work of Hödicke, Koberling and Lüpertz, who says his discovery of it liberated him; he went through "this strange kind of experience, which I attempted, still quite unconsciously, to reduce to a formula; it was already there, in a kaleidoscope of *l'art informel* and representation, this bounded form in which an explosion took place."[7] Perhaps the term *nordismo* is applicable here, a colloquial Italian word now often used to designate, "almost derogatorily, works of art characterized by a great inner tension, expressiveness, an emphasis on light-dark and color contrasts, an estrangement in motifs of movement, in the elongation of figures, in the distortion of physiognomies,

and in the disproportion of natural forms"[8] — in short, a distinctly manneristic approach.

Baselitz states that he never painted representationally, in the traditional, illustrative sense. His theme is painting itself, and the motifs recognizable in his pictures merely denote a certain already established genre — still life, nude or landscape. In 1969 Baselitz's procedure led him, quite logically, to rotate the subjects he had retained as a point of departure 180 degrees in order to divest them of content, of conventional significance. Since then he has continually developed new, sometimes dazzling possibilities in shaping his pictorial syntax. "What matters in painting," he says, "is not the content factor, but visual invention . . . the necessity of the pictorial structure."[9]

Solidly rooted in the European tradition, Baselitz's approach changed after his move to West Germany from *Tachiste* beginnings to a gesturally agitated, introverted style. If initially he plunged into "obsessive imagery, wallowed in abnormalities, and challenged the chaos in his own nature to produce radical, autobiographically direct statements that exploded the boundaries of *tachisme* (not to mention good taste) and even of the painted canvas itself,"[10] in 1965 Baselitz began to establish controlled, stable, contained configurations that, despite sudden shifts in his method, continue to govern his work to this day. His *Idols* and *Heroes* — young painters, poets, mercenaries, all basically unheroic figures — are injured and deformed and inhabit empty, devastated landscapes. In spite of their innate courage they seem helpless in the face of a hostile environment. These are programmatic images of resignation, not of triumph; yet they nevertheless convey a sense of great determination.

Baselitz's approach, which continues to be misconstrued as brutal, is in fact vehement, summary and innovative, as witnessed by his inversion of motifs. Baselitz explained this as follows:

> If you assume that what is represented in a picture manifests itself quite independently of that which exists outside it, you can stand the thing on its head as well as not — simply in order to make the picture work, not to interpret what's going on outside it. . . . When you see a landscape, a tree, a dream, you can distill them into an image. The image is quite independent of them. You can find an organization for a painting that contains a vase and a tulip, or that contains a portrait with nose and eye. You can use these, but really nothing more than that.[11]

Like Baselitz, but in a different way, Lüpertz is involved in a vital, continuing process of stylistic and thematic change, and

5 Quoted in "Venedig 1980: Aktuelle Kunst made in Germany," *art* 6 (1980): 46.

6 *Edvard Munch: Sein Werk in Schweizer Sammlungen*, exh. cat., Kunstmuseum Basel (Basel, 1985): 145-70.

7 "Markus Lüpertz en una entrevista con Walter Grasskamp," *Origines y visión*, exh. cat., Fundació Caixa de Pensions, Barcelona (1984): 42.

8 Ronte, Dieter. "Nordismus in Wien um 1900," unpublished manuscript, n.d., n.p. See also *Georg Baselitz*, German television feature, ARD network, Dec. 15, 1987: "The tradition of German painting is a tradition of ugly pictures. From Dürer through Caspar David [Friedrich] to Nolde — when they were in no position to draw beautifully, do beautiful calligraphy, when they had to work against handicaps and incapability and chaos. Well, what's left over just has to be ugly."

9 "Georg Baselitz über die Nacht: Gespräch mit Dieter Koepplin," *Parkett* 11 (1986): 46.

10 Harten, Jürgen. In *Georg Baselitz — Gerhard Richter*, exh. cat., Städtische Kunsthalle Düsseldorf (Dusseldorf, 1981): n.p.

11 Baselitz, Georg. "Ich arbeite an Erfindungen." In *Documenta — Documente: Künstler im Gespräch*, Werner Kruger and Wolfgang Pehnt, eds. (Cologne, 1984): 15-16.

his painting is sometimes marked by a comparable pathos and subversiveness. In the early 1960s he decisively announced his "invention of the dithyramb in the twentieth century."[12] Lüpertz's enthusiastic brushwork both expresses the elegance of his invention and defines the process of painting as a problem of speed — recalling the days of action painting. The objects in his work, visually exaggerated and rhythmically articulated, take on an alternative significance; real things are combined with imagined ones to produce symbolic arrangements. Lüpertz tends to merge basic, geometric elements with planes of color in subdued hues, rapidly outlining them in black. A translation of trivial motifs into images of weight and dignity — which is what Lüpertz understands by painting — gives rise to the dithyrambic form which, in apparent contrast to his always impatient and summary brushwork, Lüpertz subjects to a variety of repetitions in sequences of pictures. The resulting imagery bears a certain resemblance to a *mise-en-scène* — vibrant, yet static and monumental. Applying the principles of sequence and of theme and variation, Lüpertz effortlessly draws the viewer into the events enacted on the picture plane, in the way advocated earlier by the Futurists and by Theo van Doesburg in the journal *De Stijl*. In Lüpertz's view, any kind of idealistic claim on behalf of dogmatic artistic objectives must take second place to the compelling drama of art conquering space.

Realistic styles of whatever brand, even prewar *Neue Sachlichkeit*, long remained suspect in West Germany because of their supposed appropriation by fascist art ideology. To this day, professional observers of the German art scene look askance at strictly representational imagery devoid of mystical or symbolic allusions. Apart from the Berlin realists prominent in the late 1960s, whose talent could not quite match their political commitment, only very few artists working in a realistic vein — among them Tadeusz of Dusseldorf — have been able to develop independent styles. Tadeusz's approach, which he applies to nudes, slaughterhouse scenes, architectural subjects and still lifes, stands in contradistinction to that of, say, Baselitz.

Though he evinces an impressive mastery of the plane both in form and color, Tadeusz cleaves closely to the object. His studies of models in the studio, or of the slaughterhouses of Pistoia and Florence, are translated into painted imagery with the help of drawing and photography. Tadeusz distills from his immediate environment and travel impressions the carefully articulated compositions of his paintings, yet his familiar and often-repeated motifs never communicate a purely narrative fascination. The overpowering complexity he derives from a mundane visual impression produces an eerily oppressive mood. Disturbing elements stand juxtaposed with tranquilly ornamental patterns, contradicting and intensifying one another. Tadeusz's skilled manipulation of perspective and his use of extremely high vantage points result in disquieting shifts in perception. Force fields in flux and bodies in space, emphatically exaggerated rhythms and increasingly drastic color contrasts, keep the picture plane in constant agitation. Disso-

nances and conflicts predominate. Tadeusz heightens our sensitivity to objects, simultaneously registering and analyzing, lending the events he transmutes into art a unique, significant interpretation.

With Tadeusz as with Baselitz, subject matter becomes painted image effortlessly, the difference between the two painters being Tadeusz's closer scrutiny of the motif. Though Beckmann occupies him less than the artists of the Italian and Spanish Renaissance, Tadeusz's art calls to mind Beckmann's words:

> I am seeking for the bridge which leads from the visible to the invisible, like the famous cabalist who once said: "If you wish to get hold of the invisible you must penetrate as deeply as possible into the visible." My aim is always to get hold of the magic of reality and to transfer this reality into painting.... It is not the subject which matters but the translation of the subject into the abstraction of the surface by means of painting. Therefore I hardly need to abstract things, for each object is unreal enough already, so unreal that I can only make it real by the means of painting.[13]

This statement applies both to Tadeusz and to the quite different art of Kiefer. Kiefer, too, takes history, culture and national and artistic identity as his themes, employing historical reference and elements of the irrational and the mystical. Applying straw, charred wood and lead to paint-encrusted canvases, Kiefer creates impressive visual montages and in strict central perspective delineates architectural structures of historical ill-repute, all the while celebrating a pure painting whose effect seems both detached and forceful. He goes to nineteenth-century literary sources for inspiration, translating them into gigantic tableaux that resemble stage settings and that do not so much challenge existing taboos as reveal a universal reluctance to face certain phenomena. Even the written word, which suggests an increment of content, is subjected to the dictates of free painting. Kiefer's more recent works, less symbolic than their predecessors, evince a dark, harsh language and highly charged content that no longer detract from his sensitive handling of paint. The colors not only obey their intrinsic laws, but also reflect the existential dimension of the artist's personality — which is indeed the source of their energy.

> With the aid of his sensibility the artist overcomes styles and methods to achieve sovereignty over the image. Expressiveness, rather than remaining a deformation at the farthest extreme of imitation, leads to a nonpositive affirmation of the subject, a supercharging of the subject through color. This is the source of the recalcitrance, the beauty, of [his] painting.[14]

The work of Richter and Polke has also changed over the years. Without wholly relinquishing his point of departure in photographic realism, Richter now creates primarily abstract compositions, which he frequently pits against precisely rendered realistic images that appear to be set in motion by disquieting lighting effects. This considered juxtaposition em-

12 Baselitz, Georg. *Dithyrambisches Manifest*. (Berlin, 1966).

13 Beckmann, Max. "Über meine Malerei: Vortrag, gehalten in den New Burlington Galleries, London, 1938." In *Max Beckmann, Malerei und Graphik: Autobiographische Texte* (Stuttgart, 1965): 20, 22.

14 Gohr, Siegfried. In *Expressive Malerei nach Picasso*, exh. cat., Galerie Beyeler (Basel, 1983): n.p.

phasizes the seeming harshness of the canvases, which teem with ostensibly wild brushwork. However, the drips and smears are hardly fortuitous; everything is presented with detachment and control. It is part of Richter's conception to reflect on processes of change not only with a view to visual innovation but also — particularly in the abstract paintings he has done since 1976 — with a view to destroying and transcending them. "Abstract paintings," writes Richter,

> are fictitious models because they visualize a reality which we can neither see nor describe, but which we may nevertheless conclude to exist. We attach negative names to this reality: the un-known, the un-graspable, the infinite, and for thousands of years we have depicted it in terms of substitute images like heaven and hell, gods and devils. ... Thus paintings are all the better, the more beautiful, intelligent, crazy, and extreme, the more clearly perceptible and the less decipherable metaphors they are for this incomprehensible reality.[15]

And, as Richter put it in 1970: "Success used to involve having a style . . . *we* don't need one."[16]

Polke passed through a phase of Pop-oriented canvases based on the screens of photographic printing processes; he enlarged printed news photos until they lost their original focus and meaning in becoming minutely rendered works of art. Since then he has taken an entirely different tack, in terms of both subject matter and technique. Polke began employing unusual grounds — woolen blankets, furs, home textiles bought by the roll in department stores, packaging foils, silver compounds, special lacquers, chlorinated rubber and iron glitter. The resulting constellations reveal the ironic and trivial aspects of even the most portentous subjects, showing that a well-visualized idea can be presented with allusive humor and lightness of touch without necessarily becoming banal or blatant. There is a similarity here to some of Penck's analytical configurations, the meanings of which are reduced to symbolic short-hand notations that have increasingly lost their ritualistic character and proliferate over the plane, almost inevitably introducing a certain decorative effect.

What all of the members of the first generation of new figurative painters, who began to work in the 1960s, have in common is a deep involvement with the potentials of painting, a productive and engaging confrontation with the gestural or monochrome abstraction of artists not represented in this exhibition, such as Emil Schumacher, Walter Stöhrer, Raimund Girke, Gotthard Graubner and Ulrich Erben. The intensity of their approaches sometimes stands in sharp contrast to the more easily digestible — and more superficial — styles of their successors. The differences that come to light are not solely due to the divergent experiences of two generations. To judge their work by the same yardstick would be unfair, for many younger painters would not measure up. It would be more constructive to compare the painting of the older generation to the work of the adherents of the Italian *Arte Povera* movement which emerged concurrently, if under completely different conditions, than to label it with the misleading term *Transavanguardia*, that current brand of Italian painting that has garnered success through anachronistic, narrative elements, clever allusions and surprising knowledge of recent Italian art-history.

German audiences, their hunger for figurative images stilled, are already beginning to question their initial euphoria and to reconsider the new painting in its full range. Yet although post-Minimalist and Conceptual tendencies are again gaining ground because of renewed skepticism that has resulted in a glutted art market, German avant-garde painters of the 1960s and 1970s continue to produce figuratively inspired and vitally rendered canvases. Out of skepticism and self-doubt, all of these artists have developed convincing positions, and the growing self-confidence of their work leads one to expect that the days of the easel painting are *not* numbered.

15 Richter, Gerhard. In *Documenta VII*, exh. cat., vol. 1 (Kassel, 1982): 84-85 (English translation: 443).

16 Richter, Gerhard. In *Noch Kunst*, Rolf-Gunter Dienst, ed. (Dusseldorf, 1970): 198.

Abstraction and Fiction

Heinrich Klotz

I.

Joseph Beuys used to stop in front of students' canvases and inquire with a faintly ironic smile: "Well, still painting, are we?" For Beuys the canvas was no longer a serious medium of art, but for some of his students it had become so again. Walter Dahn, for example, one of the many who revered their teacher, had tried various genres, returning time and again to photography or experimenting with video, but never giving up painting with brush on canvas. Dahn was indignant when his paintings were marketed to corporate buyers; still, he kept on painting.

Should art become regressive and ignore the consequences of abstraction and Minimalism? Can it, after the cognitive flights of these pure forms, reintroduce sensuousness of color, naive fiction, images of the material world? And even if such restoration were possible, would it not lead to a recommercialization of art? Such questions imply that the revival of figurative painting on canvas represents a relapse into an obsolete craft, nothing more than a conservative recapitulation of what has long since been accomplished. To put a counterview in perhaps oversimplified terms, the static image, in contrast to "moving pictures" and the relentlessness of imagery in a continual process of change, seeks to preserve what it depicts and make it lasting, permanent. Every pictorial composition that establishes certain formal relationships is a counterforce to ephemeral visual bombardment. At the very least, a painting on canvas argues for the survival of the handmade in a world of technological perfectionism. It records the movements of a hand, the stroke of a brush, the flow of color, as signs of human presence in an environment strewn with the anonymous products of technology. The imagery of the new media expunges all traces of its human origin; but while the production plant replaces tools, the painted canvas still attests in some degree to the mode of its making.

It is an idiosyncrasy of German painting after 1960 that none of its prominent exponents showed much concern for the achievements of hard-edge abstraction. While in German-speaking Switzerland the version of geometric abstraction known as Concrete Art celebrated triumphs with the likes of Richard Lohse and Max Bill, in West Germany it remained a marginal phenomenon. During the postwar reconstruction period, with its blind faith in technology and love of gloss and sheen, German artists sought the opposite, an art of the imperfect, the subjective. Painters like Georg Baselitz and A. R. Penck worked in consciously atavistic styles, and, like the better publicized Beuys, created highly charged personal mythologies. With every heavy, slashing brushstroke they rejected the Brave New World, reminding us that an automated existence is not necessarily a meaningful one. Markus Lüpertz, with his "German motifs" — helmets, officers' caps, sheaves of wheat — and

Anselm Kiefer, with his amalgam of German mythology and Third Reich symbolism, very soon transformed these apparent archaisms into powerfully disquieting images of the recent past, images that plunged the German public into the dilemma of admiring the work aesthetically while recognizing the unpalatability of its content.

In these circumstances, the emergence in Germany of a Barnett Newman or a Frank Stella was unthinkable. On the other hand, direct parallels to American Pop Art did become apparent. In 1963 Gerhard Richter, for instance, chose blurred amateur photographs as points of departure, much in the way that Warhol used newspaper illustrations or Lichtenstein elaborated on the comic strip. And just as Warhol had declared everything to be art, so Richter came to the provocative conclusion that an amateur photograph is more beautiful than any painting by Cézanne. Yet, while the Americans often derived essentially positive statements from the material they appropriated, Richter's amateur photos made ambiguous, even threatening commentaries on petty-bourgeois life.

II.

One key to contemporary German painting is the pursuit of a variety of intellectual strategies aimed at restoring the credibility of painting on canvas. These strategies originated in response to attempts to play abstraction against figuration and vice versa. No medium is better suited than painting to staging confrontations between these two poles of twentieth-century art and to exploiting the possibilities for aesthetic challenge and enlightenment that issue from the clash.

Perhaps the most familiar example is Baselitz, who in the late 1960s began inverting his motifs and, while accepting the premises of representation, nevertheless painted in a quasi-abstract, nonrepresentational mode. Baselitz leaves it up to us to shake off the disorienting effects of an upside-down image and detach ourselves from the subject matter so that the "abstraction" can emerge from the process of perception itself.

The canvases Lüpertz made between 1963 and 1968 had a certain affinity to American Pop Art. Though he was not familiar with American artists at the time, he too deployed large, individual objects on the picture plane. Despite the tangible plasticity of these motifs, which Lüpertz calls "dithyrambs," they are not actual things, not objects taken from reality. One might term them "invented things" or "abstract objects" that exist solely in the image itself and take on a semblance of real objects only in the context of abstraction. Later, Lüpertz began transforming actual objects into painted imagery — roof tiles, tree trunks and steels helmets. These bordered on the unrecognizable, nearly tipping over into abstraction; they were almost

pure forms, yet still things. Deemphasizing content permitted the emergence of an image situated on the very threshold of objective representation.

Richter has run the gamut of twentieth-century styles and modes with unmatched virtuosity. He is a coolly intellectual pyrotechnician who has carried the notion of pluralism in painting to radical extremes. By juxtaposing apparent incompatibles, Richter has made the painting on canvas into a field in which he undogmatically meditates on the various positions of contemporary art. In addition to photographically derived imagery he has composed abstractions of paint swaths and veils, gone from gestural fingerpainting straight to rigorously geometric grids, charging every stylistic move with parody, exploding the programmatic earnestness of the earlier avant-garde. Currently Richter is painting grand abstract symphonies, qualifying their textural sumptuousness by pairing them with small, painted photographic images of infinitely beautiful landscapes or of the slowly burning candle of *vanitas*. For him, abstraction and figuration are no longer diametrical opposites but viable alternatives that emphasize the richness of his pluralism.

None of Richter's pictures claims to be definitive in itself; each is explained by reference to the entire oeuvre. There is, however, no serial principle of fragmentation involved here; each image seems in itself whole and complete, yet it is not. Richter's rapid shifts in standpoint and style, his apparent penchant for sheer multiplicity, imply that his aim is not simply to fall back on the eclectic storehouse of history, but to test the possibilities of the here and now. His exercises represent perhaps the most intelligent strategies developed by any contemporary artist to rescue painting on canvas as a meaningful medium; they are feats of intellectual daring given visual expression. With each successive picture he proves that, in spite of all fashionable misgivings, painting is indeed a viable means of addressing reality.

Baselitz, Lüpertz and Richter as well as Jörg Immendorff, Sigmar Polke and Penck belong to the first generation of the new German painting. All of them have found highly personal solutions to the problem of how painting can continue beyond the seemingly definitive conclusions of abstraction. Their strategies have countered the threat to painting posed by the attenuated programmatic discourse of late modernism. To the history of twentieth-century painting they have contributed one essential finding, namely, that doubt concerning the validity of the painted image can itself be transmuted into painted imagery, and that intellectual reflection on the medium need not preclude the creation of an aesthetic presence.

III.

Others of the same generation — K.H. Hödicke, Kiefer, Bernd Koberling and Norbert Tadeusz — have returned in their work more directly to the narrative, figurative image. For Hödicke, having experimented with other media, painting continued to be an effective means of conveying sense experience. He is enormously skillful at managing the flow of thinned acrylic across the canvas to create sweeping broad strokes that seem illuminated from within. Hödicke's work has exercised deci-

sive influence on the younger generation of Berlin's "New Wild" painters, or Neo-Fauves — Rainer Fetting, Helmut Middendorf, Salomé, Bernd Zimmer — yet his accomplishment is by no means defined by his role as father figure to the new movement. Like Polke, he was one of the first German artists of this period to arrive at a new kind of representation through abstraction, an aim he pursued with tenacity and imagination. His canvases of the 1960s transmuted geometric abstraction into evocations of the external world. These images, based on the distorted patterns of shopwindow reflections or of street paving, were both abstract and figurative, postmodern reincarnations of the perceptible world shaped by the experience of abstraction. Hödicke's return to subject matter was not simply a reinstatement of realism or illusionism. Rather, he was arguing from the most recent positions in art, taking hard-edge abstraction as a point of departure from which to work forward to a style that was distinctly representational, even if it bore signs of its abstract origins. This was no mere recapitulation; it was a new standpoint, the result of a long, painstaking process.

K.H. Hödicke, *Große Reflexion* (Large Reflection). 1965

In certain paintings by Kiefer abstract image becomes landscape. At first glance one sees color fields, flecks and linear tangles; then a few patches at the upper margin turn into the silhouettes of trees jutting above the high horizon. As the viewer looks closely, brushstrokes and linear configurations metamorphose into an unplowed field, with broad channels that extend into the distance to end at the edge of a wood. But why should Kiefer have been interested in depicting a landscape, an unplowed field, if the possibility had not offered itself of translating an abstraction into a representational motif, of letting flecks and patches of paint flip over into a mimetic, fictional image? Recognizing and decoding, acts of cognition, have become central to the changeover from modernism to postmodernism. The viewer is no longer asked to enjoy the "pure forms" of a nonobjective composition but to recognize

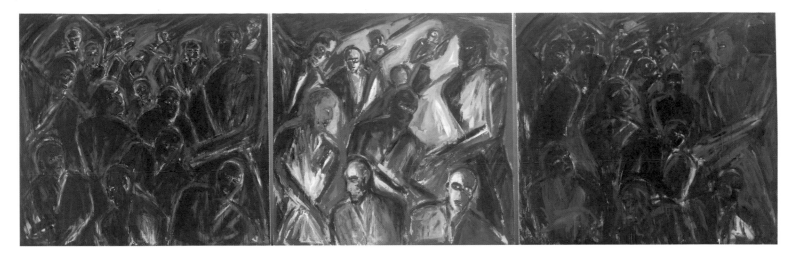

Helmut Middendorf, *Großstadteingeborene* (Big-City Natives). 1980

in an apparently abstract painting, an object-related representation.

The reemergence of the figure restores to painting the great potential of the narrative image. Conveying one's own experience of the world again becomes the painter's concern. Perhaps the most direct approach came from the Berlin painters Fetting, Middendorf, Salomé and Zimmer. Confessing to what moves them the most, they laid themselves open, stripped themselves bare in defiance of all programmatic or theoretical caution. When Middendorf and Fetting depicted discotheques — singers, guitarists, dancers, the crazies and eccentrics of the Berlin New Wave scene — they were showing us exactly what they had experienced.

Middendorf's triptych of 1980, *Big-City Natives*, one of the cult pictures of the present generation, evokes their world scene — figures in blue or black, swaying to music, bathed in red light. To some extent the image relies on Picasso's *Les Demoiselles d'Avignon*, a painting that Middendorf has studied closely at New York's Museum of Modern Art and to which he has repeatedly paid homage. The angular bodies lined up in shallow space along the picture plane recall Picasso's early Cubism; their movements appear restrained by the confines of the canvas. The primitivism of the figures, harshly outlined as if in a woodcut, corresponds to the elemental force of the music and underground atmosphere of SO 36, the Berlin rock club where the four Neo-Fauves gathered nightly.

In 1978 Fetting ventured his first "remake" of van Gogh's painting of himself stalking down a country road lined with cypresses in Provence. The following year Fetting confronted the picture again, this time spiriting van Gogh to Berlin and depicting him with clenched fist, as if to say art is a goal that must be pursued against all odds, and placing him in front of the wall that divides the city. The rapid and spontaneous rendering of the figure recalls Abstract Expressionist technique; indeed Fetting seems to be acknowledging both his teacher Hödicke and an American artist whom he greatly admires, Willem de Kooning. In making this gesture of respect, Fetting found himself. His homage to van Gogh, a subjective reinterpretation, amounts to a personal confession made in defiance of the honorable precept advanced by such artists as Bill and Josef Albers, that paintings must be kept free of all "self-expression."

The paintings of Zimmer, a student of Hödicke and Koberling, are likewise brilliant translations of abstraction into figuration. One canvas is dominated by an expansive yellow plane that the viewer initially reads nonobjectively, until the two brown areas at the upper right and a dark blue band above suddenly suggest plowed fields and sky — the image becomes a landscape, a field of wheat in bloom. The greenish yellow hue flows in streaks down to the lower edge of the canvas, its texture evoking waving stalks and blossoms. A picture like this was conceivable only on the basis of American color-field painting. An abstract plane redirected toward figuration, Zimmer's field in flower assumes mimetic significance. The forms and colors of a mountain stream rushing between rocks and moss in another owe much to the techniques of Abstract Expressionism. Zimmer's painting technique remains in the modern tradition, yet by turning it in the direction of mimesis he breaks with the conventional idea of artistic advance, in effect denying that such an advance can be strictly linear.

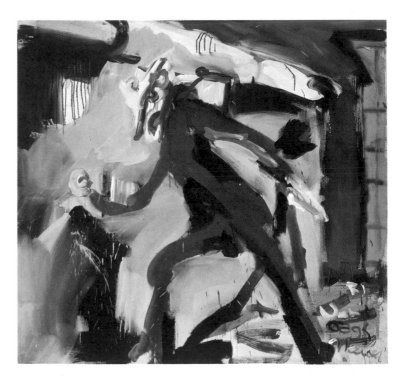

Rainer Fetting, *Van Gogh und Mauer* (Van Gogh Wall). 1979

Bernd Zimmer, *Rapsfeld* (Colza Field). 1980

IV.

During the years the Neo-Fauves emerged, Peter Bömmels, Walter Dahn and Jiri Georg Dokoupil, Hans Peter Adamski, Gerhard Naschberger and Gerard Kever, all Cologne painters, formed the core of a quite different group, the Mülheimer Freiheit, which existed for a short time after 1980, until the artists went their separate ways.

Dokoupil, at first closely associated with Dahn, began a dazzling series of experiments with diverse techniques and subjects. A highly conscious artist, he always finds his imagery by way of reflection. Hardly had the public become used to one approach when Dokoupil, running the gamut from primitivism to abstraction, from surrealist balancing acts to monochrome color fields, would unleash some surprising innovations. He reviewed all the styles of twentieth-century art to emphasize that he would confess no allegiance, adopt no one creed. His pluralism, his seemingly inexhaustible capacity for innovative quick-change, turned out to be a sharply effective cure for the ailment of programmatic orthodoxy. The only constant factor underlying all of Dokoupil's imagery is irony. The eclecticism so characteristic of art in our century takes on new features in Dokoupil's work. By keeping all styles at his disposal, he deprives them of their claim to be absolute and definitive.

Dahn is less of a virtuoso. From 1981 to 1983 he remained true to a primitive approach that drew as much sustenance from Beuys's drawings as from children's scribbles on city walls. Jean Dubuffet was another predecessor, though his compositions in the manner of primitive graffiti were in the end cultivated and tasteful. Dahn went a step further and consciously let the naive vividness, the unfettered vitality and involuntary ugliness of primitive images, enter his work without the blandishments of Dubuffet's sophisticated handling. A washed, rapidly rendered ground might spread across the canvas, forming a foil for isolated objects, apparently naive motifs that spring from banal fantasies to provide the subject of the composition: *Camel, Drinker, One-day Wonder, The Fox and the Baby, The Red Table.* The camel's humps have grown faces and shout at one another; a man eats a broom; the drunk's arm turns into a bottle; a table becomes a red face, spreading terror.

Dahn paints in defiance of "good" painting, smearing his figures on the canvas as if the notion of beauty were just as absurd as the belief in significant themes. That crocodile-leather shoes can turn back into crocodiles on the feet of the wearer is just one of those things that some artist had to point out sooner or later. Though his style verges on caricature, Dahn's skinny smoker's leg pierced by a burning cigarette is a kind of shorthand for the question of fate. Ironically, Dahn's directness permits his images to congeal into symbols. Using this approach, there is nothing that cannot be said. With the aid of aesthetic devaluation, of true primitivism, the utterance, the story, again becomes a viable possibility.

V.

The overtones of irony and sarcasm toward the bourgeois world present in Dahn's and Dokoupil's work comes through loud and clear in that of Werner Büttner, Martin Kippenberger and Albert and Markus Oehlen, all of whom are active in Hamburg. Political protests and demonstrations accomplish nothing — that is the insight shared by these members of the post-1968 generation, who make a joke of protest and aestheticize even the harshest criticism of society. Nothing is certain, not even pain in the face of the world's state makes sense; there is no valid truth. These artists juggle with questions of value, but what gets expressed in their work is always a sense of the grotesque.

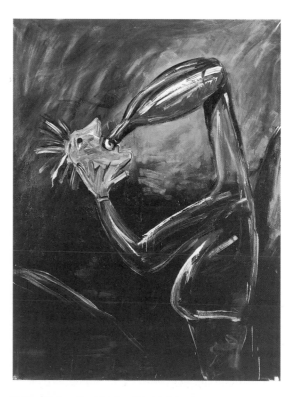

Walter Dahn, *Der Trinker* (The Drinker). 1981

Kippenberger, mimicking the idyllic popular illustrative style of the 1950s, paints a pregnant woman bearing a clown as embryo; Albert Oehlen presents a barbecue for dinosaurs and his self-portrait as Hitler. Werner Büttner's own likeness disappears entirely beneath a great towel he has draped over his

Werner Büttner, *Badende Russen* (Bathing Russians). 1981

head for a visit to the steam bath. These are consciously parodistic themes, and the painters know full well that as protest their work is harmless. Their inability to shake a jaded public has, so to speak, been painted into the composition. The senseless vandalizing of telephone booths, a subject of Büttner's, becomes a symbol for general meaninglessness. For the 1980 *Zeitgeist* exhibition in Berlin, Büttner did a large canvas titled *Bathing Russians*: uniforms neatly folded on a beach and, in front of them, rows of just as neatly placed boots. This satiric commentary on military order, says the artist, was also intended as an appeal for peace; the Russians out swimming in the ocean, whom the viewer is asked to imagine, are naked, defenseless. Now and then Büttner will paint poetic imagery that belies his sarcasm — a pair of red women's shoes on a large, otherwise empty canvas, for instance. Yet such themes are the exception in his oeuvre.

Albert Oehlen, *Morgenlicht fällt ins Führerhauptquartier* (Morning Light Falls into the Führer's Central Headquarters). 1982

Abstract images occasionally turn up in Kippenberger's sequential paintings. In context they seem like tasteful ornaments, consciously light in effect — abstraction as pleasing, meaningless reminiscence. Albert Oehlen once depicted an empty room, rendered in long, tenuous strokes and fragmented planes, the floor resembling a blood-red sea. Were it not for the swastika projecting into the space from below, one might consider the picture nonrepresentational. Oehlen titled it *Morning Light Falls into the Führer's Central Headquarters*. The darkest chapter of German history is treated with offhand sarcasm in an almost abstract painting. "Blink for a right turn and turn left" seems to be the motto of these Hamburg artists; that at least is how they put it in one of their many nonsense manifestos.

VI.

There are many things you cannot express in painting that you can express in film, photography, performance, installations and books. Though, as Dieter Hacker once replied to the skeptics who have written off painting: "Painting is a very significant medium, if a limited one. But what you can express in painting cannot be expressed in any of the other media." The return to mimetic, narrative painting by way of abstraction — and not by way of a retreat to pre-abstract modes — is symptomatic of a phenomenon that has proven decisive for the postmodern ethos. The absolute image, what Alexander Rodchenko called "a plane with colors on it," has lost its original character and again become a fictional representation of something given in reality. Yet instead of congealing into a photographically realistic image, it has "refigured" itself, out of the forms and colors of abstraction. The transition from absolute to fictional image represents the turning point from modernism to postmodernism.

This reopens the vast realm of narrative themes to painting. Instead of seeking the highest degree of objectivity in a nonobjective mode, the artist is openly subjective. Associated with this recourse to narration and interpretation is a repudiation of polish and finish, a move away from modernism's theoretical emphasis on nonrepresentation. In some people's eyes, the simple fact that the young painters in the Federal Republic of Germany who are known as the Neo-Fauves are again speaking about their individual experiences and interpretations of existence makes them appear questionable. Yet in jettisoning the sophisticated theories of modernism and employing the work of art as a medium of narrative fantasy, they are actually more "neonaive" than Neo-Fauve. The theoretical discourse of modernism aimed precisely at discounting fiction and breaking down the barriers between art and life, as in the work of Beuys. That these artists paint "stories" implies a demand on the viewer to suspend disbelief in the fiction.

Telling stories, Plato said, means inventing lies. Invented reality is not reality. Thus, every story told in paint on canvas is a manifestation of that very element in art that modernism hoped to eliminate, not realizing that this would eliminate art itself; life, after all, is not art. Postmodernism conveys disenchantment about the attempt to expunge illusion from art. The fiction has returned, and in the work of the younger painters, it

gathers from abstract shapes and colors a semblance of figuration — but without pretending that modernism can be undone, as illusionistic realism would.

In view of the many of themes that the new painting asserts are once more acceptable, it is difficult to avoid the impression that for decades the need to convey a discernible message had been accumulating like water behind the dam of abstract and Conceptual art. In Berlin, Hamburg and Cologne, the centers of the new painting in Germany, groups of painters emerged who, in their own individual ways, broke the ban on narration and subjective interpretation. What underlies the visual narratives of all these artists and lends significance to their farewell to abstraction is a lack of respect for the established values of European civilization. Middendorf's rock clubs and Dahn's graffiti, the pluralism of Dokoupil and the sarcastic treatment of rules and morality in the work of Büttner, the Oehlens and Kippenberger all illustrate the impressive range of possibilities of combining pure form with a compelling, previously unuttered message.

Norbert Tadeusz, *Valentano*. 1987

Double Exposure — The Golden Shot?
By one who set out to unlearn fear

Hans Albert Peters

Focussing and Initiation

Painters who paint figuratively are bad artists: such was the conviction of many sensitive, intelligent, knowledgeable artists, critics, collectors and certainly museum curators in the years immediately following World War II and for a long time after. To an entire generation of people interested in art, representational art — in particular, figurative painting — was the expression of a world view that had throttled itself and was therefore to be rejected as a manifestation of an outworn *Zeitgeist*. Anyone who did not summarily dismiss it became highly suspect. For many with knowledge and understanding, such a person was no free spirit, no daring transgressor of taboos, but rather a poor wretch, an intellectual garden dwarf whose ancestral pedigree might as well be the seemingly endless line of *Headfoots* produced by Horst Antes. Not a few of us smiled at those artists still vainly attempting to wrest vital qualities of expression and insight from the human figure or, more generally, from the representational image. Such "annihilating" criticism was aimed fairly indiscriminately at any painting that had not been pushed to complete nonrepresentation — or at least to the brink of it.

For a long time few artists, dealers, collectors and critics took exception to this prevailing viewpoint. Notwithstanding the well-earned respect accorded to Rudolf Springer and Hein Stünke and their broad-based gallery programs, and in spite of the admiration both for Prince Franz von Bayern's sure hand in building up his collection and for Dieter Koepplin, without doubt the most courageous museum curator of our generation, the issue remained unclear: were we dealing with personalities independent of fad and convention, or even with the avant-garde of tomorrow and beyond? In the end, the insight and passionate commitment of Michael Werner provided the answer.

Around 1970, almost out of the blue, figurative painting exploded (there really is no other word for it) in German galleries, exhibiting institutions and museums, after Dutch and Swiss exhibition organizers and heads of museums had surprisingly taken the first steps. What had changed so radically, after twenty-five years, to make this possible? What were, what are, the reasons for this *volte-face* (for that is precisely what it was)? It is not enough to assert that, since the general proclamation of postmodernism, almost everything is possible at the same time with almost equal priority. True, after 1970 figurative painting was being done again with much verve and significant results, as it was in the 1950s by such artists as Pablo Picasso and Fernand Léger, Jean Dubuffet and Francis Bacon; but why had the "signs of the times" for almost a quarter of a century been so ill-disposed towards it? After all, in the course of thousands of years figurative painting had repeatedly and

forcefully renewed itself and at the very least offered time and again a view of the world that later generations could identify with or criticize. Why had we had no faith in the self-regenerative power of an art that had for so long clarified the human image and man's image of the world? And why do we see only now what we overlooked then? Did we want to see it at all? Or were we, in the 1950s, really too stupid to see it in its true light? Were we under a spell? If we were, who had cast it, and why?

First Exposure

Hamburg, early May 1953. The Deutsche Künstlerbund (German Artists' League), reestablished in 1950, convenes in a mood of protest. It is no novelty for voices in discussions among artists to grow loud when the subject is art; but in this instance it is a fight for justice and liberty, which several members see seriously at risk. "Dictatorship of the Abstractionists!"[1] cries Edgar Ende,[2] the Munich Surrealist and leader of the Neue Gruppe, to the assembly. He hits the nail on the head. Eight years after the Nazis' reign of terror only to be faced by another dictatorship, this one engineered by artists?

The previous day, the panel of the Deutsche Künstlerbund's third annual show had refused the right of exhibition at the Hamburg Kunsthalle to the original members — Otto Dix, Max Pechstein, Ernst Thomas, Max Unhold and a number of other highly significant painters who worked in a late Expressionist or realist manner.[3] Do world-famous artists not deserve a bonus or, at the very least, respect, even if they submit works weaker than their best? In any case, quality is always a debatable point. Ultimately it is a work's frame of reference that determines its quality. What quality was at issue, though, when ten nonrepresentational artists, among them Willi Baumeister, Ernst Geitlinger and Georg Meistermann, pressed through their rejection of figurative painting in general and of the five representational artists, Ernst Heckel, Gerhard Marcks, Edwin Scharff, Ernst Schumacher and Toni Stadler, in particular, with such utter contempt?

The issue was ideology. For the entire creative effort of Baumeister, Geitlinger, Meistermann and those who worked by their side or in their wake was determined by the conviction that representational painting had had its day, was exhausted

1 *Der Spiegel* 29 (July 15, 1953); quoted in *Carl Hofer 1878-1955*, exh. cat., Staatliche Kunsthalle, Berlin (Berlin, 1978): 695.

2 *Edgar Ende: Gemälde, Gouachen und Zeichnungen* (Munich, Hamburg, Mannheim and Wuppertal, 1988).

3 *Carl Hofer*: 695.

1 Konrad Klapheck. *Schreibmaschine* (Typewriter). 1955

2 Konrad Klapheck. *Die gekränkte Braut* (The Offended Bride). 1957

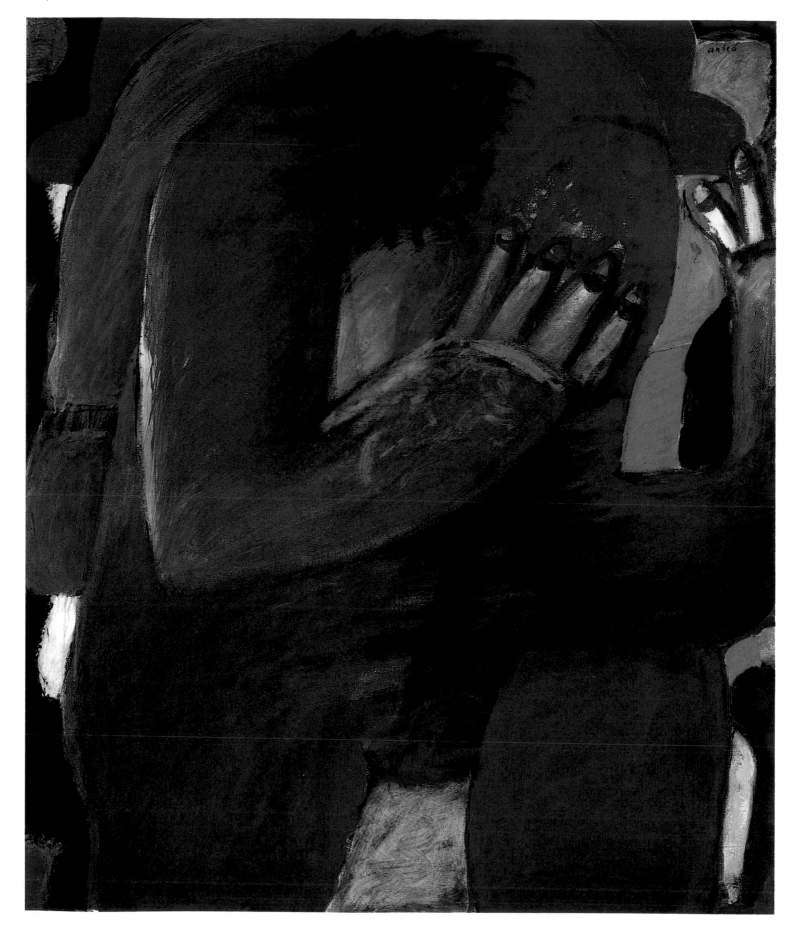

5 Horst Antes. *Grosse blaue Figur* (Large Blue Figure). 1962-63

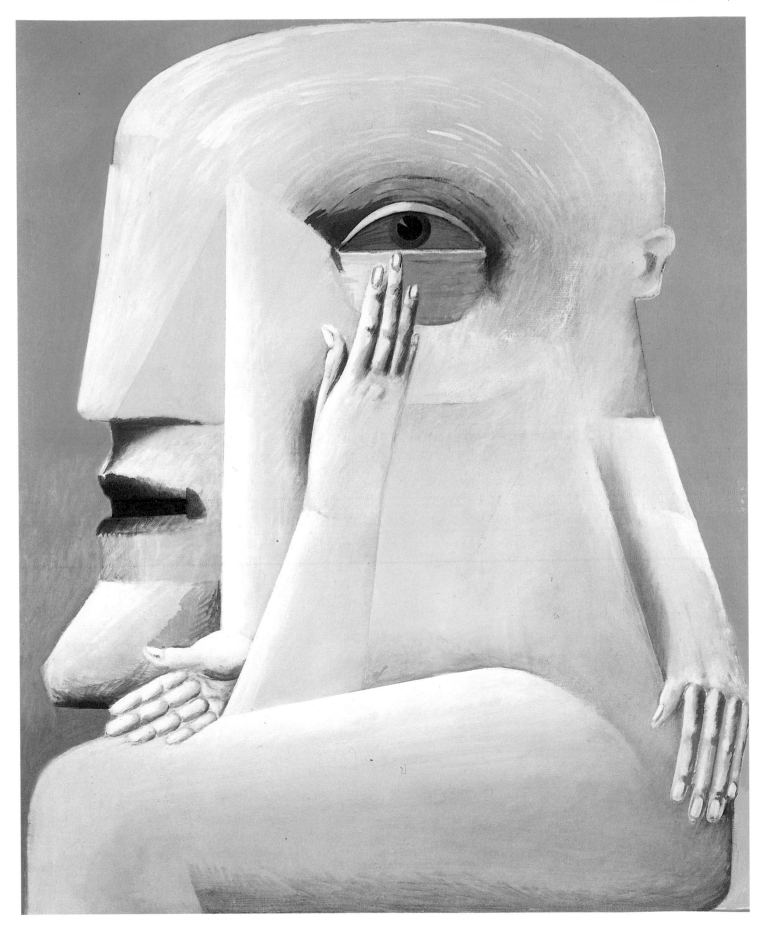

6 Horst Antes. *Sitzende Figur, gelb* (Seated Figure, Yellow). 1975

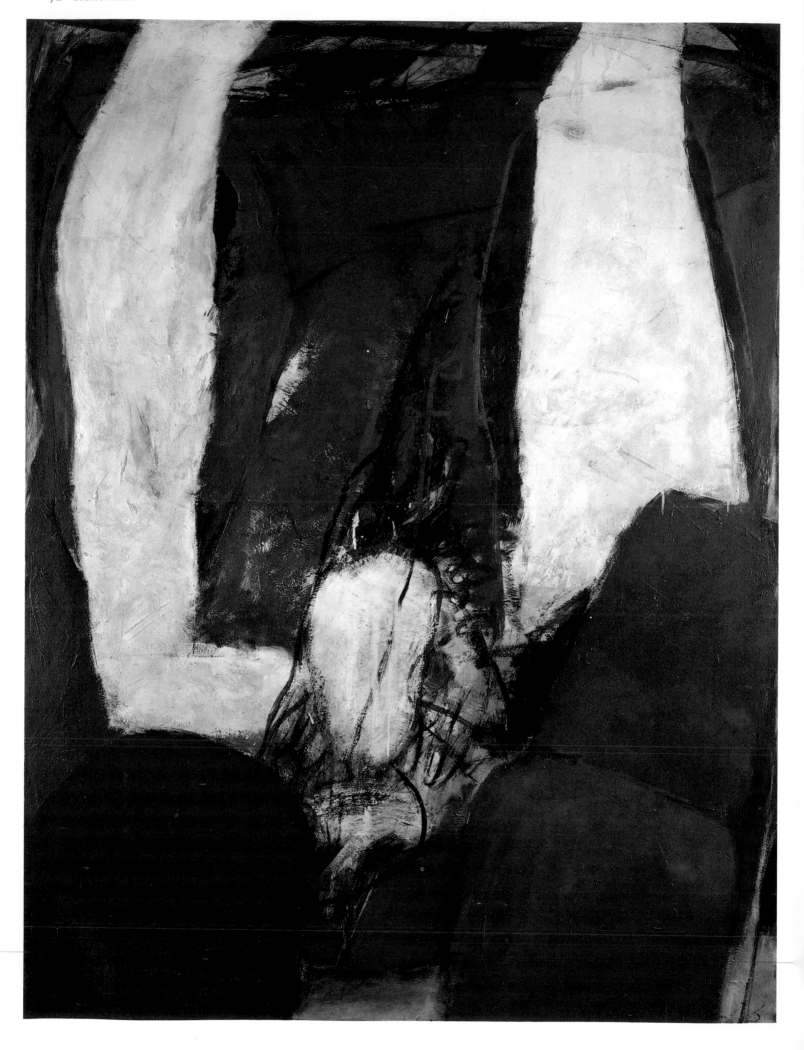

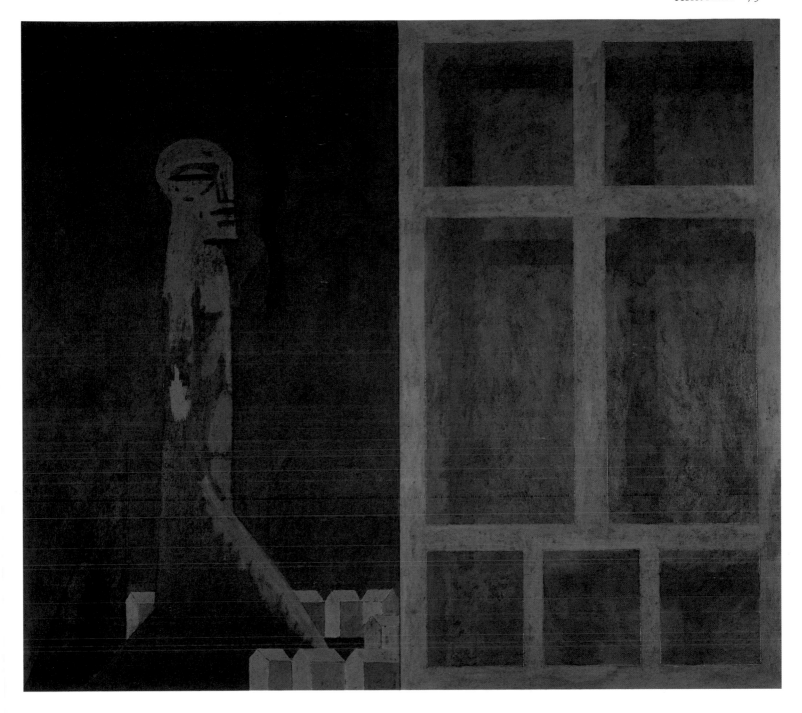

8 Horst Antes. *Kniende Figur, Dorf, Berliner Fenster* (Kneeling Figure, Village, Berlin Window). 1988

7 Horst Antes. *Figur Gebärende*
 (Figure: Woman in Labor). 1959-60

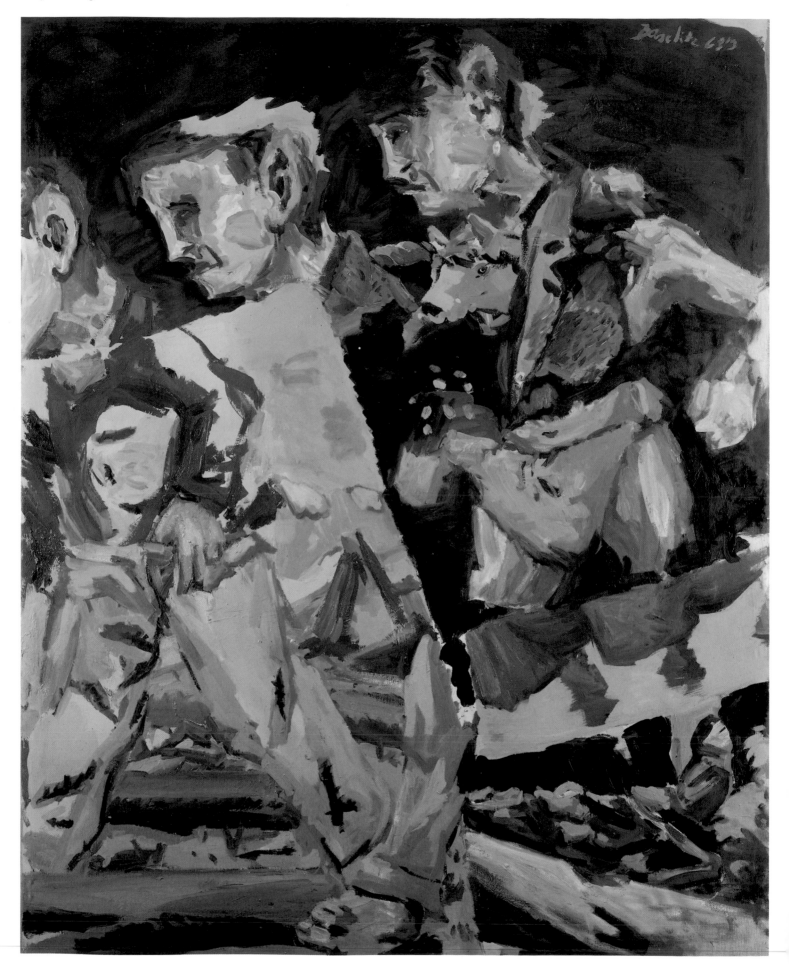

11　Georg Baselitz. *Meissener Waldarbeiter* (Meissen Woodcutters).　1968-69

12　Georg Baselitz. *B für Larry* (B for Larry).　1967

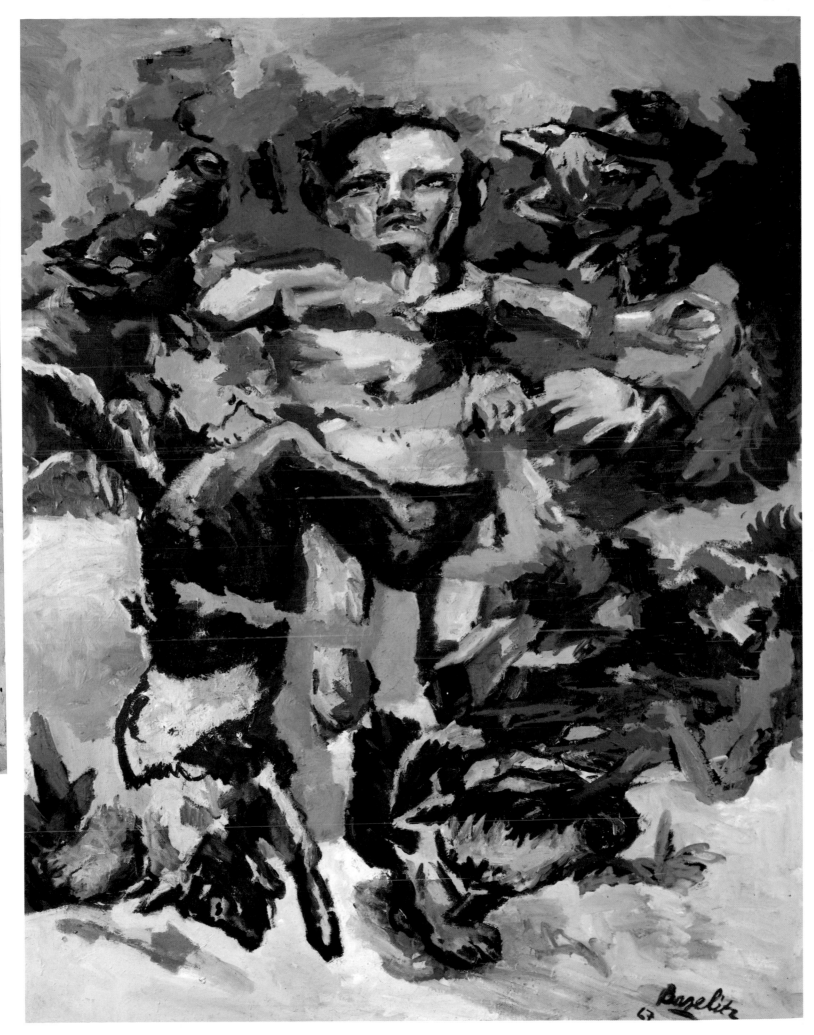

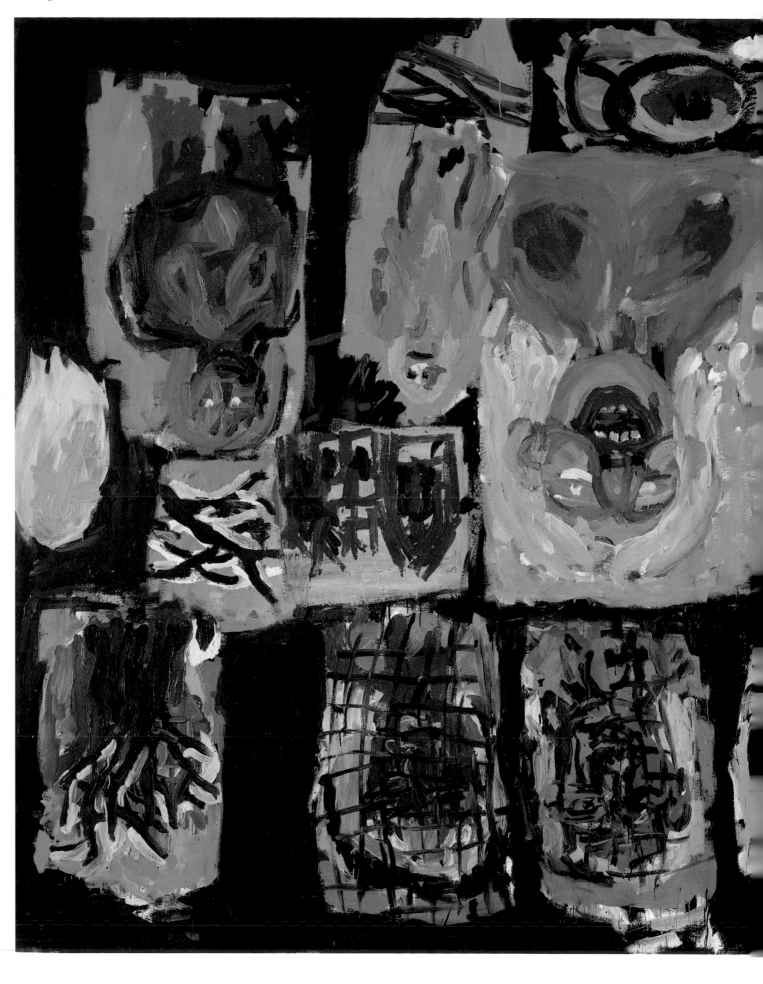

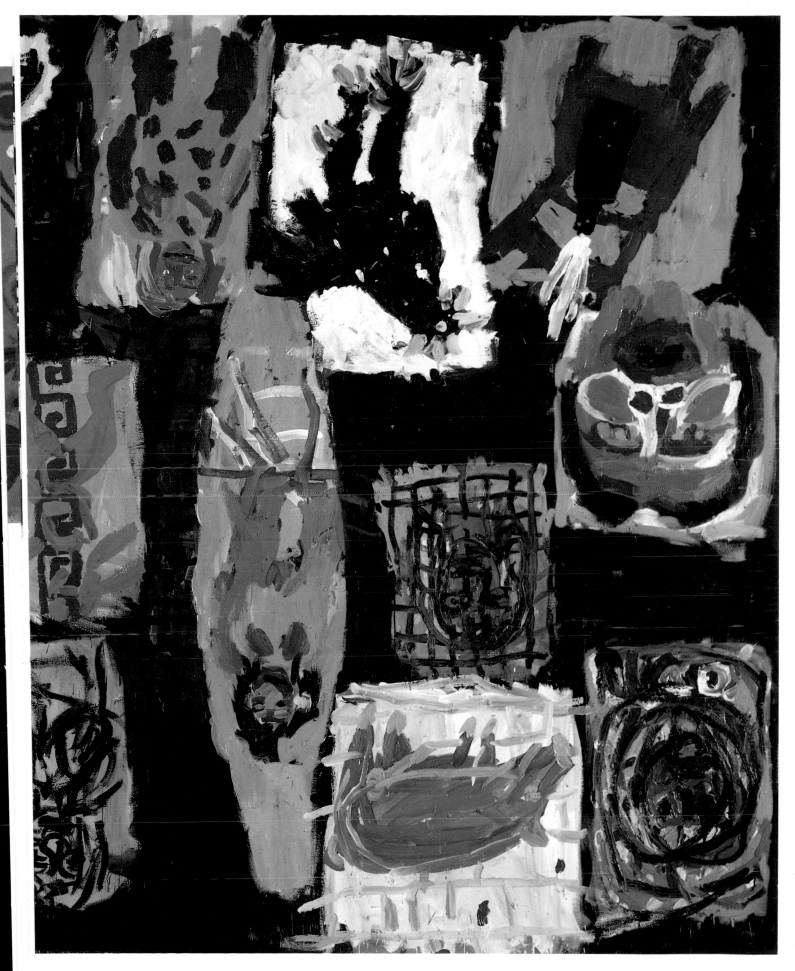

23 Georg Baselitz. *Das Malerbild* (The Painter's Picture). 1987– 88

30 Jörg Immendorff. *Naht* (Seam). 1981

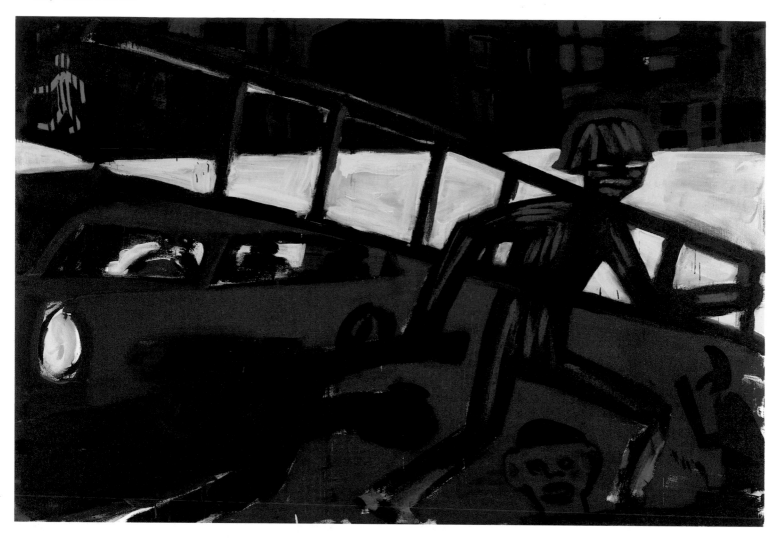

35 K. H. Hödicke. *Im Blaulicht* (In the Flashing Light). 1983

36 K. H. Hödicke. *Tod eines Radfahrers*
(Death of a Cyclist). 1963

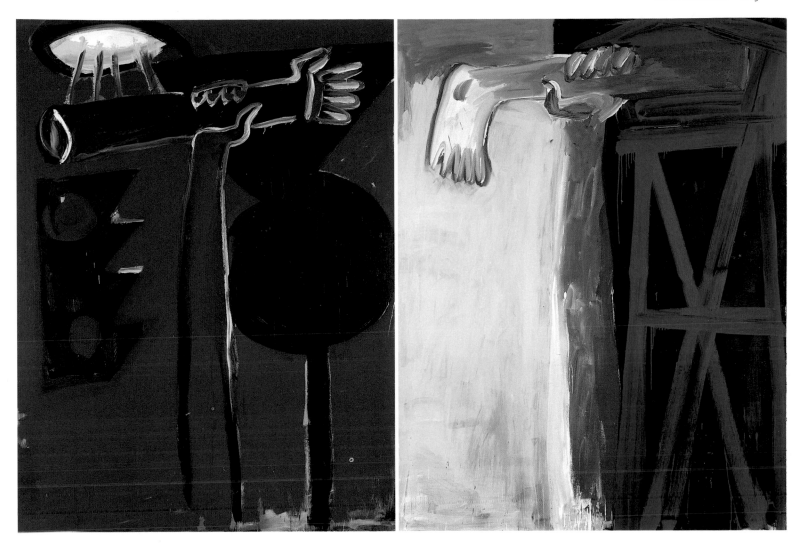

37 K. H. Hödicke. *Grosses Tor* (Large Gate). 1986

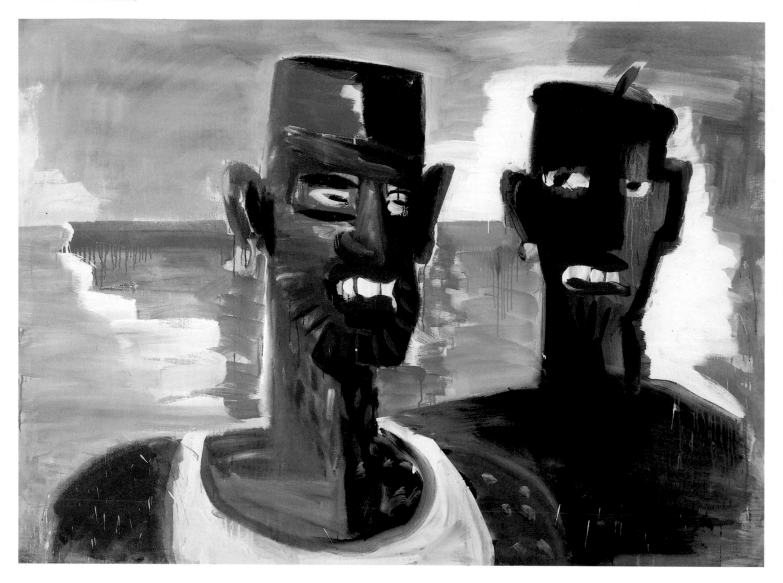

38 K. H. Hödicke. *Selbst und Fremdenlegionär* (Self and Foreign Legionnaire). 1982

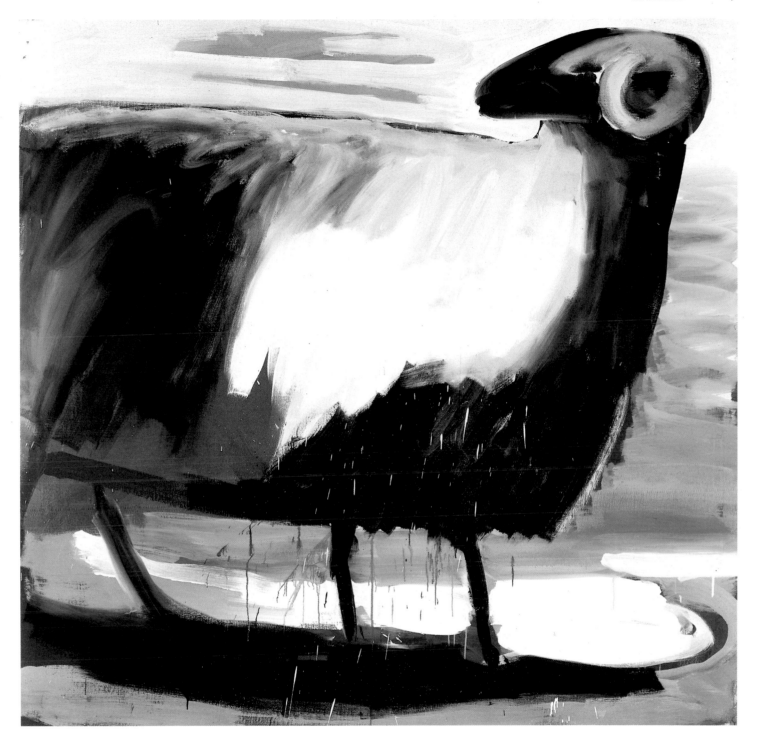

39 K. H. Hödicke. *Sheep.* 1982

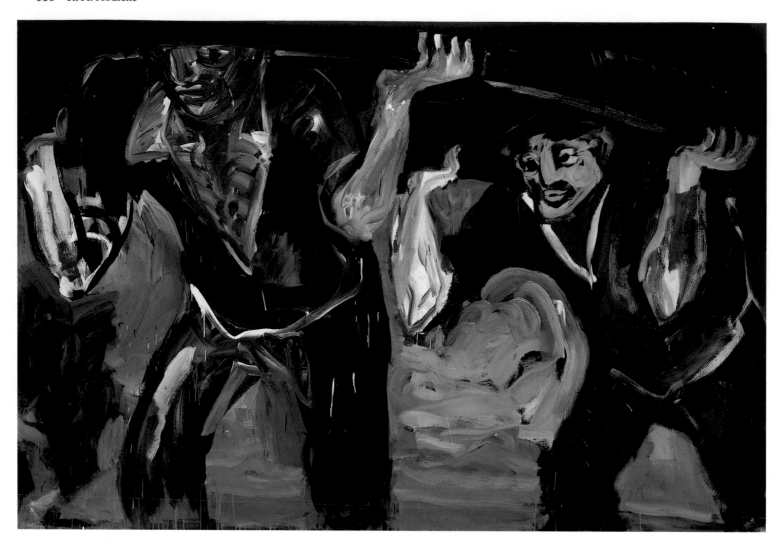

40 K. H. Hödicke. *Grosser Curragh* (Large Curragh). 1987

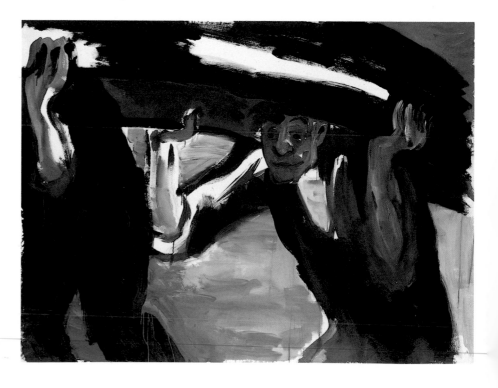

41 K. H. Hödicke. *Kleiner Curragh* (Small Curragh). 1987

42 K. H. Hödicke. *Felsen der Sirene* (Siren Rocks). 1983

43 Markus Lüpertz. *Donald Ducks Heimkehr* (Donald Duck's Homecoming). 1963

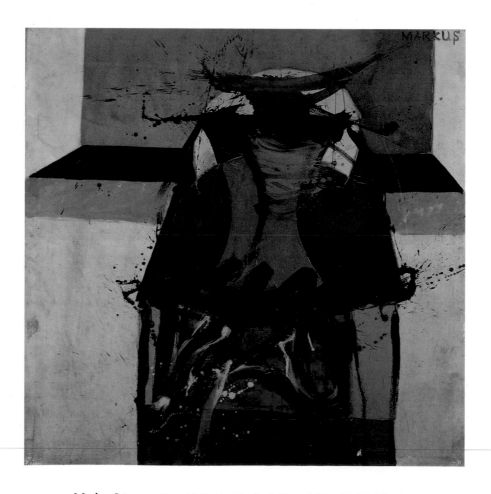

44 Markus Lüpertz. *Donald Ducks Hochzeit* (Donald Duck's Wedding). 1963

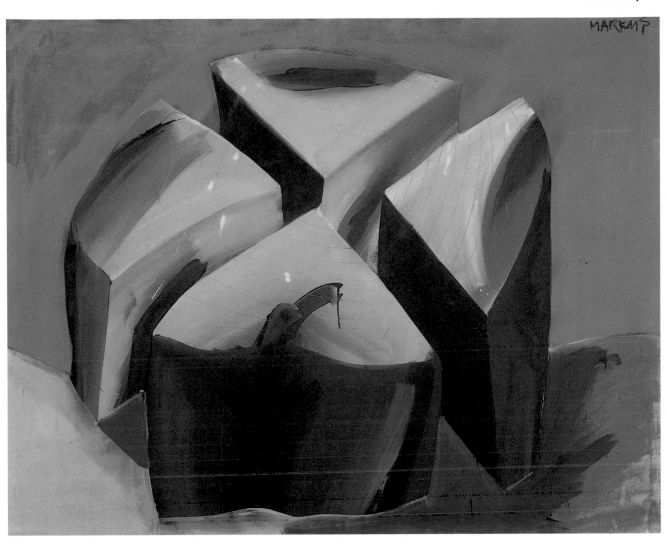

45 Markus Lüpertz. *Baumstamm dithyrambisch* (Tree Trunk, Dithyrambic). 1966

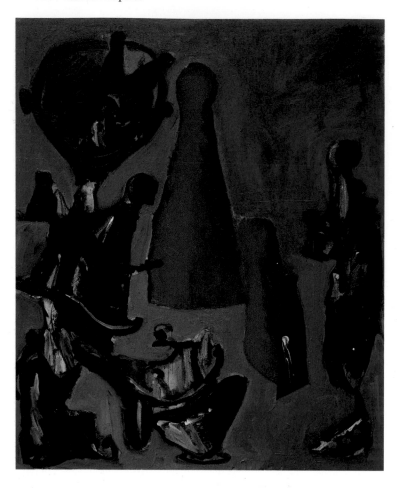

46 Markus Lüpertz. *Väter und Söhne*
(Fathers and Sons). 1983

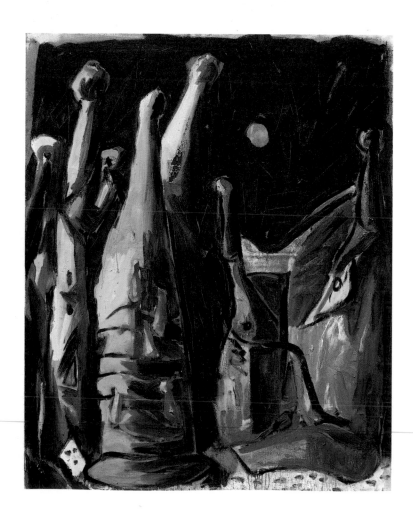

47 Markus Lüpertz. *Bewohner: Nächtliches Trinkgelage*
(Inhabitants: Late-Night Drinking Bout). 1983

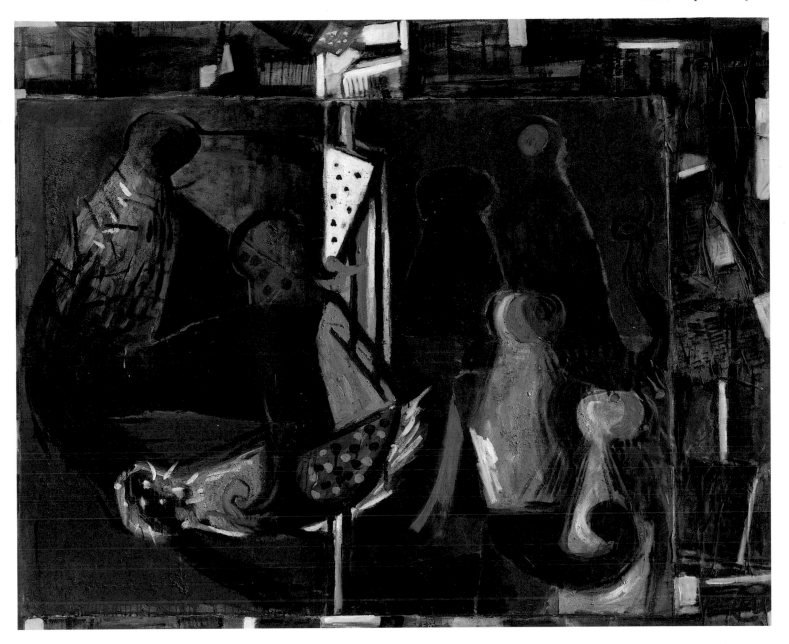

48 Markus Lüpertz. *Bewohner: Hexen verstellen die Peripherie oder wenn Grün Gesetz wird*
(Inhabitants: Witches Cutting off the Escape Routes or When Green Becomes Mandatory). 1983

49 Markus Lüpertz. *Melonen – Mathematik IX*
(Melons – Mathematics IX). 1984-85

50 Markus Lüpertz. *Melonen – Mathematik IV*
(Melons – Mathematics IV). 1984-85

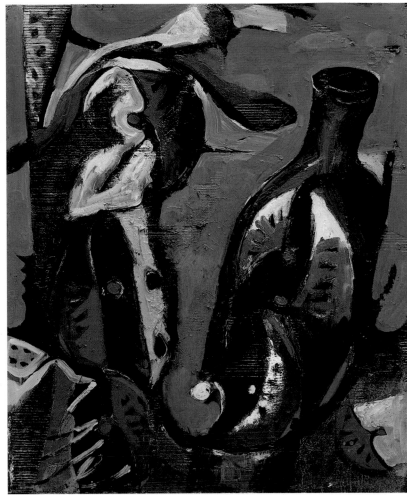

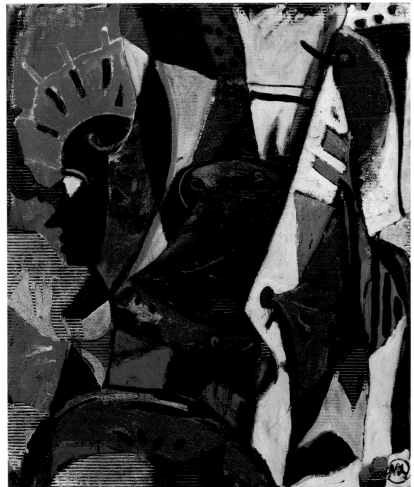

51 Markus Lüpertz. *Melonen – Mathematik XXI*
(Melons – Mathematics XXI). 1984-85

52 Markus Lüpertz. *Melonen – Mathematik VIIIX*
(Melons – Mathematics VIIIX). 1984-85

53 Markus Lüpertz. *Melonen – schwarzes Profil*
oder Dante sieht Beatrice XIII (Melons – Black Profile
or Dante Sees Beatrice XIII). 1984-85

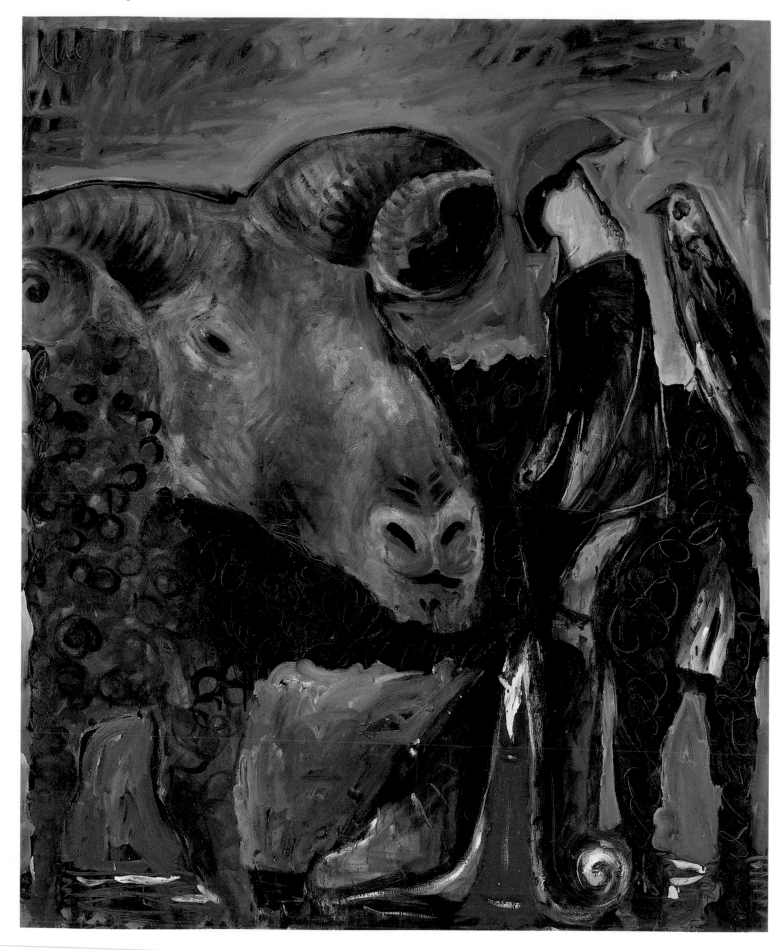

54 Markus Lüpertz. *Hirte mit Vogel (Zyklus: Zwischenraumgespenster)* (Shepherd with Bird [Ghosts of Negative Space Cycle]). 1986

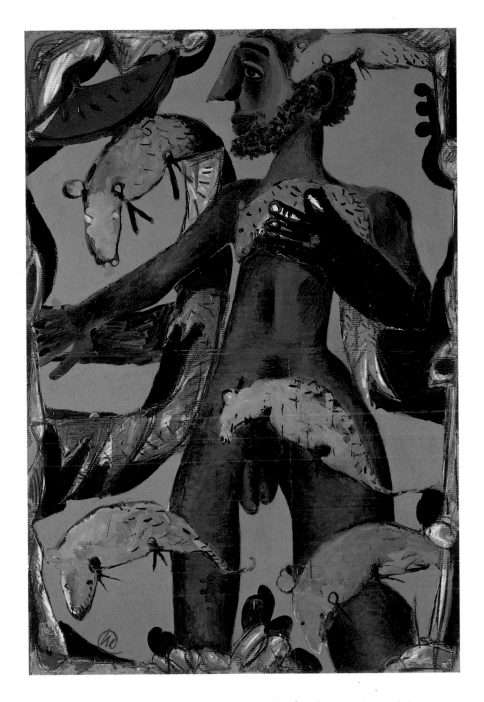

55 Markus Lüpertz. *Der heilige Franziskus verhindert die Vernichtung der Ratten*
(St. Francis Preventing the Extermination of the Rats). 1987

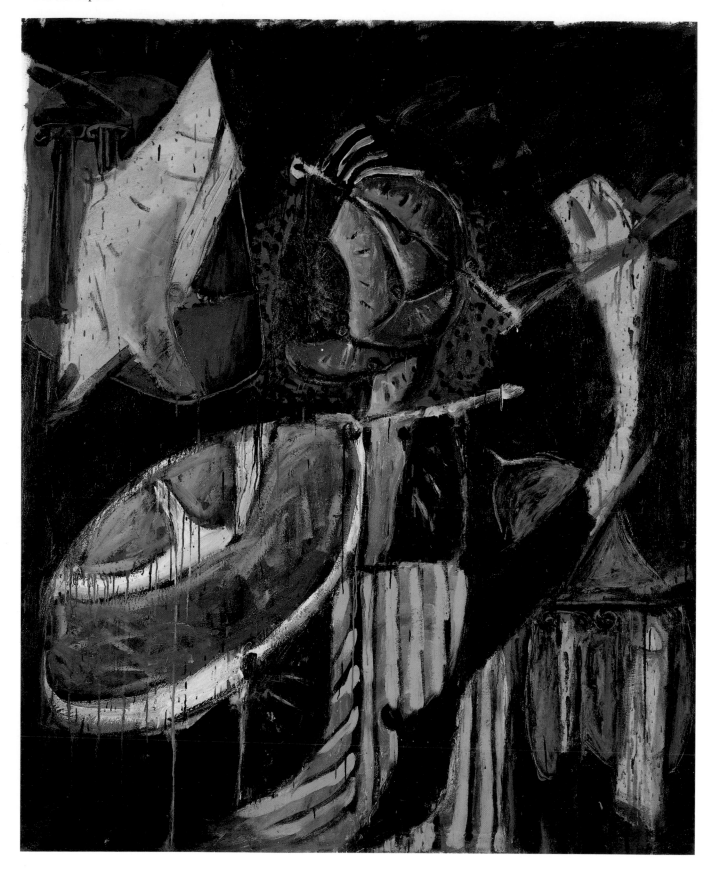

56 Markus Lüpertz. *Griechisches Interieur* (Greek Interior). 1985-86

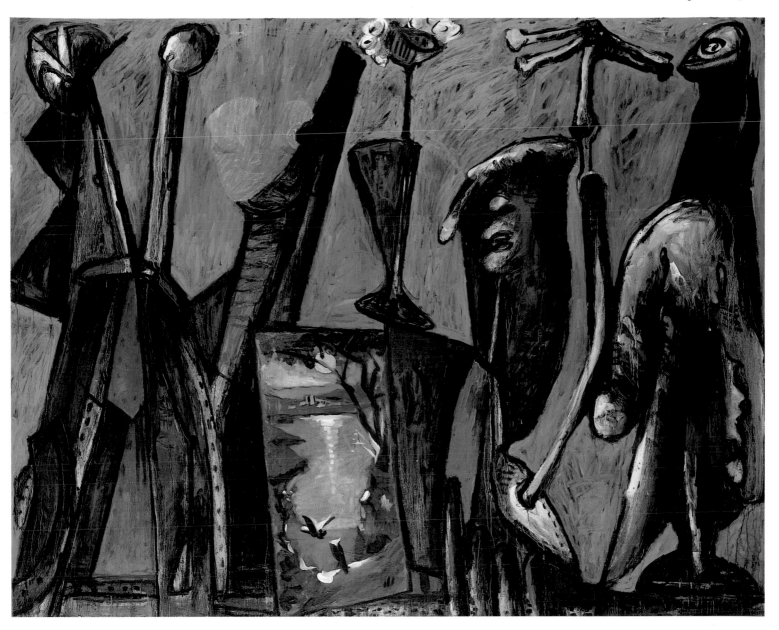

57 Markus Lüpertz. *Das Abendmahl in M. L.* (The Last Supper in M. L.). 1988

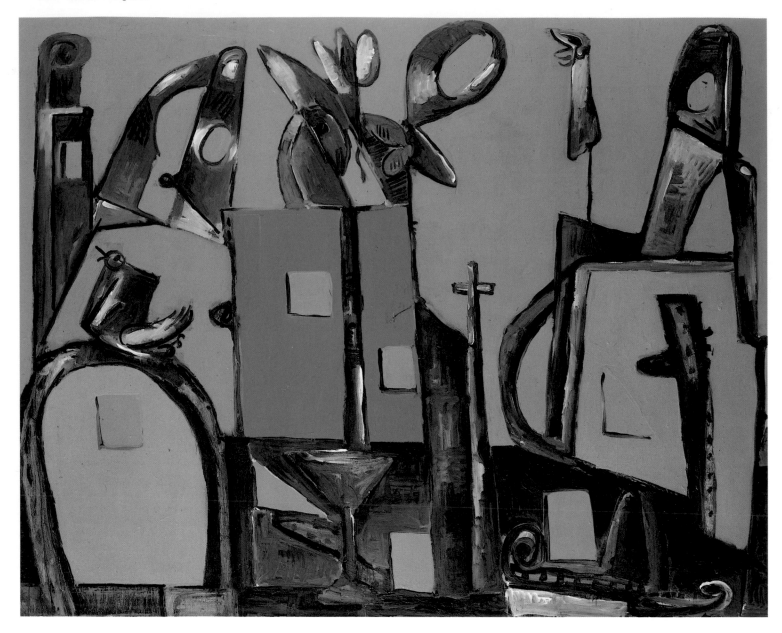

58 Markus Lüpertz. *Vogelfriedhof* (Bird Cemetery). 1988

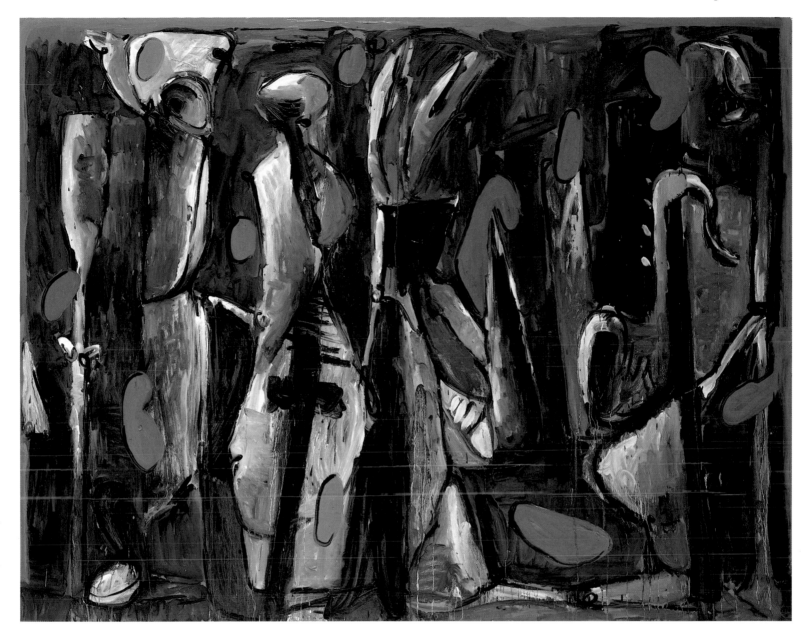

59 Markus Lüpertz. *Das Tuch der Erinnerungen* (The Fabric of Memories). 1988

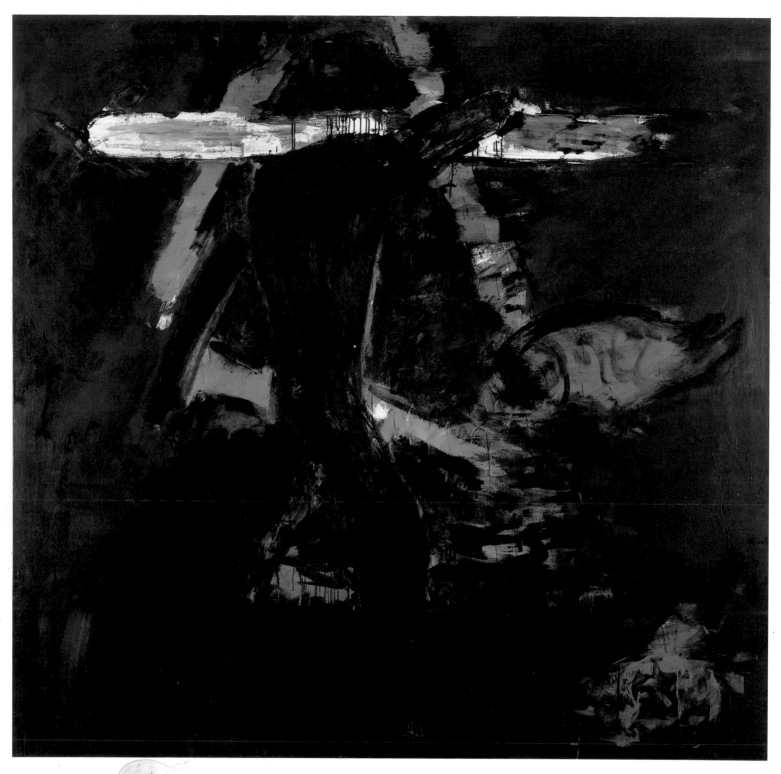

67 Bernd Koberling. *Strand* (Beach). 1985

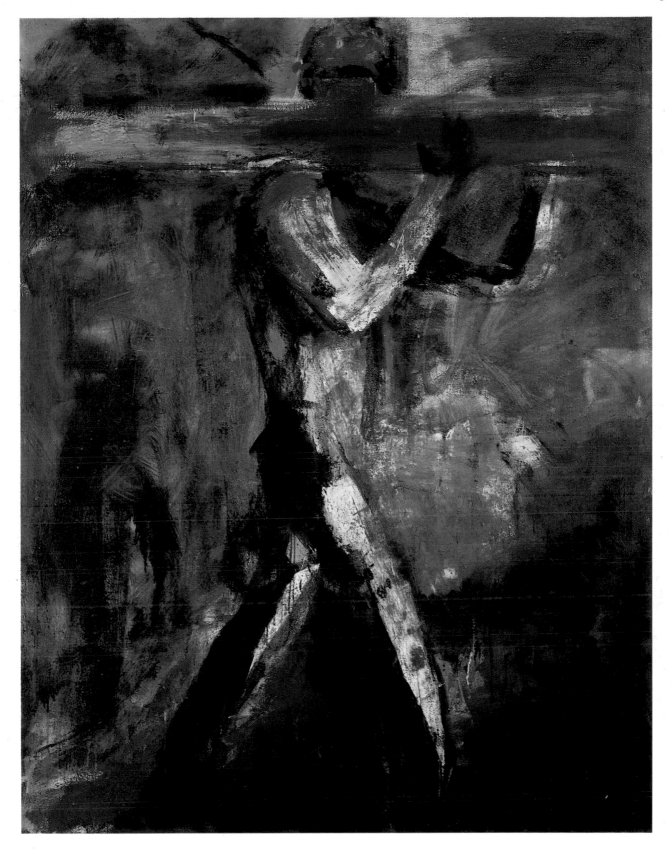

68 Bernd Koberling. *Horizont* (Horizon). 1985

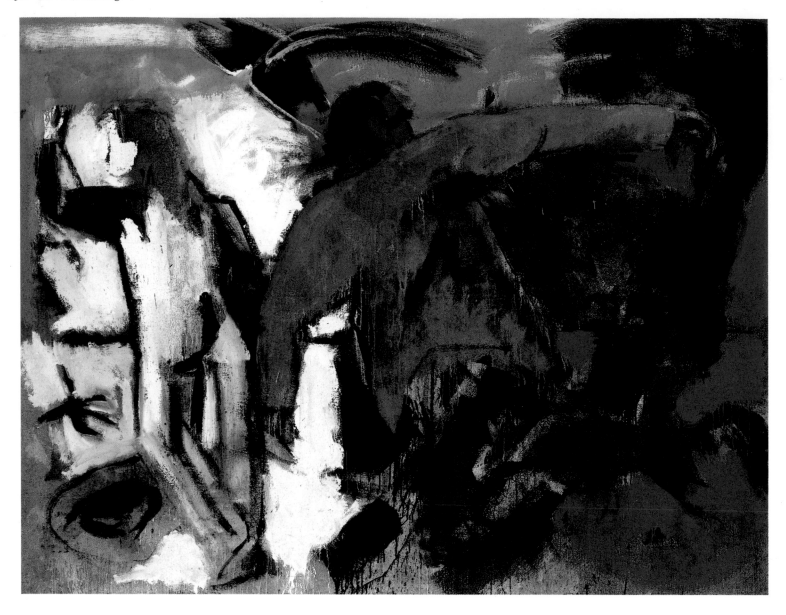

69 Bernd Koberling. *Fluchten* (Flights; Perspectives). 1982-83

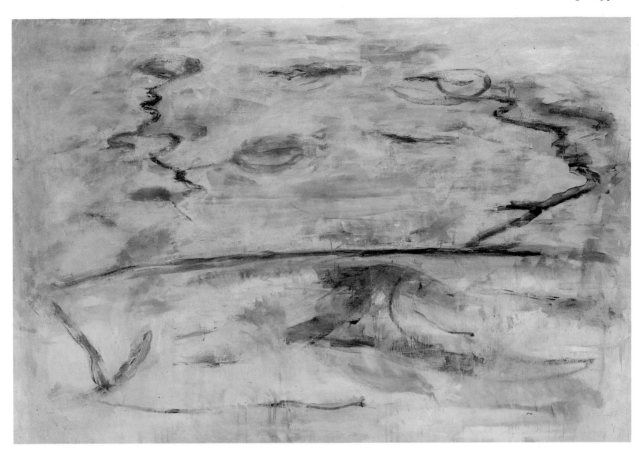

70 Bernd Koberling. *Landlinien II* (Land Lines II). 1988

71 Bernd Koberling. *Landlinien I* (Land Lines I). 1987-88

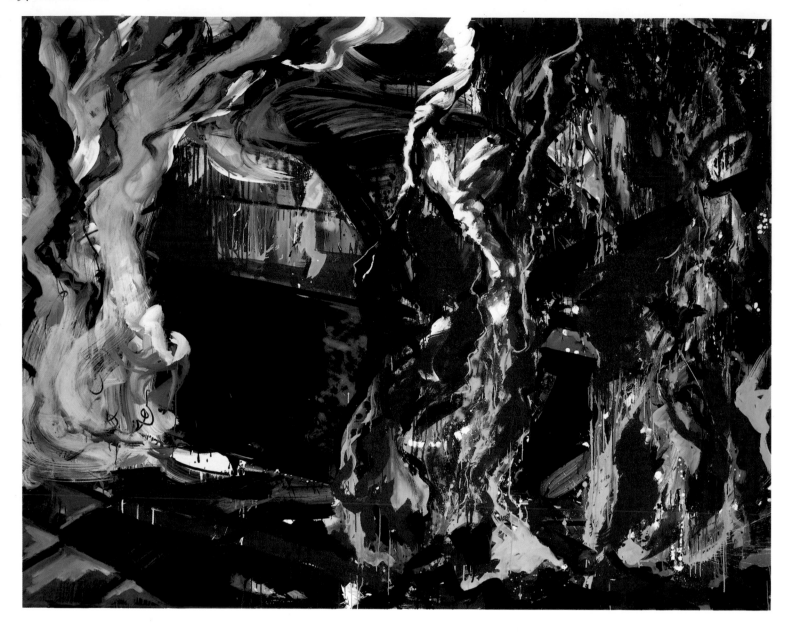

72 Bernd Zimmer. *Auto, brennend* (Car, Burning). 1982

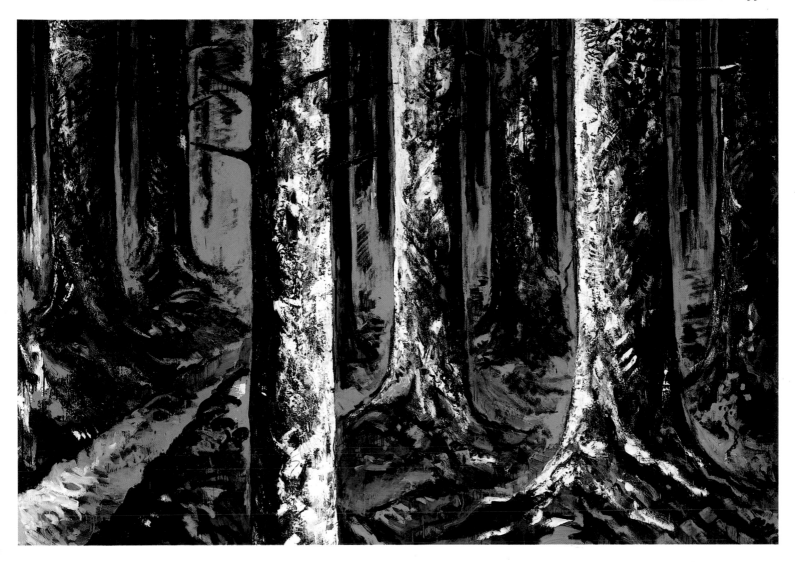

73 Bernd Zimmer. *Fichtenwald* (Spruce Forest). 1985-86

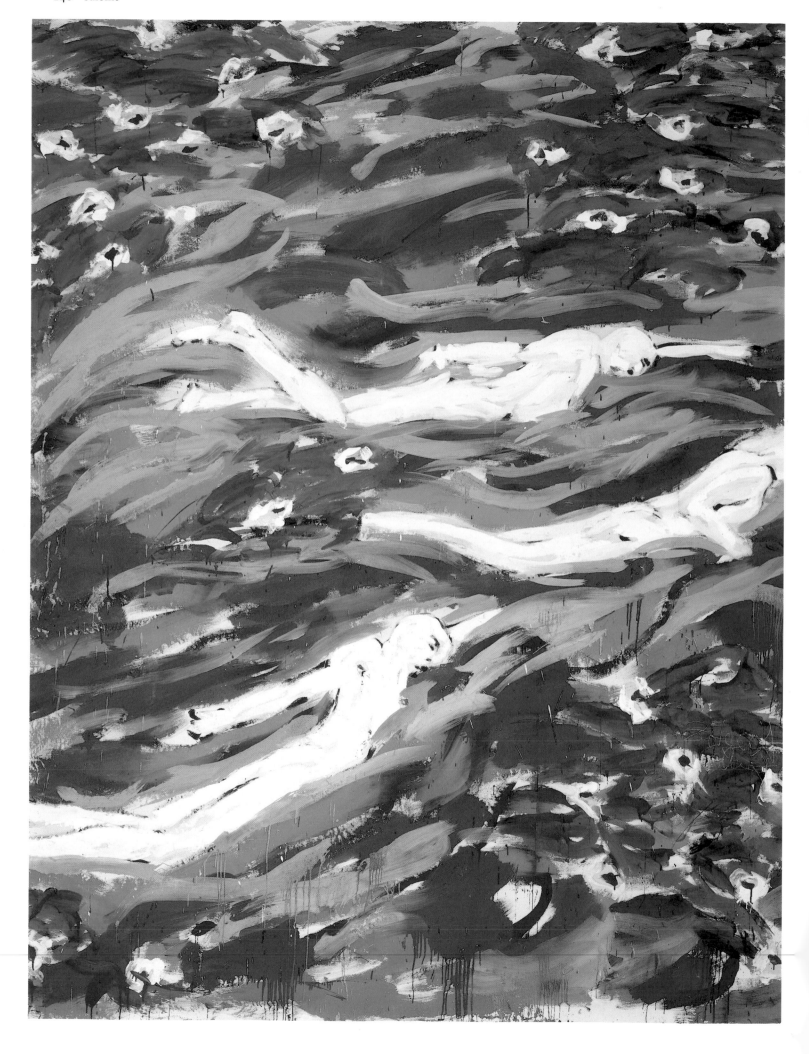

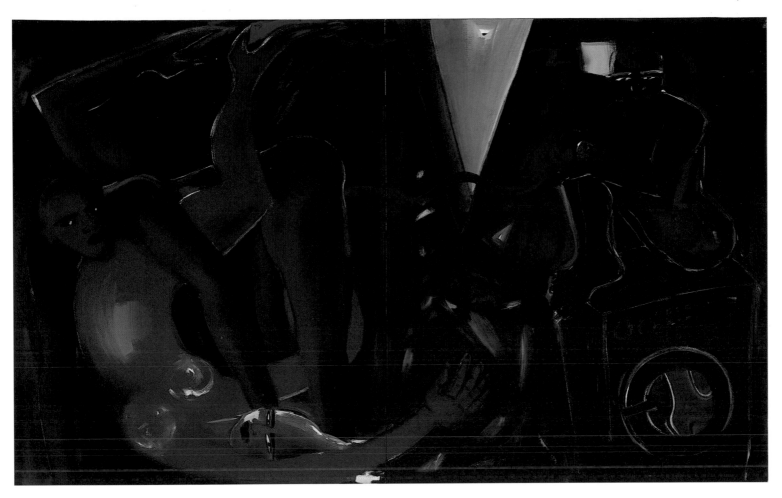

79 Elvira Bach. *Der verlorene Schuh* (The Lost Shoe). 1986

78 Salomé. *Kampf im Seerosenteich* (Battle in a Lily Pond). 1982

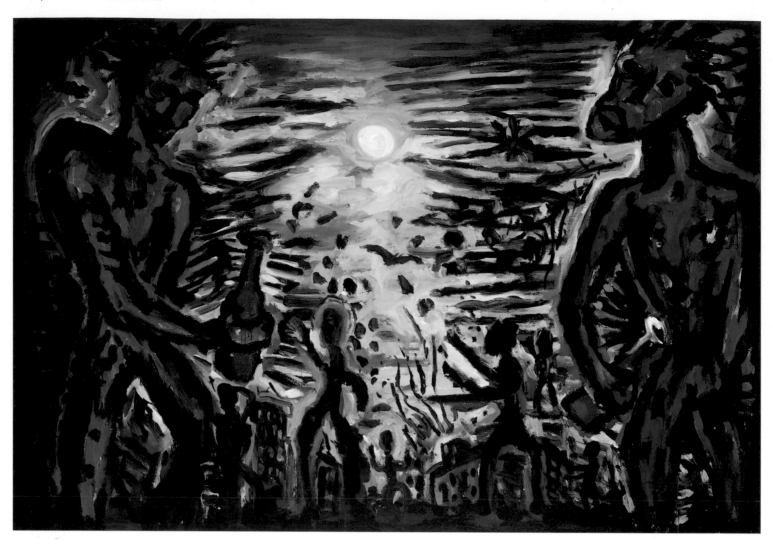

80 Helmut Middendorf. *Im Kessel I* (In the Cauldron I). 1987

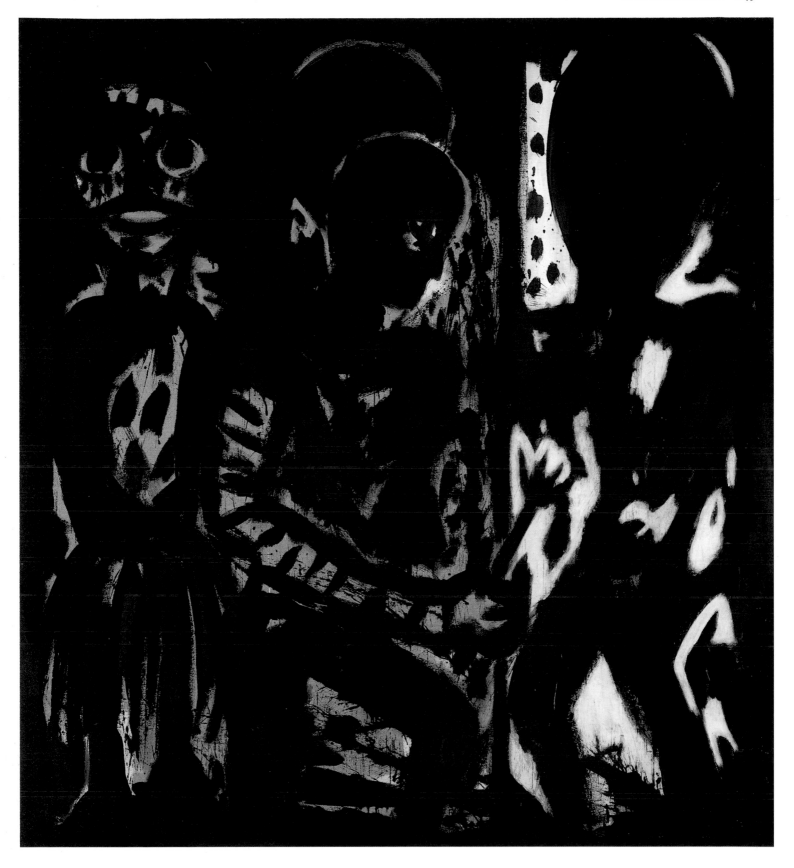

81 Helmut Middendorf. *Der Maler* (The Painter). 1987

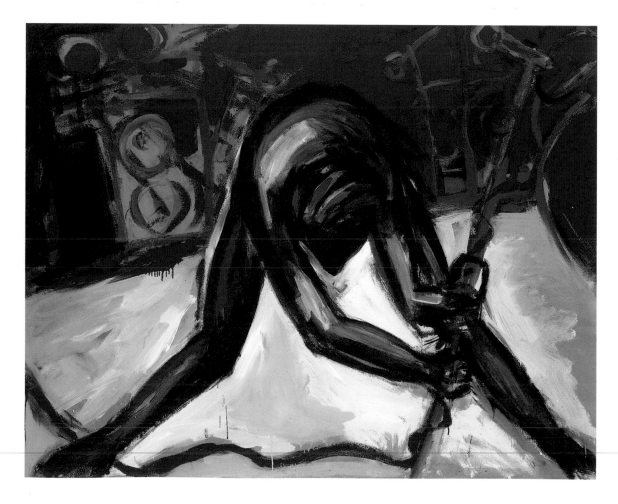

82 Helmut Middendorf. *Singer*. 1981

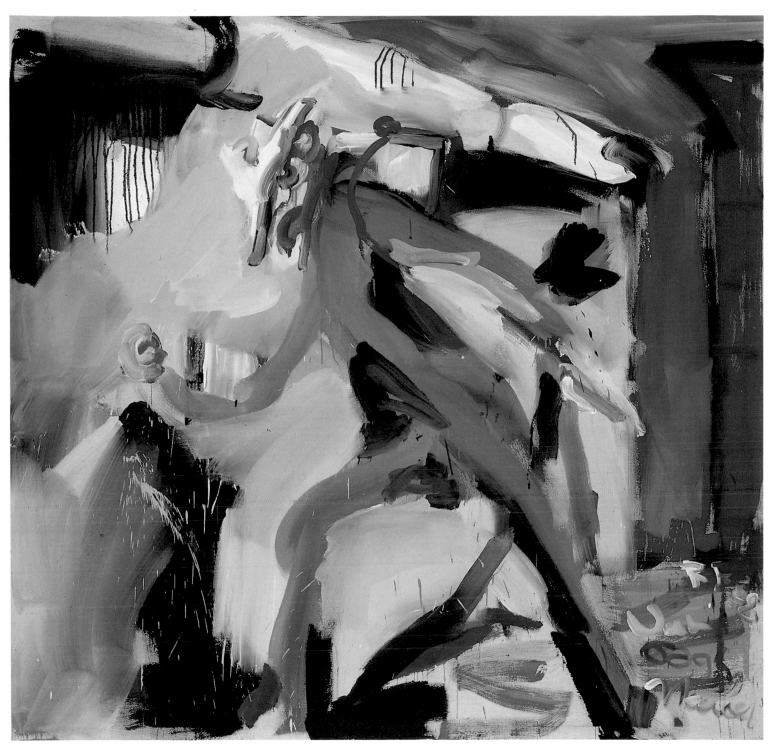

83 Rainer Fetting. *Van Gogh und Mauer* (Van Gogh and Wall). 1978

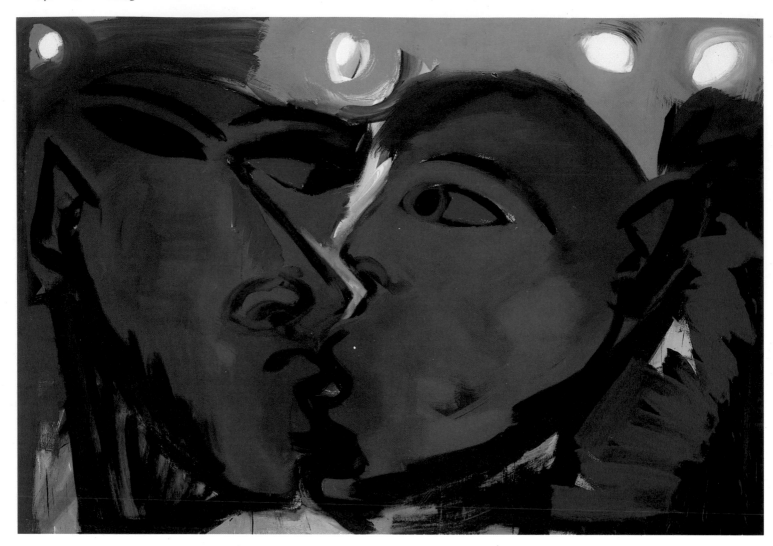

84 Rainer Fetting. *Kuss II* (Kiss II). 1981

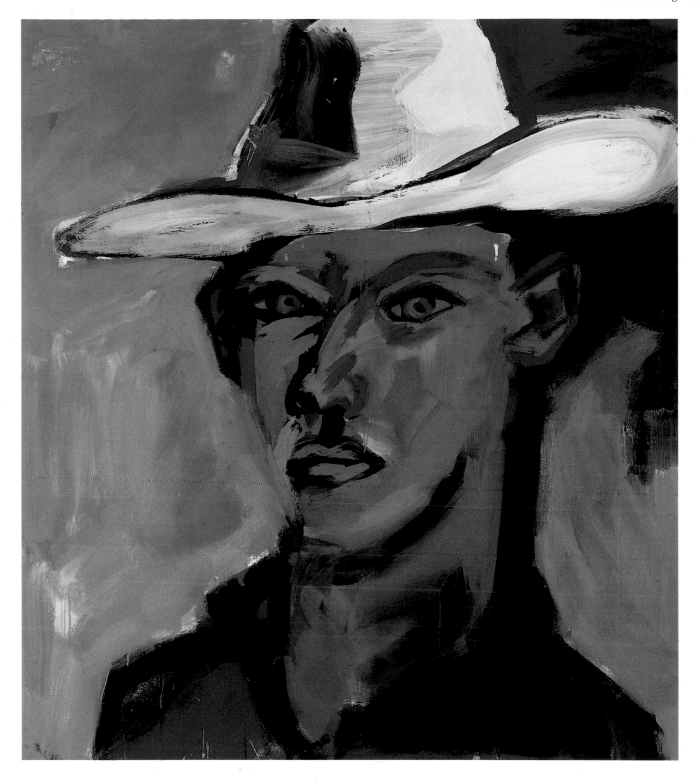

85 Rainer Fetting. *Selbst mit gelbem Hut* (Self with Yellow Hat). 1982

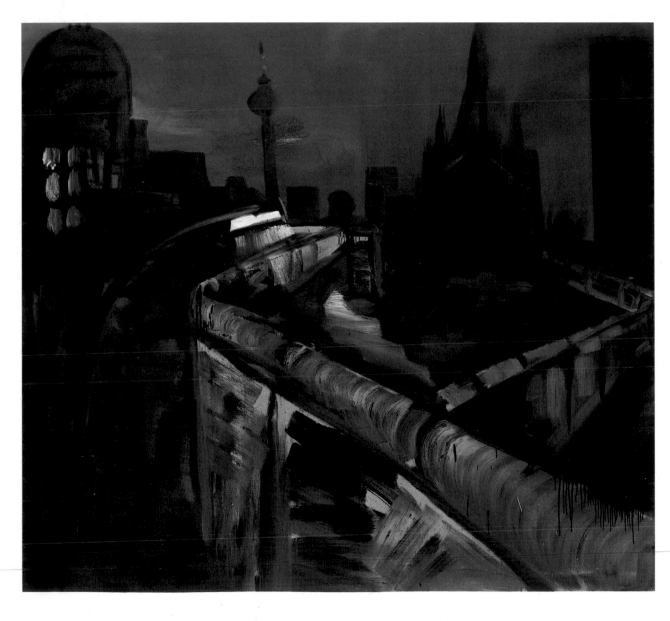

88 Rainer Fetting. *Südstern mit Mauer* (Südstern Station with Berlin Wall). 1988

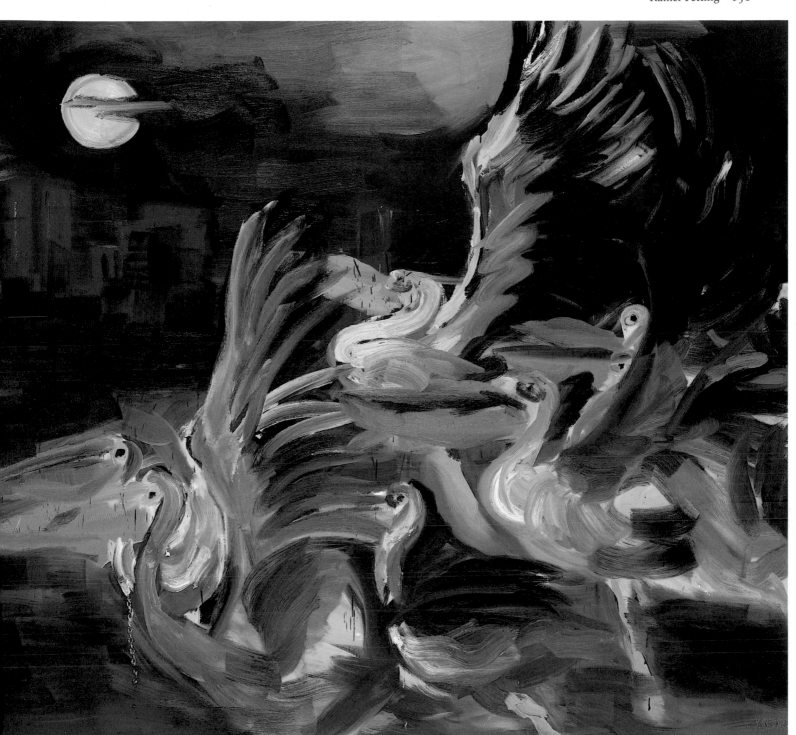

89 Rainer Fetting. *Night of the Pelicans.* 1987

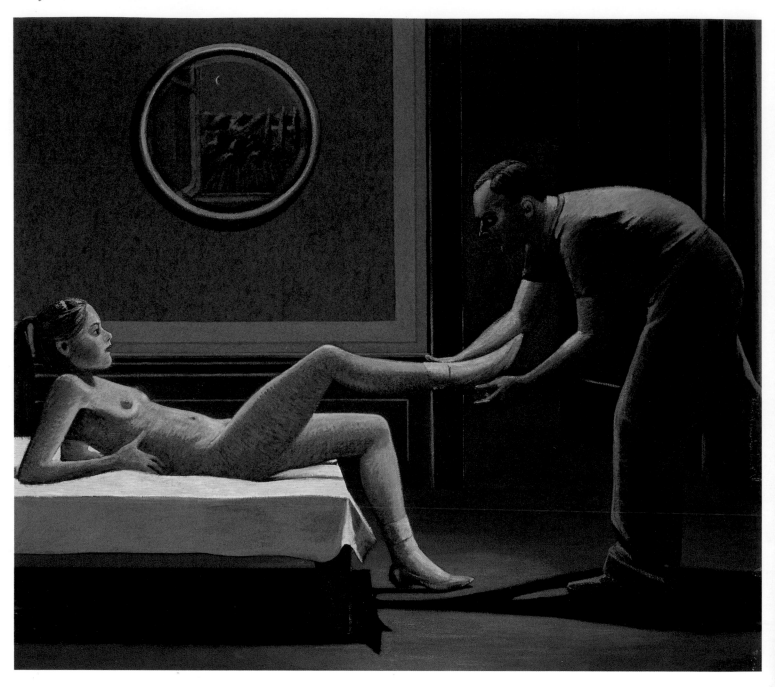

90 Hermann Albert. *Akt auf weissem Laken und Mann* (Nude on White Sheet with Man). 1982

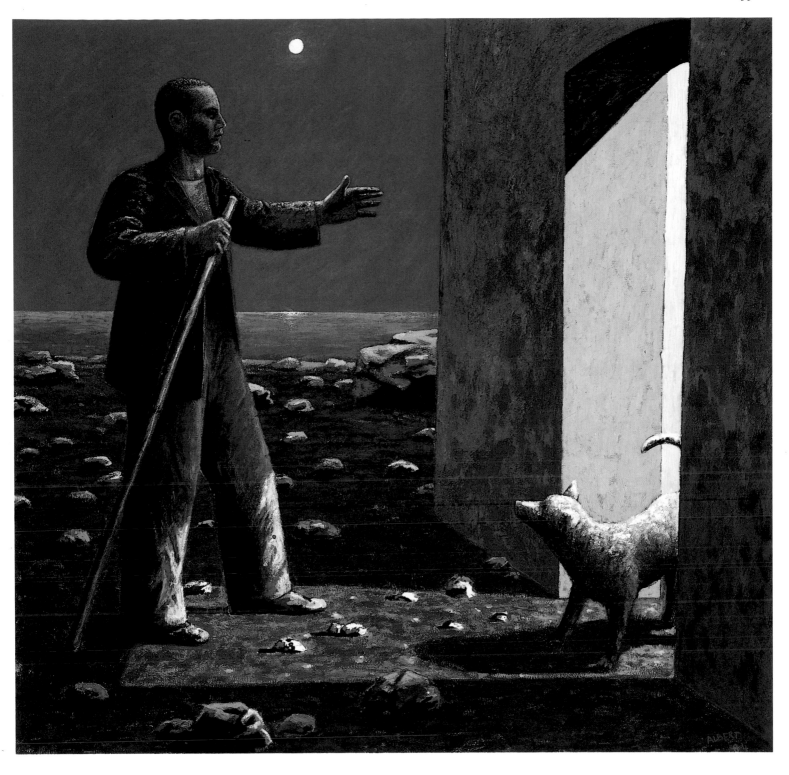

91 Hermann Albert. *Die Heimkehr* (The Homecoming). 1984

94 Peter Chevalier. *Der Wanderer IV* (The Wayfarer IV). 1982

95 Peter Chevalier. *Die Brut* (The Incubation). 1985

96 Peter Chevalier. *Am frühen Morgen* (In the Early Morning). 1981

97 Peter Chevalier. *Geburt des Zyklopen* (Birth of the Cyclops). 1988

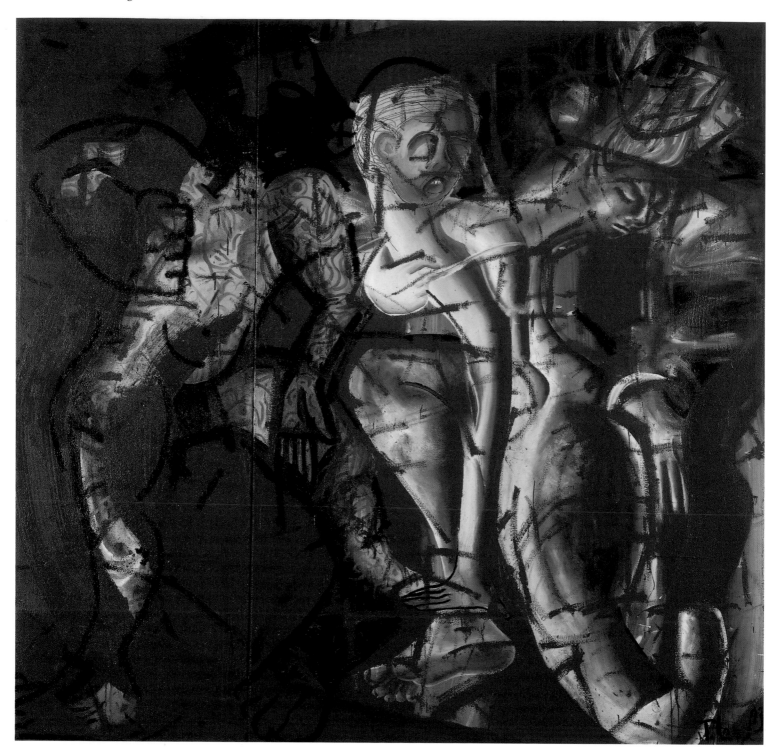

100 Thomas Lange. *Kalimera Kreta.* 1983

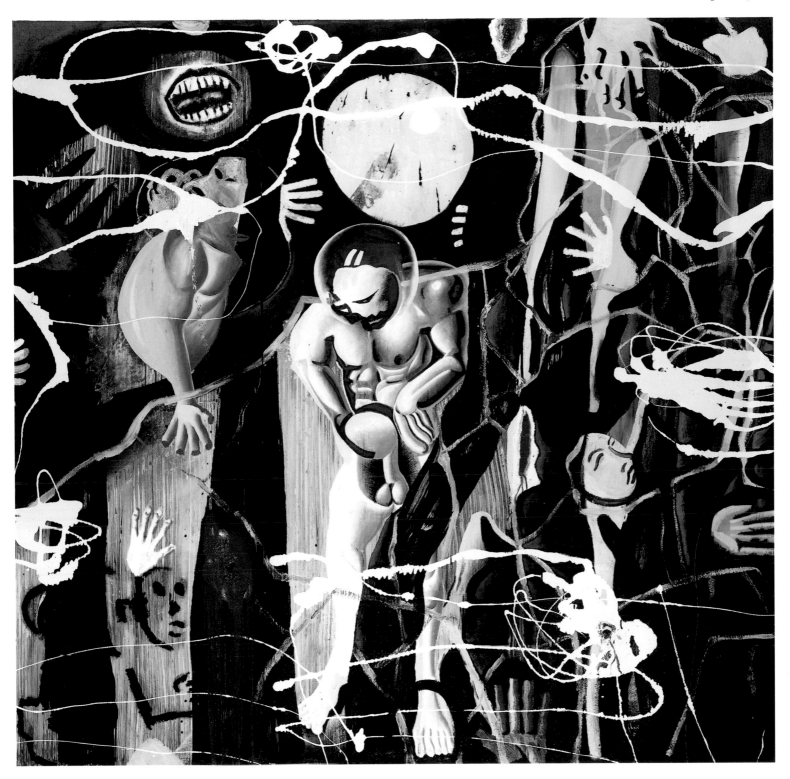

101 Thomas Lange. *Alpenlandschaft* (Alpine Landscape). 1988

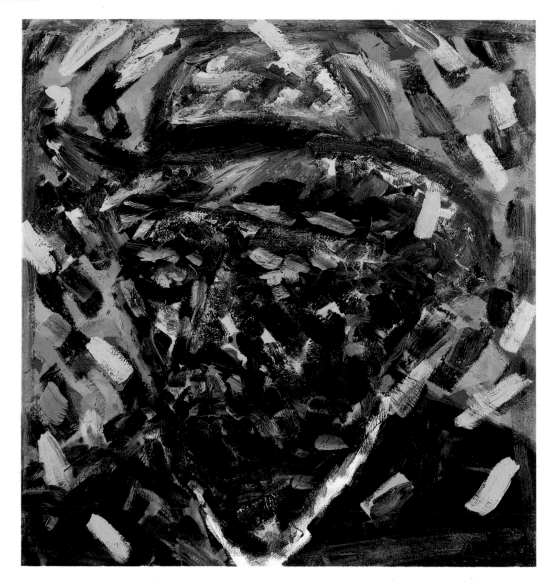

106 Friedemann Hahn. *Kopf nach van Gogh* (Head After van Gogh). 1985

108 Friedemann Hahn. *Szene aus* Lust for Life: *Krähenschlag*
(Scene from *Lust for Life*: Crow Attack). 1985

107 Friedemann Hahn. *Szene aus*
 Lust for Life: *Krähenschlag*
 (Scene from *Lust for Life*: Crow Attack). 1984

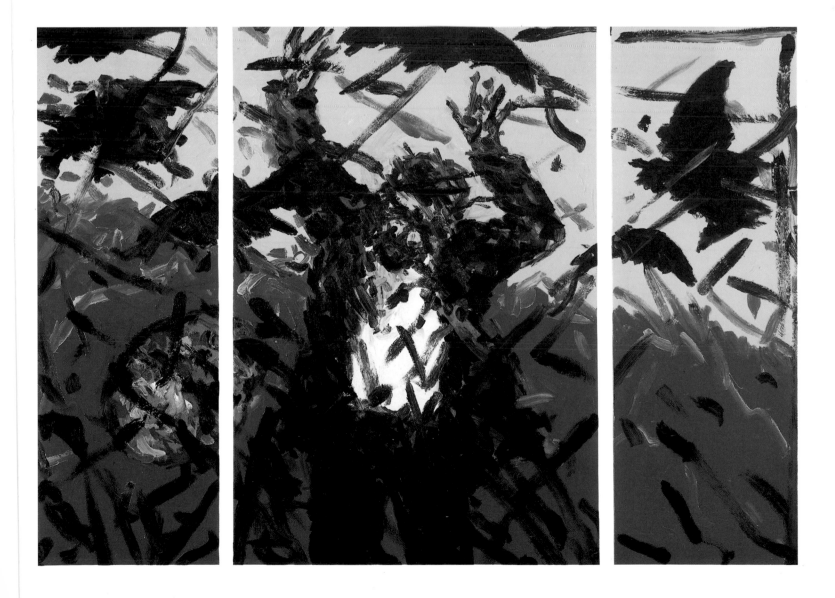

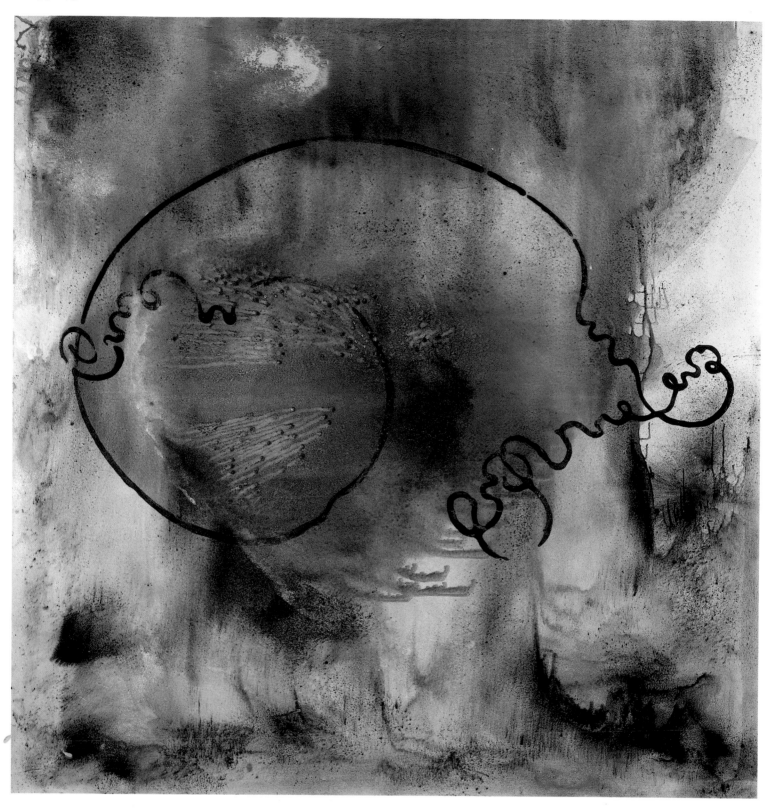

113 Sigmar Polke. *Audacia.* 1986

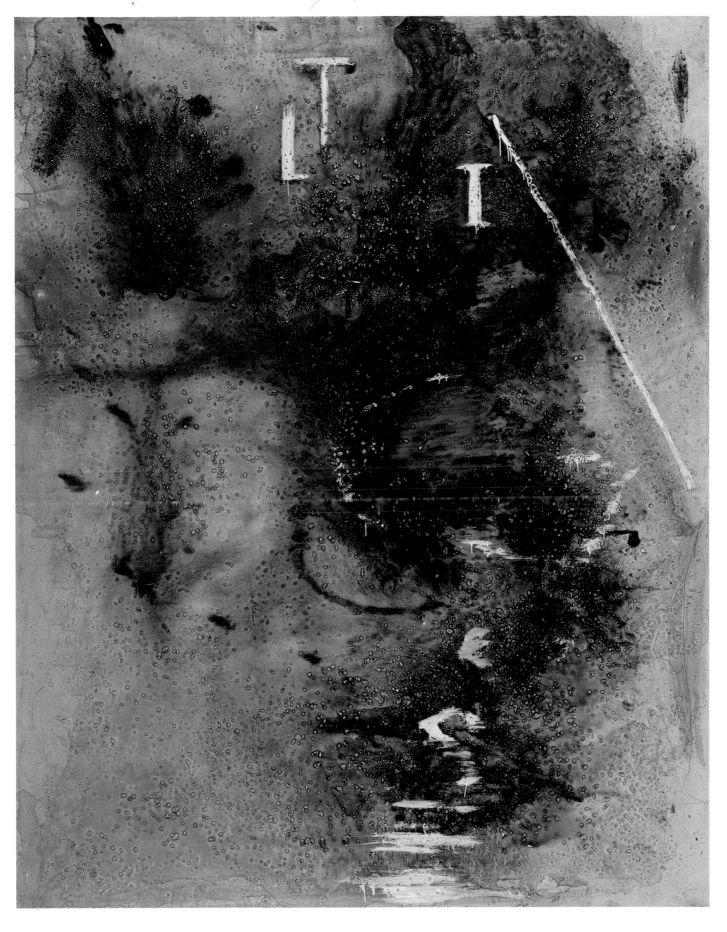

114 Sigmar Polke. *Lingua Tertii Imperii.* 1983

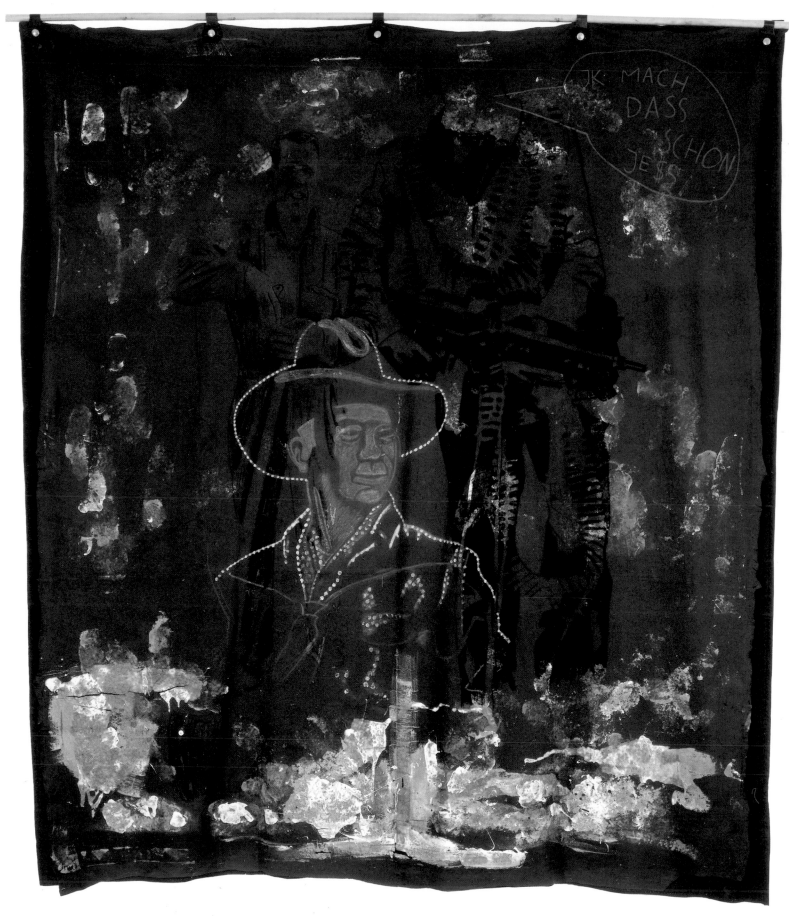

116 Sigmar Polke. *Ich mach das schon Jess* (I'll Take Care of That, Jess). 1972

117 Sigmar Polke. *Tischrücken* (Seance). 1981

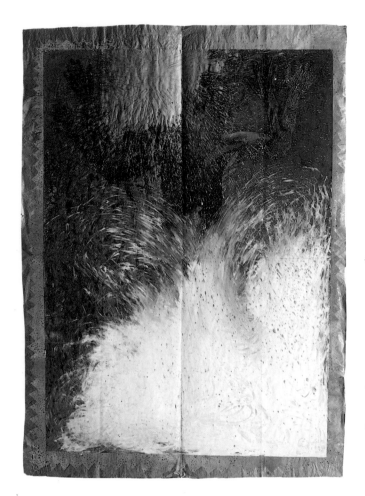

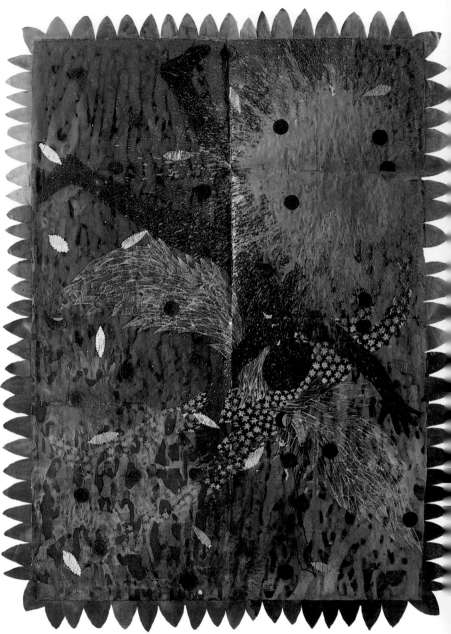

118 Michael Buthe. *Horch El ayachi, Marrakesj.* 1975-78

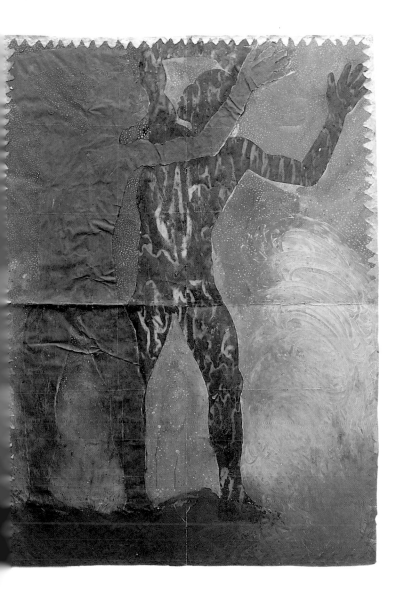

НАШ АДРЕС: Москва, А-47, ГСП, ул. «Правды», 24.

119 C. O. Paeffgen. *Pferdsprung in Moskau*
(Horse Jump in Moscow). 1972

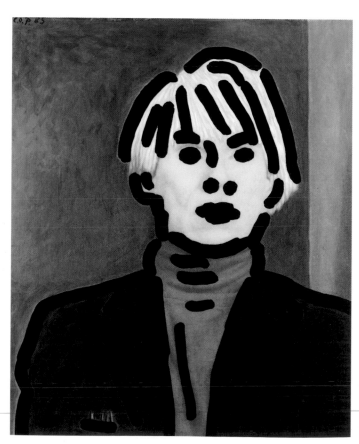

120 C. O. Paeffgen. *Andy Warhol*. 1985

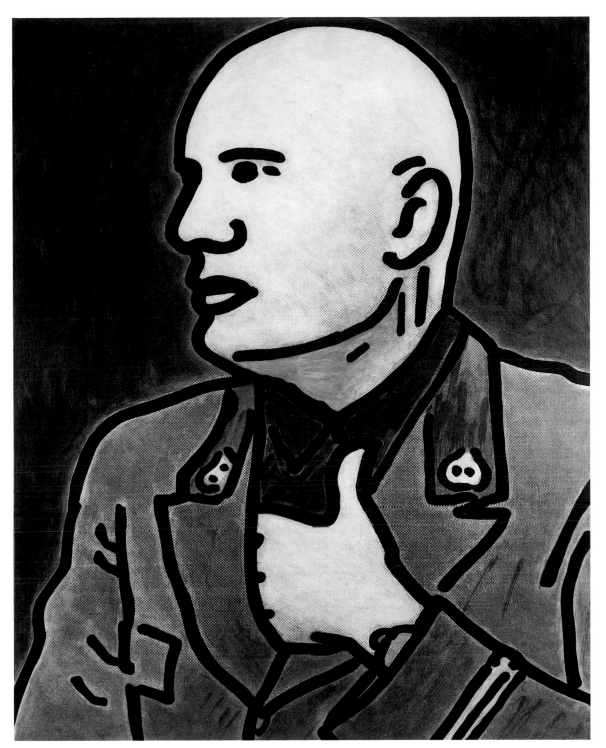

121 C. O. Paeffgen. *Mussolini.* 1980

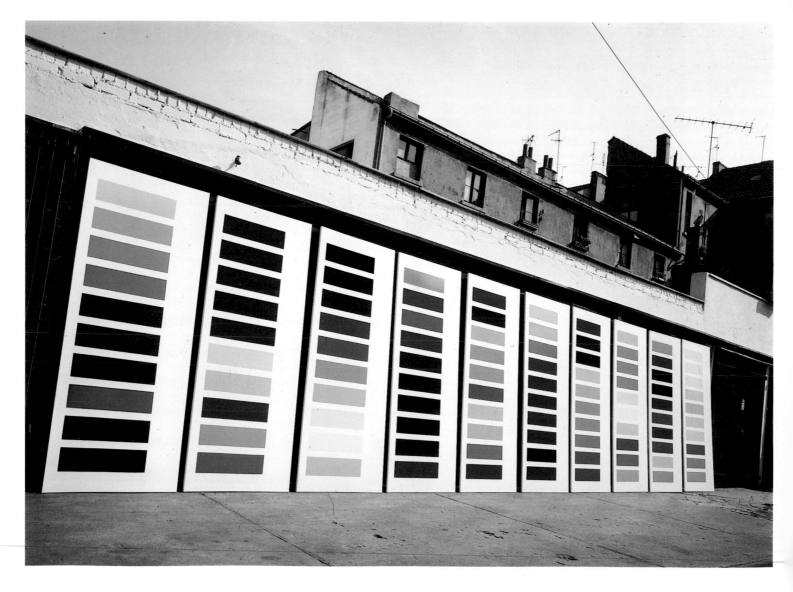

122 Gerhard Richter. *Zehn grosse Farbtafeln* (Ten Large Color Charts). 1966

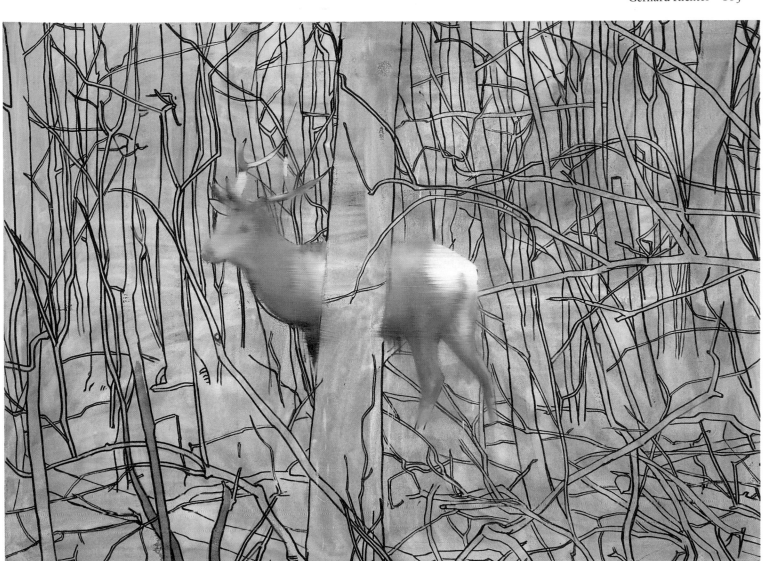

123 Gerhard Richter. *Hirsch* (Deer). 1963

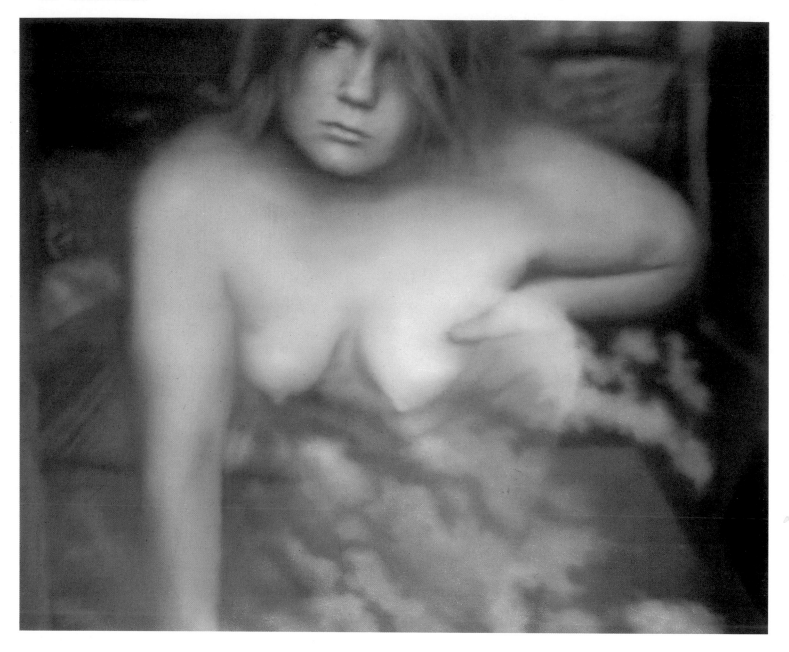

124 Gerhard Richter. *Brigid Polk*. 1971

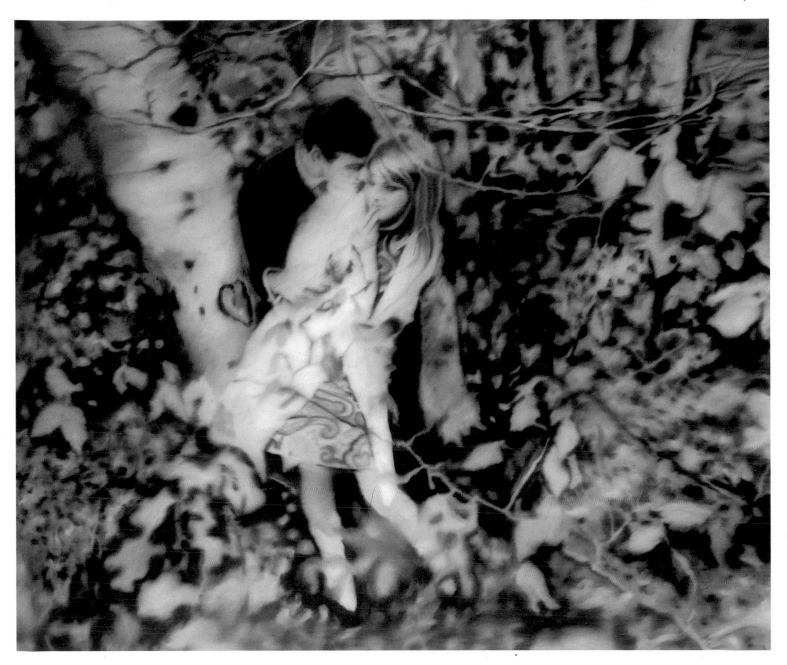

125 Gerhard Richter. *Liebespaar im Wald* (Lovers in the Forest). 1966

126 Gerhard Richter. *Tourist (grau)* (Tourist [Gray]). 1975

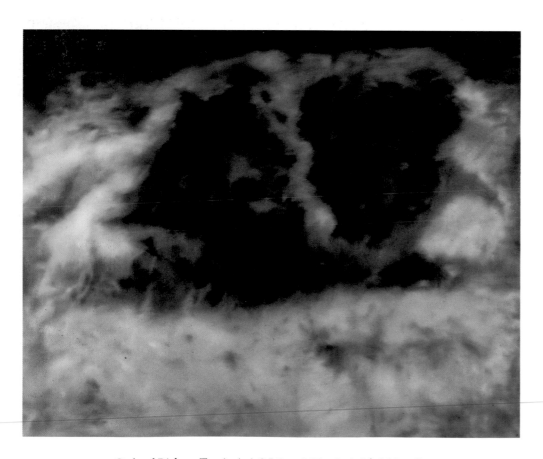

127 Gerhard Richter. *Tourist (mit 2 Löwen)* (Tourist [with 2 Lions]). 1975

128 Gerhard Richter. *Tourist (mit 1 Löwen)* (Tourist [with 1 Lion]). 1975

129 Gerhard Richter. *Tourist (mit 1 Löwen)* (Tourist [with 1 Lion]). 1975

130 Gerhard Richter. *Abstraktes Bild* (Abstract Painting). 1984

131 Gerhard Richter. *Landschaft bei Koblenz* (Landscape near Koblenz). 1987

132 Gerhard Richter. *Landschaft bei Koblenz* (Landscape near Koblenz). 1987

133 Gerhard Richter. *St. Bridget.* 1988

134 Gerhard Richter. *St. James.* 1988

135 Walter Dahn. *Untitled* [from the *Ex Voto* series]. 1987

138 Jiri Georg Dokoupil. *Wenn es mit mir nicht weitergeht,*
wird das Apfelmädchen die Herrschaft übernehmen
(If I Can't Go On, the Apple Girl Will Take Over). 1984

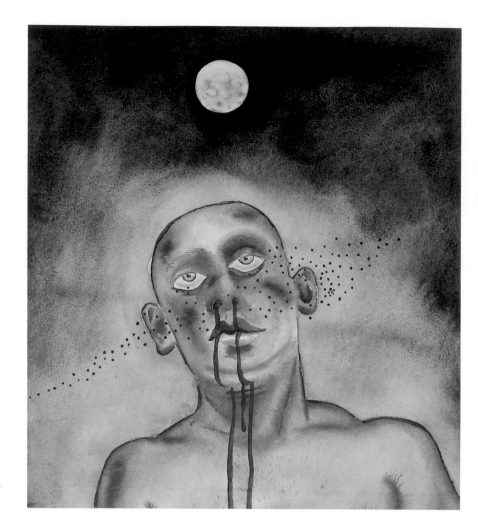

139 Jiri Georg Dokoupil. *Nosebleeding
Self-Portrait, No. VII.* 1984

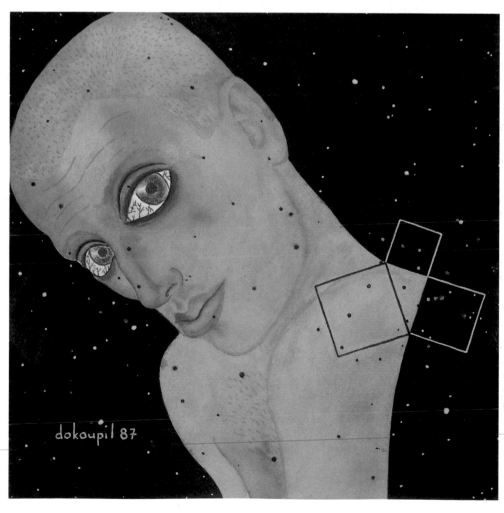

140 Jiri Georg Dokoupil. *Untitled.* 1987

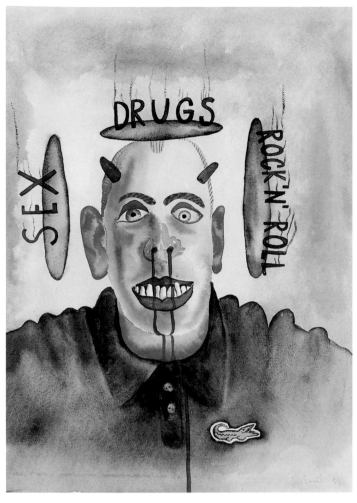

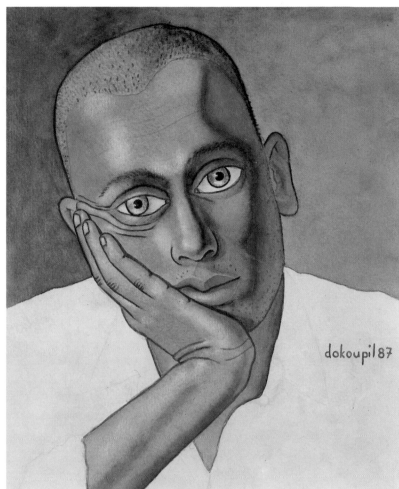

141 Jiri Georg Dokoupil. *Nosebleeding Self-Portrait, No. II.* 1984

142 Jiri Georg Dokoupil. *Untitled.* 1987

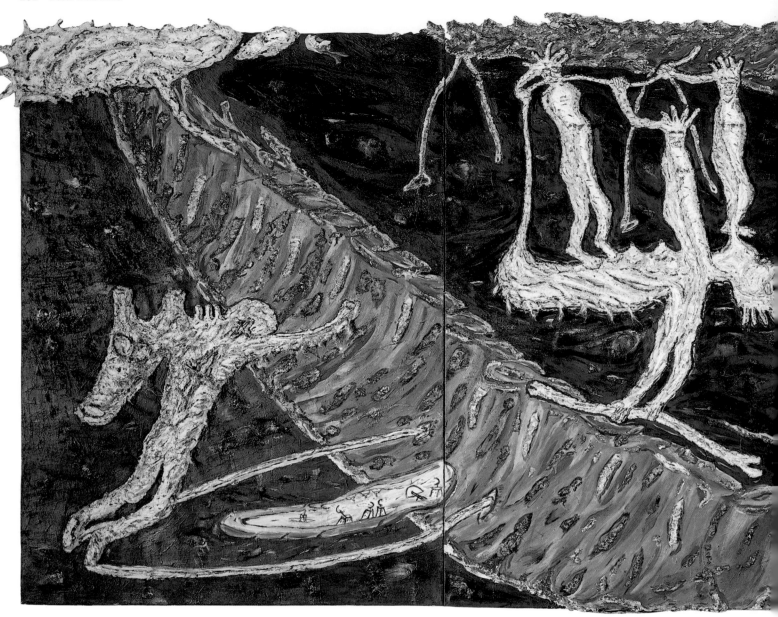

143 Peter Bömmels. *Untitled.* 1983

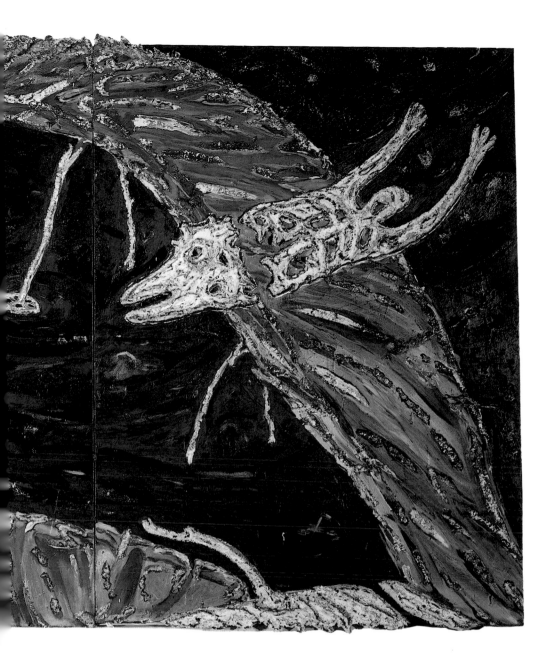

145 Andreas Schulze. *Apfel* (Apple). 1983

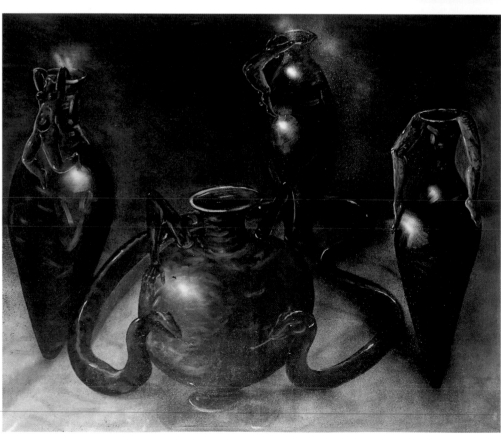

146 Rosemarie Trockel. *Moschus* (Musk). 1984

147 Rosemarie Trockel. *Made in Western Germany.* 1987

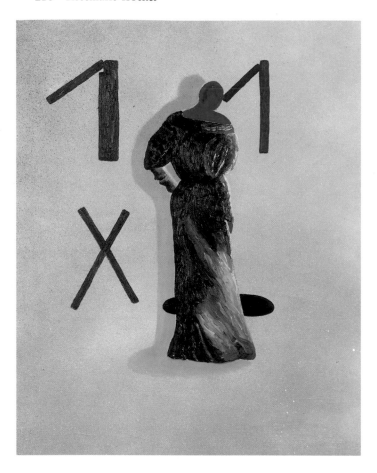

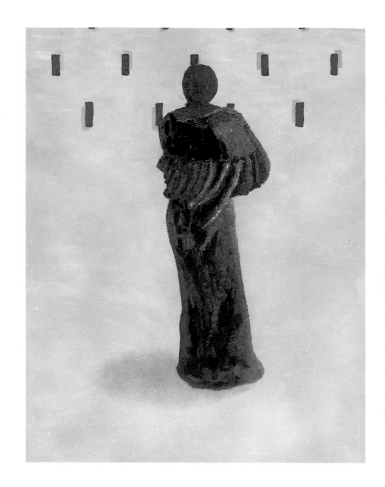

148 Rosemarie Trockel. *Ohne Titel* (Untitled). 1985

149 Rosemarie Trockel. *Ohne Titel* (Untitled). 1985

150 Rosemarie Trockel. *Ohne Titel* (Untitled). 1985

151 Axel Kasseböhmer. *Stoff* (Fabric). 1981

152 Axel Kasseböhmer. *Stilleben* 2 (Still Life 2). 1982

153 Axel Kasseböhmer. *Landschaft 15* (Landscape 15). 1984

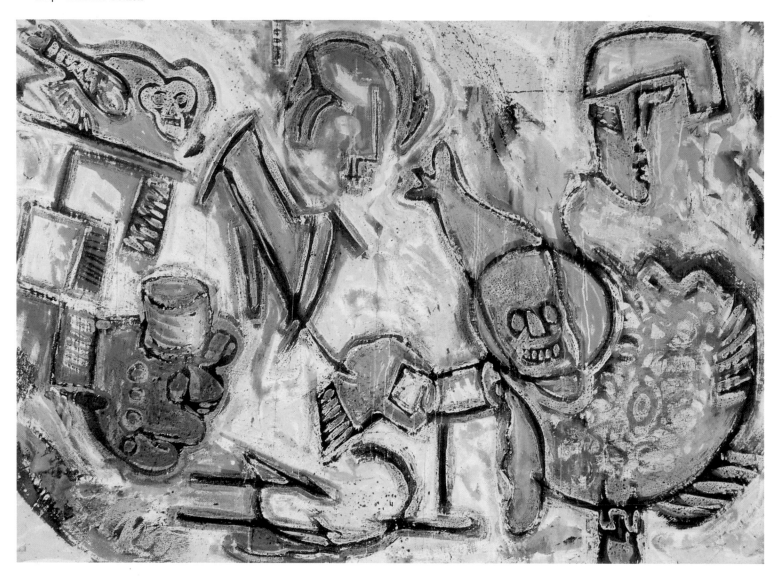

154 Markus Oehlen. *Essen und Trinken* (Eating and Drinking). 1982

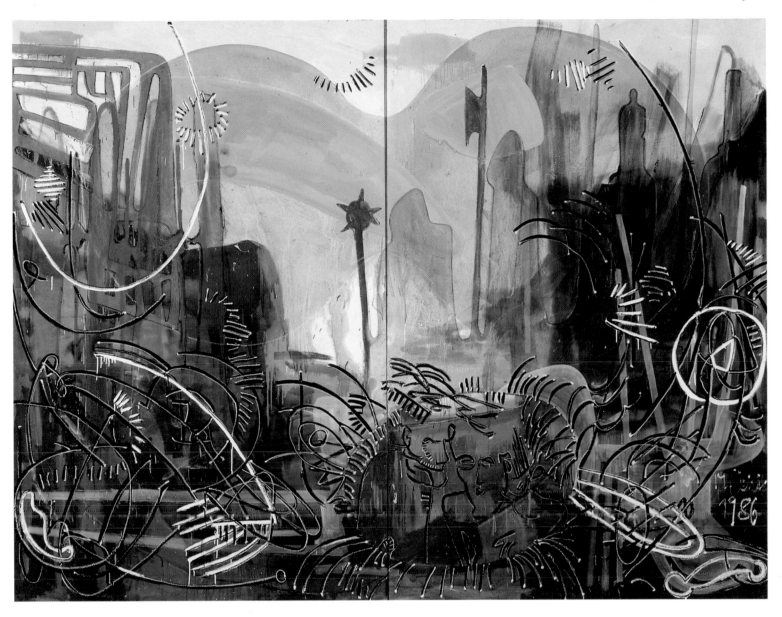

155 Markus Oehlen. *Problem.* 1986

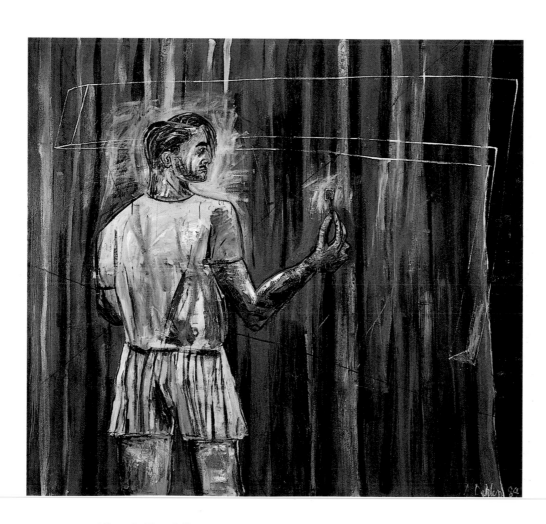

156 Albert Oehlen. *Selbstporträt mit blauer Mauritius und verschissener Unterhose*
(Self-Portrait with Blue Mauritius and Shitty Underpants). 1987

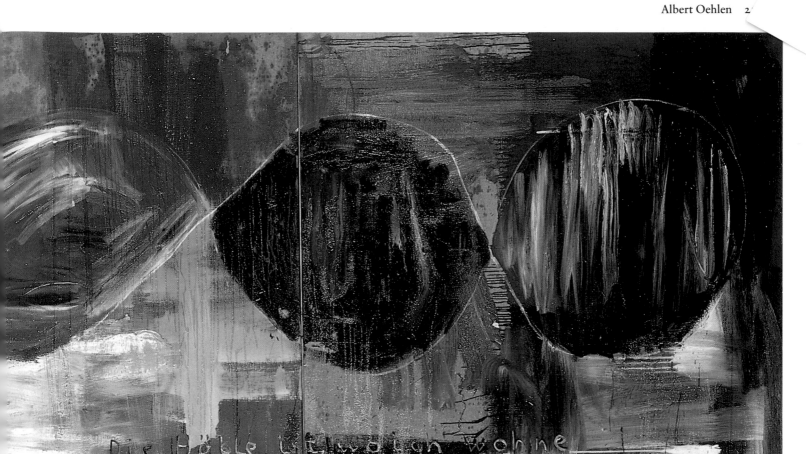

157 Albert Oehlen. *Auskunft* (Information). 1985

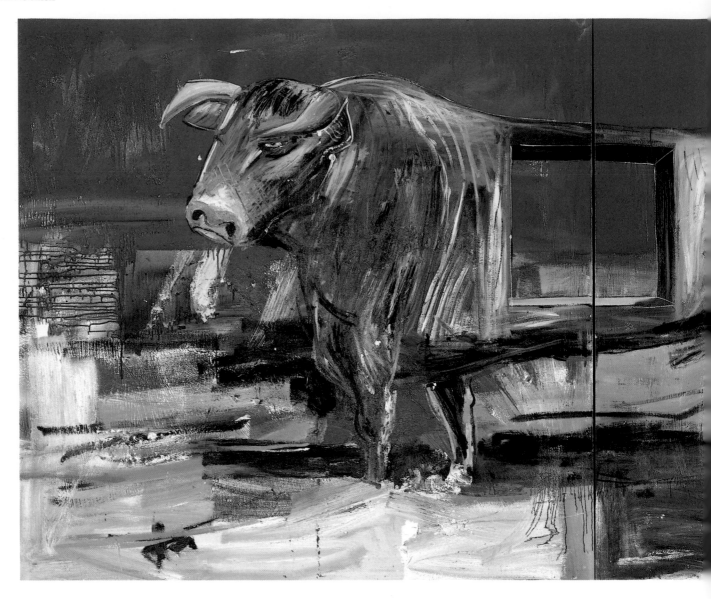

158 Albert Oehlen. *Stier mit Loch* (Bull with Hole). 1986

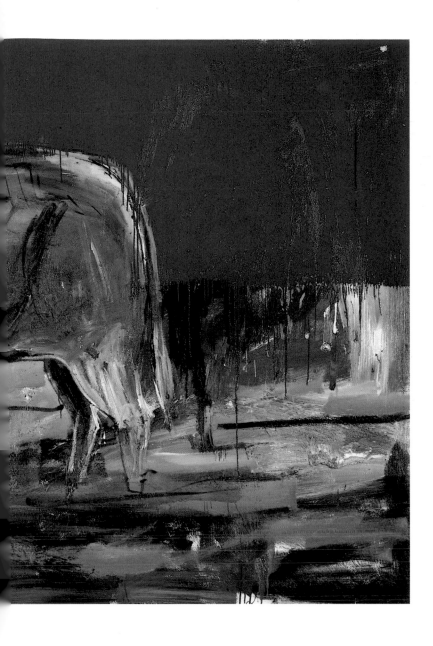

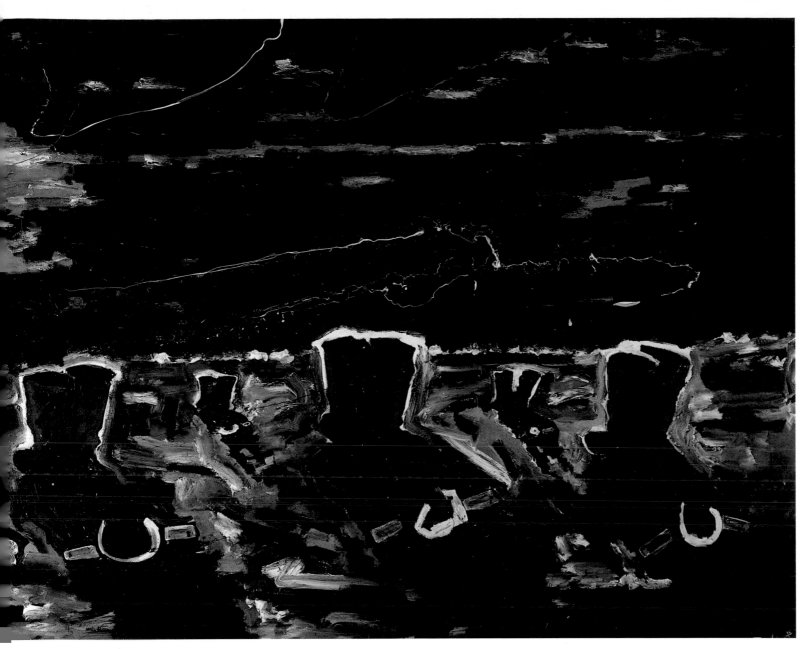

159 Werner Büttner. *Bathing Russians.* 1984

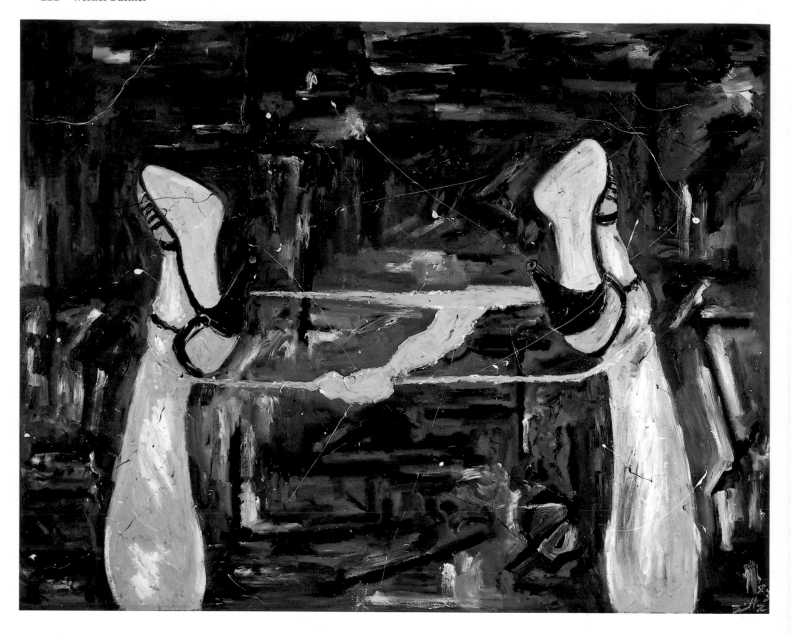

160 Werner Büttner. *Weltende* (End of the World). 1983

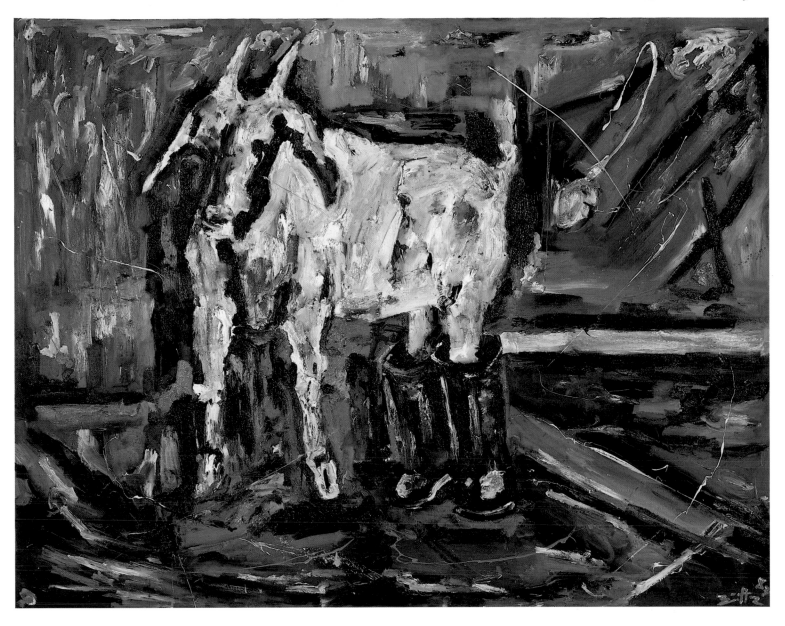

161 Werner Büttner. *Alter Trick* (Old Ploy). 1983

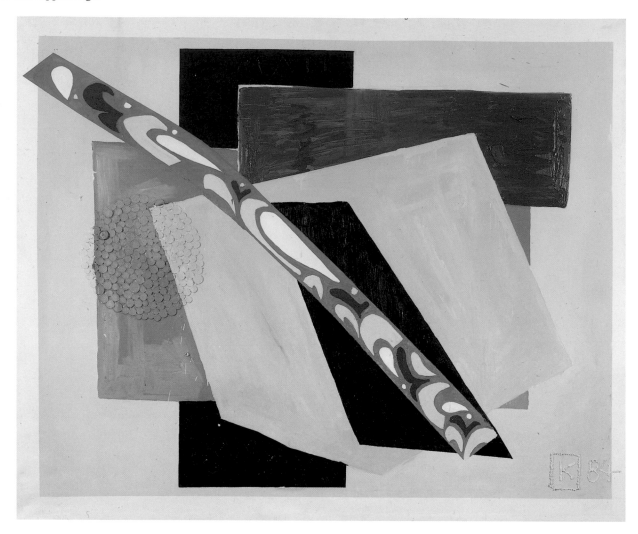

162 Martin Kippenberger. *Women and Money III.* 1984

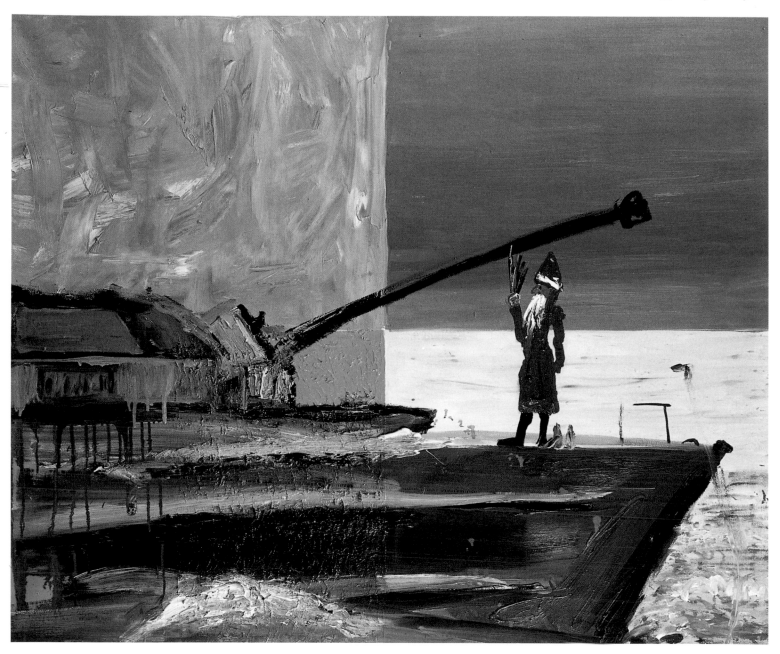

163 Martin Kippenberger. *Krieg, böse* (War, Bad). 1983

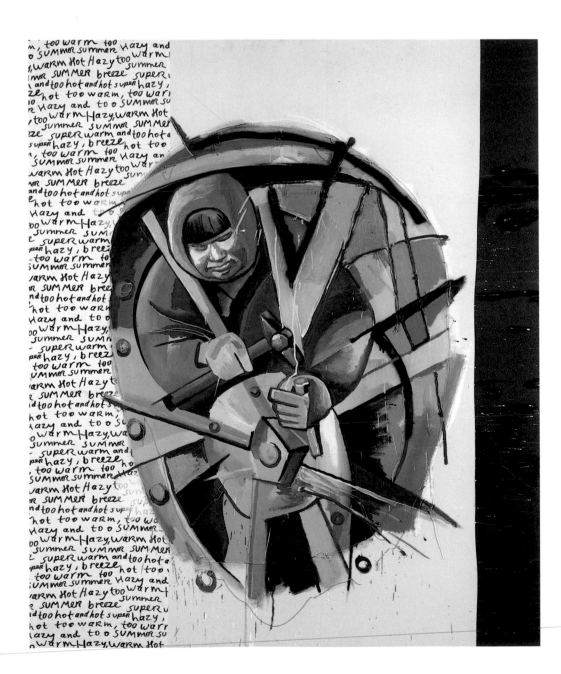

164 Martin Kippenberger. *Kulturbäuerin bei der Reparatur ihres Traktors*
(Collective Farmer Repairing Her Tractor). 1985

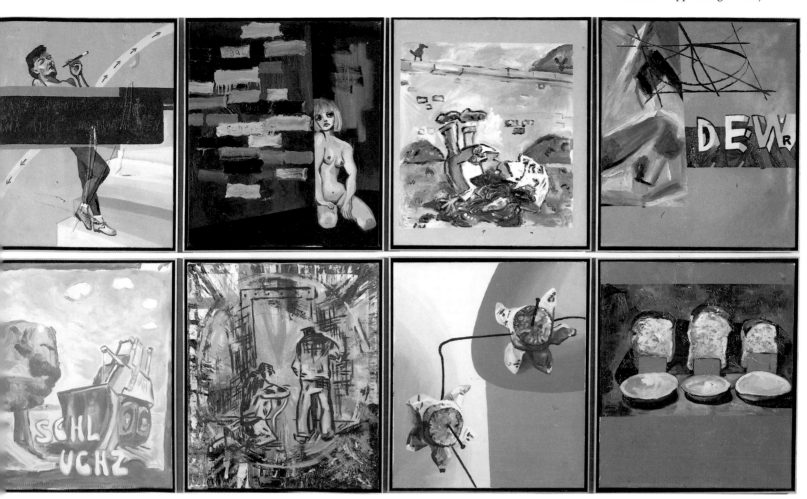

165 Martin Kippenberger. *From the Nose Drops Misery into Your Porcelain.* 1984

168 Georg Herold. *Ägypten* (Egypt). 1985

169 Georg Herold. *Gesättigte Kohlenwasserstoffe* (Saturated Hydrocarbons). 1985

170 Christa Näher. *Untitled.* 1987

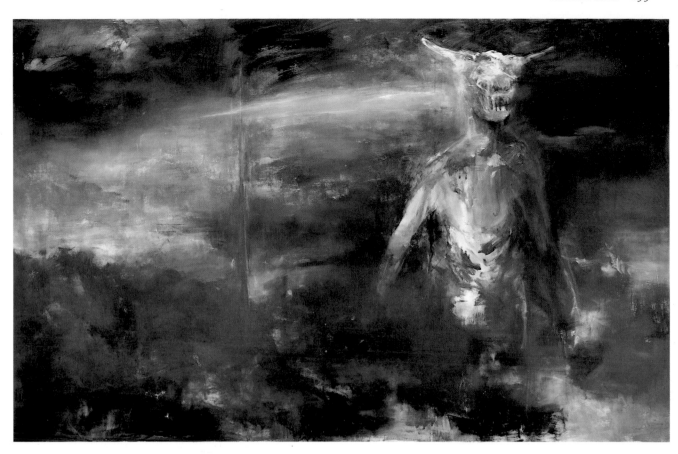

171 Christa Näher. *Minotaurus*. 1985

172 Christa Näher. *Untitled.* 1988

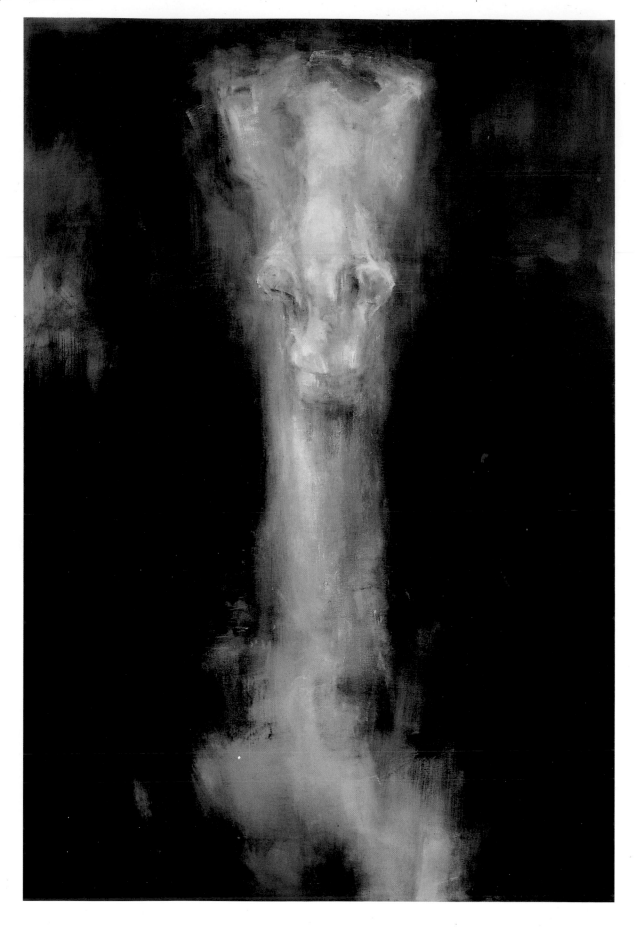

173 Christa Näher. *Untitled.* 1988

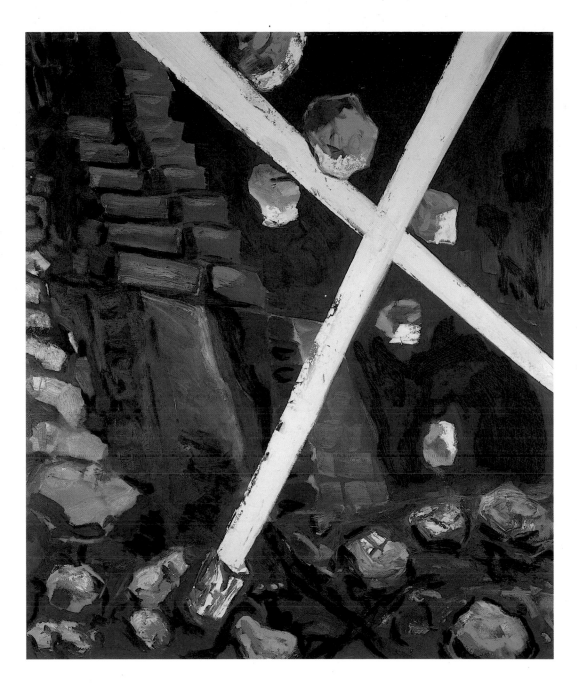

174 Volker Tannert. *Simulation.* 1981

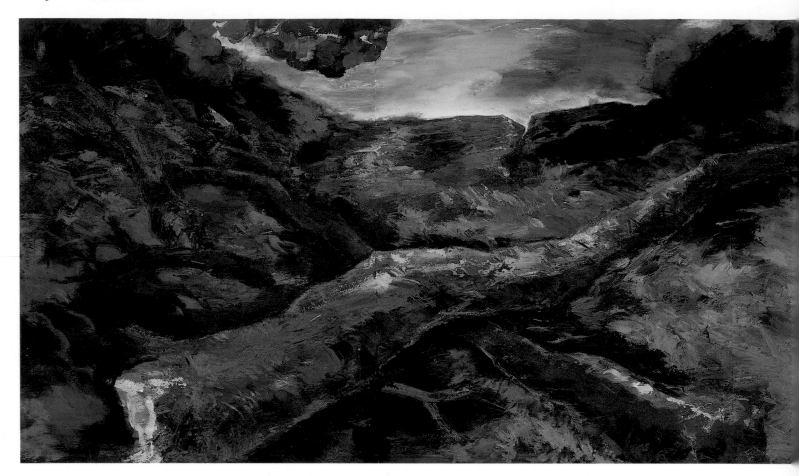

175 Volker Tannert. *Untitled.* 1984

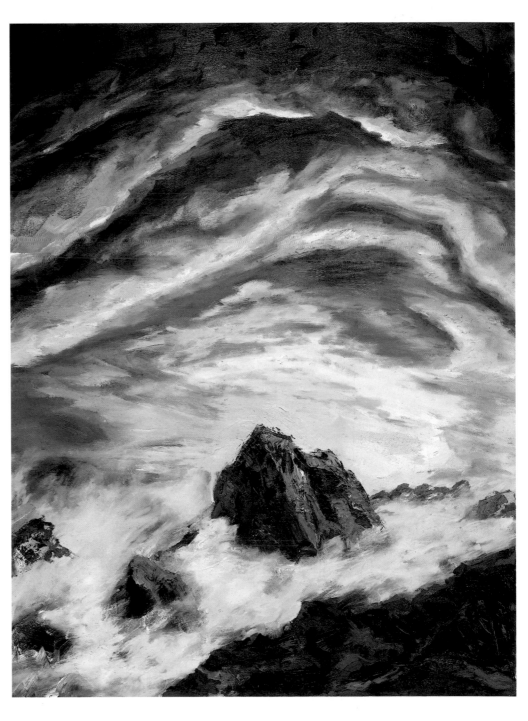

176 Volker Tannert. *Die Vereinigung mit der Vergangenheit erfolgt meist bei Nebel*
(Becoming One with the Past Usually Occurs in Fog). 1983

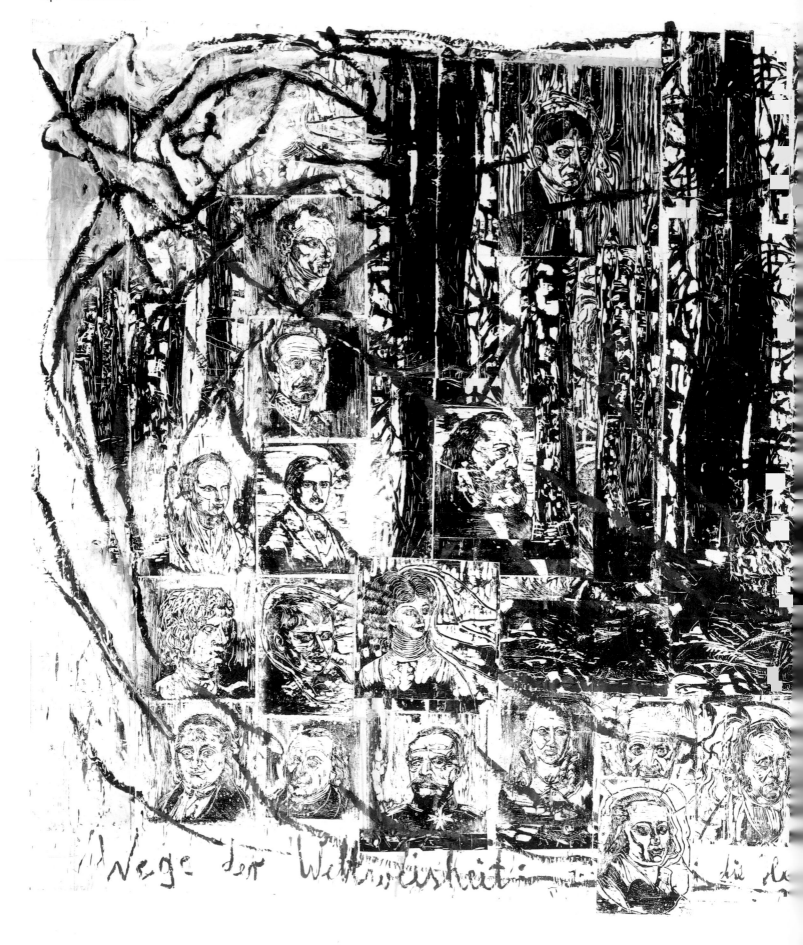

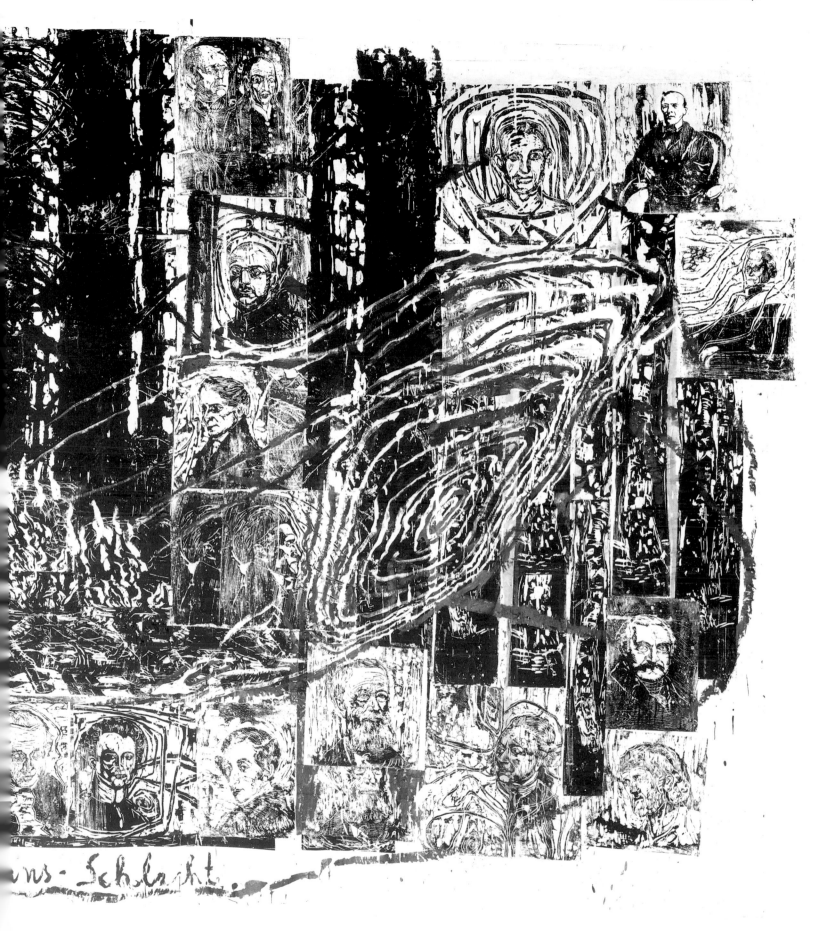

177 Anselm Kiefer. *Wege der Weltweisheit: die Hermanns-Schlacht*
(Ways of Worldly Wisdom: Arminius's Battle). 1980

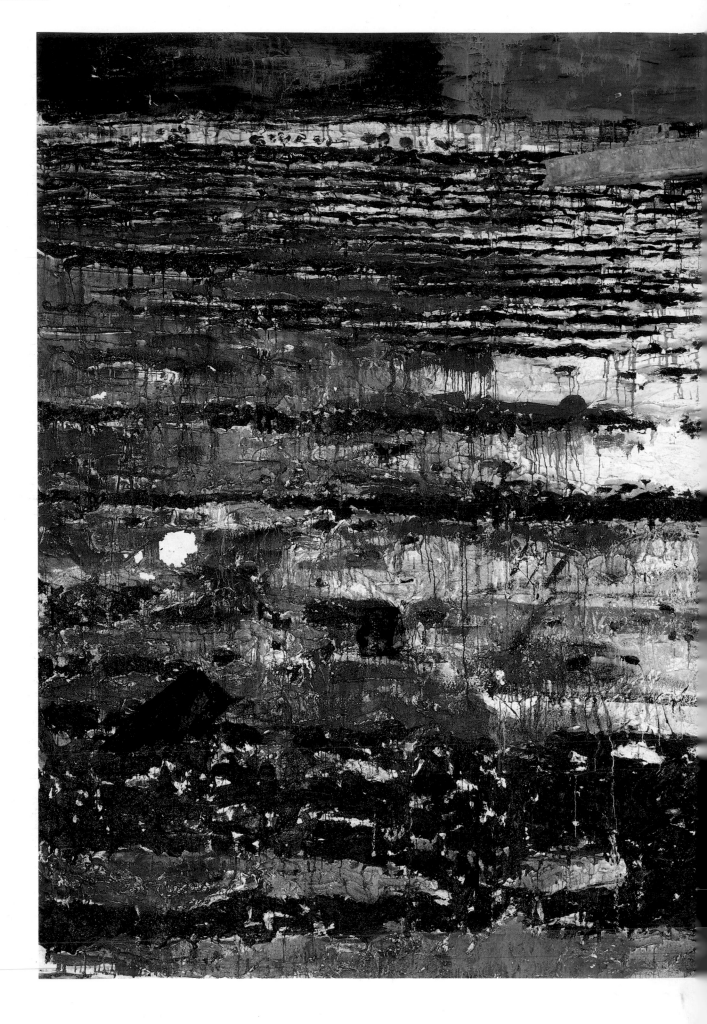

178 Anselm Kiefer. *Hoffmann von Fallersleben auf Helgoland* (Hoffmann von Fallersleben on Helgoland). 1983-86

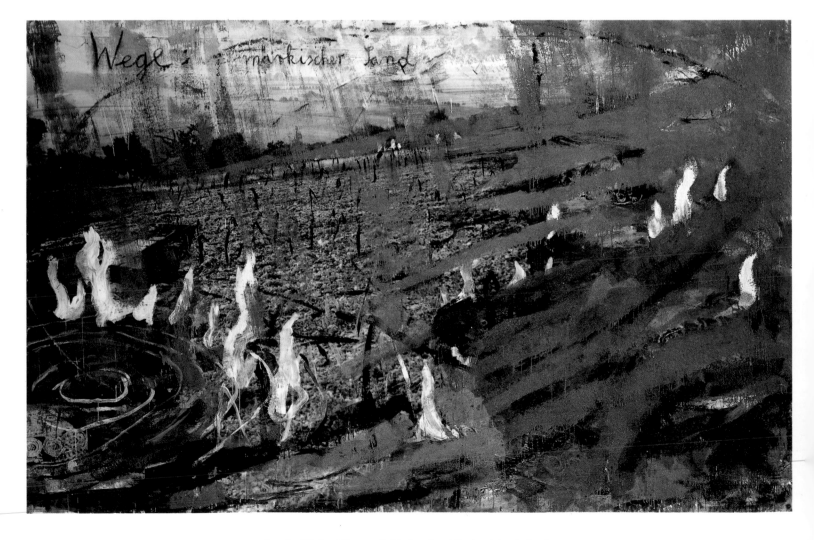

179 Anselm Kiefer. *Wege: märkischer Sand* (Paths: March Sand). 1980

Documentation

Catalogue

*Indicates the work is not exhibited at the Solomon R. Guggenheim Museum.

Hermann Albert
Akt auf weissem Laken und Mann (Nude on White Sheet with Man). 1982
Tempera on canvas, 74⁷/₁₆ x 84¹/₄ in.
(189 x 214 cm.)
Collection Meister, Braunschweig
Cat. no. 90

Hermann Albert
Die Heimkehr (The Homecoming). 1984
Tempera on canvas, 88⁹/₁₆ x 88⁹/₁₆ in.
(225 x 225 cm.)
Collection Meister, Braunschweig
Cat. no. 91

Hermann Albert
Paar in heroischer Landschaft (Couple in Heroic Landscape). 1984
Tempera on canvas, 94¹/₂ x 88⁹/₁₆ in.
(240 x 225 cm.)
Collection Wally Goodman, San Francisco
*Cat. no. 93

Hermann Albert
Mezzogiorno. 1987
Tempera on canvas, 94¹/₂ x 118¹/₈ in.
(240 x 300 cm.)
Courtesy Raab Galerie, Berlin and London
Cat. no. 92

Horst Antes
Figur Gebärende (Figure: Woman in Labor).
1959-60
Tempera on canvas, 55⁵/₁₆ x 41⁵/₁₆ in.
(140.5 x 105 cm.)
Courtesy Galerie Neumann, Dusseldorf
Cat. no. 7

Horst Antes
Grosse blaue Figur (Large Blue Figure). 1962-63
Oil on canvas, 47¹/₄ x 39³/₈ in. (120 x 100 cm.)
Collection Kunstmuseum Düsseldorf
Cat. no. 5

Horst Antes
Sitzende Figur, gelb (Sitting Figure, Yellow). 1975
Acrylic on canvas, 59¹/₁₆ x 47¹/₄ in. (150 x 120 cm.)
Collection Piepenbrock, Osnabrück
Cat. no. 6

Horst Antes
Kniende Figur, Dorf, Berliner Fenster (Kneeling Figure, Village, Berlin Window). 1988
Acrylic and sawdust on plywood, 70⁷/₈ x 78³/₄ in.
(180 x 200 cm.)
Collection Piepenbrock, Osnabrück
Cat. no. 8

Elvira Bach
Der verlorene Schuh (The Lost Shoe). 1986
Synthetic resin on canvas, 78³/₄ x 126 in.
(200 x 320 cm.)
Courtesy Raab Galerie, Berlin and London
Cat. no. 79

Ina Barfuss
Teamwork. 1987
Acrylic on canvas, 87³/₈ x 46⁷/₁₆ in. (222 x 118 cm.)
Courtesy Galerie Springer, Berlin
Cat. no. 99

Ina Barfuss
Kopfgeld (Head Money). 1987
Acrylic on canvas, 89 x 75³/₁₆ in. (226 x 191 cm.)
Courtesy Galerie Springer, Berlin
Cat. no. 98

Georg Baselitz
Drei Streifen – Der Maler im Mantel – Zweites Frakturbild (Three Bands – The Painter in a Coat – Second Fracture Painting). 1966
Oil on canvas, 98⁷/₁₆ x 74¹³/₁₆ in. (250 x 190 cm.)
Collection Kleihues
Cat. no. 10

Georg Baselitz
B für Larry (B for Larry). 1967
Oil on canvas, 98⁷/₁₆ x 78³/₄ in. (250 x 200 cm.)
Saatchi Collection, London
Cat. no. 12

Georg Baselitz
Meissener Waldarbeiter (Meissen Woodcutters).
1968-69
Oil on canvas, 98⁷/₁₆ x 78³/₄ in. (250 x 200 cm.)
Saatchi Collection, London
Cat. no. 11

Georg Baselitz
Blondes Mädchen kommt – Wilhelm (Malerzyklus) (Blond Girl Coming – Wilhelm [Painters' Cycle]).
1983-87
Oil on canvas, 79¹⁵/₁₆ x 65³/₈ in. (203 x 166 cm.)
Private Collection
Cat. no. 22

Georg Baselitz
Wilhelms-Kirche – Georg (Malerzyklus) (Wilhelm's Church – Georg [Painters' Cycle]).
1986-87
Oil on canvas, 78³/₄ x 78³/₄ in. (200 x 200 cm.)
Private Collection
Cat. no. 19

Georg Baselitz
Blonde ohne Stahlhelm – Otto D. (Malerzyklus) (Blond Without Helmet – Otto D. [Painters' Cycle]). 1987
Oil on canvas, 78¹/₈ x 60⁵/₈ in. (198.5 x 154 cm.)
Mary Boone & Michael Werner Gallery
Cat. no. 18

Georg Baselitz
Der Ausgang – Karl (Malerzyklus) (The Exit – Karl [Painters' Cycle]). 1987
Oil on canvas, 78³/₄ x 63³/₄ in. (200 x 162 cm.)
Mary Boone & Michael Werner Gallery
Cat. no. 17

Georg Baselitz
Mädchen kommt – Carl Frederik (Malerzyklus) (Girl Coming – Carl Frederik [Painters' Cycle]).
1987
Oil on canvas, 78³/₄ x 63³/₄ in. (200 x 162 cm.)
Mary Boone & Michael Werner Gallery
Cat. no. 21

Georg Baselitz
Mädchen kommt – Markus (Malerzyklus) (Girl Coming – Markus [Painters' Cycle]). 1987
Oil on canvas, 78³/₄ x 78³/₄ in. (200 x 200 cm.)
Mary Boone & Michael Werner Gallery
Cat. no. 20

Georg Baselitz
Rechts und links eine Kirche – Jörg (Malerzyklus) (Churches Right and Left – Jörg [Painters' Cycle]).
1987
Oil on canvas, 78³/₄ x 78³/₄ in. (200 x 200 cm.)
Mary Boone & Michael Werner Gallery
Cat. no. 13

Georg Baselitz
Beladener Stuhl – Kurt (Malerzyklus) (Loaded Chair – Kurt [Painters' Cycle]). 1987-88
Oil on canvas, 78³/₄ x 78³/₄ in. (200 x 200 cm.)
Mary Boone & Michael Werner Gallery
Cat. no. 16

Georg Baselitz
Das Malerbild (The Painters' Picture). 1987-88
Oil on canvas, 110¹/₄ x 177³/₁₆ in. (280 x 450 cm.)
Collection Gerald S. Elliott, Chicago
Cat. no. 23

Georg Baselitz
Edvard. 1987-88
Oil on canvas, 78³/₄ x 78³/₄ in. (200 x 200 cm.)
Mary Boone & Michael Werner Gallery
Cat. no. 14

Georg Baselitz
Die Mühle brennt – Richard (Malerzyklus) (The Burning Mill – Richard [Painters' Cycle]).
1988
Oil on canvas, 78³/₄ x 78³/₄ in. (200 x 200 cm.)
Mary Boone & Michael Werner Gallery
Cat. no. 15

Peter Bömmels
Untitled. 1983
Papier mâché and oil on canvas, 90¹/₂ x 197⁷/₈ in.
(230 x 500 cm.)
The Sonnabend Collection, New York
*Cat. no. 143

Peter Bömmels
Das Hinterlandrennen (The Back-Country Race).
1985
Acrylic and shellac on burlap, 86⁵/₈ x 173¹/₄ in.
(220 x 440 cm.)
Courtesy Sonnabend Gallery, New York
Cat. no. 144

Werner Büttner
Alter Trick (Old Trick). 1983
Oil on canvas, 74^{13}/$_{16}$ x 94^1/$_2$ in. (190 x 240 cm.)
Collection Paul Maenz, Cologne
Cat. no. 161

Werner Büttner
Weltende (End of the World). 1983
Oil on canvas, 74^{13}/$_{16}$ x 94^1/$_2$ in. (190 x 240 cm.)
Collection Paul Maenz, Cologne
Cat. no. 160

Werner Büttner
Bathing Russians. 1984
Oil on canvas, 74^{13}/$_{16}$ x 189 in. (190 x 480 cm.)
Courtesy Metro Pictures, New York
Cat. no. 159

Michael Buthe
Horch El ayachi, Marrakesj. 1975-78
Watercolor and gold on paper, three parts, total,
128^3/$_8$ x 217^{11}/$_{16}$ in. (326 x 553 cm.)
Courtesy Galerie Moderne Kunst Dietmar Werle,
Cologne
*Cat. no. 118

Peter Chevalier
Am frühen Morgen (In the Early Morning). 1981
Oil on canvas, 80^{11}/$_{16}$ x 78^3/$_4$ in. (205 x 200 cm.)
Private Collection, Berlin
Cat. no. 96

Peter Chevalier
Der Wanderer IV (The Wayfarer IV). 1982
Oil on canvas, 90^3/$_{16}$ x 73^{13}/$_{16}$ in. (229 x 187.5 cm.)
Collection Hans E. Berg, Herten; Courtesy Galerie
Gmyrek, Dusseldorf
Cat. no. 94

Peter Chevalier
Die Brut (The Incubation). 1985
Oil on canvas, 86^5/$_8$ x 94^1/$_2$ in. (220 x 240 cm.)
Private Collection, Berlin
*Cat. no. 95

Peter Chevalier
Geburt des Zyklopen (Birth of the Cyclops). 1988
Oil on canvas, 91^3/$_4$ x 89^3/$_8$ in. (233 x 227 cm.)
Collection Hans E. Berg, Herten; Courtesy Galerie
Gmyrek, Dusseldorf
Cat. no. 97

Walter Dahn
Untitled [from the *Ex Voto* series]. 1987
Acrylic on cotton duck, 118^1/$_8$ x 78^3/$_4$ in.
(300 x 200 cm.)
Courtesy Galerie Paul Maenz, Cologne
Cat. no. 137

Walter Dahn
Untitled [from the *Ex Voto* series]. 1987
Acrylic on cotton duck, 118^1/$_8$ x 78^3/$_4$ in.
(300 x 200 cm.)
Collection Dr. Rainer Speck, Cologne
Cat. no. 136

Walter Dahn
Untitled [from the *Ex Voto* series]. 1987
Acrylic on cotton duck, 118^1/$_8$ x 78^3/$_4$ in.
(300 x 200 cm.)
Collection Dr. Eleonore and Dr. Michael Stoffel
Cat. no. 135

Jiri Georg Dokoupil
Nosebleeding Self-Portrait, No. II. 1984
Watercolor on paper, 21^5/$_8$ x 15^3/$_4$ in. (55 x 38.5 cm.)
Collection Paul Maenz, Cologne
Cat. no. 141

Jiri Georg Dokoupil
Nosebleeding Self-Portrait, No. VII. 1984
Watercolor on paper, 16^9/$_{16}$ x 15^{15}/$_{16}$ in.
(42 x 38 cm.)
Collection Paul Maenz, Cologne
Cat. no. 139

Jiri Georg Dokoupil
Wenn es mit mir nicht weitergeht, wird das Apfel-
mädchen die Herrschaft übernehmen (If I Can't Go
On, the Apple Girl Will Take Over). 1984
Acrylic and mixed media on canvas, two parts,
total, 90^9/$_{16}$ x 307^1/$_{16}$ in. (230 x 780 cm.)
Courtesy Galerie Paul Maenz, Cologne
Cat. no. 138

Jiri Georg Dokoupil
Untitled. 1987
Watercolor on paper, 12^{13}/$_{16}$ x 12^{13}/$_{16}$ in.
(32.5 x 32.5 cm.)
Collection Paul Maenz, Cologne
Cat. no. 140

Jiri Georg Dokoupil
Untitled. 1987
Watercolor on paper, 12^{13}/$_{16}$ x 10^3/$_{16}$ in.
(32.6 x 25.8 cm.)
Collection Paul Maenz, Cologne
Cat. no. 142

Rainer Fetting
Van Gogh und Mauer (Van Gogh and Wall). 1978
Dispersion on canvas, 78^3/$_4$ x 78^3/$_4$ in.
(200 x 200 cm.)
Private Collection, Federal Republic of Germany
Cat. no. 83

Rainer Fetting
Kuss II (Kiss II). 1981
Acrylic on canvas, 63 x 90^9/$_{16}$ in. (160 x 230 cm.)
Collection Paul Maenz, Cologne
Cat. no. 84

Rainer Fetting
Selbst mit gelbem Hut (Self with Yellow Hat). 1982
Dispersion on canvas, 66^{15}/$_{16}$ x 59^1/$_4$ in.
(170 x 150.5 cm.)
Collection of the artist
Cat. no. 85

Rainer Fetting
N. Y. Strassenarbeiter I (N. Y. Street Worker I).
1984
Oil on canvas, 94^7/$_8$ x 103^{15}/$_{16}$ in. (241 x 264 cm.)
Collection of the artist
Cat. no. 86

Rainer Fetting
Night of the Pelicans. 1987
Oil on canvas, 100 x 129^{15}/$_{16}$ in. (254 x 330 cm.)
Collection of the artist
Cat. no. 89

Rainer Fetting
Südstern mit Mauer (Südstern Station with Berlin
Wall). 1988
Oil on canvas, 78^3/$_4$ x 87 in. (200 x 221 cm.)
Collection of the artist
Cat. no. 88

Rainer Fetting
Winter – Tompkins Square Park. 1988
Oil on canvas, 110^1/$_4$ x 77^9/$_{16}$ in. (280 x 197 cm.)
Collection of the artist
Cat. no. 87

Dieter Hacker
Beckmann, Matisse und Picasso malen eine Frau
(Beckmann, Matisse and Picasso Paint a Woman).
1981
Oil on canvas, 75^9/$_{16}$ x 112^5/$_8$ in. (192 x 286 cm.)
Collection Kunstmuseum Düsseldorf
Cat. no. 102

Dieter Hacker
Weisse Strasse: Hommage an Edward Hopper
(White Street: Homage to Edward Hopper). 1987
Oil on canvas, 77^3/$_{16}$ x 112^5/$_8$ in. (196 x 286 cm.)
Collection Munson-Williams-Proctor Institute
Museum of Art, Utica, New York
Cat. no. 103

Friedemann Hahn
Greta Garbo und Erich von Stroheim in As You
Desire Me, *1932* (Greta Garbo and Erich von
Stroheim in *As You Desire Me 1932*). 1978
Oil on canvas, two parts, total, 63 x 70^7/$_8$ in.
(160 x 180 cm.)
Private Collection, Berlin
Cat. no. 109

Friedemann Hahn
Szene aus Lust for Life: *Krähenschlag*
(Scene from *Lust for Life*: Crow Attack). 1984
Oil on canvas, three parts, total, 78^3/$_4$ x 106^5/$_{16}$ in.
(200 x 270 cm.)
Private Collection, Berlin
Cat. no. 107

Friedemann Hahn
Szene aus Lust for Life: *Krähenschlag*
(Scene from *Lust for Life*: Crow Attack). 1985
Oil on canvas, three parts, total, 91^3/$_4$ x 128^{15}/$_{16}$ in.
(233 x 325 cm.)
Courtesy Galerie Hans Barlach, Hamburg and
Cologne
*Cat. no. 108

Friedemann Hahn
Kopf nach van Gogh (Head After van Gogh). 1985
Oil on canvas, 63^3/$_4$ x 57^1/$_{16}$ in. (162 x 145 cm.)
Private Collection, Hamburg
Cat. no. 106

Thomas Hartmann
Kreuzung (Crossroads). 1986
Oil on canvas, 67^1/$_8$ x 90^3/$_4$ in. (170.5 x 230.5 cm.)
Private Collection, Berlin
Cat. no. 104

Thomas Hartmann
Die Kartoffelernte (The Potato Harvest). 1987
Oil on canvas, 74^{13}/$_{16}$ x 94^1/$_2$ in. (190 x 240 cm.)
Courtesy Galerie Hans Barlach, Hamburg and
Cologne
Cat. no. 105

Georg Herold
Der Leser (The Reader). 1982
Dispersion on canvas, 66^{15}/$_{16}$ x 57^1/$_{16}$ in.
(170 x 145 cm.)
Collection Dr. Rainer Speck, Cologne
Cat. no. 166

Georg Herold
Ägypten (Egypt). 1985
Dispersion on canvas, 82^7/$_8$ x 98^7/$_{16}$ in.
(210.5 x 250 cm.)
Collection Dr. Rainer Speck, Cologne
*Cat. no. 168

Georg Herold
Gesättigte Kohlenwasserstoffe
(Saturated Hydrocarbons). 1985

Dispersion on canvas, 82¹¹/₁₆ x 98⁷/₁₆ in.
(210 x 250 cm.)
Collection Dr. Eleonore and Dr. Michael Stoffel
Cat. no. 169

Georg Herold
Untitled. 1985
Dispersion on cotton duck, 99³/₁₆ x 80¹¹/₁₆ in.
(252 x 205 cm.)
Collection F. C. Gundlach
Cat. no. 167

K. H. Hödicke
Stilleben mit spanischer Puppe 1: Hommage à Velázquez (Still Life with Spanish Doll 1: Homage to Velázquez). 1963
Synthetic resin on canvas, 63 x 57¹/₈ in.
(160 x 145 cm.)
Courtesy Galerie Gmyrek, Dusseldorf
Frontispiece

K. H. Hödicke
Tod eines Radfahrers (Death of a Cyclist). 1963
Synthetic resin on canvas, 59¹/₁₆ x 59¹/₁₆ in.
(150 x 150 cm.)
Courtesy Galerie Gmyrek, Dusseldorf
Cat. no. 36

K. H. Hödicke
Passanten (Passersby). 1976
Synthetic resin on canvas, 74¹³/₁₆ x 86⁵/₈ in.
(190 x 220 cm.). Collection Voswinkel, Dusseldorf;
Courtesy Galerie Gmyrek, Dusseldorf
Cat. no. 34

K. H. Hödicke
Sonnenflecken (Sunspots). 1976
Synthetic resin on canvas, 78³/₄ x 106⁵/₁₆ in.
(200 x 270 cm.)
Courtesy Galerie Gmyrek, Dusseldorf
Cat. no. 33

K. H. Hödicke
Herbst (Autumn). 1977
Synthetic resin on canvas, 74¹³/₁₆ x 61 in.
(190 x 155 cm.)
Collection Stober, Berlin
Cat. no. 32

K. H. Hödicke
Sommer (Summer). 1977
Synthetic resin on canvas, 74¹³/₁₆ x 61 in.
(190 x 155 cm.)
Collection Stober, Berlin
Cat. no. 31

K. H. Hödicke
Selbst und Fremdenlegionär (Self and Foreign Legionnaire). 1982
Synthetic resin on canvas, 66¹⁵/₁₆ x 90⁹/₁₆ in.
(170 x 230 cm.)
Courtesy Galerie Gmyrek, Dusseldorf
Cat. no. 38

K. H. Hödicke
Sheep. 1982
Synthetic resin on canvas, 78³/₄ x 78³/₄ in.
(200 x 200 cm.)
Courtesy Galerie Gmyrek, Dusseldorf
Cat. no. 39

K. H. Hödicke
Felsen der Sirene (Siren Rocks). 1983
Synthetic resin on canvas, 90⁹/₁₆ x 66¹⁵/₁₆ in.
(230 x 170 cm.)
Courtesy Galerie Gmyrek, Dusseldorf
Cat. no. 42

K. H. Hödicke
Im Blaulicht (In the Flashing Light). 1983
Synthetic resin on canvas, 78³/₄ x 114³/₁₆ in.
(200 x 290 cm.)
Collection Peter Pohl, Berlin; Courtesy Galerie
Gmyrek, Dusseldorf
Cat. no. 35

K. H. Hödicke
Grosses Tor (Large Gate). 1986
Synthetic resin on canvas, two parts, total,
90⁹/₁₆ x 133⁷/₈ in. (230 x 340 cm.)
Courtesy L. A. Louver Gallery, Venice, California
Cat. no. 37

K. H. Hödicke
Grosser Curragh (Large Curragh). 1987
Synthetic resin on canvas, 78³/₄ x 114³/₁₆ in.
(200 x 290 cm.)
Courtesy Galerie Gmyrek, Dusseldorf
Cat. no. 40

K. H. Hödicke
Kleiner Curragh (Small Curragh). 1987
Synthetic resin on canvas, 57¹/₁₆ x 74¹³/₁₆ in.
(145 x 190 cm.). Courtesy Galerie Gmyrek,
Dusseldorf
Cat. no. 41

Jörg Immendorff
Für alle Lieben in der Welt (For All the Nice People in the World). 1966
Oil on board, 61 x 61 in. (155 x 155 cm.)
Collection Dr. Eleonore and Dr. Michael Stoffel
Cat. no. 28

Jörg Immendorff
Café Deutschland IV. 1978
Oil on canvas, 111 x 129¹⁵/₁₆ in. (282 x 330 cm.)
Collection Garnatz
Cat. no. 29

Jörg Immendorff
Naht (Seam). 1981
Oil on canvas, 71 x 161 in. (180.3 x 409 cm.)
Collection Kunstmuseum Düsseldorf
Cat. no. 30

Axel Kaseböhmer
Stoff (Fabric). 1981
Oil on canvas, 81¹/₈ x 91⁵/₁₆ in. (206 x 232 cm.)
Courtesy Monika Sprüth Galerie, Cologne
Cat. no. 151

Axel Kaseböhmer
Stilleben 2 (Still Life 2). 1982
Oil on canvas, 39⁹/₁₆ x 113³/₄ in. (100.5 x 289 cm.)
Collection Schürmann
Cat. no. 152

Axel Kaseböhmer
Landschaft 15 (Landscape 15). 1984
Oil and wax on canvas, 59¹/₁₆ x 118¹/₈ in.
(150 x 300 cm.)
Courtesy Monika Sprüth Galerie, Cologne
Cat. no. 153

Anselm Kiefer
Wege der Weltweisheit: die Hermanns-Schlacht (Ways of Worldly Wisdom: Arminius's Battle). 1980
Woodcuts on offset paper, painted over with acrylic and shellac, on canvas, 157¹/₂ x 275⁹/₁₆ in. (400 x 700 cm.)
Collection Marx
Cat. no. 177

Anselm Kiefer
Wege: märkischer Sand (Paths: March Sand). 1980
Oil, emulsion, shellac, sand and photograph (on projection paper) on canvas, 112 x 173¹/₂ in.
(284.5 x 440.7 cm.)
Saatchi Collection, London
Cat. no. 179

Anselm Kiefer
Hoffmann von Fallersleben auf Helgoland (Hoffmann von Fallersleben on Helgoland). 1983-86
Emulsion, acrylic, shellac and dispersion on canvas with lead boat, steel bracket, steel bars, ferns and charred wood, two parts, total, 149⁵/₈ x 220¹/₂ in.
(380 x 560 cm.)
Collection Marx
Cat. no. 178

Martin Kippenberger
Krieg, böse (War, Bad). 1983
Oil on canvas, 39³/₈ x 47¹/₄ in. (100 x 120 cm.)
Collection of the artist
Cat. no. 163

Martin Kippenberger
From the Nose Drops Misery into Your Porcelain. 1984
Oil on canvas, 59¹³/₁₆ x 179¹⁵/₁₆ in. (152 x 457 cm.)
Collection Earl Millard
Cat. no. 165

Martin Kippenberger
Women and Money III. 1984
Oil, gum and coins on canvas, 59¹/₁₆ x 71¹/₁₆ in.
(150 x 180.5 cm.)
Courtesy Metro Pictures, New York
Cat. no. 162

Martin Kippenberger
Kulturbäuerin bei der Reparatur ihres Traktors (Collective Farmer Repairing Her Tractor). 1985
Oil, dispersion, lacquer and silicone on fabrics, 70⁷/₈ x 59¹/₁₆ in. (180 x 150 cm.)
Collection Dr. Rainer Speck, Cologne
Cat. no. 164

Konrad Klapheck
Schreibmaschine (Typewriter). 1955
Oil and collage on canvas, 26³/₄ x 29¹/₈ in.
(68 x 74 cm.)
Private Collection; Courtesy Galerie Gmyrek,
Dusseldorf
Cat. no. 1

Konrad Klapheck
Die gekränkte Braut (The Offended Bride). 1957
Oil on canvas, 20⁷/₈ x 25 in. (53 x 63.5 cm.)
Private Collection; Courtesy Galerie Gmyrek,
Dusseldorf
Cat. no. 2

Konrad Klapheck
Heldenlied (Vorzeichnung) (Epic [Sketch]). 1975
Charcoal and colored pencil on prepared canvas, 88³/₁₆ x 110⁵/₈ in. (224 x 281 cm.)
Harvard University Art Museums (Busch-Reisinger Museum), Gift of Lufthansa German Airlines
Cat. no. 3

Konrad Klapheck
Heldenlied (Epic). 1975
Oil on canvas, 88³/₁₆ x 110⁵/₈ in. (224 x 281 cm.)
Collection Neue Galerie – Sammlung Ludwig,
Aachen
Cat. no. 4

Bernd Koberling
Selbst mit roter Angeljacke (Self with Red Fishing Jacket). 1963
Synthetic resin on canvas, three parts, total, 28^{15}/$_{16}$ x 65^{3}/$_{4}$ in. (71 x 167 cm.)
Collection Karin Koberling
Cat. no. 66

Bernd Koberling
Fluchten (Flights; Perspectives). 1982-83
Synthetic resin and oil on burlap, 75^{9}/$_{16}$ x 96^{7}/$_{16}$ in. (192 x 245 cm.)
Collection Monika Verhoeven, Cologne; Courtesy Galerie Gmyrek, Dusseldorf
Cat. no. 69

Bernd Koberling
Horizont (Horizon). 1985
Synthetic resin and oil on canvas, 66^{15}/$_{16}$ x 51^{3}/$_{16}$ in. (170 x 130 cm.)
ACT Collection, London; Courtesy Galerie Gmyrek, Dusseldorf
Cat. no. 68

Bernd Koberling
Strand (Beach). 1985. Oil on linen, 78^{3}/$_{4}$ x 78^{3}/$_{4}$ in. (200 x 200 cm.)
Collection M. Riklis, New York
Cat. no. 67

Bernd Koberling
Landlinien I (Land Lines I). 1987-88
Oil on canvas, 88^{9}/$_{16}$ x 126 in. (225 x 320 cm.)
Private Collection; Courtesy Galerie Buchmann, Basel
Cat. no. 71

Bernd Koberling
Landlinien II (Land Lines II). 1988
Oil on canvas, 88^{9}/$_{16}$ x 126 in. (225 x 320 cm.)
Courtesy Galerie Buchmann, Basel
Cat. no. 70

Dieter Krieg
Untitled. 1985
Oil on canvas, 100^{13}/$_{16}$ x 71^{1}/$_{4}$ in. (256 x 181 cm.)
Collection of the artist
Cat. no. 25

Dieter Krieg
Untitled. 1985
Acrylic and oil on canvas, 105^{1}/$_{2}$ x 61^{7}/$_{16}$ in. (268 x 156 cm.)
Collection of the artist
Cat. no. 24

Dieter Krieg
Untitled. 1985
Acrylic and oil on canvas, 76^{3}/$_{8}$ x 157^{7}/$_{8}$ in. (194 x 401 cm.)
Collection of the artist

Thomas Lange
Kalimera Kreta. 1983
Oil on burlap, two parts, total, 120^{1}/$_{16}$ x 124^{7}/$_{16}$ in. (305 x 316 cm.)
Collection of the artist
Cat. no. 100

Thomas Lange
Alpenlandschaft (Alpine Landscape). 1988
Oil and mixed media on canvas, two parts, total, 122^{7}/$_{16}$ x 121^{5}/$_{8}$ in. (311 x 309 cm.)
Collection of the artist
*Cat. no. 101

Markus Lüpertz
Donald Ducks Heimkehr (Donald Duck's Homecoming). 1963
Distemper on cotton duck, 80^{11}/$_{16}$ x 81^{1}/$_{8}$ in. (205 x 206 cm.)
Private Collection
Cat. no. 43

Markus Lüpertz
Donald Ducks Hochzeit (Donald Duck's Wedding). 1963
Distemper on cotton duck, 79^{1}/$_{2}$ x 79^{1}/$_{2}$ in. (202 x 202 cm.)
Private Collection
Cat. no. 44

Markus Lüpertz
Baumstamm dithyrambisch (Tree Trunk, Dithyrambic). 1966
Distemper on canvas, 76^{3}/$_{4}$ x 96^{7}/$_{16}$ in. (195 x 245 cm.)
Collection Dr. Eleonore and Dr. Michael Stoffel
Cat. no. 45

Markus Lüpertz
Bewohner: Hexen verstellen die Peripherie oder wenn Grün Gesetz wird (Inhabitants: Witches Cutting Off the Escape Routes or When Green Becomes Mandatory). 1983
Oil and collage on canvas, 61 x 74^{13}/$_{16}$ in. (155 x 190 cm.)
Collection Dr. Eleonore and Dr. Michael Stoffel
Cat. no. 48

Markus Lüpertz
Bewohner: Nächtliches Trinkgelage (Inhabitants: Late-Night Drinking Bout). 1983
Oil on canvas, 63^{3}/$_{4}$ x 51^{3}/$_{16}$ in. (162 x 130 cm.)
Collection Dr. Eleonore and Dr. Michael Stoffel
Cat. no. 47

Markus Lüpertz
Väter und Söhne (Fathers and Sons). 1983
Oil on canvas, 63^{3}/$_{4}$ x 51^{3}/$_{16}$ in. (162 x 130 cm.)
Collection Dr. Eleonore and Dr. Michael Stoffel
Cat. no. 46

Markus Lüpertz
Melonen – Mathematik VIIIX (Melons – Mathematics VIIIX). 1984-85
Oil on corrugated cardboard, 48^{1}/$_{16}$ x 38^{3}/$_{16}$ in. (122 x 97 cm.)
Collection Reinhard Becker, Monheim
Cat. no. 52

Markus Lüpertz
Melonen – Mathematik IV (Melons – Mathematics IV). 1984-85
Oil on corrugated cardboard, 48^{1}/$_{16}$ x 38^{3}/$_{16}$ in. (122 x 97 cm.)
Courtesy Galerie Lelong, Zurich
Cat. no. 50

Markus Lüpertz
Melonen – Mathematik IX (Melons – Mathematics IX). 1984-85
Oil on corrugated cardboard, 48^{1}/$_{16}$ x 38^{3}/$_{16}$ in. (122 x 97 cm.)
Collection Rotthof, Dusseldorf
Cat. no. 49

Markus Lüpertz
Melonen – schwarzes Profil oder Dante sieht Beatrice XIII (Melons – Black Profile or Dante Sees Beatrice XIII). 1984-85
Oil on corrugated cardboard, 48^{1}/$_{16}$ x 38^{3}/$_{16}$ in. (122 x 97 cm.)
Courtesy Galerie Beaumont, Luxembourg
Cat. no. 53

Markus Lüpertz
Melonen – Mathematik XXI (Melons – Mathematics XXI). 1984-85
Oil on corrugated cardboard, 48^{1}/$_{16}$ x 38^{3}/$_{16}$ in. (122 x 97 cm.)
Collection Schmidt-Drenhaus, Cologne
Cat. no. 51

Markus Lüpertz
Griechisches Interieur (Greek Interior). 1985-86
Oil on canvas, 78^{3}/$_{4}$ x 63^{3}/$_{4}$ in. (200 x 162 cm.)
Collection Raymond J. Learsy
Cat. no. 56

Markus Lüpertz
Hirte mit Vogel (Zyklus: Zwischenraumgespenster) (Shepherd with Bird [Ghosts of Negative Space Cycle]). 1986
Oil on canvas, 78^{3}/$_{4}$ x 63^{3}/$_{4}$ in. (200 x 162 cm.)
Private Collection, Darmstadt
Cat. no. 54

Markus Lüpertz
Der heilige Franziskus verhindert die Vernichtung der Ratten (St. Francis Preventing the Extermination of the Rats). 1987
Oil and crayon on corrugated cardboard and wood, 94^{7}/$_{8}$ x 61^{13}/$_{16}$ in. (241 x 157 cm.)
Private Collection, Rome
Cat. no. 55

Markus Lüpertz
Das Abendmahl in M. L. (The Last Supper in M. L.). 1988
Oil on canvas, 63^{3}/$_{4}$ x 78^{3}/$_{4}$ in. (162 x 200 cm.)
Private Collection, Switzerland; Courtesy Galerie Lelong, Zurich
Cat. no. 57

Markus Lüpertz
Das Tuch der Erinnerungen (The Fabric of Memories). 1988
Oil on canvas, 63^{3}/$_{4}$ x 78^{3}/$_{4}$ in. (162 x 200 cm.)
Courtesy Galerie Lelong, Zurich
Cat. no. 59

Markus Lüpertz
Vogelfriedhof (Bird Cemetery). 1988
Oil on canvas, 63^{3}/$_{4}$ x 78^{3}/$_{4}$ in. (162 x 200 cm.)
Courtesy Galerie Lelong, Zurich
Cat. no. 58

Helmut Middendorf
Grossstadteingeborene (Big City Natives). 1980
Synthetic resin and oil on canvas, 74^{13}/$_{16}$ x 224^{7}/$_{16}$ in. (190 x 570 cm.)
Private Collection, Federal Republic of Germany

Helmut Middendorf
Singer. 1981
Synthetic resin on canvas, 51^{3}/$_{16}$ x 63^{3}/$_{4}$ in. (130 x 162 cm.)
Courtesy Galerie Gmyrek, Dusseldorf
*Cat. no. 82

Helmut Middendorf
Der Maler (The Painter). 1987
Synthetic resin on canvas, 78^{3}/$_{4}$ x 70^{7}/$_{8}$ in. (200 x 180 cm.)
Courtesy Galerie Folker Skulima, Berlin
Cat. no. 81

Helmut Middendorf
Im Kessel I (In the Cauldron I). 1987
Synthetic resin on canvas, 82^{11}/$_{16}$ x 118^{1}/$_{8}$ in. (210 x 300 cm.)
Courtesy Galerie Folker Skulima, Berlin
Cat. no. 80

Christa Näher
Minotaurus. 1985
Acrylic on canvas, 94½ x 126 in. (240 x 320 cm.)
Joshua Gessel Collection
Cat. no. 171

Christa Näher
Untitled. 1987
Oil on canvas, three parts, total, 98⁷/₁₆ x 248 in.
(250 x 630 cm.)
Courtesy Galerie Grässlin-Ehrhardt, Frankfurt
Cat. no. 170

Christa Näher
Untitled. 1988
Oil on canvas, 106⁵/₁₆ x 70⁷/₈ in. (270 x 180 cm.)
Courtesy Galerie Grässlin-Ehrhardt, Frankfurt
*Cat. no. 173

Christa Näher
Untitled. 1988
Oil on canvas, three parts, total, 114³/₁₆ x 248 in.
(290 x 630 cm.)
Courtesy Galerie Grässlin-Ehrhardt, Frankfurt
*Cat. no. 172

Albert Oehlen
*Selbstporträt mit blauer Mauritius und
verschissener Unterhose (Self-Portrait with Blue
Mauritius and Shitty Underpants).* 1984
Oil on canvas, 94½ x 102³/₈ in. (240 x 260 cm.)
Collection Schürmann
Cat. no. 156

Albert Oehlen
Auskunft (Information). 1985
Oil on canvas, 51³/₁₆ x 102³/₈ in. (130 x 260 cm.)
Courtesy Galerie Max Hetzler, Cologne
Cat. no. 157

Albert Oehlen
Stier mit Loch (Bull with Hole). 1986
Oil and lacquer on canvas, two parts, total,
74¹³/₁₆ x 149⁵/₈ in. (190 x 380 cm.)
Collection Paul Maenz, Cologne
Cat. no. 158

Markus Oehlen
Essen und Trinken (Eating and Drinking). 1982
Dispersion and wax on canvas, 57⁷/₈ x 78³/₄ in.
(147 x 200 cm.)
Courtesy Galerie Max Hetzler, Cologne
Cat. no. 154

Markus Oehlen
Problem. 1986
Oil on canvas, two parts, total, 98⁷/₁₆ x 126 in.
(250 x 320 cm.)
Courtesy Galerie Max Hetzler, Cologne
Cat. no. 155

C. O. Paeffgen
Pferdsprung in Moskau (Horse Jump in Moscow).
1972
Acrylic on photo-canvas, 63³/₈ x 43¹¹/₁₆ in.
(161 x 111 cm.)
Fröhlich Collection, Stuttgart
Cat. no. 119

C. O. Paeffgen
Mussolini. 1980
Acrylic on photo-canvas, 57¹/₁₆ x 45¹/₄ in.
(145 x 115 cm.)
Courtesy Galerie Moderne Kunst Dietmar Werle,
Cologne
Cat. no. 121

C. O. Paeffgen
Andy Warhol. 1985
Acrylic on photo-canvas, 55¹/₈ x 45¹/₄ in.
(140 x 115 cm.)
Collection Kunstmuseum Düsseldorf
Cat. no. 120

A. R. Penck
N. Y., N. Y. 1984
Acrylic on canvas, 97⁵/₈ x 346⁷/₁₆ in.
(248 x 880 cm.)
Mary Boone & Michael Werner Gallery
Cat. no. 27

A. R. Penck
Quo vadis Germania? 1984
Dispersion on canvas, 118¹/₈ x 393¹¹/₁₆ in.
(300 x 1000 cm.)
Mary Boone & Michael Werner Gallery
Cat. no. 26

Sigmar Polke
Liebespaar II (Lovers II). 1965
Oil and enamel on canvas,
74¹³/₁₆ x 55¹/₈ in. (190 x 140 cm.)
Saatchi Collection, London
Cat. no. 110

Sigmar Polke
Freundinnen (Girlfriends). 1965-66
Oil on canvas, 59¹/₁₆ x 75¹¹/₁₆ in. (150 x 192.2 cm.)
Fröhlich Collection, Stuttgart
Cat. no. 111

Sigmar Polke
Urlaubsbild (Vacation Picture). 1966
Oil on canvas, 39³/₈ x 35⁷/₁₆ in. (100 x 90 cm.)
Fröhlich Collection, Stuttgart
Cat. no. 112

Sigmar Polke
Ich mach das schon Jess (I'll Take Care of That,
Jess). 1972
Oil on felt, 124 x 112³/₁₆ in. (315 x 285 cm.)
Saatchi Collection, London
*Cat. no. 116

Sigmar Polke
Tischrücken (Seance). 1981
Dispersion on printed fabric, 70⁷/₈ x 86⁵/₈ in.
(180 x 220 cm.)
Collection Dr. Rainer Speck, Cologne
Cat. no. 117

Sigmar Polke
Hannibal mit seinen Panzerelefanten (Hannibal
with His Armored Elephants). 1982
Dispersion and lacquer on canvas, 102³/₈ x 78³/₄ in.
(260 x 200 cm.)
Saatchi Collection, London

Sigmar Polke
Paganini. 1982
Dispersion on canvas, 78³/₄ x 177³/₁₆ in.
(200 x 450 cm.)
Saatchi Collection, London
Cat. no. 115

Sigmar Polke
Lingua Tertii Imperii. 1983
Mixed media and lacquer on canvas,
102³/₈ x 78³/₄ in. (260 x 200 cm.)
Fröhlich Collection, Stuttgart
Cat. no. 114

Sigmar Polke
Audacia. 1986
Oil and lacquer on canvas, 78³/₄ x 74³/₄ in.
(200 x 190 cm.)
Collection Raymond J. Learsy
Cat. no. 113

Gerhard Richter
Hirsch (Deer). 1963
Oil on canvas, 59¹/₁₆ x 78³/₄ in. (150 x 200 cm.)
Private Collection; Courtesy Luhring, Augustine &
Hodes Gallery, Inc.
Cat. no. 123

Gerhard Richter
Liebespaar im Wald (Lovers in the Forest). 1966
Oil on canvas, 66¹⁵/₁₆ x 78³/₄ in. (170 x 200 cm.)
Private Collection, Berlin
Cat. no. 125

Gerhard Richter
Zehn grosse Farbtafeln (Ten Large Color Charts).
1966
Enamel on canvas, ten parts, total, 98⁷/₁₆ x 374 in.
(250 x 950 cm.)
Collection Reinhard Onnasch, Berlin
Cat. no. 122

Gerhard Richter
Brigid Polk. 1971
Oil on canvas, 48¹/₄ x 59¹/₁₆ in. (122.5 x 150 cm.)
Private Collection, Berlin
*Cat. no. 124

Gerhard Richter
Tourist (grau) (Tourist [Gray]). 1975
Oil on canvas, 78³/₄ x 78³/₄ in. (200 x 200 cm.)
Private Collection
Cat. no. 126

Gerhard Richter
Tourist (mit 1 Löwen) (Tourist [with 1 Lion]).
1975
Oil on canvas, 74¹³/₁₆ x 90⁹/₁₆ in. (190 x 230 cm.)
Private Collection
Cat. no. 128

Gerhard Richter
Tourist (mit 1 Löwen) (Tourist [with 1 Lion]).
1975
Oil on canvas, 66¹⁵/₁₆ x 78³/₄ in. (170 x 200 cm.)
Private Collection
Cat. no. 129

Gerhard Richter
Tourist (mit 2 Löwen) (Tourist [with 2 Lions]).
1975
Oil on canvas, 74¹³/₁₆ x 90⁹/₁₆ in. (190 x 230 cm.)
Private Collection
Cat. no. 127

Gerhard Richter
Abstraktes Bild (Abstract Painting). 1984
Oil on canvas, 74¹³/₁₆ x 196⁷/₈ in. (190 x 500 cm.)
Collection Dr. Eleonore and Dr. Michael Stoffel
Cat. no. 130

Gerhard Richter
Landschaft bei Koblenz (Landscape near Koblenz).
1987
Oil on canvas, 55¹/₈ x 78³/₄ in. (140 x 200 cm.)
Private Collection, San Francisco; Courtesy
Marian Goodman Gallery and Sperone Westwater,
New York
Cat. no. 132

Gerhard Richter
Landschaft bei Koblenz (Landscape near Koblenz).
1987
Oil on canvas, 55¹/₈ x 78³/₄ in. (140 x 200 cm.)
Collection The Montreal Museum of Fine Arts;
Courtesy Marian Goodman Gallery and Sperone
Westwater, New York
Cat. no. 131

Gerhard Richter
St. Andrew. 1988
Oil on canvas, 78³/₄ x 102³/₈ in. (200 x 260 cm.)
Los Angeles County Museum of Art, Modern and
Contemporary Art Council Fund

Gerhard Richter
St. Bridget. 1988
Oil on canvas, 78³/₄ x 102³/₈ in. (200 x 260 cm.)
Collection Fundació Caixa de Pensions
Cat. no. 133

Gerhard Richter
St. James. 1988
Oil on canvas, 78³/₄ x 102³/₈ in. (200 x 260 cm.)
Courtesy Anthony d'Offay Gallery, London
Cat. no. 134

Salomé
Selbstporträt, NYC (Self-Portrait, NYC). 1978
Dispersion on canvas, 63 x 70⁷/₈ in. (160 x 180 cm.)
Collection Deutsches Architekturmuseum,
Frankfurt
Cat. no. 77

Salomé
TV VII 1978
Synthetic resin on canvas, 71¹/₄ x 63 in.
(181 x 160 cm.)
Collection of the artist
Cat. no. 76

Salomé
Kampf im Seerosenteich (Battle in a Lily Pond).
1982
Mixed media on canvas, 157¹/₂ x 118¹/₈ in.
(400 x 300 cm.)
Private Collection, Japan
*Cat. no. 78

Eugen Schönebeck
Der Gehängte (The Hanged Man). 1962
Oil on canvas, 55¹/₈ x 47¹/₄ in. (140 x 120 cm.)
Private Collection; Courtesy Galerie Silvia Menzel,
Berlin

Eugen Schönebeck
Der Gefolterte (The Tortured Man). 1963
Oil on canvas, 63¹³/₁₆ x 51¹/₄ in. (162 x 130 cm.)
Private Collection; Courtesy Galerie Silvia Menzel,
Berlin
Cat. no. 9

Andreas Schulze
Apfel (Apple). 1983
Dispersion on canvas, 90⁹/₁₆ x 157¹/₂ in.
(230 x 400 cm.)
Private Collection, Cologne
Cat. no. 145

Norbert Tadeusz
Bett, Frau mit Bluse (Bed, Woman with Blouse).
1966
Oil on canvas, 39³/₈ x 39³/₈ in. (100 x 100 cm.)
Courtesy Galerie Gmyrek, Dusseldorf
Cat. no. 65

Norbert Tadeusz
Sakral-Raum (Sacred Room). 1971
Oil on canvas, 78³/₄ x 66¹⁵/₁₆ in. (200 x 170 cm.)
Collection Schmidt-Drenhaus, Cologne; Courtesy
Galerie Gmyrek, Dusseldorf
Cat. no. 60

Norbert Tadeusz
Bügelbrett (Ironing Board). 1973
Oil on canvas, 78³/₄ x 55¹/₈ in. (200 x 140 cm.)
Private Collection, Berlin
Cat. no. 61

Norbert Tadeusz
Empoli, Ochse (Empoli, Ox). 1983
Oil on canvas, 78³/₄ x 86⁵/₈ in. (200 x 220 cm.)
Courtesy Galerie Gmyrek, Dusseldorf
Cat. no. 63

Norbert Tadeusz
Strohwagen (Hay Wagon). 1983
Oil on canvas, 81⁵/₁₆ x 118¹/₈ in. (206.5 x 300 cm.)
Courtesy Galerie Gmyrek, Dusseldorf
Cat. no. 62

Norbert Tadeusz
Inferno. 1987
Acrylic on canvas, 117¹¹/₁₆ x 165³/₈ in.
(299 x 420 cm.)
Courtesy Galerie Gmyrek, Dusseldorf
Cat. no. 64

Norbert Tadeusz
Valentano. 1987
Oil and oil crayon on canvas, 128¹⁵/₁₆ x 243⁵/₁₆ in.
(325 x 618 cm.)
Courtesy Galerie Gmyrek, Dusseldorf

Volker Tannert
Simulation. 1981
Oil on burlap, 94¹/₂ x 78³/₄ in. (240 x 200 cm.)
Collection Dr. Eleonore and Dr. Michael Stoffel
Cat. no. 174

Volker Tannert
*Die Vereinigung mit der Vergangenheit erfolgt
meist bei Nebel* (Becoming One with the Past
Usually Occurs in Fog). 1983
Oil on canvas, 86⁵/₈ x 63 in. (220 x 160 cm.)
Courtesy Sonnabend Gallery, New York
Cat. no. 176

Volker Tannert
Untitled. 1984
Oil on canvas, 70⁷/₈ x 166¹/₈ in. (180 x 422 cm.)
Collection First Bank System, Inc.
Cat. no. 175

Rosemarie Trockel
Moschus (Musk). 1984
Oil on canvas, 66¹⁵/₁₆ x 78³/₄ in. (170 x 200 cm.)
Collection Susan and Lewis Manilow
Cat. no. 146

Rosemarie Trockel
Untitled. 1985
Oil on wood, 23⁵/₈ x 19¹¹/₁₆ in. (60 x 50 cm.)
Collection Kamran T. Diba
Cat. no. 148

Rosemarie Trockel
Untitled. 1985
Oil on canvas, 23⁵/₈ x 19¹¹/₁₆ in. (60 x 50 cm.)
Collection Wurlitzer
Cat. no. 149

Rosemarie Trockel
Untitled. 1985
Oil on canvas, 19¹¹/₁₆ x 15³/₄ in. (50 x 40 cm.)
Courtesy Monika Sprüth Galerie, Cologne
Cat. no. 150

Rosemarie Trockel
Made in Western Germany. 1987
Wool, 98¹³/₁₆ x 213 in. (251 x 541 cm.)
Courtesy Donald Young Gallery, Chicago
Cat. no. 147

Bernd Zimmer
Auto, brennend (Car, Burning). 1982
Dispersion on canvas, 78³/₄ x 98⁷/₁₆ in.
(200 x 250 cm.)
Collection Galerie Gmyrek, Dusseldorf
Cat. no. 72

Bernd Zimmer
Fichtenwald (Spruce Forest). 1985-86
Oil on canvas, 90⁹/₁₆ x 133⁷/₈ in. (230 x 340 cm.)
Collection Neue Galerie – Sammlung Ludwig,
Aachen
Cat. no. 73

Bernd Zimmer
Nr. 22 (Föhn) (No. 22 [South Wind]). 1987
Acrylic, oil and sand on canvas, 91¹⁵/₁₆ x 91¹⁵/₁₆ in.
(231 x 231 cm.)
Courtesy Galerie Gmyrek, Dusseldorf
Cat. no. 74

Bernd Zimmer
Nr. 39 (grüner Rauch) (No. 39 [Green Fumes]).
1988
Oil, acrylic and tar on canvas, 91⁵/₁₆ x 90⁹/₁₆ in.
(232 x 230 cm.)
Courtesy Galerie Gmyrek, Dusseldorf
Cat. no. 75

1985 Freiburg, Augustiner Museum. *Elvira Bach.*
Geneva, Galerie Pierre Hubert. *Elvira Bach.*
Los Angeles, Davies Long Gallery. *Elvira Bach.*
New York, Gabrielle Bryers Gallery. *Elvira Bach.*
1986 Venice, Galleria Capricorno. *Elvira Bach.*
Zwevegem-Otegem, Belgium, Deweer Art Gallery.
Elvira Bach.
1987 Atlanta, Hillman Holland Gallery. *Elvira Bach.*
Berlin, Raab Galerie; London, Raab Gallery; and New
York, Charles Cowles Gallery. *Elvira Bach.* Catalogue
includes "I was, I am, I shall be: always Elvira Bach,
Larva, Chrysalis, Butterfly" by Ottmar Bergmann.
Bremen, Galerie am Hofmeierhaus. *Elvira Bach.*
Bremerhaven, Kunstverein. *Elvira Bach.*
Munich, Galerie Pfefferle. *Elvira Bach.*

Selected Bibliography

EDELMAN, Robert G. "Elvira Bach." *Art in America*
(July 1985): 133-34. Review of Bach exhibition at
Gabrielle Bryers Gallery, New York.

GRIMES, Nancy. "Elvira Bach." *Artnews* (September
1987): 148. Review of Bach exhibition at Charles
Cowles Gallery, New York.

HEARTNEY, Eleanor. "Elvira Bach and Berlin Group at
Charles Cowles." *Art in America* (September 1987):
176.

HONNEF, Klaus. "Elvira Bach." *Kunstforum Interna-
tional* (December 1983): 86-95.

KORNBICHLER, Thomas. "Elvira Bach." *Kunstwerk*
(September 1985): 36-37.

KUSPIT, Donald B. [Review of Bach exhibition at Ga-
brielle Bryers Gallery, New York.] *Artforum* (October
1985): 124-25.

———. [Review of Bach exhibition at Charles Cowles
Gallery, New York.] *Artforum* (Summer 1987): 116.

LARSEN, Susan C. [Review of *The Human Condition*
exhibition at San Francisco Museum of Modern Art,
an international group show in which Bach was
included.] *Burlington Magazine* (October 1984):
660.

LARSON, Kay. [Review of Bach exhibition at Charles
Cowles Gallery, New York.] *New York Magazine*
(March 23, 1987): 17.

OHFF, Heinz. [Review of Bach exhibition at Raab
Galerie, Berlin.] *Das Kunstwerk* (June 1987): 69.

SMITH, Roberta. [Review of Bach exhibition at Charles
Cowles Gallery, New York.] *The New York Times*
(March 20, 1987): C23.

WYKES-JOYCE, M. "Elvira Bach." *Arts Review*
(November 25, 1983): 659. Review of Bach exhibition
at Edward Totah Gallery, London.

———. "Elvira Bach," *Arts Review* (May 8, 1987): 295.
Review of Bach exhibition at Raab Gallery, London.

Ina Barfuss

1949 Born in Lüneburg.
1968-74 Studies at the Hochschule für
Bildende Künste, Hamburg. She belongs to a
group of students that formed around Polke.
1978 Moves to Berlin. Makes collaborative
paintings with her husband, Thomas Wach-
weger.
1988 Barfuss explains that her work is "con-
cerned with 'beautiful illusion.' It's about the
marketing of the 'positive man/woman' who is
constantly being foisted upon us in fashion,
everyday life and politics. My paintings deal
with the egoism of elegant mindlessness that
determines the present-day image of man and
woman – even in art. I seek the pictorial ciphers

behind which man and woman, with their long-
ings and failings, with their love and their hate,
hide" (Statement to the author).
current Lives and works in Berlin.

Selected Exhibitions

1977 Zurich, Galerie Silvio R. Baviera. *Ina Barfuss.*
1980 Zurich, Galerie Silvio R. Baviera. *Ina Barfuss.*
1981 Zurich, Galerie Silvio R. Baviera. *Ina Barfuss.*
1982 Berlin, Neue Gesellschaft für Bildende Künste.
*Ina Barfuss: Der moderne Mensch – Bilder und
Zeichnungen, 1979-1982.* Catalogue includes "Mo-
derner Mensch/alltägliche Hölle: Zu Bildern von Ina
Barfuss" by Barbara Straka, "'Keine Katastrophe ohne
Idylle/Keine Idylle ohne Katastrophe'" by Ulla Frohne,
"Ventile" by Michael Elsen and "Inneres-zersetzt" by
Jeannot L. Simmen.
Munich, Galerie Six Friedrich. *Ina Barfuss: Neue
Arbeiten, 1982.*
1983 Cologne, Monika Sprüth Galerie. *Ina Barfuss:
"Heimliche Herrschaft."*
1984 Hamburg, Galerie Vera Munro. *Ina Barfuss:
Bilder und Papierarbeiten.*
1986 Berlin, Haus am Waldsee. *Ina Barfuss/Thomas
Wachweger: Ausstellung in 2 Folgen.*
Dortmund, Museum am Ostwall, and Ulm, Ulmer
Museum. *Ina Barfuss/Thomas Wachweger: Die Kunst
der Triebe – Arbeiten von 1980 bis 1985.*
1987 Cologne, Monika Sprüth Galerie. *Ina Barfuss.*
Hamburg, Galerie Vera Munro. *Ina Barfuss.*
1988 Berlin, Galerie Springer. *Ina Barfuss.*

Selected Bibliography

BARFUSS, Ina, and Thomas Wachweger. [Two images
made for the issue by these artists.] *Artscribe 50*
(1965): 40-43.

BEYER, Lucie. [Review of Barfuss exhibition at Monika
Sprüth Galerie, Cologne.] *Flash Art* (January 1984):
41.

FAUST, Wolfgang Max. [Review of Barfuss exhibition
at Haus am Waldsee, Berlin.] *Artforum* (February
1987): 129-30.

———, and Max Raphael. "Gemeinschaftsbilder: Ein
Aspekt der neuen Malerei; Ina Barfuss und Thomas
Wachweger: Das Bild als Kraftritual." *Kunstforum
International* (November 1983): 44-55.

HAHNE, H. [Review of *Die Kunst der Triebe* exhibition
at Museum am Ostwall, Dortmund.] *Kunstwerk*
(February 1986): 91-92.

HONNEF, Klaus. "Ina Barfuss." *Kunstforum Interna-
tional* (December 1983): 96-101.

OHFF, Heinz. "Ina Barfuss." *Kunstwerk* (September
1985): 40-41.

POHLEN, Annelie. [Review of Barfuss exhibition at
Monika Sprüth Galerie, Cologne.] *Artforum* (January
1984): 85-86.

SANDQUIST, G. "Vilda Kvinnor." *Paletten* 1 (1984):
16-17.

SIMMEN, Jeannot L. "New Painting in Germany."
Flash Art (November 1982): 54-58.

Georg Baselitz

1938 Born Georg Kern in Deutschbaselitz,
now GDR.
1956 Moves to Berlin (GDR). Studies under
Womacka at the Hochschule für Bildende und
Angewandte Kunst, Berlin (GDR), from which
he is later expelled for "social and political im-
maturity." Begins his friendship with Penck.
1957-64 Moves to West Berlin, where he
studies at the Hochschule für Bildende Künste,
under Hann Tier. He is introduced to the work
of Jackson Pollock, Philip Guston and other new
American painters who have their first exhibi-
tions in Berlin in the late 1950s. In 1958 he
assumes the name of his birthplace and begins
his friendship with Schönebeck.
1961 "I am warped, bloated and sodden with
memories. The destinies that make no one look
up: I have them all on record. By night, troubles
soon come to mind, like starlings in late summer
– a negative film. The influence of stars is unde-
niable, the purity of the night sky is awesome,
only the source is poisoned. The many killings,
which I daily experience in my own person, and
the disgrace of having to defend my excessive
births, lead to a malady of age and experience.
Ramparts are built, byways pursued, sweets on
offer, and more and more slides, sleepier and
sleepier" (translation of Georg Baselitz and
Eugen Schönebeck, "Pandemonium I: Berlin/
November 1961," in Schrenk, 1984: 172).

Writes the first *Pandämonium* manifesto for
an exhibition of the same name with fellow stu-
dent Schönebeck. Schönebeck, like Baselitz, had
studied in Berlin (GDR) before moving to the
West in 1955. However, Schönebeck gave up
painting entirely when he was just thirty years
old. In a relatively short period of activity, his
work evolved from the agressively figurative
mode he had once explored with Baselitz to his
own unique style of realism influenced by the art
of Fernand Léger, the Russian realist painter
Alexander Deineka, as well as by the works of
the Mexican muralists. (Walter Grasskamp,
"Biographies of the Artists," in Joachimides,
Rosenthal and Schmied, 1985: 500.)
1962 Writes second *Pandämonium* manifesto
(again with Schönebeck). In the same year
Baselitz marries Elke Kretzshmar, and son
Daniel is born.
1963 Exhibition at Galerie Werner Katz,
Berlin; subsequent confiscation of Baselitz's
paintings *Die grosse Nacht im Eimer* (Big Night
Down the Drain) and *Der nackte Mann* (The
Naked Man) by the public prosecutor's office.
Legal battles go on for two years. In the highest
court of appeals, a decision is finally reached to
return the paintings.

1965 Wins the Villa Romana Prize, Florence. While in Florence, Baselitz introduces animals and landscape into his art, and discovers the work of the Italian Mannerists.

1966 Leaves Berlin, moves to Osthofen, near Worms, where he lives in relative isolation. "This isolation was the consequence of the Berlin exhibition and the scandal that followed. I went into the country, to a little village, and had nothing more to do with artists, dealers and the like. ("An Interview with Georg Baselitz by Jean-Louis Froment and Jean-Marc Poinsot," in *Georg Baselitz: Sculpture and Early Woodcuts*. London: 1988: n. p.)
Die grossen Freunde, exhibition at Galerie Rudolf Springer, Berlin. The exhibition is accompanied by a poster-size handout. The poster/manifesto ironically explains "Why the Picture 'Great Friends' is a Good Picture," and lists seven "formal" criteria and two "content" criteria by which to judge a painting's worth. Son Anton is born.

1968 Receives a grant from the Cultural Group of the Federal Association of German Industry.

1969 Portraits and landscapes are turned upside down. By inverting the subject, Baselitz forces a nonliteral and nonillusionistic reading of the painting. "The reality is the picture," he says, "it is most certainly not in the picture" (quoted by Gachnang, in catalogue of Baselitz exhibition in Braunschweig, 1981: 71). "Baselitz means to give us such disruptive, disturbing works – images which generate pandemonium. His famous upside-down figures, disrupting the rigid expectations of ordinary petrified perception, are insubordinate. The uncanny flux of his images – at times deluge-like, and in general like a secret process unexpectedly exposed or spontaneously candid – undoes the petrified facade of the depicted objects. Baselitz's images are implusive in a way disturbing to the opinionated mind, for they evoke the alienness of the unconsciousness as such as well as of repressed feelings for the particular objects" (Kuspit, 1986: 24).

1974 Moves to Schloss Derneburg, near Hildesheim.

1977 Teaches at the Akademie der Bildenden Künste, Karlsruhe.
1978 Appointed professor, Akademie der Bildenden Künste, Karlsruhe.
1983 Appointed professor, Hochschule der Künste, Berlin.
Participates in the Venice Biennale.
1986 Wins prize of the NORD/LB, Hannover, and the Kaiserring Prize from the city of Goslar.
current Lives and works in Berlin and Derneburg.

Selected Exhibitions

1961 Berlin. *Erstes Pandämonium*. Manifesto and exhibition with Eugen Schönebeck.
1962 Berlin. *Zweites Pandämonium*. Manifesto and exhibition with Eugen Schönebeck.
1963 Berlin, Galerie Werner & Katz. *Georg Baselitz*.
1964 Berlin, Galerie Michael Werner. *Georg Baselitz*.
1965 Badenweiler, Galerie Krohn. *Georg Baselitz*.
Berlin, Galerie Michael Werner. *Georg Baselitz*.
Munich, Galerie Friedrich & Dahlem. *Georg Baselitz*.
1966 Berlin, Galerie Rudolf Springer. *Die Grossen Freunde*.
Cologne, Galerie Michael Werner. *Georg Baselitz*.
Munich, Galerie Friedrich & Dahlem. *Georg Baselitz*.
1967 Erlangen, Galerie Beck. *Georg Baselitz*.
Zurich, Galerie Obere Zäune. *Georg Baselitz*.
1969 Erlangen, Galerie Beck. *Georg Baselitz*.
1970 Antwerp, Wide White Space Gallery. *Georg Baselitz: Tekeningen en Schilderijen*.
Basel, Kunstmuseum. *Georg Baselitz: Zeichnungen*. Catalogue includes foreword by Dieter Koepplin and excerpt from the *Zweites Pandämonium* manifesto.
Munich, Galerie Heiner Friedrich. *Georg Baselitz*.
Stuttgart, Galerie Berner. *Georg Baselitz*.
1971 Cologne, Galerie Borgmann. *Georg Baselitz*.
Heidelberg, Galerie Rothe. *Georg Baselitz*.
Munich, Galerie Tobiès & Silex. *Georg Baselitz*.
1972 Vienna, Galerie Nächst St. Stephan. *Georg Baselitz*.
1974 Leverkusen, Städtisches Museum. *Georg Baselitz: Das druckgraphische Werk*.
1976 Bern, Kunsthalle. *Georg Baselitz: Malerei, Handzeichnungen, Druckgraphik*.
Munich, Galerieverein München and Staatsgalerie moderner Kunst. *Georg Baselitz*.
1977 Kassel, *Documenta 6: Malerei, Plastik und Performance*. Catalogue includes essay by Theo Kneubühler.
1979 Eindhoven, Stedelijk Van Abbemuseum. *Georg Baselitz: Schilderijen 1977-78*. Catalogue includes essay by Rudi Fuchs.
Groningen, Groninger Museum. *Georg Baselitz: Tekeningen*. Catalogue includes essays by F. Haks and P. Ter Hofstede and 1975 interview with Baselitz by Johannes Gachnang.
London, The Whitechapel Art Gallery. *Georg Baselitz*.
Paris, Galerie Nancy Gillespie & Elisabeth de Laage. *Georg Baselitz*.
1980 Bordeaux, Centre d'arts plastiques contemporains de Bordeaux. *Baselitz, Beuys, Penck: 300 dessins 1945-1978*.
London, The Whitechapel Art Gallery. *Georg Baselitz: Model for a Sculpture*.
Venice, *XXXIX Esposizione Internazionale d'Arte Venezia*, West German Pavilion. *Settore Arti Visive 1980*. Catalogue includes essay by Klaus Gallwitz.
1981 Amsterdam, Stedelijk Museum. *Georg Baselitz: Strassenbild*. Catalogue includes "Georg Baselitz" by A. van Grevenstein.
Braunschweig, Kunstverein Braunschweig. *Georg Baselitz*. Catalogue includes "Ein Gespräch mit Georg Baselitz" by Johannes Gachnang.
Cologne, Galerie Michael Werner. *Georg Baselitz*.
Dusseldorf, Städtische Kunsthalle. *Georg Baselitz; Gerhard Richter*. Catalogue includes essays by Jürgen Harten and Ulrich Krempel.
Eindhoven, Stedelijk Van Abbemuseum. *Georg Baselitz: Linosneden uit 1976 tot 1979*.
New York, Brooke Alexander Gallery. *Georg Baselitz: Prints 1976-1981*.

New York, Xavier Fourcade, Inc. *Georg Baselitz: New Paintings and Drawings 1979-1981*.
1982 Cologne, Galerie Michael Werner. *Georg Baselitz: Zeichnungen*.
Hamburg, Galerie Neuendorf. *Georg Baselitz*.
London, Anthony d'Offay Gallery. *Ruins: Strategies of Destruction in the Fracture Paintings of Georg Baselitz 1966-1969*. Catalogue includes essay by R. Jablonka.
London, Waddington Galleries. *Georg Baselitz: Recent Paintings, Drawings and Prints*.
New York, Sonnabend Gallery. *Georg Baselitz*.
1983 Akron, Akron Art Museum. *Georg Baselitz*. Catalogue includes "Georg Baselitz: Paintings" by I. Michael Danoff.
Amsterdam, Stedelijk Museum; Basel, Kunsthalle; and London, The Whitechapel Art Gallery. *Georg Baselitz: Paintings 1960-83*. Catalogue includes essay by Richard Calvocoressi.
Berlin, Galerie Folker Skulima. *Georg Baselitz*.
Bordeaux, Centre d'arts plastiques contemporains de Bordeaux. *Georg Baselitz*.
Cologne, Galerie Michael Werner. *Georg Baselitz: Holzplastiken*. Catalogue includes texts by Andreas Franzke, R. H. Fuchs and Siegfried Gohr.
Cologne, Galerie Zwirner. *Georg Baselitz: 16 Holzschnitte-rot und schwarz 1981/82*.
Hamburg, Galerie Neuendorf. *Georg Baselitz: Zeichnungen 1961-1983*. Catalogue includes "Georg Baselitz: Zeichnungen 1961-1983" by Franz Dahlem and Günther Gercken.
Los Angeles, Gallery 6, Los Angeles County Museum of Art. *Georg Baselitz: Two Sculptures and Three Linocuts*.
Milan, Studio d'Arte Cannaviello. *Georg Baselitz*.
New York, Sonnabend Gallery. *Georg Baselitz*.
New York, Xavier Fourcade, Inc. *Georg Baselitz: Six Paintings 1962-1969: Four Paintings 1982-1983*.
1984 Basel, Kunsthalle. *Georg Baselitz: Das malerische Werk 1960-1983, Linolschnitte 1976-1979*.
Basel, Kunstmuseum, and Eindhoven, Stedelijk Van Abbemuseum. *Georg Baselitz: Zeichnungen 1958-1983*.
Berkeley, University Art Museum, University of California, and Los Angeles, Los Angeles County Museum of Art. *Georg Baselitz*.
Cologne, Galerie Thomas Borgmann. *Georg Baselitz: Retrospektive 1960-83*.
London, Waddington Galleries. *Georg Baselitz*.
Lyon, Musée Saint Pierre d'Art Contemporain. *Georg Baselitz: Xylographies 1974-1983, provenant des collections du Cabinet des estampes, Génève*.
Munich, Staatliche Graphische Sammlung. *Georg Baselitz: Druckgraphik*.
New York, Mary Boone & Michael Werner Gallery. *Georg Baselitz*. Catalogue includes "Scenes from the Passion" by Norman Rosenthal and "The Revised Testament" by Klaus Kertess.
Paris, Gillespie-Laage-Salomon. *Georg Baselitz: Gravures 1964-1983*.
Vancouver, Vancouver Art Gallery. *Georg Baselitz*. Catalogue includes essay by J.-A. B. Danzker.
1985 Berlin, DAAD Galerie, and Eindhoven, Stedelijk Van Abbemuseum. *Georg Baselitz: "Sächsische Motive," 54 Aquarelle (1971/75)*.
Bielefeld, Kunsthalle. *Georg Baselitz: Skulpturen, Gemälde, Zeichnungen und Holzschnitte*.
Karlsruhe, Badischer Kunstverein. *Georg Baselitz: Zeichnungen 1958-1983*.
London, Anthony d'Offay Gallery. *Georg Baselitz: Paintings 1964-67*.
Munich, Galerie Fred Jahn. *Georg Baselitz: Zeichnungen und Druckgraphik*.
New York, Mary Boone & Michael Werner Gallery. *Georg Baselitz*.
Paris, Bibliothèque Nationale. *Georg Baselitz: Gravures et Sculptures*.
Paris, Grande Halle de la Villette Biennale de Paris. *Georg Baselitz*.
Paris, Gillespie-Laage-Salomon. *Georg Baselitz*.
Pittsburgh, Hewlett Gallery, Carnegie-Mellon University. *Georg Baselitz: Selected Drawings 1978-1984*.
1986 Basel, Galerie Beyeler. *Georg Baselitz*.
Goslar, Mönchehaus Museum für Moderne Kunst, and Vienna, Galerie Heike Curtze. *Georg Baselitz: 16 Holzschnitte*.

New York, Mary Boone & Michael Werner Gallery. *Georg Baselitz.*

Vienna, Wiener Secession. *Georg Baselitz: Bäume.*

1987 Basel, Galerie Buchmann, and Frankfurt, Galerie Neuendorf. *Georg Baselitz: Adler, 53 Gouachen und Zeichnungen.* Catalogue includes "The Sacrifice of the Eagle" by Günther Gercken.

Cologne, Galerie Michael Werner. *Georg Baselitz: Neue Arbeiten.*

Hannover, Kestner-Gesellschaft. *Georg Baselitz: Skulpturen und Zeichnungen 1979-87.*

London, Anthony d'Offay Gallery. *Georg Baselitz: Sculpture & Early Woodcuts.* Catalogue includes "An interview with Georg Baselitz by Jean-Louis Froment and Jean-Marc Poinsot."

Milan, Christian Stein. *Baselitz.*

Minneapolis, First Bank Skyway Gallery. *Georg Baselitz: Paintings, Drawings, Prints 1966-1986.*

New York, Mary Boone & Michael Werner Gallery. *Georg Baselitz.* Catalogue includes "Baselitz: Paintings 1964-1978" by Trevor Fairbrother.

New York, Brooke Alexander Gallery. *Georg Baselitz: Early Prints and Drawings.*

1988 Berlin, Galerie Fahnemann. *Georg Baselitz: Adler-Serie, Zeichnungen – 1979.*

Frankfurt, Städelsches Kunstinstitut and Städtische Galerie. *Georg Baselitz: Zeichnungen, Bilder und Skulpturen.* Catalogue includes "Der Weg der Erfindung Georg Baselitz" by Klaus Gallwitz, "Pandämonium" by Eugen Schönebeck and "Vom Detail zum Ganzen" by Ursula Grzechca-Mohr.

Paris, Galerie Beaubourg. *Georg Baselitz: Peintures.*

Selected Bibliography

BASELITZ, Georg. "Vier Wanden en Bovenlicht of Beter: Geen Werk aan de Wand." *Museumjournaal* 5-6 (1982): 265-67.

BASS, Ruth. "Georg Baselitz." *Artnews* (Summer 1983): 189. Review of Baselitz exhibition at Xavier Fourcade, Inc., New York.

BAUERMEISTER, Volker. "Georg Baselitz." *Kunstwerk* (January 1982): 33. Review of Baselitz exhibition at Kunstverein Braunschweig.

BECKER, W. *New German Painting from the Ludwig Collection.* Catalogue of exhibition at Provinciaal Museum, Hasselt, Belgium, 1985.

BEYER, Lucie. [Review of Baselitz exhibition at Galerie Michael Werner, Cologne.] *Flash Art* (March 1985): 50.

BLAU, D. [Review of Baselitz exhibition at Brooke Alexander Gallery, New York.] *Flash Art* (February-March 1982): 56.

BROCK, B. "Speciale Germania: Avanguardia e Mito." *D'Ars* (December 1981): 28-45.

CALVOCORESSI, Richard. "A Source for the Inverted Imagery in Georg Baselitz's Painting." *Burlington Magazine* (December 1985): 894-99.

COLLIER, Caroline. [Review of Baselitz exhibition at Waddington Galleries, London.] *Flash Art* (January 1983): 66.

COLLINS, M. "Georg Baselitz: Effluents and Inventions." *Artscribe* (October 1983): 20-25.

DIETRICH-BOORSCH, Dorothea. "The Prints of Georg Baselitz: An Introduction." *The Print Collector's Newsletter* (January-February 1982): 165-67.

ENGELHARD, Günter. "Georg Baselitz: Heftig, aber nicht wild." *Art: Das Kunstmagazin* (September 1983): 32-47.

FEAVER, William. [Review of Baselitz exhibition at The Whitechapel Art Gallery, London.] *Artnews* (January 1981): 201, 203.

FRIEDRICHS, Yvonne. [Review of Baselitz/Richter exhibition at Kunsthalle, Dusseldorf.] *Kunstwerk* (April 1981): 80-81.

FUCHS, Rudi. "Georg Baselitz." *Art of Our Time: The Saatchi Collection.* London: Lund Humphries in association with Rizzoli, 1985.

——. "Baselitz: peinture." *Artstudio* (Autumn 1986): 34-47.

GELDZAHLER, Henry. "Georg Baselitz." *Interview* (May 1984): 82-84.

GODFREY, Tony. [Review of Baselitz exhibition at Galerie Beyeler, Basel.] *Burlington Magazine* (September 1986): 700-1.

GOHR, Siegfried. "In the Absence of Heroes: The Early Work of Georg Baselitz." *Artforum* (Summer 1982): 67-69.

——. *Georg Baselitz: Druckgraphik 1963-1983.* Munich: Prestel-Verlag, 1984.

GORELLA, Arwed D. "Der Fall Baselitz und das Gespräch." *Tendenzen: Blätter für engagierte Kunst,* no. 30 (1964): n. p.

GUIDIERI, Remo. "Georg Baselitz's 'Pastorale.'" *Arts Magazine* (June 1986): 35-37.

HAYT-ATKINS, Elizabeth, and Susan Kandel. "Georg Baselitz." *Flash Art* (March 1988): 189. Review of Baselitz exhibition at Mary Boone & Michael Werner Gallery, New York.

HEINRICH, Theodore Allen. "Documenta 6, Part III: Painting." *Artscanada* (April-May 1978): 60-62.

HERRAIZ, Enrique García. "Crónica de Nueva York: La Vuelta de los europeos, Georg Baselitz." *Goya* (March-June 1982): 308-9. Review of Baselitz exhibitions at Xavier Fourcade, Inc., Brooke Alexander Gallery and Sonnabend Gallery, New York.

JAHN, Fred, with Johannes Gachnang. *Baselitz: Peintre-Graveur.* Vol. I, *Werkverzeichnis der Druckgraphik 1963-1974.* Bern and Berlin: Verlag Gachnang & Springer, 1983.

JANUSZCZAK, W. [Review of Baselitz exhibitions at Waddington Galleries and Anthony d'Offay Gallery, London.] *Studio International* (January-February 1983): 52-53.

KRAMER, Hilton. "Art: Neo-Expressionism of Georg Baselitz." *The New York Times* (March 26, 1982): 23. Review of Baselitz exhibition at Sonnabend Gallery, New York.

KUSPIT, Donald B. [Review of Baselitz exhibition at Xavier Fourcade, Inc., New York.] *Art in America* (February 1982): 139-40.

——. [Review of Baselitz exhibition at Sonnabend Gallery, New York.] *Artforum* (October 1983): 75-76

——. "The Archaic Self of Georg Baselitz." *Arts Magazine* (December 1983): 76-77.

——. "Pandemonium: The Root of Georg Baselitz's Image." *Arts Magazine* (June 1986): 24-29.

LESSARD, D. "Orientations de la peinture, allemande actuelle." *Vie des Arts* (Autumn 1982): 26-28.

LIEBMANN, Lisa. [Review of Baselitz exhibition at Xavier Fourcade, Inc., New York.] *Artforum* (March 1982): 69-70.

MORGAN, S. [Review of Baselitz exhibitions at Waddington Galleries and Anthony d'Offay Gallery, London.] *Artforum* (February 1983): 86-87.

MÜLLER, Hans-Joachim. "Ausstellungs-Rückschau: Biennale Venedig 1980." *Kunstwerk* (April 1980): 58-69.

PIENE, Nan R. "Report from Germany." *Art in America* (January-February 1967): 108. Review of Baselitz exhibition at Galerie Michael Werner, Cologne.

PINCUS-WITTEN, Robert. "Georg Baselitz: From Nolde to Kandinsky to Matisse – A Speculative History of Recent German Painting." *Arts Magazine* (June 1986): 30-34.

POHLEN, Annelie. [Review of Baselitz exhibition at Galerie Michael Werner, Cologne.] *Flash Art* (December 1981-January 1982): 58-59.

PULIAFITO, Isabella. [Review of Baselitz and Kiefer exhibitions at Venice Biennale.] *Artforum* (November 1981): 97.

RAYNOR, Vivien. "Art: Upside-Down World of Baselitz." *The New York Times* (April 14, 1984): 14. Review of Baselitz exhibition at Mary Boone Gallery, New York.

——. [Review of Baselitz exhibition at Brooke Alexander Gallery, New York.] *The New York Times* (April 24, 1987): C22.

RENARD, D. [Interview with Baselitz.] *Beaux Arts Magazine* (April 1985): 36-41.

RODITI, Edouard. "Germany: The New 'Ecole de Berlin.'" *Arts Magazine* (September 1965): 47.

RUSSELL, John. [Review of Baselitz exhibition at Xavier Fourcade, Inc.] *The New York Times* (December 11, 1981): C26.

——. "Art: Georg Baselitz and his Upside-Downs." *The New York Times* (April 8, 1983): C23. Review of Baselitz exhibition at Xavier Fourcade, Inc., New York.

——. "Sculptures by Georg Baselitz," *The New York Times* (June 3, 1983): C21. Review of Baselitz exhibition at Sonnabend Gallery, New York.

——. [Review of Baselitz exhibition at Mary Boone & Michael Werner Gallery, New York.] *The New York Times* (April 18, 1986): C27.

——. [Review of Baselitz exhibition at Mary Boone & Michael Werner Gallery, New York.] *The New York Times* (December 4, 1987): C28.

SAATCHI, Doris. "The Painter and his Castle: The Surprising Surroundings where Georg Baselitz Lives and Works." *House and Garden* (December 1983): 180-91.

SAGER, Peter and LORD SNOWDON. [Photographs.] "Alles auf den Kopf Gestellt." *Zeit Magazin* (November 1985): 30-36.

SANNA, J. de. [Review of Baselitz exhibition at Galleria Christian Stein, Milan.] *Artforum* (September 1987): 139-40.

SANS, Jérôme. [Review of Baselitz exhibition at Centre d'arts plastiques contemporains de Bordeaux.] *Flash Art* (Summer 1983): 71.

SCHÜTZ, Sabine. [Review of Baselitz exhibition at Galerie Michael Werner, Cologne.] *Kunstforum International* (December 1987-January 1988): 270-71.

SMITH, Roberta. [Review of Baselitz exhibition at Sonnabend Gallery, New York.] *The Village Voice* (March 23, 1982): 85.

——. "Germanations." *The Village Voice* (June 28, 1983): 97. Review of Baselitz sculpture exhibition at Sonnabend Gallery, New York.

SOKOLOV, M. "Ekologicheskie Problemy v Iskussive Zapada." *Dekorativnde* 9 (1983): 35-37.

STEINHAUSER, Monika. [Review of Baselitz exhibition at Galerieverein München and Staatsgalerie moderner Kunst, Munich.] *Pantheon* (July 1976): 249-50.

THOMPSON, Jon B. "Venice: Aspects of the 1980 Biennale." *Burlington Magazine* (November 1980): 793-94.

THWAITES, John Anthony. [Review of Baselitz exhibition at Galerie Tobiès & Silex, Cologne.] *Art and Artists* (May 1972): 52.

WECHSLER, Max. [Review of Baselitz exhibitions at Kunsthalle and Kunstmuseum, Basel.] *Du,* no. 4 (1984): 66-67.

WINTER, Peter. [Review of Baselitz exhibition at Kestner-Gesellschaft, Hannover.] *Das Kunstwerk* (September 1987): 139-41.

ZELLWEGER, Harry. [Review of Baselitz exhibitions at Kunsthalle and Kunstmuseum, Basel.] *Kunstwerk* (August 1984): 58-60.

ZUTTER, J. "Drei Vertegensoordigers van een nieuwe duitse Schilderkunst." *Museumjournaal* (April 1978): 52-61.

Peter Bömmels

1951 Born in Frauenberg.
1970-76 Studies sociology, political science and pedagogy at the University of Cologne.
1977-80 Works with an experimental child-care group, and coedits *Spex*, a rock music magazine.
1980-82 Member of artist's group Mülheimer Freiheit, along with Dahn, Dokoupil and others. The Mülheimer Freiheit took its name from the street in Cologne where its members' studios were located. The group officially disbanded in 1982.
1986-87 Visiting professor at the Hochschule für Bildende Künste, Hamburg.
current Lives and works in Cologne.

Selected Exhibitions

1982 Cologne, Galerie Paul Maenz. *Peter Bömmels: "The Confession."*
1983 Cologne, Galerie Paul Maenz. *Peter Bömmels: Die Haarbilder.*
Dortmund, Museum am Ostwall. *Peter Bömmels: Bilder, die die Welt bedeuten.*
1984 Antwerp, "121" Art Gallery. *Kölner Schule: P. Bömmels, W. Dahn und J. G. Dokoupil: Zeichnungen.*
Berlin, Galerie Reinhard Onnasch. *Peter Bömmels: Gesundschweissen.*
Hannover, Kunstmuseum Hannover mit Sammlung Sprengel. *Präsent '84: Peter Bömmels "Für Immer."*
New York, Sonnabend Gallery. *Peter Bömmels: New Works.*
Ulm, Ulmer Museum. *Peter Bömmels: Der grosse und der kleine Rhythmus.*
1985 Basel, Galerie Buchmann. *Peter Bömmels: Via Mala Replica.*
Cologne, Galerie Paul Maenz. *Lichtzähne zeigen.*
São Paulo, *XVIII Bienal de São Paulo*, Federal Republic of Germany. *Peter Bömmels.*
1986 Berlin, Galerie Reinhard Onnasch. *Peter Bömmels: Menschen-Versuche.*
Munich, Galerie Artinizing. *Bömmels: Rote Serie (Zeichnungen).*
New York, Sonnabend Gallery. *Peter Bömmels.*
1987 Cologne, Galerie Paul Maenz. *Bömmels: Sieben Steine zur Lage.*
Copenhagen, Galerie Arnesen. *Peter Bömmels: Malerier og Papirarbejder.*
Munich, Galerie Artinizing. *The Salvation Army is still leading Revolution.*

1988 Hamburg, Galerie Harald Behm. *Peter Bömmels: Reliefs und Zeichnungen.*

Selected Bibliography

BEYER, Lucie. [Review of Bömmels exhibition at Galerie Paul Maenz, Cologne.] *Flash Art* (November 1983): 73.

COTTER, H. [Review of Bömmels exhibition at Sonnabend Gallery, New York.] *Flash Art* (April 1986): 83.

FAUST, Wolfgang Max. "Mühlheimer Freiheit: Eine Interviewmontage." *Kunstforum International* (December 1981-January 1982): 117-22.

——. [Review of Bömmels exhibition at Galerie Reinhard Onnasch, Berlin.] *Artforum* (Summer 1986): 136-37.

FROHNE, Ursula. [Review of Bömmels exhibition at Galerie Reinhard Onnasch, Berlin.] *Flash Art* (November 1984): 44.

KUSPIT, Donald B. [Review of Bömmels exhibition at Sonnabend Gallery, New York.] *Artforum* (Summer 1984): 91-92.

MESEURE, A. [Review of Bömmels exhibition at Museum am Ostwall, Dortmund.] *Pantheon* (January-March 1984): 56-57.

NEMECZEK, Alfred. "Malerei '81: die Sache mit den Wilden." *Art: Das Kunstmagazin* (October 1981): 22-43.

OLIVER, C., interviewer. "The Second Bombing: The Mühlheimer Freiheit Group." *Artscribe* (December 1983): 22-26.

POHLEN, Annelie. "Deutsche Kunst Heute: Zwischen Präzision und Parodie." *Kunstforum International* (April-May 1982): 233-36. Review of Bömmels exhibition at Galerie Paul Maenz, Cologne.

——. "5 x Malerei." *Kunstforum International* 69 (1984): 175-76.

SCHÜTZ, Sabine. "Peter Bömmels." *Kunstforum International* (December 1983): 102-11.

1976 Wins the Villa Romana Prize, Florence.
1984 "For me colors have specific symbolism, just like the beeswax I use in my pictures. Gold for example is a symbol of sun, warmth, and light. Wax is reminiscent of bees and flowers. It is the symbol of life. . . . The blue I buy here in town [Cologne] has something to do with light, with firmament. For certain pictures . . . I use a blue from Marrakech. It comes in dark stones, which I crush in a mortar. The Tuaregs use that indigo to stain their belongings and their bodies blue. Anyway, this is a color completely different from all the blues we can buy here in tubes" (quoted in Schmidt-Wulffen, 1984:48).
current Lives and works in Cologne and Marrakesh, Morocco.

Selected Exhibitions

1971 Bern, Galerie Toni Gerber. *Michael Buthe: Hommage an die Sonne.*
1972 Cologne, Galerie Müllenhof. *Michael Buthe.*
1973 Cologne, Galerie Oppenheim. *Michael Buthe: Eine Reise in den Orient.*
Cologne, Kunstverein, and Lucerne, Kunstmuseum. *Michael Buthe: Le Dieu de Babylone.*
Stuttgart, Galerie Müller. *Michael Buthe.*
1975 Cologne, Oppenheim-Studio. *Michael Buthe: Zarathustra.*
1976 Cologne, Künstleratelier. *Michael Buthe: Musée du Echnaton.*
Dusseldorf, Kunstmuseum. *Michael Buthe: Hommage an einen Prinzen aus Samarkant.*
Leverkusen, Städtisches Museum, Schloss Morsbroich. *Michael Buthe: Tarahumaras.*
Paris, Galerie Bama. *Michael Buthe: Le Voyage de Marco Polo.*
1980 Essen, Museum Folkwang. *Michael Buthe: Die endlose Reise der Bilder.* Catalogue includes text by Zdenek Felix.
1981 Paris, Galerie Bama. *Michael Buthe.*
1982 New York, Holly Solomon Gallery. *Michael Buthe.*
Vienna, Galerie nächst St. Stephan. *Michael Buthe.*
1984 Ghent, Museum van Hedendaagse Kunst, and Munich, Museum Villa Stuck. *Michael Buthe: Inch Allah.* Catalogue includes "Michael Buthe – Inch Allah" by Jan Hoet.
1985 Cologne, Galerie Moderne Kunst Dietmar Werle. *Michael Buthe.*
1987 Cologne, Galerie Moderne Kunst Dietmar Werle. *Michael Buthe: Tu prone jö swie un jeune Barbar?*
Cologne, Graphisches Kabinett, Museum Ludwig. *Michael Buthe.* Accompanied by *Die Sonne von Taormina: Übermalte Photographien von Wilhelm von Gloeden* by Michael Buthe and Alfred M. Fischer. Cologne: Verlag der Buchhandlung Walther König und Edition Dietmar Werle.
Stuttgart, Galerie Schurr. *Michael Buthe.*
1988 Humlebaek, Denmark, Louisiana Museum of Modern Art. *Michael Buthe: Kouki & Ramses.*

Selected Bibliography

BUTHE, Michael. *Die wunderbare Reise des Saladin Ben Ismael.* Cologne: Lamuv Verlag, 1977.

CATOIR, B. [Review of Buthe exhibition at Galerie Möllenhof, Cologne.] *Kunstwerk* (January 1973): 65-66.

——. [Review of Buthe exhibition at Museum Villa Stuck, Munich.] *Kunstwerk* (December 1984): 82-87.

FLECK, R. [Review of Buthe exhibition at Galerie nächst St. Stephan, Vienna.] *Flash Art* (February-March 1982): 64.

KRAUTER, Anne. [Review of Buthe exhibition at Galerie Schurr, Stuttgart.] *Artforum* (Summer 1987): 134-35.

KUSPIT, Donald B. [Review of Buthe exhibition at Holly Solomon Gallery, New York.] *Arts* (December 1982): 18.

Michael Buthe

1944 Born in Sonthofen.
1966-69 Studies in Kassel at the Werkkunstschule and the Hochschule für Bildende Künste under A. Bode.

LIEBMANN, Lisa. [Review of Buthe exhibition at Holly Solomon Gallery, New York.] *Art in America* (February 1983): 140.

PIGUET, P. [Review of Buthe exhibition at Galerie Bama, Paris.] *L'Oeil* (December 1986): 88.

POHLEN, Annelie. [Review of Buthe exhibition at Museum Folkwang, Essen.] *Flash Art* 98-99 (1980): 43.

——. "Beauty Action." *Artforum* (December 1985): 60-63.

SCHMIDT-WULFFEN, Stephan. "Michael Buthe." *Flash Art* (Summer 1984): 48-49.

STRASSER, C. [Review of Buthe exhibition at Galerie Bama, Paris.] *Flash Art* (December 1981-January 1982): 63.

WIESE, Stephan von. "Les Mythes individuels de Michael Buthe." *Art Press* (October 1981): 14.

——. *Michael Buthe: Skulptura in Deo Fabulosa.* Munich: Verlag Silke Schreiber, 1983.

WINTER, Peter. [Review of Buthe exhibition at Museum Folkwang, Essen.] *Kunstwerk*, no. 4 (1980): 83-84.

WIRTH, G. [Review of Buthe exhibition at Galerie Müller, Stuttgart.] *Kunstwerk* (January 1974): 88.

Werner Büttner

1954 Born in Jena (GDR).

1960 At six years of age, he emigrates to West Germany. The family stays in a refugee camp outside Munich until they take an apartment in the Neue Heimat.

1974 Meets Albert Oehlen.

1974-81 Studies law at the Freie Universität, Berlin, for nine semesters. After quitting his studies, Büttner works as an aide in the Tegel jail in Berlin, drives an armored truck and is a typesetter for the publisher Axel Springer.

1976 Founds the Liga zur Bekämpfung des widersprüchlichen Verhaltens (League for Struggle against Contradictory Conduct) with Albert Oehlen, in order to organize political action on a personal level.

1977 Moves to Hamburg. Albert Oehlen and he publish the first edition of the journal of the Dum-Dum league. The journal consists of photocopied selections of the artists' poems, drawings and photographs. Two other editions follow.

1978 With Albert Oehlen, paints *One Day We Shall Nail Up the Window, Then the Light Will Come in from the Other Side,* a mural for a bookstore in Hamburg, which gives them public exposure.

1980 Establishes a sperm bank for refugees from the GDR with Albert Oehlen and Herold. See Albert Oehlen biography, p. 275.

1981-82 Founds the Kirche der Ununterschiedlichkeit (Church of Indifference) with Albert and Markus Oehlen. The Kirche der Ununterschiedlichkeit produces a record in the following year. The group, as its name indicates, makes both ironic and serious social commentary and criticism.

1982 "Offener Brief an den deutschen Pöbel" (Open Letter to the German Rabble) in *Sounds* (February 1982), Hamburg. Since 1982 frequently participates in joint projects and exhibitions with Albert Oehlen and Kippenberger. Cuts a record called "Die Rache der Erinnerung" (The Revenge of Memory) with Immendorff, Kippenberger, Markus and Albert Oehlen and Penck. See Albert Oehlen biography.

1983 Writes a book called *Schrecken der Demokratie* (Horrors of Democracy).

1984 Publishes *Wahrheit ist Arbeit* (Truth is Work) with Kippenberger and Albert Oehlen. See Albert Oehlen biography.

current Lives and works in Hamburg.

Selected Exhibitions

1981 Stuttgart, Max-Ulrich Hetzler. *Werner Büttner: Gemälde.*

1983 Cologne, Galerie Max Hetzler. *Werner Büttner: "Die Probleme des Minigolfs in der europäischen Malerei."*

1984 Cologne, Galerie Max Hetzler. *Werner Büttner: La Lutta Continua – Drei Beispiele.*
Essen, Museum Folkwang Essen. *Wahrheit ist Arbeit: Werner Büttner, Martin Kippenberger, Albert Oehlen.* Exhibition organized by Zdenek Felix, with catalogue by the artists.
New York, Metro Pictures. *Werner Büttner, Martin Kippenberger, Albert Oehlen and Markus Oehlen.* The first New York show for these four artists.

1985 Cologne, Galerie Max Hetzler. *Werner Büttner: "Das Auge auf's Kleine und Grosse auf's Auge."*
New York, Metro Pictures. *Werner Büttner.*
Vienna, Galerie Peter Pakesch. *Werner Büttner: "Kosmoprolet."*

1986 Cologne, Galerie Borgmann-Capitain. *Werner Büttner: "Halbe Stunde moderne Kunst und andere versammelte Werke (Alles Papier)."*
Frankfurt, Galerie Grässlin-Ehrhardt. *Werner Büttner: "Wie Aber Enden Solchen Geschichten?"*
Hamburg, Kunstverein, and London, Institute of Contemporary Arts. *Werner Büttner/Georg Herold/Albert Oehlen: "Können wir vielleicht mal unsere Mutter wiederhaben! What About having our mother back!"* Catalogue includes introduction by Tony Godfrey and "German Women and Mothers and the Rule of Insanity" by Bazon Brock. Hamburg: Verlag Michael Kellner.
New York, Metro Pictures. *Werner Büttner: "Half an Hour of Modern Art."*

1987 Cologne, Galerie Max Hetzler. *Viva Büttner.* Accompanied by book *Viva Büttner.*
Essen, Museum Folkwang, and Munich, Kunstverein als Gast im Museum Villa Stuck. *Werner Büttner: Bilder und einige Skulpturen.* Catalogue includes texts by Zdenek Felix, Helmut R. Leppien et al.
Hamburg, Halle K3 auf dem Kampnagelgelände. *Neue Kunst in Hamburg, 1987: Werner Büttner, Markus Oehlen et al.*
Vienna, Galerie Peter Pakesch. *Werner Büttner: Skulpturen und Malerei.*

1988 Hamburg, Galerie Ascan Crone. *Werner Büttner.*

Selected Bibliography

BEYER, Lucie. "Werner Büttner and Albert Oehlen." *Flash Art* (January 1984): 41-42. Review of Büttner exhibition at Galerie Hetzler and Oehlen exhibition at Galerie Zwirner, Cologne.

BÜTTNER, Werner. *Schrecken der Demokratie.* Cologne: Verlag Buchhandlung Walther König, 1983.

——. *In Praise of Tools and Women.* Hamburg: Meterverlag, 1986.

——. *Und das Meer lag da wie Nudeln aus Gold und Silber.* Klagenfurt: Ritter Verlag, 1987.

DREHER, Thomas. [Review of Büttner exhibition at Kunstverein als Gast im Museum Villa Stuck, Munich.] *Kunstwerk* (June 1987): 106-7.

FAUST, Wolfgang Max, and Max Raphael. "Gemeinschaftsbilder: Ein Aspekt der neuen Malerei; Werner Büttner, Albert und Markus Oehlen, Martin Kippenberger: Erschlägt Wirklichkeit Kunst?" *Kunstforum International* (November 1983): 56-69.

GERCKEN, Günther, Raffael Jablonka, Thomas Wulffen et al. *Neue Kunst in Hamburg 1987.* Hamburg, 1987. Catalogue of exhibition at Kampnagelgelände, Hamburg.

HEARTNEY, Eleanor. "Four Germans." *Artnews* (February 1985): 140. Review of Büttner, Kippenberger, Albert and Markus Oehlen exhibition at Metro Pictures, New York.

HONNEF, Klaus. "Werner Büttner." *Kunstforum International* (December 1983): 112-19.

KUSPIT, Donald B. [Review of Büttner, Kippenberger, Albert and Markus Oehlen exhibition at Metro Pictures, New York.] *Artforum* (January 1985): 90.

POHLEN, Annelie. [Review of Büttner exhibition at Galerie Max Hetzler, Cologne.] *Artforum* (January 1984): 85-86.

SCHMIDT-WULFFEN, Stephan, interviewer. "Werner Büttner and Albert Oehlen." *Flash Art* (January 1985): 22-25.

UPSHAW, Reagan. "Werner Büttner." *Art in America* (November 1985): 167-68. Review of Büttner exhibition at Metro Pictures, New York.

Peter Chevalier

1953 Born in Karlsruhe.

1976-80 Studies painting under Hermann Albert and Alfred Winter-Rust at the Hochschule für Bildende Künste, Braunschweig.

1985 Receives the Bernhard Sprengel Prize, Hannover.

1986 "One thing is abundantly clear about Peter Chevalier's pictures; they have their own reality that is far from our everyday world. The observer is presented with the relativity of the relative. A dialectic results, which belongs to the picture and is only logical within it – a dialectic which allows the large to become small or, as in the case of the human figure, the small to appear large. Other diametrical pairs present in the works include near and far, light and dark, and fast and slow. These diametrical pairs produce a momentary but monumental cessation of time for the observer, without placing the pictures outside time itself. The arrangement of objects is basically oriented to the surface of the painting, and it is this surface which must be grappled with. It therefore becomes clear that for the

painter reality is the canvas where his view of the world becomes tangible" (Schulz, in catalogue of Chevalier exhibition in Braunschweig, 1986: n. p.).

current Lives and works in Berlin.

Selected Exhibitions

1981 Berlin, Galerie Poll. *Peter Chevalier: Bilder und Zeichnungen.*
1982 Dusseldorf, Galerie Gmyrek. *Peter Chevalier: Bilder, Gouachen, Zeichnungen.*
1983 Berlin, Raab Galerie. *Peter Chevalier.* Catalogue includes texts by Roland Hagenberg and Jeannot Simmen.
Munich, Galerie Hermeyer. *Peter Chevalier: Bilder und Zeichnungen.*
1984 Dusseldorf, Galerie Gmyrek. *Peter Chevalier: Zeichnung.*
New York, Galleri Bellman. *Peter Chevalier: Paintings.*
New York, Luhring, Augustine and Hodes Gallery. *Peter Chevalier.*
1985 Freiburg, Kunstverein Freiburg. *Peter Chevalier.*
New York, Luhring, Augustine and Hodes Gallery. *Peter Chevalier: New Paintings.*
1986 Berlin, Raab Galerie. *Chevalier: Ideale Landschaft, Stadt am Meer – Bilder 1985/86.*
Braunschweig, Kunstverein Braunschweig. *Peter Chevalier: Bilder und Zeichnungen.* Catalogue includes "Vom Eigenleben der Bilder" by Wilhelm Bojescul, "Die Reiche des Schweigens" by Giovanni Testori and "Die Stille der Dinge" by Bernhard Schulz.
San Francisco, Rena Bransten Gallery. *Peter Chevalier.*
1987 London, Raab Gallery. *Peter Chevalier: Paintings and Drawings.*
Milan, Studio d'Arte Cannaviello. *Peter Chevalier.*
1988 Dusseldorf, Galerie Gmyrek. *Peter Chevalier: Neue Bilder.* Munich, Galerie Hermeyer. *Peter Chevalier: Neue Bilder und Zeichnungen.*

Selected Bibliography

BEAUMONT, Mary Rose. [Review of Chevalier exhibition at Raab Gallery, London.] *Arts Review* (October 23, 1987): 716.
BUSCHE, Ernst. "Peter Chevalier." *Die Zeit* (November 20, 1981).
FRIEDRICHS, Yvonne. [Review of Chevalier exhibition at Galerie Gmyrek, Dusseldorf.] *Kunstwerk* (February 1985): 94.
HEARTNEY, Eleanor. [Review of Chevalier exhibition at Luhring, Augustine and Hodes Gallery, New York.] *Flash Art* (October-November 1985): 50-51.
JENSEN, Birgit. "Lange, Santarossa, Chevalier." *Flash Art* (Summer 1984): 40-43.
KUSPIT, Donald B. [Review of Chevalier exhibition at Luhring, Augustine and Hodes Gallery, New York.] *Art in America* (October 1985): 152.
RUSSELL, John. "Catherine Lee and Peter Chevalier." *The New York Times* (May 11, 1984): C20. Review of Chevalier exhibition at Galleri Bellman, New York.
SCHULZ, Bernhard. "Peter Chevalier." *Kunstwerk* (September 1985): 42-43.
——. "The Return of Things: Notes on the Paintings of Albert, Chevalier and Others" *Flash Art* (May-June 1986): 51-53.
WINTER, Peter. "Peter Chevalier: Bilder, Gouachen, Zeichnungen." *Kunstwerk* (June 1982): 62-63. Review of Chevalier exhibition at Galerie Gmyrek, Dusseldorf.
——. [Review of Chevalier exhibition at Kunstverein, Braunschweig.] *Kunstwerk* (February 1987): 54.

Walter Dahn

1954 Born in Krefeld.
1971-77 Studies at the Kunstakademie, Dusseldorf, under Joseph Beuys.
1979 Becomes interested in pop music. He designs album covers and produces several records.
1980 Member of the Mülheimer Freiheit group, along with Dokoupil, Bömmels and others. The Mülheimer Freiheit took its name from the street in Cologne where its members' studios were located. Although the group disbanded in 1982, Dahn continues to execute numerous paintings with Dokoupil. This cooperative method refutes the notion of the individual artist. According to Dahn and Dokoupil, when they work together on a canvas "a third person" who paints with a "single brush" is created (Wolfgang Max Faust, "Hunger for Images

and Longing for Life: Contemporary German Art," in Faust, Radford and Ruhrberg, 1986: 24).

1983-84 Lectures at the Kunstakademie, Dusseldorf, with Dokoupil.
1984 "I don't want any mystification," says Dahn, "I'm thinking about getting more simplistic. I'm thinking about doing abstract paintings" (Quoted in Levin, 1984: 122).
1984 Makes graffiti-style spray paintings.
current Lives and works in Cologne.

Selected Exhibitions

1982 Cologne, Galerie Paul Maenz. *Walter Dahn: New Paintings.* Catalogue includes text by Ira Bartell.
1983 Cologne, Galerie Paul Maenz. *Dahn/Dokoupil: Die Duschenbilder.* Catalogue includes text by Patrick Frey.
Munich, Galerie Six Friedrich. *Dahn/Dokoupil.*
New York, Mary Boone Gallery. *Dahn/Dokoupil.*
1984 Antwerp, "121" Art Gallery. *Kölner Schule: P. Bömmels, W. Dahn und J. G. Dokoupil: Zeichnungen.*
Groningen, Groninger Museum. *Dahn & Dokoupil, Dusch- & Africabilder.* Catalogue includes "Masken der Verzauberung: Zu den schlammbedeckten Spiegeln von Dahn und Dokoupil" by Wilfried W. Dickhoff.
Munich, Galerie Six Friedrich. *Walter Dahn.*
New York, Marian Goodman Gallery. *Walter Dahn.*
1985 Bonn, Rheinisches Landesmuseum. *Walter Dahn.*
San Francisco, Gallery Paule Anglim. *Dahn/Dokoupil.*
1986 Basel, Kunsthalle Basel; Eindhoven, Stedelijk Van Abbemuseum; and Essen, Museum Folkwang. *Walter Dahn: Gemälde 1981-1985.* Catalogue, Wilfried Dickhoff ed., includes texts by Jean-Christophe Ammann, Rainer Crone, Jutta Koether et al.
Basel, Museum für Gegenwartskunst, and Karlsruhe, Badischer Kunstverein (1987). *Walter Dahn: Zeichnungen 1972-1985; 12 Skulpturen 1984-1985.* Catalogue includes text by Dieter Koepplin and interview with Dahn.
Cologne, Galerie Paul Maenz, and Munich, Galerie Six Friedrich. *Walter Dahn: Bilder.*
Grenoble, Musée de Grenoble. *Walter Dahn: Peintures 1986.* Catalogue includes "Walter Dahn: Une iconographie du présent" by Jean-Paul Monery.
Hamburg, Galerie Vera Munro. *Walter Dahn: Bilder, Zeichnungen & Skulpturen.*
1987 Marseille, Galerie Roger Pailhas. *Walter Dahn.*
1988 Aachen, Neuer Aachener Kunstverein. *Walter Dahn: Bilder und Skulpturen 1987.* Catalogue includes text by Hans Werner Bott.
Bonn, Galerie Philomene Magers. *Walter Dahn und Rosemarie Trockel.*
Cologne, Galerie Paul Maenz, *Walter Dahn.*
Hamburg, PPS Galerie F. C. Grundlach. *Walter Dahn: Photoarbeiten 1973-1988.* Catalogue includes "Drei günstige Rezensionen" by Walter Dahn.
Munich, Galerie Six Friedrich. *Walter Dahn: Zeichnungen 1986/87.* Catalogue includes "Still – Suggestion – Evokation: Zu den Pinselzeichnungen Walter Dahns aus den Jahren 1986 und 1987" by Hinrich Sieveking.
Stockholm, Galleri 16. *Walter Dahn: Paintings.*
Zurich, Galerie Elisabeth Kaufmann. *Walter Dahn.*

Selected Bibliography

ADRICHEM, J. van, interviewer. "Macht is met Bepaalde Kleuren Verbonden." *Museumjournaal* 27 (1982): 1-5.
ANON. "Interview with Paul Maenz." *Flash Art* (April-May 1984): 44-45.
BECKER, Robert. [Interview with Dahn.] *Interview Magazine* (October 1985): 114.
BEYER, Lucie. [Review of Dahn exhibition at Galerie Six Friedrich, Munich.] *Flash Art* (April-May 1984): 42.
——. [Review of Dahn exhibition at Galerie Paul Maenz, Cologne.] *Flash Art* (May-June 1988): 110-11.

DAHN, Walter. *20 Zeichnungen von 1976.* Cologne, 1984.

——. [*Paintings from 1983.*] Cologne, 1984. Includes texts by Wilfried Dickhoff, Jiri Georg Dokoupil and Jutta Koether.

——. *20 Bilder von 1984.* Cologne, 1985. Includes poem by George Condo and Walter Dahn.

——. *Probedrucke zu den Siebdruckbildern 1985.* Munich: Galerie Six Friedrich, 1986. Includes text by Wilfried Dickhoff.

——, and Wilfried Dickhoff. *15 Gemälde 1986.* Essen: Bacht GmbH, 1987. Includes essay by Ralf Schneider.

DICKHOFF, Wilfried, ed. *Walter Dahn: Gemälde 1987.* Kleine Enzyklopädie der Kunst, Editions xyz [1988].

——, ed. *Walter Dahn: Irrationalismus & Moderne Medizin – Arbeiten/Works 1984-88.* Cologne: Verlag der Buchhandlung Walther König, 1988.

DREHER, Thomas. [Review of Dahn exhibition at Galerie Paul Maenz, Cologne.] *Kunstwerk* (May 1987): 73-74.

FAUST, Wolfgang Max. "Mühlheimer Freiheit: Eine Interviewmontage." *Kunstforum International* (December 1981-January 1982): 117-22.

——, and Max Raphael. "Gemeinschaftsbilder: Ein Aspekt der neuen Malerei; Walter Dahn und Georg Jiri Dokoupil: Ein Pinsel und die dritte Person." *Kunstforum International* (November 1983): 30-43.

FRENCH, Christopher. "Hollow Expressionism." *Artweek* (May 4, 1985): 7. Review of Dahn/Dokoupil exhibition at Gallery Paule Anglim, San Francisco.

FREY, Patrick, interviewer. "Pourquoi peindre des tableaux?" *Wolkenkratzer* (July 1985): 48.

HAAS, Bruno. [Review of Trockel/Dahn exhibition at Galerie Philomene Magers, Bonn.] *Noema: Art Magazine* 18-19 (1988): 102.

HONNEF, Klaus. "Walter Dahn." *Kunstforum International* (December 1983): 120-31.

——, ed. "Die Welt als Imagination – Die Imagination als Welt." *Kunstforum International* (June-August 1986): 156.

KOETHER, Jutta. [Review of Dahn exhibition at Galerie Paul Maenz, Cologne.] *Artforum* (May 1988): 159.

KUSPIT, Donald B. [Review of Dahn/Dokoupil exhibition at Mary Boone Gallery, New York.] *Artforum* (November 1983): 82-83.

LEVIN, Kim. [Review of Dahn exhibition at Marian Goodman Gallery, New York.] *The Village Voice* (December 18, 1984): 122.

POHLEN, Annelie. [Review of Dahn exhibition at Rheinisches Landesmuseum, Bonn.] *Artforum* (February 1986): 116.

REIN, Ingrid. [Review of Dahn exhibition at Galerie Six Friedrich, Munich.] *Artforum* (Summer 1987): 34.

SCHMIDT-WULFFEN, Stephan. [Review of Dahn exhibition at Rheinisches Landesmuseum, Bonn.] *Flash Art* (October-November 1985): 58.

——. "Walter Dahn: Ritualisierung des Alltäglichen." *Kunstforum International* (October-November 1985): 180-85.

SMITH, Roberta. "Germanations." *The Village Voice* (June 28, 1983): 97. Review of Dahn/Dokoupil exhibition at Mary Boone Gallery, New York.

Jiri Georg Dokoupil

1954 Born in Krnov, Czechoslovakia (near the border with Poland). "My rejection of any form of programming in my art," said Dokoupil in 1981, "probably has something to do with the fact that I grew up in Czechoslovakia: this made

me mistrustful of any dogma or predetermination" (quoted in Crone, 1983: 54).

1968 Flees Czechoslovakia with family, going first to Vienna and then to West Germany. He attends West German high school without any prior knowledge of German.

1976-78 Training is influenced by Conceptual Art. Dokoupil studies art in Cologne and Frankfurt, as well as in New York at Cooper-Union under Hans Haacke. While in New York, he attends lectures by Joseph Kosuth.

1980 Joins the artists' group Mülheimer Freiheit along with Dahn, Bömmels and others. See Dahn biography, p. 259.

1983-84 Lectures at the Kunstakademie, Dusseldorf, with Dahn.

1984 Dokoupil works in a continuously variable range of styles and subjects. The artist relates, "If I see somebody doing something the right way, then there is only one possibility for me: copy him" (quoted by John Coleman, [Review of Dokoupil exhibition at ICA, London], *Flash Art* [March 1984]: 42). "Dokoupil is always becoming someone else, with the result that the 'aesthetic of diversity' is matched at the level of subjectivity with a conception of the 'multiple self'" (Wolfgang Max Faust, "Hunger for Images and Longing for Life: Contemporary German Art," in Faust, Radford and Ruhrberg, 1986: 24).

current Lives and works in Cologne, New York and Tenerife.

Selected Exhibitions

1982 Amsterdam, Galerie Helen van der Meij. *Jiri Georg Dokoupil.*
Cologne, Galerie Paul Maenz. *Jiri Georg Dokoupil: "Neue Kölner Schule."*
Paris, Galerie Chantal Crousel. *Jiri Georg Dokoupil: "Love Songs."*

1983 Amsterdam, Galerie Helen van der Meij. *Jiri Georg Dokoupil.*
Cologne, Galerie Paul Maenz. *Dahn/Dokoupil: Die Duschenbilder.* Catalogue includes text by Patrick Frey.
Kassel, *Documenta 7.*
Munich, Galerie Six Friedrich. *Jiri Georg Dokoupil: Bilder und Zeichnungen.*
New York, Mary Boone Gallery. *Georg Dokoupil.*

Paris, Galerie Crousel-Hussenot. *Jiri Georg Dokoupil: Œuvres récentes.*

1984 Antwerp, "121" Art Gallery. *Kölner Schule: P. Bömmels, W. Dahn und J. G. Dokoupil – Zeichnungen.*
Cologne, Galerie Paul Maenz. *Jiri Georg Dokoupil.*
Essen, Museum Folkwang; Groningen, Groninger Museum; Lucerne, Kunstmuseum; and Lyon, Espace Lyonnais d'Art Contemporain. *Dokoupil: Arbeiten, 1981-1984.* Catalogue includes short texts by Jean-Christophe Ammann, Heiner Bastian, Walter Dahn et al.
Groningen, Groninger Museum. *Dahn & Dokoupil, Dusch- & Africabilder.* Catalogue includes "Masken der Verzauberung: Zu den schlammbedeckten Spiegeln von Dahn und Dokoupil" by Wilfried W. Dickhoff.
Stuttgart, Galerie Schurr. *Jiri Georg Dokoupil.*

1985 Lucerne, Kunstmuseum. *Jiri Georg Dokoupil: Arbeiten 1981-1984.*
New York, Leo Castelli/Sonnabend. *Jiri Georg Dokoupil.*
Paris, Galerie Crousel-Hussenot. *Jiri Georg Dokoupil.*
San Francisco, Gallery Paule Anglim. *Dahn/Dokoupil.*
São Paulo, *XVIII Bienal de São Paulo,* Federal Republic of Germany. *Jiri Georg Dokoupil.*

1986 Antwerp, "121" Art Gallery. *Jiri Georg Dokoupil: New Paintings.*
Bari, Galleria Marilena Bonomo. *Jiri Georg Dokoupil.*
New York, Leo Castelli Gallery. *Jiri Georg Dokoupil.*
New York, Sonnabend Gallery. *Jiri Georg Dokoupil.*

1987 Cologne, Galerie Paul Maenz. *Jiri Georg Dokoupil.*
Milan, Studio Marconi. *Jiri Georg Dokoupil: 1980-7.*
Zurich, Galerie Bruno Bischofberger. *Jiri Georg Dokoupil: Neue Bilder.*

1988 Cologne, Galerie Paul Maenz, and New York, Sonnabend Gallery. *Jiri Georg Dokoupil.*

Selected Bibliography

ADRICHEM, J. van, interviewer. "Macht is met Bepaalde Kleuren Verbonden." *Museumjournaal* 27 (1982): 1-5.

——. "Interview with Paul Maenz." *Flash Art* (April-May 1984): 44-45.

BEYER, Lucie. [Review of Dokoupil exhibition at Galerie Schurr, Stuttgart.] *Flash Art* (Summer 1984): 74.

BORDAZ, Jean-Pierre. [Review of Dokoupil exhibition at Galerie Chantal Crousel, Paris.] *Flash Art* (March 1983): 70.

COLLINS, James. [Review of Dokoupil exhibition at Folkwang Museum, Essen.] *Flash Art* (March 1985): 65-66.

CRONE, Rainer. "Jiri Georg Dokoupil: The Imprisoned Brain." *Artforum* (March 1983): 50-55.

ELLIS, Steven. [Review of Dokoupil exhibition at Leo Castelli Gallery, New York.] *Art in America* (January 1986): 35-36.

FAUST, Wolfgang Max. "Mühlheimer Freiheit: Eine Interviewmontage." *Kunstforum International* (December 1981-January 1982): 117-22.

——, and Max Raphael. "Gemeinschaftsbilder: Ein Aspekt der neuen Malerei; Walter Dahn und Georg Jiri Dokoupil: Ein Pinsel und die dritte Person." *Kunstforum International* (November 1983): 30-43.

FRENCH, Christopher. "Hollow Expressionism." *Artweek* (May 4, 1985): 7. Review of Dahn/Dokoupil exhibition at Gallery Paule Anglim, San Francisco.

GRIMES, Nancy. [Review of Dokoupil exhibition at Leo Castelli Gallery, New York.] *Artnews* (December 1985): 120-21.

GROOT, Paul. [Review of Dokoupil exhibition at Galerie Helen van der Meij, Amsterdam.] *Flash Art* (May 1983): 70.

HANDY, E. [Review of Dokoupil exhibition at Leo Castelli Gallery, New York.] *Arts Magazine* (December 1985): 117.

HAPGOOD, S. [Review of Dokoupil exhibition at Leo Castelli Gallery, New York.] *Flash Art* (December 1985-January 1986): 42-43.

HECHT, A., and Alfred Nemeczek. "Meine nächsten Bilder sind immer die Besten." *Art: Das Kunstmagazin* (August 1984): 86-93.

IANACCI, Anthony. [Review of Dokoupil exhibition at Studio Marconi, Milan.] *Artscribe International* (January-February 1988): 75.

"Jiri Georg Dokoupil: Two Letters from the Artist's Mother." *Flash Art* (January 1985): 18-21.

JONES, M. "Jiri Georg Dokoupil." *Arts Magazine* (January 1986): 107. Review of Dokoupil exhibition at Leo Castelli Gallery, New York.

KUSPIT, Donald B. [Review of Dahn/Dokoupil exhibition at Mary Boone Gallery, New York.] *Artforum* (November 1983): 82-83.

———. [Review of Dokoupil exhibition at Sonnabend Gallery, New York.] *Artforum* (March 1987): 121-22.

MAENZ, Paul. "Conversation between Dokoupil and Maenz." *Flash Art* (April 1986): 45-47.

MARCADE, Bernard. "This Never-Ending End." *Flash Art* (October-November 1985): 38.

NEMECZEK, Alfred. "Malerei '81: Die Sache mit den Wilden." *Art: Das Kunstmagazin* (October 1981): 22-43.

OTTMANN, Klaus. "The World According to ... Byars, Beuys, Dokoupil." *Flash Art* (December 1985-January 1986): 56.

POHLEN, Annelie. "Georg Jiri [sic] Dokoupil." *Artforum* (October 1982): 83. Review of Dokoupil exhibition at *Documenta 7*, Kassel.

REIN, Ingrid. [Review of Dokoupil exhibition at Galerie Schurr, Stuttgart.] *Artforum* (November 1984): 111.

SALVIONI, Daniela. [Review of Dokoupil exhibitions at Sonnabend Gallery, New York, and Galerie Paul Maenz, Cologne.] *Flash Art* (April 1987): 90-91.

SCHMIDT-WULFFLEN, Stephan. [Review of Dokoupil exhibitions at Museum Folkwang, Essen, and Galerie Paul Maenz, Cologne.] *Flash Art* (January 1985): 49.

SCHÜTZ, Sabine. "Georg Jiri [sic] Dokoupil." *Kunstforum International* (December 1983): 132-43.

SMITH, Roberta. "Germanations." *The Village Voice* (June 28, 1983): 97. Review of Dahn/Dokoupil exhibition at Mary Boone Gallery, New York.

———. [Review of Dokoupil exhibition at Sonnabend Gallery, New York.] *The New York Times* (November 28, 1986): C28.

STACHELHAUS, Heiner. [Review of Dokoupil exhibition at Museum Folkwang, Essen.] *Kunstwerk* (December 1984): 60.

VERZOTTI, G. "Portrait of the Artist as an Infant." *Flash Art* (May-June 1986): 44-45.

WESTFALL, S. "Surrealist Modes Among Contemporary New York Painters." *Art Journal* (Winter 1985): 315-18.

Rainer Fetting

1949 Born in Wilhelmshaven. The son of an art teacher, Fetting begins to paint when he is a child.

1969-72 Completes carpentry apprenticeship. Fetting works as a volunteer stage designer at the Landesbühne Niedersachsen Nord, Wilhelmshaven.

1972 Moves from Wilhelmshaven to Berlin to attend art school and to avoid the compulsory military draft; young men from Berlin are exempted from national service.

1972-78 Studies at the Hochschule der Künste, Berlin, under Hans Jaenisch.

1975-present Makes and produces film and video.

1977 Cofounds Galerie am Moritzplatz, Berlin, with Salomé, Middendorf and Zimmer. The gallery, now defunct, originally consists of about ten members and is created out of the need for exhibition space for artists and students. Koberling, Hödicke, Polke and Lüpertz are among the various other artists to show their work there. The gallery is located in the factory building where Fetting and Salomé live.

1977-78 Paints a series of eight works related to the theme of van Gogh and the Berlin Wall (*Van Gogh und die Mauer*) which combines his interest in landscape and his fascination with the artist. In her biographical essay, Anne Seymour writes of Fetting's admiration for van Gogh: "Van Gogh is the classic, tragic artist-figure, wanting to belong to society, wanting to change it, but always outside it, the misfit condemned to watch and feel more intensely than those taking part and condemned symbolically to speak without his audience hearing" (catalogue of Fetting exhibition in London and New York, 1982: 6-7).

1978-79 Scholarship from the Deutscher Akademischer Austauschdienst (DAAD) for study in New York.

1979 Designs stage sets and murals with Zimmer and Middendorf.

1980 Participates with Zimmer, Middendorf and Salomé in the exhibition *Heftige Malerei* at Haus am Waldsee, Berlin. Thereafter these artists were called "Heftige Maler" (Violent Painters) or "Die neuen Wilden" (The New Wild Ones or Neo-Fauves).

1982 "Fetting can often be the chief protagonist in his own work in ways involving various layers of fact and fiction. He appears directly reflected in the self-portraits, in a hat, with a cigarette; in subject pictures disguised with a bow and arrow.... In whatever guise he is forever posing, dressing up, playing games" (Seymour, in catalogue of Fetting exhibition in London and New York, 1982: 14).

current Lives in New York and Berlin.

Selected Exhibitions

1977 Berlin, Galerie am Moritzplatz. *Rainer Fetting: Stadtbilder*.

1978 Berlin, Galerie am Moritzplatz. *Rainer Fetting: Figur und Portrait*. Catalogue includes text by Ernst Busche.

1979 Berlin, Musikhalle SO 36. *Kulissenbild New York*. With Bernd Zimmer.
Berlin, Musikhalle SO 36. *Kulissenbild Berlin*. With Helmut Middendorf.

1981 Berlin, Galerie Lietzow. *Rainer Fetting*.
London, Anthony d'Offay Gallery. *Rainer Fetting*.
New York, Mary Boone Gallery. *Rainer Fetting/ Helmut Middendorf*.
New York, Mary Boone Gallery. *Rainer Fetting*.
Zurich, Galerie Bruno Bischofberger. *Rainer Fetting*.

1982 Berlin, Galerie Silvia Menzel. *Rainer Fetting: Zeichnungen*.
Cologne, Galerie Paul Maenz. *Rainer Fetting*.
London, Anthony d'Offay Gallery, and New York, Mary Boone Gallery. *Rainer Fetting: Paintings 1979-81*. Catalogue includes "Rainer Fetting" by Anne Seymour.
New York, Mary Boone Gallery. *Rainer Fetting*.

1983 Amsterdam, Galerie Helen van der Meij. *Rainer Fetting*.
Berlin, Galerie Silvia Menzel and Raab Galerie. *Rainer Fetting*. Catalogue includes "Keys of Life and Lightning Strikes" by Wolfgang Max Faust.
Bordeaux, Centre d'arts plastiques contemporains de Bordeaux. *Salomé, Luciano Castelli, Rainer Fetting: Peintures 1979-1982*. Catalogue includes essay by Catherine Strassler.
Milan, Studio d'Arte Cannaviello. *Rainer Fetting*.
Stockholm, Galeri 5. *Rainer Fetting*.

1984 Berlin, Raab Galerie. *Rainer Fetting: Paintings 1983/84*.
Brussels, Mineta Move Art Gallery. *Rainer Fetting*.
Milan, Studio d'Arte Cannaviello. *Rainer Fetting*.
New York, Marlborough Gallery. *Rainer Fetting: Holzbilder*. Catalogue includes "Painting in a New Key: Rainer Fetting" by Richard Sarnoff.
Paris, Galerie Daniel Templon. *Rainer Fetting*.

1985 Berlin, Raab Galerie. *Rainer Fetting: Frühe Bilder, 1973-1984*. Catalogue includes conversation between Fetting and Klaus Ottmann.
Geneva, Galerie Pierre Hubert. *Rainer Fetting*.
Milan, Studio d'Arte Cannaviello. *Rainer Fetting*.
Munich, Galerie Thomas. *Rainer Fetting*.
Paris, Galerie Daniel Templon. *Rainer Fetting*.

1986 Basel, Kunsthalle Basel, and Essen, Museum Folkwang. *Rainer Fetting*. Catalogue includes essays by Zdenek Felix, Jean-Christophe Ammann, Demosthenes Davvetas, Sibylle Kretschmer and Rainer Fetting.
Berlin, Raab Galerie, and London, Raab Gallery. *Rainer Fetting*.
New York, Marlborough Gallery. *Rainer Fetting*.
San Francisco, Gallery Paule Anglim. *Rainer Fetting: Paintings*.

1987 Cannes, Galerie Becker. *Rainer Fetting*.
London, Raab Gallery. *Rainer Fetting*.
Oslo, Galleri Dobloug. *Rainer Fetting*.
Paris, Galerie Daniel Templon. *Rainer Fetting*.
Vienna, Galerie Würthle. *Rainer Fetting: Bilder und Plastiken*. Fetting's first exhibition in Austria.
Wilhelmshaven, Kunstverein. *Rainer Fetting*.

1988 Helsinki, Galerie Kaj Forshblom. *Rainer Fetting*.
Milan, Studio d'Arte Cannaviello. *Rainer Fetting*.
Munich, Galerie Pfefferle. *Rainer Fetting*.

Selected Bibliography

ANON. "Label Berlin." *Connaissance des Arts* (January 1985): 86. Review of Fetting exhibition at Galerie Daniel Templon, Paris.

———. [Review of Fetting exhibition at Galerie Pierre Hubert, Geneva.] *L'Oeil* (October 1985): 75.

BASTIAN, Heiner. "Bilder von Rainer Fetting: Bilder in Berlin." *Du* (January 1982): 16-21.

BEAUMONT, Mary Rose. "Rainer Fetting." *Arts Review* (September 24, 1982): 485. Review of Fetting exhibition at Anthony d'Offay Gallery, London.

CASADEMONT, Joan. [Review of Fetting/Middendorf exhibition at Mary Boone Gallery, New York.] *Artforum* (September 1981): 74-75.

FAUST, Wolfgang Max, and Max Raphael. "Gemeinschaftsbilder: Ein Aspekt der neuen Malerei; Salomé, Luciano Castelli und Rainer Fetting: Bild Erotismen." *Kunstforum International* (November 1983): 70-85.

1984 Berlin, Galerie Silvia Menzel. *Thomas Hartmann: Langsame Flüchtlinge.* Accompanied by catalogue.
Vechta, Kunstverein Kaponier. *Thomas Hartmann.*
1985 Berlin, Galerie Silvia Menzel. *Thomas Hartmann.*
Bremen, Gesellschaft für Aktuelle Kunst. *Thomas Hartmann.* Accompanied by catalogue.
1986 Hamburg, Galerie Hans Barlach. *Thomas Hartmann: Bilder 1984 bis 1986.*
1987 Berlin, Galerie Georg Nothelfer. *Thomas Hartmann: Über die Städte.*
Bremen, Galerie Rolf Ohse. *Thomas Hartmann: Zwei Jahre Berlin – Neue Arbeiten auf Leinwand und Papier.*
Cologne, *Galerie Hans Barlach. Thomas Hartmann.*
1988 Bremen, Galerie Rolf Ohse. *Thomas Hartmann.*
Emden, Kunsthalle. *Thomas Hartmann.* Catalogue includes "'Ich male nicht für mich …': Thomas Hartmann auf der Suche nach der verlorenen Form" by Gerhard Finckh.
Kiel, Stadtgalerie im Sophienhof. *Thomas Hartmann.*

Georg Herold

1947 Born in Jena (GDR).
1969-73 Studies art in Halle, GDR.
1973 Attempts to flee GDR, but is caught and imprisoned. However, eight months later he is released to the West.
1974-76 Studies at the Akademie der Bildenden Künste, Munich.
1977-83 Studies at the Hochschule für Bildende Künste, Hamburg, under Polke.
1980 Establishes a sperm bank for refugees from the GDR with Albert Oehlen and Büttner. See Albert Oehlen biography, p. 275.
1988 Works with a variety of materials: cardboard, brick, paper, canvas, thread, cactus,

adhesive tape, photographs and pumice. Herold also moves freely between sculpture, object-works and painting. Indeed, the strictly separate categories of art production become confused in his work. The artist explains: "My work is all one production, the materials and methods change as my needs and moods change. When I choose to paint, I want to clear out my head and relax, it is like a meditation. When I decide to make object-works, I am looking for something more immediate and quicker. Materials, too, are used for specific reasons; for example, I use roof laths and pumice because neither is conventional and neither has art-historical precedents. I am always looking for materials that allow me to produce an image that is 'wrong,' that is not obvious; an image that will make the viewer see something differently" (Telephone conversation with the author, August 4, 1988).
current Lives and works in Cologne.

Selected Exhibitions

1982 Cologne, Galerie Gugu Ernesto. *Goethe–Latte.*
Dusseldorf, Galerie Arno Kohnen. *Der Bügelmeister.*
1983 Bonn, Galerie Klein. *Ein Kreuzweg.*
1984 Cologne, Galerie Max Hetzler. *P. F. U. 1 Difesa della Cultura.*
1985 Berlin, Neue Gesellschaft für Bildende Kunst. *Unschärferelation.* Catalogue includes "Unschärferelation: Georg Herold im RealismusStudio" by Barbara Straka, "Das Subversive kennt keine Richtung" by Reiner Speck and text by S. D. Sauerbier.
Cologne, Galerie Max Hetzler. *Georg Herold.*
1986 Hamburg, Kunstverein, and London, Institute of Contemporary Arts. *Werner Büttner/Georg Herold/Albert Oehlen: "Können wir vielleicht mal unsere Mutter wiederhaben! What About Having our mother back!"* Catalogue includes introduction by Tony Godfrey and "German Women and Mothers and the Rule of Insanity" by Bazon Brock, Hamburg: Verlag Michael Kellner.

Selected Bibliography

DICKHOFF, Wilfried. "Members Only." *Artforum* (January 1988): 107-8.

K. H. Hödicke

1938 Born in Nuremberg.
1945 Family flees to Vienna; his mother dies.
1957 Family moves to Berlin.
1959-64 Begins architectural studies at the Technische Universität, Berlin. After one semester changes to the Hochschule für Bildende Künste, Berlin, where he studies under Fred Thieler.
1961 Member of the group VISION, along with Koberling.
1964 Founding member of the Galerie Grossgörschen 35 in Berlin, with Lüpertz, Koberling and others. The gallery, located in an old factory, is an artists' cooperative, established to show work by young talent. Its first exhibition is a one-man show of Hödicke's work.
1966-67 Lives in New York, and produces experimental short films. After his stay in New York, Hödicke continues to make films. Indeed, he does not confine himself to any one medium, but exercises media freedom by creating installations, conceptual object-works, film and video, in addition to painting pictures.

1968 Wins the Villa Massimo Prize, Rome.
1969 In the 1960s, Hödicke has learned "to allow color to come. The spiritual impulse comes from my arm, from my body to the canvas and to the paper. A color is affixed and then pushed apart until the figure emerges. The figure cannot be inserted; it must originate from the color" (quoted in Winter, 1984: 51).
1974 Professor at the Hochschule für Bildende Künste, Berlin. Hödicke teaches his students to mix their own paints by adding inexpensive colored pigments to an acrylic or oil base. This mixed paint, called *Kunstharz* (synthetic resin), is not only less expensive than commercial pigments but it also enables the artist to achieve brillant colors impossible with traditional paint. Hödicke also encourages his students to use ordinary house paint because it allows very rapid and immediate application. Hödicke's gestural painting style, his thin paint application and his varied approach to art media are a profound influence on the following generation of German painters.
1980 Member of the Akademie der Künste, Berlin.
1983 Wins the German Critics' Association Prize.
current Lives and works in Berlin.

Selected Exhibitions

1964 Berlin, Galerie Grossgörschen. *K. H. Hödicke.*
1965 Dusseldorf, Galerie Niepel. *K. H. Hödicke.*
1967 Berlin, Galerie René Block. *Ein Environment: "Passage mit Fenstern" von K. H. Hödicke.*
Dusseldorf, Galerie Niepel. *K. H. Hödicke.*
1975 Edinburgh, Fruit Market Gallery, Scottish Arts Council. *Eight from Berlin.*
1976 New York, René Block Gallery. *K. H. Hödicke.*
1977 Karlsruhe, Badischer Kunstverein. *K. H. Hödicke.* Catalogue includes "K. H. Hödicke, eine Reise nach Berlin" by Michael Schwarz.
New York, René Block Gallery. *K. H. Hödicke.* An installation piece with six large buckets of liquid tar which were affixed perpendicularly to a wall in the gallery. Hödicke first executed this work in a Berlin art gallery in 1969.
1980 Berlin, DAAD-Galerie. *K. H. Hödicke: Kalenderblätter.*

Berlin, Galerie Springer. *Tjuonajokk-Symphonie.*
1981 Berlin, Haus am Waldsee. *K.H. Hödicke: Bilder 1962-1980.* Catalogue includes texts by Eberhard Roters and Jeannot Simmen.
New York, Annina Nosei Gallery. *K.H. Hödicke.*
1982 Venice, California, L.A. Louver Gallery. *K.H. Hödicke: Selected Paintings 1979-1982.*
1983 Berlin, Galerie Folker Skulima. *K.H. Hödicke.*
Dusseldorf, Galerie Gmyrek. *K.H. Hödicke: Standbilder 1980-1982.* Catalogue includes text by Ulrich Krempel.
New York, Annina Nosei Gallery. *K.H. Hödicke.*
1984 Berlin, Galerie Folker Skulima. *K.H. Hödicke.*
Hamburg, Kunstverein. *K.H. Hödicke: Berlin & Mehr.* Catalogue includes "Zu K.H. Hödicke" by Uwe M. Schneede.
Madrid, Galeria Fernando Vijande. *K.H. Hödicke: Pinturas 1975-1984.*
1985 Milan, Studio d'Arte Cannaviello. *K.H. Hödicke.*
1986 Dusseldorf, Galerie Gmyrek. *K.H. Hödicke: Ausgewählte Arbeiten.*
Dusseldorf, Kunstsammlung Nordrhein-Westfalen; Mannheim, Städtische Kunsthalle; and Wolfsburg, Städtische Galerie (1987). *K.H. Hödicke: Gemälde, Skulpturen, Objekte und Filme.* Catalogue includes texts by Erika Billeter, Al Hansen, K.H. Hödicke, Jörn Merkert, Giovanni Testori and Helmut Wietz.
1986 Zurich, Galerie Emmerich-Baumann. *K.H. Hödicke: Malerei.*
1987 Dusseldorf, Galerie Gmyrek. *K.H. Hödicke: Achtzehn Bronzen.* Catalogue includes "Die Geburt der Gestalt aus dem Geist des Kartons" by Ulrich Luckhardt.
New York, Marisa Del Re Gallery; Venice, California, L.A. Louver Gallery; and Berlin, Galerie Folker Skulima (1988). *K.H. Hödicke: Paintings.* Catalogue includes "Karl Horst Hödicke" by Donald B. Kuspit.
1988 Berlin, Berlinische Galerie. *K.H. Hödicke.* Catalogue includes "Was soll denn das beinhalten· Zu den Arbeiten von K.H. Hödicke in der Berlinischen Galerie" by Jörn Merkert.
1989 Dusseldorf, Galerie Gmyrek. *K.H. Hödicke: Neue Arbeiten.*

Selected Bibliography

Busche, Ernst. "Karl Horst Hödicke: 'Kalenderblätter.'" *Kunstwerk* (February 1980): 54. Review of Hödicke exhibitions at DAAD-Galerie and Galerie Springer, Berlin.

Casademont, Joan. [Review of Hödicke exhibition at Annina Nosei Gallery, New York.] *Artforum* (December 1981): 73.

Grasskamp, Walter. "*K.H. Hödicke.*" *Artefactum* 17 (1987): 33-37.

Hödicke, K.H. *Purzelbaum: Bilder und Gedichte.* Freiburg: Kunstverein Freiburg, 1984.

Hutton, Jon. [Review of Hödicke exhibition at Annina Nosei Gallery, New York.] *Arts Magazine* (January 1982): 16.

Klotz, Heinrich. "Die wilden Abenteuer der Farbe am Punkt Null." *Art: Das Kunstmagazin* (July 1984): 76-87.

Kuspit, Donald B. [Review of Hödicke exhibition at Annina Nosei Gallery, New York.] *Art in America* (November 1981): 171.

MacMillan, Duncan. [Review of *Eight from Berlin* exhibition at Fruit Market Gallery, Edinburgh.] *Studio International* (November-December 1975): 249-50.

Merkert, Jörn. "La foire à la réalité: sur l'art de K.H. Hödicke." *Artstudio* (Autumn 1986): 72-79.

Ohff, Heinz. "K.H. Hödicke: Paintings 1962-1980" *Kunstforum International* 34, no. 2 (1981): 121-22. Review of Hödicke exhibition at Haus am Waldsee, Berlin.

——. "Hödicke und seine Schüler." *Weltkunst* (November 1981): 3476-79.

Russell, John. [Review of Hödicke exhibition at Haus am Waldsee, Berlin.] *Kunstwerk* (February 1981): 72.

——. [Review of Hödicke exhibition at Annina Nosei Gallery, New York.] *The New York Times* (May 20, 1983): C15.

——. [Review of Hödicke exhibitions at Galerie Silvia Menzel and Galerie Folker Skulima, Berlin.] *Kunstwerk* (February 1985): 59.

Schulz, Bernhard. "La Métropole retrouvée" *Flash Art* (January 1985): 53-54. Review of Hödicke exhibition at Palais des Beaux-Arts, Brussels.

Schwarze, Dirk. *Kunstforum International* 87 (1987): 331-33

Tatransky, Valentin. [Review of Hödicke exhibition at René Block Gallery, New York.] *Arts Magazine* (September 1977): 20.

Vielhaber, Christiane. "Karl Horst Hödicke" *Kunstwerk* (December 1986): 88-89. Review of Hödicke exhibition at Kunstsammlung Nordrhein-Westfalen, Dusseldorf.

Winter, Peter. "Bildräume mit Fragezeichen." *Kunstwerk* (July 1975): 32-34, 37.

——. [Review of Hödicke exhibition at Kunstverein, Hamburg.] *Kunstwerk* (December 1984): 51-52.

Woodville, Louisa. [Review of summer group show at Annina Nosei Gallery, New York, in which Hödicke was included.] *Arts Magazine* (September 1983): 18.

Jörg Immendorff

1945 Born in Bleckede.

1963-64 Studies stage design for three semesters under Teo Otto at the Kunstakademie, Dusseldorf. In class, he paints on car doors, windows and glass. This nontraditional approach to painting leads to a break with his tutor.

1964 Enters classes of Joseph Beuys at the Kunstakademie, Dusseldorf.

1965-66 Participates in various art activities and demonstrations at the Kunstakademie, Dusseldorf.

1968 Becomes a Maoist in the highly charged political atmosphere of protest against the Vietnam War.

1968-70 Involved in so-called "LIDL" activities in Dusseldorf and other German cities.

LIDL was an action space, meeting place and anti-academy. LIDL is a nonsense word supposedly derived from sound of a baby's rattle. (Cowart, 1983: 85.)

1968-80 Teaches art at a secondary school in Dusseldorf.

1977 First meeting with Penck in Berlin (GDR). With Penck writes a manifesto on their collaborative art activity. They form an action coalition which results in various joint art activities and exhibitions.

1978 Begins work on *Café Deutschland* theme in response to discussions with Penck and to seeing Renato Guttuso's *Café Greco* (a portrayal of the well-known Roman café and artists' gathering place), exhibited at the Venice Biennale in 1976. "In Immendorff's cycle the elegance and 'Gemütlichkeit' or cosiness of the Italian original is replaced by a gloomy political scenario characterized by the paradox of disintegration and hope. Amidst this he arranges the props of present-day Germany — the Berlin Wall, the eagle of the German national emblem, the love of pleasure, the flags of East and West Germany, personalities from Helmut Schmidt to Brecht, but also personal images (self-portraits, the painting of his fellow-artist Penck)" (Wolfgang Max Faust, "Hunger for Images and Longing for Life: Contemporary German Art," in Faust, Radford and Ruhrberg, 1986: 21).

1979 Since the end of the 1970s, active in the Green movement in Dusseldorf (Initiative Bunte Liste Düsseldorf [IBL]).
Visits Penck in his Dresden studio.

1981 Paints *Naht,* which is the German word for "seam" or "stitches." The most notable German seam, the Berlin Wall, figures prominently in Immendorff's work.
Guest professor at the Konsthoegskolan, Stockholm.

1982 Makes a record called "Die Rache der Erinnerung" (The Revenge of Memory) with Büttner, Kippenberger, Markus and Albert Oehlen and Penck. See Albert Oehlen biography, p. 275.

1982-85 Holds lectureships at the art academies of Hamburg, Zurich, Cologne and Trondheim.

1984 Opening of his café, La Paloma, in the St. Pauli district of Hamburg.

1986 Designs sets and costumes for Richard Strauss's *Elektra* at the Stadttheater, Bremen.

1987 Collaborates with André Heller on the fantasy-fair "Luna, Luna." Receives second prize for his fresco design for the foyer of St. Paul's Church in Frankfurt.

current Lives and works in Dusseldorf and Hamburg.

Selected Exhibitions

1978 Cologne, Galerie Michael Werner. *Jörg Immendorff: Bilder und Aquarelle von 1977-1978; Die Freude am Malen mit dem Wunsch die Mauer zu überwinden-verbinden!*
Dusseldorf, Galerie Maier-Hahn. *Jörg Immendorff: Neue Bilder und Plastiken.*
1979 Amsterdam, Galerie Helen van der Meij. *Jörg Immendorff: Schilderijen/Tekeningen.*
Basel, Kunstmuseum. *Jörg Immendorff "Café Deutschland."* Catalogue includes "Jörg Immendorffs 'Café Deutschland'" by Dieter Koepplin.
Cologne, Galerie Michael Werner. *Jörg Immendorff.*
Dusseldorf-Oberkassel, Galerie Maier-Hahn. *Jörg Immendorff: Neue Bilder und Plastiken.*
1980 Bern, Kunsthalle. *Jörg Immendorff: Malermut*

rundum. Catalogue includes "Weitere Gedanken zu den neuen Bildern von Jörg Immendorff" by Johannes Gachnang and "Hier siehst du Malermut rundum: Eine Bildbetrachtung" by Max Wechsler.

Eindhoven, Stedelijk Van Abbemuseum. *Jörg Immendorff: Pinselwiderstand (4x)*.

Eindhoven, Stedelijk Van Abbemuseum. *Jörg Immendorff: LIDL 1966-1970*. Catalogue documents Immendorff's LIDL period with photographs, drawings, texts and manifestos.

1982 Cologne, Galerie Michael Werner. *Jörg Immendorff: Neue Werke*.

Düsseldorf, Städtische Kunsthalle. *Jörg Immendorff: Café Deutschland Adlerhälfte*. Catalogue includes text by Jürgen Harten and "Wunschtrauer" by Ulrich Krempel.

Dusseldorf-Oberkassel, Galerie Strelow. *Jörg Immendorff*.

Eindhoven, Stedelijk Van Abbemuseum. *Jörg Immendorff, Eisende: Eine Serie von Bildern aus 1981*.

Munich, Galerie Fred Jahn. *Jörg Immendorf: Grüsse von der Nordfront; Bilder und Gouachen 1981*.

New York, Sonnabend Gallery. *Jörg Immendorff: Paintings*.

Paris, Galerie Daniel Templon. *Jörg Immendorff*.

1983 Berlin, Galerie Springer. *Jörg Immendorff, "Café Deutschland": Linolschnitte 1983*. Catalogue includes essays by Diedrich Diederichsen and Ulrich Krempel.

London, Nigel Greenwood, Inc. *Café Deutschland: Linocuts by Jörg Immendorf*.

Milan, Studio d'Arte Cannaviello. *Jörg Immendorff*.

New York, Sonnabend Gallery. *Jörg Immendorff: Paintings and Prints*.

Oxford, Museum of Modern Art. *Jörg Immendorff: Café Deutschland and Related Works*. Catalogue includes "The Last Café" by David Elliott and "The Long March or Incitements of the Times: A Compilation" by Harald Szeeman.

Paris, Galerie Gillespie-Laage-Salomon. *Jörg Immendorff: Café Deutschland; Linogravures*.

Zurich, Kunsthaus. *Jörg Immendorff: Retrospektive*. Catalogue includes essays by D. Diedrichsen, Johannes Gachnang, Siegfried Gohr, Jörg Huber, Tom Stooss and Harald Szeemann.

1984 Chicago, Roger Ramsay Gallery, Inc. *Café Deutschland: Overpainted Linocuts by Jörg Immendorf*.

Cologne, Galerie Michael Werner. *Beben/Heben*.

Hamburg, Galerie Ascan Crone. *Immendorff: Neue Bilder und Skulpturen*. Catalogue includes texts by Erich Fried and Peter Schneider.

Munich, Galerie Sabine Knust, Stuck-Villa. *Linolschnittserie "Café Deutschland gut."*

New York, Mary Boone & Michael Werner Gallery. *Jörg Immendorff*.

Paris, Galerie Gillespie-Laage-Salomon. *Jörg Immendorff: Café Deutschland; Linogravures*.

1985 Braunschweig, Kunstverein. *Jörg Immendorff*.

1986 Cologne, Galerie Michael Werner. *Jörg Immendorff: Zwölf Bilder, 1978*.

London, Nigel Greenwood Gallery. *Jörg Immendorff*.

New York, Mary Boone & Michael Werner Gallery. *Jörg Immendorff*.

1987 Cologne, Galerie Michael Werner. *Jörg Immendorff*.

Selected Bibliography

AMMANN, Jean-Christophe. "Schweizer Brief." *Art International* (October 1969): 68. Review of *Düsseldorfer Szene* exhibition at Kunstmuseum, Lucerne, in which Immendorff, Polke and Richter were included.

ANON. "Penck e Immendorff." *Domus* (April 1982): 70-71.

BEYER, Lucie [Review of Immendorff exhibition at Galerie Michael Werner, Cologne.] *Flash Art* (Summer 1984): 73.

BRENSON, Michael. "Jörg Immendorf." *The New York Times* (February 11, 1984): 18. Review of Immendorff exhibition at Mary Boone Gallery, New York.

CABUTTI, L. "Lo spettacolo continua." *Arte* (March 1983): 70-81.

FLAMMERSFELD, Marie-Louise. "Jörg Immendorf: 'Maler-Mut Rundum.'" *Du* (April 1981): 88-89.

GACHNANG, Johannes, and Siegfried Gohr. "Jörg Immendorffs 'Café Deutschland.'" *Kunstforum International*, no. 26 (1978): 238-42.

GAMBREL, J. [Review of Immendorff exhibition at Sonnabend Gallery, New York.] *Art in America* (February 1984): 149.

GOHR, Siegfried. "Das 'Café Deutschland' von Jörg Immendorff." *Kunstmagazin* 18 (1978): 48-49.

GROOT, P. [Review of Immendorff exhibition at Stedelijk Van Abbemuseum, Eindhoven.] *Artforum* (November 1981): 91-92.

GRÜTERICH, Marlis. [Review of Immendorff exhibition at Galerie Michael Werner, Cologne.] *Pantheon* (April-June 1980): 100-1.

HEGEWISCH, Katharina. [Review of Immendorff exhibition at Galerie Sabine Knust, Stuck-Villa, Munich.] *Kunstwerk* (April 1984): 74-75.

HERGOTT, F., interviewer. "Jörg Immendorff: Le peintre, les bons et les méchants." *Art Press* (May 1985): 25-27.

HILL, P., interviewer. "Jörg Immendorff." *Artscribe* (October 1983): 34-35.

HUBER, Jörg. "Vielschichtige Aktionsräume." *Du* 12 (1983): 87-88. Review of Immendorff exhibition at Kunsthaus, Zurich.

——. "Jörg Immendorff." *Flash Art* (April-May 1984): 46-47.

IMMENDORFF, Jörg. *Brandenburger Tor: Weltfrage*. Includes poem by A. R. Penck. New York: The Museum of Modern Art, 1982.

——. [Project designed by the artist.] *Art & Text* (Summer 1983-Autumn 1984): 74-83.

KOETHER, Jutta. "Under the Influence." *Flash Art* (April 1987): 48.

——. [Review of Immendorff exhibition at Galerie Michael Werner, Cologne.] *Artscribe International* (September-October 1987): 89.

KUSPIT, Donald B. [Review of Immendorff exhibition at Sonnabend Gallery, New York.] *Artforum* (January 1983): 74-75.

LICHTENSTEIN, Therese. [Review of Immendorff exhibition at Sonnabend Gallery, New York.] *Arts Magazine* (December 1983): 34.

MARCK, J. Van der. "Report from Pittsburgh: The Triennial Revived." *Art in America* (May 1986): 49-55.

MEISEL, R. "Malerei zur Lage der Nation." *Art: Das Kunstmagazin* (February 1982): 64-71.

MOUFARREGE, N. A. "X Equals Zero, as in Tic-Tac-Toe." *Arts Magazine* (February 1983): 116-21.

NABAKOWSKI, G. "Kommen Sie 'Mal einem Punker mit einem Buch!': Jörg Immendorff." *Kunstforum International* (June 1982): 156-57. Review of Immendorff exhibition at Kunsthalle, Dusseldorf.

NOUENE, P. le. "Jörg Immendorff." *Opus International* (Autumn 1979): 43-44.

POHLEN, Annelie. [Review of Immendorff exhibition at Kunsthalle, Dusseldorf.] *Flash Art* (Summer 1982): 68.

——. [Review of Immendorff exhibition at Mary Boone & Michael Werner Gallery, New York.] *The New York Times* (January 17, 1986): C22.

SILVERTHORNE, Jeanne. [Review of Immendorff exhibition at Mary Boone Gallery, New York.] *Artforum* (April 1986): 106-7.

STACHELHAUS, Heiner. [Review of Immendorff exhibitions at Städtische Kunsthalle, Dusseldorf, and Galerie Strelow, Dusseldorf-Oberkassel.] *Kunstwerk* (June 1982): 61-62.

STURTEVANT, A. [Review of Immendorff exhibition at Mary Boone Gallery, New York.] *Arts Magazine* (April 1986): 126.

TILLIM, Sidney. [Review of Immendorff exhibition at Mary Boone Gallery, New York.] *Art in America* (September 1986): 142-43.

VETTESE, Angela. [Review of Immendorff exhibition at Studio d'Arte Cannaviello, Milan.] *Flash Art* (November 1983): 75.

Axel Kasseböhmer

1952 Born in Herne.

1988 "Axel Kasseböhmer does not see the still life as an image of a static world of objects. His painted objects are expressions of a sharpened individual perception, artistically transformed formal possibilities of reproduction, variations on the precision of the object in itself. In this series, old or familiar things, objects which already exist in the 'huge mass of images,' are repeatedly recreated. The stages and products of art history, in the form of existing paintings, provide an inexhaustible world of values and images of values. The artist finds them, selects from them, paints them and transforms them" (Messler, 1988: 77).

current Lives and works in Dusseldorf.

Selected Exhibitions

1982 Munich, Galerie Rüdiger Schöttle. *Axel Kasseböhmer*.

Stuttgart, Galerie Ursula Schurr. *Axel Kasseböhmer*.

1983 Düsseldorf, Galerie Arno Kohnen. *Axel Kasseböhmer*.

1984 Cologne, Monika Sprüth Galerie. *Axel Kasseböhmer*.

1985 Cologne, Monika Sprüth Galerie. *Axel Kasseböhmer*.

Munich, Galerie Rüdiger Schöttle. *Axel Kasseböhmer*.

Rotterdam, Galerie 't Venster. *Axel Kasseböhmer*.

1987 Cologne, Monika Sprüth Galerie. *Axel Kasseböhmer*.

1988 Frankfurt, Galerie Grässlin-Ehrhardt. *Axel Kasseböhmer*.

Selected Bibliography

BEYER, Lucie. [Review of Kasseböhmer exhibition at Monika Sprüth Galerie, Cologne.] *Flash Art* (May-June 1986): 60-61.

KOETHER, Jutta. [Review of Kasseböhmer exhibition at Monika Sprüth Galerie, Cologne.] *Artforum* (December 1987): 130-31.

MESSLER, Norbert. [Review of Kasseböhmer exhibition at Monika Sprüth Galerie, Cologne.] *Artscribe* (January-February 1988): 77.

Anselm Kiefer

(No portrait at the request of the artist)

1945 Born in Donaueschingen.

1963-66 Travels to France, Holland, Italy and Sweden.

1965 Studies law and French at the university in Freiburg.

1966 Abandons his law studies after three semesters.

1966-68 Studies painting under Peter Dreher in Freiburg.

1969 Writes *Du bist Maler* (You're a Painter), one of the first of Kiefer's many art books. It "announced the new impetus and dedication in his art. Instead of unemotionally advancing a preexistent, stylistic mode, he began to use art to explore his own psyche and that of his country-men" (Rosenthal, in catalogue of Kiefer exhibition in Chicago, Philadelphia and New York, 1987: 14).
Studies painting under Antes at the Akademie der Bildenden Künste, Karlsruhe.

1970-72 Studies painting under Joseph Beuys at the Kunstakademie, Dusseldorf.

1971 Moves to Buchen (Odenwald) where he converts an old stone schoolhouse into a home and studio. Kiefer marries, and his son Daniel is born.
Uses words and images together. However, the words "are not as titles or captions; they are more like figures, human pictographs, marching along roads and horizon lines. The verbal references are to war songs, to poems, to characters in myth, to geography" (Liebmann, 1982: 91).

1973 Makes Richard Wagner's operas *Der Ring des Nibelungen* and *Parsifal* the focus of a long series of works. "Like Wagner, Kiefer has been especially interested in treating myths from the Edda, a body of ancient Icelandic literature that remains a major source of German mythology" (Rosenthal, in catalogue of Kiefer exhibition in Chicago, Philadelphia and New York, 1987: 260).

1974 Uses enlarged and sometimes damaged photographs as picture grounds. Even when Kiefer uses traditional canvas or burlap sup-ports, he builds up the surface of the pictures with many layers of thick paint. In places he cuts away or burns the surface. Kiefer calls these paintings "works of the scorched earth," and he writes that "painting = burning." The artist em-ploys lead, sand, oil, emulsions, shellac, wood and paper in his picture-making. Later, in the 1980s, Kiefer introduces dried flowers, straw and ferns in his works.

1975 Daughter Sarah is born.

1976 Publishes his autobiography on the occa-sion of a one-man exhibition in Bonn; the last entry reads: "The essential is not yet done." Kiefer fiercely guards his privacy and is silent on matters of a personal nature. He will not, for example, allow the publication of his portrait photograph in exhibition catalogues.

1983 Receives the Hans Thoma Prize.

1984 Travels to Israel.

current Lives and works in Buchen (Oden-wald).

Selected Exhibitions

1969 Karlsruhe, Galerie am Kaiserplatz. *Anselm Kiefer.*

1973 Amsterdam, Galerie im Goethe-Institut. *Der Nibelungen Lied.*

1974 Cologne, Galerie Michael Werner. *Malerei der verbrannten Erde.*
Rotterdam, Galerie t'Venster/Rotterdamse Kunst-stichting. *Heliogabal.*

1975 Cologne, Galerie Michael Werner. *Bücher.*

1976 Cologne, Galerie Michael Werner. *Siegfried vergisst Brünhilde.*

1977 Amsterdam, Galerie Helen van der Meij. *Anselm Kiefer.*
Bonn, Kunstverein. *Anselm Kiefer.* Accompanied by catalogue.
Cologne, Galerie Michael Werner. *Ritt an die Weichsel.*

1978 Bern, Kunsthalle. *Anselm Kiefer: Bilder und Bücher.* Organized by Johannes Gachnang, Theo Kneubühler and Anselm Kiefer.
Dusseldorf, Galerie Maier-Hahn. *Anselm Kiefer: Wege der Weltweisheit – Die Hermannsschlacht.*

1979 Amsterdam, Galerie Helen van der Meij. *Anselm Kiefer: Bücher.*
Eindhoven, Stedelijk Van Abbemuseum. *Anselm Kiefer.* Catalogue includes "Über die Malerei und Anselm Kiefer" by R. H. Fuchs.

1980 Groningen, Groninger Museum. *Anselm Kiefer: Holzschnitte und Bücher.* Catalogue includes "Holz-(schnitt)-wege" by Günther Gercken.
Mannheim, Kunstverein. *Anselm Kiefer.*
Venice, XXXIX *Esposizione Biennale Internazionale d'Arte Venezia,* West German Pavilion. *Verbrennen, verholzen, versenken, versanden.* Catalogue includes "Die Helden der Geschichte" by Klaus Gallwitz.

1981 Cologne, Galerie Paul Maenz. *Anselm Kiefer.*
Essen, Museum Folkwang, and London, Whitechapel Art Gallery. *Anselm Kiefer: Bilder und Bücher.* Catalogue includes "Palette mit Flügeln" by Zdenek Felix and "Anselm Kiefer: Les Plaintes d'un Icare" by Nicholas Serota.
Freiburg, Kunstverein, Schwarzes Kloster. *Anselm Kiefer: Aquarelle 1970-1980.* Catalogue includes essay by R. H. Fuchs.
Milan, Galleria Salvatore Ala. *Anselm Kiefer.* Kiefer's first exhibition in Italy.
New York, Marian Goodman Gallery. *Anselm Kiefer: Painting, Gouaches and Books.* Kiefer's first one-man show in the United States consisted of seven medium-sized gouaches, one large painting and fifteen album-scale books.
Rotterdam, Museum Boymans-van Beuningen. *Anselm Kiefer.*

1982 Amsterdam, Helen van der Meij Gallery. *Anselm Kiefer: Woodcuts.*
Cologne, Galerie Paul Maenz. *Anselm Kiefer.*
New York, Marian Goodman Gallery. *Anselm Kiefer: New Paintings.*
New York, Mary Boone Gallery. *Anselm Kiefer.*

1983 Bernau, Hans-Thoma-Museum. *Anselm Kiefer: Bücher und Gouachen.*
London, Anthony d'Offay Gallery. *Anselm Kiefer: Paintings and Watercolors.* Catalogue includes notes by Anne Seymour.

1984 Bordeaux, Musée d'art contemporain. *Anselm Kiefer: Peintures de 1983-1984.* Catalogue includes "Mille neuf cent quarante cinq" by Jean-Louis Fro-ment and "Ciel et terre" by René Denizot.
Cologne, Galerie Paul Maenz. *Anselm Kiefer.*
Dusseldorf, Städtische Kunsthalle; Paris, ARC/Musée d'Art Moderne de la Ville de Paris; and Jerusalem, Israel Museum. *Anselm Kiefer.* Catalogue includes essays by R. H. Fuchs, Jürgen Harten and Suzanne Page.

1985 New York, Marian Goodman Gallery. *Anselm Kiefer: Auszug aus Ägypten. Departure from Egypt, 1984-1985.*

1986 Amsterdam, Stedelijk Museum. *Anselm Kiefer: Bilder 1980-1986.*
Cologne, Galerie Paul Maenz. *Anselm Kiefer.* Cata-logue includes "Exodus from Historical Time" by Gudrun Inboden.

1987 Chicago, The Art Institute of Chicago; Phila-delphia, Philadelphia Museum of Art; and New York, The Museum of Modern Art (1988). *Anselm Kiefer: Retrospective.* Catalogue includes text by Mark Rosenthal.
New York, Marian Goodman Gallery. *Anselm Kiefer.*

Selected Bibliography

ALLEN, Jane Adams. "Images that Evoke a Bitter History." *Insight* (April 18, 1988): 62-63. Review of Kiefer retrospective at Philadelphia Museum of Art.

BASS, Ruth. [Review of Kiefer exhibition at Mary Boone Gallery, New York.] *Artnews* (February 1983): 146-47.

BEAUMONT, Mary Rose. "Anselm Kiefer." *Arts Review* (June 10, 1983): 312. Review of Kiefer exhi-bition at Anthony d'Offay Gallery, London.

——. [Review of Kiefer/Serra exhibition at Saatchi Col-lection, London.] *Arts Review* (October 24, 1986): 577.

BECKER, W. *New German Painting from the Ludwig Collection.* Hasselt, Belgium: Provinciaal Museum, 1985.

BEYER, Lucie. [Review of Kiefer exhibition at Galerie Paul Maenz, Cologne.] *Flash Art* (March 1984): 45-46.

——. [Review of Kiefer exhibition at Galerie Paul Maenz, Cologne.] *Flash Art* (May-June 1986): 61.

BOS, Saskia. "Anselm Kiefer." *Artforum* (January 1983): 85. Review of Kiefer exhibition at Helen van der Meij Gallery, Amsterdam.

BRENSON, Michael. "Art: Guggenheim's Recent Additions." *The New York Times* (August 9, 1985): C26.

DECTER, Joshua. "Rembrandt's Children." *Arts Magazine* (February 1986): 140. Review of Beuys, Kounellis, Cucchi and Kiefer exhibition at Augustine, Luhring and Hodes Gallery, New York.

DIETRICH, Dorothea. "Anselm Kiefer's 'Johannisnacht II': A Text Book." *The Print Collector's Newsletter* (May-June 1984): 41-44.

DIMITRIJEVIC, Nena. [Review of Kiefer exhibition at Anthony d'Offay Gallery, London.] *Flash Art* (November 1983): 71.

FELIX, Zdenek. [Review of Kiefer exhibition at Museum Folkwang, Essen.] *Domus* (January 1982): 71.

FEUK, D. "Tysk Hemlangtan." *Kalejdoskop* 1 (1981): 2-9.

FISHER, J. "A Tale of the German and the Jew." *Art-forum* (September 1985): 106-10.

FLAM, Jack. "Assessing an Enigmatic Painter." *The Wall Street Journal* (December 16, 1987): 24-25. Review of Kiefer retrospective at The Art Institute of Chicago.

FUCHS, Rudi. "Kiefer Schildert." *Museumjournaal* (December 1980): 302-9.

——. [Excerpts from introduction to the catalogue of the Kiefer exhibition at Stedelijk Van Abbemuseum, Eindhoven, 1979.] *Domus* (April 1981): 53.

GODFREY, Tony. [Review of Kiefer exhibition at Israel Museum, Jerusalem.] *Burlington Magazine* (September 1984): 590, 593.

GRIMES, Nancy. [Review of Kiefer exhibition at Marian Goodman Gallery, New York.] *Artnews* (September 1985): 131-32.

——. [Review of Kiefer exhibition at Marian Goodman Gallery, New York.] *Artnews* (September 1987): 127-28.

GROOT, Paul. [Review of Kiefer exhibition at Museum Boymans-van Beuningen, Rotterdam.] *Artforum* (January 1982): 87-88.

——. [Review of Kiefer exhibition at Stedelijk Museum, Amsterdam.] *Artforum* (April 1987): 142-43.

HECHT, A. "Macht der Mythen." *Art: Das Kunst-magazin* (March 1984): 20-33.

HUBER, Jörg. "Gesamtkunstwerk: the Total Work of Art." *Flash Art* (Summer 1983): 48-51. Review of Kiefer exhibition, *Der Hang zum Gesamtkunstwerk,* at Kunsthalle, Dusseldorf.

HUGHES, Robert. "Germany's Master in the Making." *Time* (December 21, 1987): 72-73.

KIEFER, Anselm. *A Book by Anselm Kiefer*. Includes essays by Theodore E. Stebbins, Jr., and Jürgen Harten. New York: George Braziller, 1986.

——. "Journey to the Creative Core." *Art International* (Spring 1988): 71-74.

KLAUW, M. v. d. "Anselm Kiefer: Das Problem der Deutschen mit der deutschen Kunst." *Kunst* (January 1987): 20-21. Review of Kiefer exhibition at Stedelijk Museum, Amsterdam.

KONTOVA, Helena. [Review of Kiefer exhibition at Galleria Salvatore Ala, Milan.] *Flash Art* (October-November 1981): 60.

KRAMER, Hilton. "The Anselm Kiefer Retrospective." *The New Criterion* (February 1988): 1-4.

KUSPIT, Donald B. "Anselm Kiefer: L'Art moderne et le mythe." *Art Press* (May 1984): 14-19.

——. "Transmuting Externalization in Anselm Kiefer." *Arts Magazine* (October 1984): 84-86.

——. [Review of Kiefer exhibition at Marian Goodman Gallery, New York.] *Artforum* (October 1987): 128.

LARSON, Kay. "The Good Earth." *New York Magazine* (June 1, 1987): 91-92. Review of Kiefer exhibition at Marian Goodman Gallery, New York.

LIEBMANN, Lisa. [Review of Kiefer exhibition at Marian Goodman Gallery, New York.] *Art in America* (Summer 1981): 125-26.

——. [Review of Kiefer exhibition at Marian Goodman Gallery, New York.] *Artforum* (June 1982): 90-91.

MADOFF, S.H. "Anselm Kiefer: A Call to Memory." *Art News* (October 1987): 125-30.

MARANO, L. "Anselm Kiefer: Culture as Hero." *Portfolio* (May 1983): 102-5.

MARCADE, Bernard. "This Never-Ending End." *Flash Art* (October-November 1985): 39.

MARTIN, R. "Anselm Kiefer." *Artscribe* (October 1983): 26-30.

MAYS, John Bentley. "Heroic Life." *C Magazine* (March 1988): 54-63.

MORGAN, S. "Anselm Kiefer." *Artforum* (September 1983): 84. Review of Kiefer exhibition at Anthony d'Offay Gallery, London.

MÜLLER, Hans-Joachim. [Review of Kiefer exhibition at Kunsthalle, Bern.] *Kunstwerk* (December 1978): 62-63.

——. "Ausstellungs-Rückschau: Biennale Venedig 1980." *Kunstwerk* (April 1980): 58-69.

OTTMANN, Klaus. "Artists in Exile: The Postavant-garde Artists." *Flash Art* (April-May 1985): 26-29.

POHLEN, Annelie. [Review of Kiefer exhibition at Museum Folkwang, Essen.] *Flash Art* (December 1981-January 1982): 59.

——. [Review of Kiefer exhibition at Kunsthalle, Dusseldorf.] *Artforum* (October 1984): 99-100.

POMIAN, K. "Malarz Spalonej Ziemi." *Kultura* 9 (1984): 15-24.

PULIAFITO, Isabella. [Review of Baselitz and Kiefer exhibitions at Venice Biennale.] *Artforum* (November 1981): 97.

RATCLIFF, Carter. [Review of Kiefer exhibition at Mary Boone Gallery, New York.] *Flash Art* (January 1983): 63.

——. "Stampede to the Figure." *Artforum* (June 1984): 47-55.

RUSSELL, John. "Anselm Kiefer's Paintings are Inimitably His Own." *The New York Times* (April 21, 1985): 33-34. Review of Kiefer exhibition at Marian Goodman Gallery, New York.

——. "The Best and Biggest in Pittsburgh." *The New York Times* (November 17, 1985): 29. Review of Carnegie International Exhibition at Carnegie Institute Museum of Art, Pittsburgh, in which Kiefer was included. An award was given to both Kiefer and Richard Serra; their work was seen to embody the two dominant styles, expressionism and Minimalism.

——. "A Painter who Lends Fire to the Gods." *The New York Times* (May 24, 1987): 19. Review of Kiefer exhibition at Marian Goodman Gallery, New York.

——. "From the Particular to the Sublime." *The New York Times* (December 13, 1987): 47. Review of Kiefer retrospective at The Art Institute of Chicago.

SCHJELDAHL, Peter. "The Germans' Marshall Arts." *The Village Voice* (August 3, 1982): 66. Review of Kiefer exhibition at Documenta 7, Kassel.

——. "Anselm Kiefer." In *Art of Our Time: The Saatchi Collection*. London: Lund Humphries in association with Rizzoli, 1985: 15-17.

——. "Our Kiefer." *Art in America* (March 1988): 116-26.

SCHMIDT-WULFFEN, Stephan. [Review of Kiefer exhibition at Kunsthalle, Dusseldorf.] *Flash Art* (Summer 1984): 73.

SCHNEIDER, Angela. "Anselm Kiefer." In *1945-1985: Kunst in der Bundesrepublik Deutschland*: 316-19. Catalogue of exhibition at Nationalgalerie, Berlin, 1985.

SCHWABSKY, Barry. [Review of Kiefer exhibition at Marian Goodman Gallery, New York.] *Arts Magazine* (September 1985): 36.

SCHWARTZ, S. "The Saatchi Collection, or a Generation comes into Focus." *The New Criterion* (March 1986): 22-37.

SHERLOCK, Maureen. "Romancing the Apocalypse: A Futile Diversion." *New Art Examiner* (June 1988): 24-28.

SISCHY, Ingrid. "Project by Anselm Kiefer." *Artforum* (June 1981): 67-73.

SMITH, Roberta. [Review of Kiefer exhibition at Marian Goodman Gallery, New York.] *The Village Voice* (May 11, 1982): 88.

——. "Kieferland." *The Village Voice* (November 30, 1982): 113. Review of Kiefer exhibition at Mary Boone Gallery, New York.

STAVITSKY, G. "The 1985 Carnegie International." *Arts Magazine* (March 1986): 58-59.

SYRING, M.L. "Die Heroisierung des Scheiterns." *Du*, no. 6 (1984): 82-83. Review of Kiefer exhibition at ARC/Musée d'Art Moderne de la Ville de Paris.

THOMPSON, Jon B. "Venice: Aspects of the 1980 Biennale." *Burlington Magazine* (November 1980): 793-94.

WELTI, A. "Maler erfinden die Landschaft." *Art: Das Kunstmagazin* (February 1983): 26-45.

WEST, Thomas. "The Energy of Broken Wings." *Art International* (Spring 1988): 75-83.

——. "Interview at Diesel Strasse." *Art International* (Spring 1988): 62-65.

WINTER, Peter. "Anselm Kiefer." *Kunstwerk* (January 1982): 60. Review of Kiefer exhibitions at Museum Folkwang, Essen, and Whitechapel Art Gallery, London.

——. "Whipping Boy with Clipped Wings." *Art International* (Spring 1988): 66-70.

YOOD, James. "The Specter of Armageddon." *New Art Examiner* (April 1988): 25-27.

ZUTTER, J. "Drei Vertegensoordigers van een nieuwe duitse Schilderkunst." *Museumjournaal* (April 1978): 52-61.

Martin Kippenberger

1953 Born in Dortmund.

1972 Studies at the Hochschule für Bildende Künste, Hamburg, under R. Hauser and F. E. Walther.

1978 Establishes Kippenbergers Büro in Berlin, an office for consulting, advising and the selling of art, and stops painting. Although Kippenberger refuses to paint, he generates ideas and themes for conceptual artworks which are completed to his instructions by another artist. Numerous exhibitions are held at the Büro. Kippenberger is an important person in the cultural scene of Berlin at this time. He has the ability to bring people and ideas together. One Cologne gallery owner explains that things just happened around Kippenberger. His groups, exhibitions and publications focused attention and energy on exciting ideas and objectives.

Founds the rock group Luxus, with Christine Hahn and Eric Mitchell, in New York. Kippenberger organizes music festivals and produces records.

1979 Founds the musical group Die Grugas. Kippenberger brings musicians, composers and performance artists together.

Cofounder of SO 36, a Punk disco in the Kreuzberg district of Berlin. The disco is the scene of many concerts and performance pieces. Here again, a forum for artistic creativity is provided through the efforts and innovation of Kippenberger. The disco closed in 1981.

1981 Leaves Berlin and starts to paint again.

1982 Since 1982 frequently participates with Albert Oehlen and Büttner in joint projects and exhibitions. Cuts a record called "Die Rache der Erinnerung" (The Revenge of Memory) with Büttner, Immendorff, Markus and Albert Oehlen and Penck. See Albert Oehlen biography, p. 275.

1984 Publishes *Wahrheit ist Arbeit* (Truth is Work) with Albert Oehlen and Büttner. See Albert Oehlen biography.

Kippenberger is interested in all aspects of book production. He founds his own publishing

house, Metter Verlag, which publishes and translates an English edition of *Wahrheit ist Arbeit*. In addition to his group book-making ventures, Kippenberger produces numerous independent artist's books, and considers them an important aspect of his artistic work.

1986-87 Delivers public lectures with Albert Oehlen.

1987 His most recent works are installations constructed of wood, metal, Masonite and found objects. The disorderly repertory of found objects he uses ranges from banana peels frozen in resin to a tabletop fashioned out of an early Richter monotone painting.

1988 Writes a novel called *Café Central*, a story about coffeehouse society, gossip and philosophy.

current Lives and works in Cologne.

Selected Exhibitions

1983 Cologne, Galerie Zwirner. *Martin Kippenberger: Bilder.*

1984 Cologne, Galerie Max Hetzler. *Martin Kippenberger I. N. P.*
Essen, Museum Folkwang. *Wahrheit ist Arbeit: Werner Büttner, Martin Kippenberger, Albert Oehlen.* Exhibition organized by Zdenek Felix, with catalogue by the artists.
New York, Metro Pictures. *Werner Büttner, Martin Kippenberger, Albert Oehlen and Markus Oehlen.* The first New York show for these four artists.
Vienna, Galerie Peter Pakesch. *Martin Kippenberger: Sind die Discos so doof wie ich glaube, oder bin ich der Doofe?* Catalogue includes text by Peter Weibel.

1985 Cologne, Galerie Max Hetzler. *Martin Kippenberger: Architektur.*
Frankfurt, Galerie Bärbel Grässlin. *Martin Kippenberger: "Hunger"; Bilder und Skulpturen.*
Hamburg, Ascan Crone Gallery. *Martin Kippenberger.*
Frankfurt, Galerie Heinrich Ehrhardt. *Martin Kippenberger: "Acht Ertragsgebirge und drei Entwürfe für Müttergenesungswerke," Bilder und Skulpturen.*
Los Angeles, Kuhlenschmidt/Simon Gallery. *Martin Kippenberger.*
New York, Metro Pictures. *Martin Kippenberger.*

1986 Darmstadt, Hessisches Landesmuseum. *Martin Kippenberger: Miete, Strom, Gas.* Catalogue edited by Detlev Gretenkort and Johann-Karl Schmidt.
Dusseldorf, CCD Galerie and Hamburg, PPS Galerie. *Martin Kippenberger: Sand in der Vaseline, Brasilien 1986.* Catalogue includes text by Martin Kippenberger and Albert Oehlen.

1987 Cologne, Galerie Gisela Capitain. *Martin Kippenberger: Petra.*
Cologne, Galerie Max Hetzler. *Martin Kippenberger: Peter.* Catalogue includes text by Diedrich Diederichsen.
Graz, Galerie Bleich-Rossi. *Martin Kippenberger: Die Reise nach Jerusalem.* Catalogue includes continuation of interview between Loriot Lottman and Michael Krebber from catalogue of Kippenberger exhibition at Galerie Peter Pakesch, Vienna, 1987.
New York, Metro Pictures. *Martin Kippenberger.* Kippenberger's first sculpture exhibition in New York.
Vienna, Galerie Peter Pakesch. *Martin Kippenberger: Peter 2.* Catalogue includes interview between Loriot Lottmann and Michael Krebber.

1988 New York, Metro Pictures. *Martin Kippenberger: Sculptures.*
Vienna, Galerie Peter Pakesch. *Martin Kippenberger.*

Selected Bibliography

ADAMS, B. [Review of Kippenberger exhibition at Galerie Max Hetzler, Cologne.] *Art in America* (November 1987): 189.

ANON. "Martin Kippenberger." *Kunstforum International* (December 1983): 154-63.

BEYER, Lucie. [Review of Kippenberger exhibition at Galerie Zwirner, Cologne.] *Flash Art* (November 1983): 72.

BISMARCK, Beatrice von. [Review of Kippenberger exhibition at Ascan Crone Gallery, Hamburg.] *Flash Art* (April-May 1985): 44-45.

BUCK, Matthias, and Christian Nagel, eds. *Martin Kippenberger: Anlehnungsbedürfnis.* Munich: Verlag Christoph Dürr, 1987.

CONAL, R. "Out of *Sturm und Drang.*" *Artweek* (November 23, 1985): 5. Review of Kippenberger exhibition at Kuhlenschmidt/Simon Gallery, Los Angeles.

FAUST, Wolfgang Max. "Martin Kippenberger." *Kunstforum International* 67 (1983): 56-70.

———, and Max Raphael. "Gemeinschaftsbilder: Ein Aspekt der neuen Malerei; Werner Büttner, Albert und Markus Oehlen, Martin Kippenberger: Erschlägt Wirklichkeit Kunst?" *Kunstforum International* (November 1983): 56-69.

HEARTNEY, Eleanor. "Four Germans." *Artnews* (February 1985): 140. Review of Kippenberger exhibition at Metro Pictures, New York.

HENTSCHEL, M. [Review of Kippenberger exhibition at Galerie Max Hetzler, Cologne.] *Artforum* (October 1987): 142.

HOFFMANN, Justin. [Review of Kippenberger exhibition at Galerie Peter Pakesch, Vienna.] *Artscribe International* (March-April 1988): 92.

HONNEF, Klaus. "Der Entwurf als Welt." *Kunstforum International* (June-August 1986): 142-43.

JONES, R. "Martin Kippenberger: Domination of the Universal." *Arts Magazine* (September 1985): 114-15.

KIPPENBERGER, Martin. *241 Bildtitel zum Ausleihen für Künstler.* Cologne: Verlag der Buchhandlung Walther König, 1986.

———. *Zeichnungen über eine Ausstellung: Günther Förg, Georg Herold, Hubert Kiecol, Meuser & Reinhard Mucha.* Vienna: Galerie Peter Pakesch, 1986. Includes essay by Peter Wiebel.

———, and Albert Oehlen. *Gedichte: Zweiter Teil.* Berlin: Rainer Verlag, 1987.

KOETHER, Jutta. [Review of Kippenberger exhibition at Galerie Max Hetzler, Cologne.] *Artscribe International* (September-October 1987): 89.

KUSPIT, Donald B. [Review of Büttner, Kippenberger, Albert and Markus Oehlen exhibition at Metro Pictures, New York.] *Artforum* (January 1985): 90.

SMITH, Roberta. "Art: Martin Kippenberger Sculptures." *The New York Times* (November 20, 1987): C36. Review of Kippenberger exhibition at Metro Pictures, New York.

SPECTOR, Nancy. [Review of Kippenberger exhibition at Metro Pictures, New York.] *Artscribe International* (May 1988): 75.

Konrad Klapheck

1935 Born in Dusseldorf, son of the art historians Richard and Anna Klapheck. His father teaches at the Kunstakademie, Dusseldorf, until his death in 1939. Klapheck's mother also teaches at the Kunstakademie (1953-66).

1954-58 Studies painting at the Kunstakademie, Dusseldorf, under Bruno Goller.

1955 Makes his first painting of a typewriter when *Tachisme* and action painting were the most favored modes of the day. According to Klapheck, he wanted to contrast this art with something "hard, precise, standing out from lyrical abstraction with prosaic super-matter-of-factness" ([Review of Klapheck exhibition at Städtische Kunsthalle, Dusseldorf], *Die Welt* [February 18, 1975]: n.p.). Therefore, in his first semester at the Dusseldorf Kunstakademie the artist set out to paint a still life that "wasn't apples and oranges"; and instead, as Klapheck relates, "I hit upon the idea of doing a typewriter. I rented one from a commercial machines place and had the school pay for the rent from the fund to pay models" (quoted in David L. Shirey, "I Love You, Smith-Corona," *Newsweek* [February 17, 1969]: 115).

1956-57 Visits Max Ernst in Paris. During his half-year stay in Paris, Klapheck is introduced to the work of Marcel Duchamp and Raymond Roussel.

1960 Receives the grant accompanying the Art Prize of the State of North Rhine-Westphalia. Later he will decline all art prizes and other honors. Marries Lilo Lang.

1961-65 In contact with the Paris Surrealist artists, including André Breton. Birth of daughter Elisa in 1962, and of son David in 1965.

1966 "My pictures are to be seen as a whole, as an epic whose protagonists are embodied not in man but in his most important everyday objects. Perhaps the latter are more fitted than a portrait of their inventors to represent today's human comedy. However clear and logical my pictures may look, it is chance I must thank for half their success. If at one point I can literally take over an image, at another, I am forced by the unpredictable consequences of the size of the canvas to paint a picture that I did not have in mind to paint. Chance is the master of inspiration. I do not use things as symbols, I simply paint them as well as I can and let myself be surprised at what they have to say. Eventually the paintings must be cleverer than their creator and go beyond his intentions" (Konrad Klapheck, in catalogue of Klapheck exhibition in Milan, 1968: n.p.).

1979 Since 1979 is professor at the Kunstakademie, Dusseldorf.

current Lives and works in Dusseldorf.

Selected Exhibitions

1959 Dusseldorf, Galerie Schmela. *Konrad Klapheck.*

1966 Hannover, Kestner-Gesellschaft. *Konrad Klapheck.* Catalogue includes "Notizen zu Konrad Klapheck" by Wieland Schmied.

1968 Milan, Galleria Schwarz. *Konrad Klapheck.*
1974 Rotterdam, Museum Boymans-van Beuningen; Brussels, Palais des Beaux-Arts; and Dusseldorf, Städtische Kunsthalle (1975). *Konrad Klapheck: Retrospektive.* Catalogue includes introduction by R. Hammacher, essays by Wieland Schmied and André Breton and commentaries by Konrad Klapheck.
1975 Dusseldorf, Städtische Kunsthalle. *Konrad Klapheck.*
New York, Sidney Janis Gallery. *Konrad Klapheck.*
1976 Basel, Galerie Beyeler. *Konrad Klapheck: Retrospektive.* Catalogue includes "Konrad Klapheck: Objekte zwischen Fetisch und Libido" by Werner Schmalenbach.
Munich, Galerie Jasa. *Konrad Klapheck.*
1977 Cologne, Galerie Rudolf Zwirner. *Klapheck: Werkverzeichnis der Druckgraphik 1960-1977.* Accompanied by catalogue, Cologne: Buchhandlung Walther König.
1979 Berlin, Galerie André. *Konrad Klapheck: Graphische Werke.*
1980 Dusseldorf, Wolfgang Wittrock Kunsthandel. *Konrad Klapheck: Werkverzeichnis der Druckgraphik 1977-1980.*
1985 Hamburg, Kunsthalle; Tubingen, Kunsthalle; and Munich, Staatsgalerie moderner Kunst. *Konrad Klapheck: Retrospektive (1955-85).* Catalogue, ed. Werner Hofmann, ed., includes essay by Peter-Klaus Schuster and notes by Konrad Klapheck.
Paris, Galerie Maeght Lelong. *Klapheck.* Catalogue includes preface by Werner Hofmann and text by Konrad Klapheck.

Selected Bibliography

ANON. "Verlorene Jahre?" *Art: Das Kunstmagazin* (January 1984): 66-75.

BRUSBERG, D. and G. Simon-Ern, eds. *Brusberg Berichte 25.* Hannover: Galerie Brusberg, 1980.

DAVAL, Jean-Luc. [Review of Klapheck retrospective at Galerie Beyeler, Basel.] *Art International* (April-May 1976): 73.

ENGELHARD, G. "Mit Präzision gegen die Angst." *Art: Das Kunstmagazin* (May 1981): 32-49.

FRANZKE, Andreas. [Review of Klapheck exhibition at Galerie Beyeler, Basel.] *Pantheon* (July 1976): 263.

GALLOWAY, David. "Taking Stock." *Art in America* (May 1986): 35.

KINKEL, H. "Konrad Klapheck oder Entdeckung eines Graphikers." *Kunst und das schöne Heim* (January 1970): 33-40.

KLAPHECK, Konrad. "Tender-Coloured Monsters." *Arte Milano* (March 1973): 28-31.

MARTIN, H. "Konrad Klapheck: Quotes and Comments." *Art International* (December 1972): 32-34.

MORSCHEL, Jürgen. [Review of Klapheck exhibition at Städtische Kunsthalle, Dusseldorf.] *Kunstwerk* (May 1975): 81.

PIERRE, J. "La Comédie mécanique de Konrad Klapheck." *Opus International* (Autumn 1979): 36-39.

PRINZ, Ursula. [Review of Klapheck graphics exhibition at Galerie André, Berlin.] *Heute Kunst (Flash Art)* (June-July 1979): 6-7.

ROH, Julianne. [Review of Klapheck exhibition at Galerie Jasa, Munich.] *Kunstwerk* (November 1976): 91-92.

ROQUE, G. "Klapheck: German Machine-Painter." *Clés pour les Arts* (December 1974): 16-17.

STOLLE, Ruth. "Crónica de Munich." *Goya* (September 1977): 151. Review of Klapheck exhibition at Galerie Jasa, Munich.

THWAITES, John Anthony. "Eight Artists, Two Generations, Singular Preoccupations." *Artnews* (October 1978): 70.

Bernd Koberling

1938 Born in Berlin.
1955-68 Trains and works as a cook.
1958-60 Studies at the Hochschule für Bildende Künste, Berlin.
1961 Member of the VISION group along with Hödicke. In a 1984 interview, the artist describes himself as a "conceptual, expressive realist. And realism is impossible without vision. For me, realism without utopian vision is empty naturalism" (Armin Wildermuth, interviewer. *Bernd Koberling: "Ein Gespräch."* Basel, 1984: 15).
1961-63 Lives in Great Britain.
1962 Begins a series of landscapes based on his travels to Lapland and Scotland. The paintings depict waterfalls, fjords and cottages on mountainsides. Koberling develops a unique method of picture-making called "over-stretching": he prepares the surface of his painting by layering plastic film over untreated areas of canvas. At a distance the surface of the work appears to be glossy, but close-up the transparent film reveals the texture of the canvas underneath. In the 1970s, Koberling uses jute, a burlap-like material, instead of canvas as support. This new material is extremely porous and causes pigments to bleed into each other and stain, rather than cover, the cloth, allowing Koberling to achieve subtle atmospheric effects and harmonious gradations of color.
1964 Founding member of the Galerie Grossgörschen 35 in Berlin, with Hödicke, Lüpertz and others. The gallery, located in an old factory, is an artists' cooperative, established to show work by young talent.
1969-70 Wins the Villa Massimo Prize, Rome.
1970 Receives the German Critics' Association Award.
1970-74 Lives in Cologne.
1976-81 Gives guest lectures in Hamburg, Dusseldorf and Berlin.
1981 Reintroduces figural representation in his work. Early in his career, Koberling had unsuccessfully tried to use a figurative mode to express his themes. His efforts were "impeded less by the continuing predominance of abstract art in West Germany than by the sudden eruption of Anglo-American Pop Art, which he first encountered at the Berlin exhibition of 1964. This collision with the 'second-hand landscape picture' (Lichtenstein, d'Arcangelo) led Koberling to abandon the direct, colorful imagery

which he had evolved: *Self-Portrait in Red Fishing Jacket* (1963)" (Walter Grasskamp, "Biographies of the Artists," in Joachimides, Rosenthal and Schmied, 1985: 489).
1981-88 Professor at the Hochschule für Bildende Künste, Hamburg.
1984 "I want to present a picture of the world as I imagine it. If, however, this world were already the ideal world, then I would not need to create any pictures at all. For if pictures were only that which they represent … that would no longer sufficiently motivate me to paint a picture" (quoted in Wildermuth, 1985: 14).
1988 Professor at the Hochschule der Künste, Berlin.
current Lives and works in Berlin.

Selected Exhibitions

1965 Berlin, Galerie Grossgörschen. *Bernd Koberling: Sonderromantik.*
1966 Berlin, Galerie René Block. *Bernd Koberling: Überspannungen.*
1968 Berlin, Galerie am Lützowplatz. *Bernd Koberling: Berge, Birken, Seen.* Catalogue includes text by Christos M. Joachimides.
1969 Cologne, Galerie Michael Werner. *Bernd Koberling: Landschaften.*
Frankfurt, Galerie Ursula Lichter. *Bernd Koberling.*
1973 Bonn, Galerie Magers. *Bernd Koberling: Malwasser.*
1975 Edinburgh, Fruit Market Gallery, Scottish Arts Council. *Eight from Berlin.*
1978 Berlin, Haus am Waldsee, and Leverkusen, Städtisches Museum. *Bernd Koberling: Malerei 1962-1977.* Catalogue includes "Bilder von der Natur" by Christos M. Joachimides and essay by Bernd Koberling.
1980 Dusseldorf, Galerie Art in Progress. *Bernd Koberling: "Unter den Bäumen," Bilder 1978-1979.*
1981 London, Nigel Greenwood Ltd. *Bernd Koberling: Works on Paper 1981.*
1982 Berlin, Reinhard Onnasch Ausstellungen. *Bernd Koberling: Inseln, Bilder aus den Jahren 1969/70 und 1980/82.* Catalogue includes "Der stille Expressionist" by Wieland Schmied.
Milan, Studio d'Arte Cannaviello. *Bernd Koberling.*
New York, Annina Nosei Gallery. *Bernd Koberling.* Koberling's first show in New York.
1983 Dusseldorf, Galerie Gmyrek. *Bernd Koberling: Moderne Peripherie.* Catalogue includes "Natur, Malerei und Schöpfungsmythos" by Jeannot Simmen.
Genoa, Galleria Chisel. *Bernd Koberling.*
1984 Basel, Galerie Buchmann. *Bernd Koberling: Malerei.*
Berlin, Galerie Reinhard Onnasch. *Bernd Koberling.*
1985 Bielefeld, Bielefelder Kunstverein. *Bernd Koberling: Bilder 1978-1984.* Catalogue includes essays by Erich Franz and Bernd Koberling.
1986 Aarhus, Aarhus Kunstmuseum, and Braunschweig, Kunstverein. *Bernd Koberling.* Catalogue includes "Zur Genese der Malerei von Bernd Koberling" by Wilhelm Bojescul.
Dusseldorf, Galerie Gmyrek. *Bernd Koberling: Berührung des Horizonts.*
Saint-Priest, France, Galerie d'Art Contemporain de Saint Priest. *Bernd Koberling.* Catalogue includes "Bernd Koberling" by Jean-Pierre Bordaz.
Venice, California, L. A. Louver Gallery. *Bernd Koberling: Recent Paintings.*
1988 Basel, Galerie Buchmann. *Bernd Koberling: "Landlinien."*
Berlin, Galerie Fahnemann. *Bernd Koberling: Bilder aus der Serie "laichen."*
Hamburg, Galerie Ascan Crone. *Bernd Koberling.*
1989 London, Nigel Greenwood Ltd. *Bernd Koberling.*

Selected Bibliography

ADOLPHS, Volker. [Review of Koberling exhibition at Galerie Gmyrek, Dusseldorf.] *Kunstwerk* (June 1986): 63-64.

BONIN, Wibke von. "Germany: Four Young Painters." *Arts* (May 1969): 54. Review of Koberling exhibition at Galerie Ursula Lichter, Frankfurt.

BUSCHE, Ernst. "Ein Könner lebt von hohen Zielen." *Art* (March 1988): 28-40, 138.

DIENST, Rolf-Gunter. "Deutsche Kunst: Eine neue Generation." *Kunstwerk* (June 1969): 8.

FOSTER, Hal. [Review of Koberling exhibition at Annina Nosei Gallery, New York.] *Art in America* (Summer 1982): 145.

FRIEDRICHS, Yvonne. [Review of Koberling exhibition at Galerie Gmyrek, Dusseldorf.] *Kunstwerk* (November 1983): 70-71.

LAWSON, Thomas. [Review of Koberling exhibition at Annina Nosei Gallery, New York.] *Artforum* (Summer 1982): 81-82.

MACMILLAN, Duncan. [Review of *Eight from Berlin* exhibition at Fruit Market Gallery, Edinburgh.] *Studio International* (November-December 1975): 249-50.

OHFF, Heinz. [Review of Koberling exhibition at Haus am Waldsee, Berlin.] *Kunstwerk* (April 1978): 55-56.

———. [Review of Koberling exhibition at Galerie Reinhard Onnasch, Berlin.] *Flash Art* (February 1985): 60.

SIMMEN, Jeannot "Natur – ganz anders: Zu den Bildern von Christa Näher und Bernd Koberling." *Du* (July 1983): 78-79. Review of Näher exhibition at Kunstverein, Bonn, and Koberling exhibition at Galerie Gmyrek, Dusseldorf.

VESCOVA, Marisa. "The Memory of Experience: Bernd Koberling." *Tema Celeste* 15 (1988): 38-46.

Dieter Krieg

1937 Born in Lindau (Lake Constance).

1958-62 Attends classes at the Botanical Institute of the Technische Hochschule, Karlsruhe. Then Krieg changes fields and studies at the Akademie der Bildenden Künste, Karlsruhe, with HAP Grieshaber and Herbert Kitzel. "Nobody but Grieshaber would have kept me," he says now. "I never finished anything. I used lac paint and as I put on more and more it all ran down. . . . They've all been destroyed. I just couldn't pick them up from the Academy" (quoted in Thwaites, 1974: 35).

1966 Submits figurative works to the German Youth Prize jury while working at the Kunsthalle, Baden-Baden. "As an attendant, I helped carry them into the jury," he recalls "I just had time to hear the Director say that they were psychopathic. Then I was recognized and had to leave the room" (quoted in Thwaites, 1974: 35). Nevertheless, Krieg receives the German Youth Prize for Painting, Baden-Baden (along with Polke).

1968 Awarded prize by the organizers of the Biennale Danuvius held in Bratislava.

1969 Receives the Art Prize of the Böttcherstrasse, Bremen.

1970 Wins the Darmstadt City Art Prize.

1971-72 Visiting instructor at the Akademie der Bildenden Künste, Karlsruhe.

1972 His subjects include steel pipes, bells, pieces of meat embellished with metal studs, records and plates, as well as giant forks, knives and spoons. What interests Krieg, he admits, "is the shock of the 'meaningless' object. From the subjective point of view it's often quite absurd" (quoted in Thwaites, 1974: 38).

1975-76 Guest lecturer at the Städelschule, Frankfurt.

1976 Creates a project called "Allen Malern herzlichen Dank" (Sincere Thanks to All Painters). From 10:00 a.m. October 8 until 1:20 p.m. on November 1 the names of all artists registered in the thirty-six volumes of the Thieme-Becker dictionary of artists were read out loud. In 147 hours and twenty minutes of taped recordings the book was read by nineteen different men and women.

1978 Professor at the Kunstakademie, Dusseldorf.

current Lives and works in Quadrath-Ichendorf.

Selected Exhibitions

1968 Cologne, Galerie der Spiegel. *Dieter Krieg: Neue Bilder.*

1969 Aachen, Gegenverkehr, Zentrum für aktuelle Kunst. *Dieter Krieg.*
Cologne, Galerie der Spiegel. *Dieter Krieg.*
Munich, Galerie Thomas. *Dieter Krieg: Bilder-Zeichnungen.*

1970 Cologne, Galerie der Spiegel. *Dieter Krieg: Neue Bilder und Gouachen.*
Mannheim, Galerie Lauter. *Dieter Krieg: Acht Malsch Wannen.*

1971 Munich, Galerie Stangl. *Dieter Krieg.*

1972 Munster, Westfälischer Kunstverein, and Bielefeld, Kunsthalle Bielefeld. *Dieter Krieg.*

1973 Cologne, Galerie der Spiegel. *Dieter Krieg.*

1974 Cologne, Galerie der Spiegel. *Dieter Krieg: Neue Arbeiten.*

1976 Cologne, Galerie der Spiegel. *Dieter Krieg.*
Munich, Galerie am Promenadeplatz. *Dieter Krieg: Neue Bilder.*

1977 Cologne, Galerie der Spiegel. *Dieter Krieg: Neue Bilder.*
Munich, Galerie am Promenadeplatz. *Dieter Krieg.*

1978 Munich, Galerie am Promenadeplatz. *Dieter Krieg: Bilder.*
Venice, *XXXVIII Esposizione Biennale Internazionale d'Arte Venezia*, German Pavilion. *Dieter Krieg: Venedig 1978.* Catalogue includes "Approaches and Similarities" by Klaus Gallwitz.

1981 Berlin, Galerie Dibbert. *Dieter Krieg.*
Munich, Galerie am Promenadeplatz. *Dieter Krieg: Neue Bilder.*

1983 Karlsruhe, Badischer Kunstverein, and Wuppertal, Von der Heydt-Museum. *Dieter Krieg: Bilder 1966-1983.*

Munich, Galerie Heinz Herzer (formerly Galerie am Promenadeplatz). *Dieter Krieg.*

1984 Constance, Galerie Schneider. *Dieter Krieg.*

1985 Munich, Galerie Heinz Herzer. *Dieter Krieg.*

1986 Berlin, Galerie Poll. *Dieter Krieg.*
Cologne, Galerie Wentzel. *Dieter Krieg: Bilder.*
Munich, Galerie Heinz Herzer. *Dieter Krieg: Malerei.*

1987 Aachen, Suermondt-Ludwig-Museum. *Dieter Krieg.*
Frankfurt, Galerie Timm Gierig. *Dieter Krieg: Bilder.* Catalogue includes essays by Klaus Gallwitz and Axel Hinrich Murken.

1988 Dusseldorf, Galerie Gmyrek. *Dieter Krieg. Malerei 1980-88.* Catalogue includes "Dieter Krieg: Vom Ausgleiten" by Marie Luise Syring.

Selected Bibliography

DIENST, Rolf-Gunter. [Review of Krieg exhibition at Galerie der Spiegel, Cologne.] *Kunstwerk* (February 1969): 78.

———. "Deutsche Kunst: Eine neue Generation." *Kunstwerk* (June 1969): 8.

———. [Review of Krieg exhibition at Gegenverkehr, Zentrum für aktuelle Kunst, Aachen.] *Kunstwerk* (December 1969): 81.

———. [Review of Krieg exhibition at Von der Heydt-Museum, Wuppertal.] *Kunstwerk* (February 1984): 42.

———. "Zu neuen Bildern von Dieter Krieg." *Kunstwerk* (December 1984): 8-17.

GALLWITZ, Klaus. "Dieter Krieg." *Kunstwerk* (October-November 1966): 28-32.

MAI, Ekkehard. "Künstlerateliers als Kunstprogramm: Werkstatt Heute." *Kunstwerk* (June 1984): 19.

MORSCHEL, Jürgen. [Review of Krieg exhibition at Galerie am Promenadeplatz, Munich.] *Kunstwerk* (February 1977): 78.

MÜLLER, C. "Dieter Krieg Bilder 1966-1983." *Pantheon* (January-March 1984): 66. Review of Krieg exhibition at Von der Heydt-Museum, Wuppertal.

NEIDEL, H. [Review of Krieg exhibition at Galerie Heinz Herzer, Munich.] *Das Kunstwerk* (November 1983): 81-82.

OHFF, Heinz. [Review of Krieg exhibition at Galerie Dibbert, Berlin.] *Kunstwerk* (April 1981): 69.

———. [Review of Krieg exhibition at Galerie Poll, Berlin.] *Kunstwerk* (June 1986): 62.

ROH, Juliane. "Dieter Krieg: Neue Bilder." *Kunstwerk* (January 1982): 77-78. Review of Krieg exhibition at Galerie am Promenadeplatz, Munich.

———. "Absurde Köpfe." *Kunstwerk* (April 1983): 41, 46.

SCHÜTZ, Sabine. [Review of Krieg exhibition at Suermondt-Ludwig-Museum, Aachen.] *Kunstforum International* (December 1987-January 1988): 274-75.

THIEL, H. "Dieter Krieg." [Review of Krieg exhibition at Galerie Müller, Cologne.] (June 1982): 163-64.

THWAITES, John Anthony. "Back to Anti-Art? John Anthony Thwaites Looks at the Career of Dieter Krieg." *Art and Artists* (May 1974): 34-39.

WESKOTT, H. "Dieter Krieg: Neue Bilder von 1979." *Kunstforum International* 5 (1979): 191. Review of Krieg exhibition at Galerie am Promenadeplatz, Munich.

WINTER, Peter. "Bildräume mit Fragezeichen." *Kunstwerk* (July 1975): 4, 8-11.

——. [Review of Albert Oehlen exhibition at Sonnabend Gallery, New York.] *Art in America* (September 1986): 143.

KIPPENBERGER, Martin, and Albert Oehlen. *Gedichte: Zweiter Teil*. Berlin: Rainer Verlag, 1987.

KUSPIT, Donald B. [Review of Büttner, Kippenberger, Albert and Markus Oehlen exhibition at Metro Pictures, New York.] *Artforum* (January 1985): 90.

OEHLEN, Albert, with poems by Wolfgang Bauer. *Ewige Feile*. Cologne: Verlag Buchhandlung Walther König, 1983.

——, with text by Rainald Goetz. *15 Zeichnungen: Tannhäuser*. n.d., n.p. Drawings by Albert Oehlen based on the costume designs of Eva Hieber.

SCHMIDT-WULFFEN, Stephan, interviewer. "Werner Büttner and Albert Oehlen." *Flash Art* (January 1985): 22-25.

SCHWARZ, Sophie. "Albert Oehlen: Killing Off Painting Yet Still Continuing." *Flash Art* (Summer 1988): 156-57. Review of Albert Oehlen exhibition at Galerie Max Hetzler, Cologne.

Markus Oehlen

1956 Born in Krefeld, son of a graphic designer and brother of Albert Oehlen.

1971-73 Trains as a draftsman.

1976-81 Trains as a designer at the Kunstakademie, Dusseldorf.

1979-83 Plays the drums in the new wave band Mittagspause.

1981 Founds the Kirche der Ununterschiedlichkeit (Church of Indifference) with Albert Oehlen and Büttner. See Büttner biography, p. 258.

1982 Makes the record "Die Rache der Erinnerung" (The Revenge of Memory) with Büttner, Immendorff, Kippenberger, Albert Oehlen and Penck. See Albert Oehlen biography, p. 275.

1984 Paints in a carefully controlled and emotionally neutral style. Oehlen experiments with stencils and batiked canvas and favors subdued tones of brown, yellow and orange. "He avoids aggressive contrasts and strikes a graceful balance between paint and line, event and emptiness" (Frohne, 1984: 40-41).

1987 Wins the Berlin Art Prize.

current Lives and works in Hamburg.

Selected Exhibitions

1982 Hamburg, Galerie Vera Munro. *Markus Oehlen.*

1983 Cologne, Galerie Max Hetzler. *Markus Oehlen: Neue Bilder.*
Vienna, Galerie Peter Pakesch. *Markus Oehlen.*

1984 Berlin, Galerie Reinhard Onnasch. *Markus Oehlen: Neue Arbeiten.*
Cologne, Galerie Max Hetzler. *Markus Oehlen: Neue Bilder.*
New York, Metro Pictures. *Werner Büttner, Martin Kippenberger, Albert Oehlen and Markus Oehlen.* The first New York show for these four artists.

1985 Berlin, Galerie Reinhard Onnasch. *Markus Oehlen.*
Berlin, Galerie Reinhard Onnasch. *Markus Oehlen.*
Cologne, Galerie Max Hetzler. *Markus Oehlen: Drei Skulpturen.*

1986 Frankfurt, Galerie Grässling-Ehrhardt. *Markus Oehlen.*

1987 Cologne, Galerie Borgmann-Capitain. *Markus Oehlen: Gouachen.*
Cologne, Galerie Max Hetzler. *Markus Oehlen.*

1988 Frankfurt, Galerie Grässlin-Ehrhardt. *Markus Oehlen: Bilder von 1988.*
Hamburg, PPS Galerie F.C. Gundlach. *Markus Oehlen: Bilder 1980-88.*

Selected Bibliography

BEYER, Lucie. [Review of Markus Oehlen exhibition at Galerie Max Hetzler, Cologne.] *Flash Art* (March 1985): 50.

BISMARCK, Beatrice von. [Review of Markus Oehlen exhibition at Reinhard Onnasch Galerie, Berlin] *Flash Art* (January-February 1988): 130.

FAUST, Wolfgang Max, and Max Raphael. "Gemeinschaftsbilder: Ein Aspekt der neuen Malerei; Werner Büttner, Albert und Markus Oehlen, Martin Kippenberger: Erschlägt Wirklichkeit Kunst?" *Kunstforum International* (November 1983): 56-69.

FROHNE, Ursula. [Review of Markus Oehlen exhibition at Galerie Reinhard Onnasch, Berlin.] *Flash Art* (April-May 1984): 40-41.

GERCKEN, Günther, Raffael Jablonka, Thomas Wulffen et al. *Neue Kunst in Hamburg 1987.* Hamburg, 1987. Catalogue of exhibition at Kampnagelgelände, Hamburg.

HEARTNEY, Eleanor. "Four Germans." *Artnews* (February 1985): 140. Review of Markus Oehlen exhibition at Metro Pictures, New York.

HONNEF, Klaus. "Markus Oehlen." *Kunstforum International* (December 1983): 182-89.

KUSPIT, Donald B. [Review of Büttner, Kippenberger, Albert and Markus Oehlen exhibition at Metro Pictures, New York.] *Artforum* (January 1985): 90.

OHFF, Heinz. [Review of Markus Oehlen exhibition at Galerie Reinhard Onnasch, Berlin.] *Kunstwerk* (April 1984): 72.

VORRATH, J. [Review of Markus Oehlen exhibition at Galerie Vera Munro, Hamburg.] *Kunstforum International* (April-May 1982): 218.

C.O. Paeffgen

1933 Born in Cologne.

1959 After studying at the university in Cologne and in Berlin, takes his first law boards.

1966-67 Is engaged in the political scene of Berlin in the 1960s, especially in the protests against the Vietnam War. Although Paeffgen did not start painting until 1970, he made and continues to make art objects, most of which are politically or at least conceptually oriented. Paeffgen begins a project which he pursues through the present: he collects small objects he

finds on the street and wraps wire tightly around each one. Every found object is thus reduced to its essential form. Then he arranges the wire-encased objects in small piles on his studio floor.

1979 Works from photographs taken from newspapers and magazines. The artist takes a felt-tip pen and outlines the images with a thick line. Next he projects a slide of the image onto a photosensitized canvas. Finally he paints on top of the image on the canvas. The subjects of his photo-paintings have included Mussolini, Hitler, Ronald Reagan and Andy Warhol. For Paeffgen these figures function like signs in a cultural and political system.

current Lives and works in Cologne.

Selected Exhibitions

1978 Munich, Galerie Gerhild Grolitsch. *C.O. Paeffgen.*

1979 Hagen, Karl Ernst Osthaus Museum. *C.O. Paeffgen: Carmen 27 Zitronenkisten.* Catalogue includes "Zur Ausstellung" by Johann Heinrich Müller.

1981 Bonn, Kunstverein. *C.O. Paeffgen.* Catalogue includes "Über die Liebe: einige Bemerkungen zum Werk von C.O. Paeffgen" by Annelie Pohlen and "Porträt-Skizze C.O.P. mit Passepartout" by Rochus Kowallek.

1983 Mönchengladbach, Städtisches Museum Abteiberg. *C.O. Paeffgen.* Catalogue includes text by Sabine Kimpel-Fehlemann.

1986 Dusseldorf, Galerie Denise René-Hans Mayer. *C.O. Paeffgen.*

1987 Baden-Baden, Staatliche Kunsthalle. *C.O. Paeffgen.* Catalogue includes "Die diskreten Konturen des C.O. Paeffgen" by Jochen Poetter and "Die Bilder von C.O. Paeffgen" by Johann Heinrich Müller.
Bonn, Galerie Philomene Magers. *C.O. Paeffgen: Fragezeichen.* Accompanied by catalogue, Cologne: Verlag der Buchhandlung Walther König, and Bonn: Galerie Philomene Magers.

1988 Hamburg, Galerie Harald Behm. *C.O. Paeffgen: Eine erotische Ausstellung.*

Selected Bibliography

DIENST, Rolf-Gunter. [Review of Paeffgen exhibition at Staatliche Kunsthalle, Baden-Baden.] *Kunstwerk* (September 1987): 192-93.

POHLEN, Annelie. [Review of Paeffgen exhibition at Galerie Denise René-Hans Mayer, Dusseldorf.] *Artforum* (April 1986): 122.

PUVOGEL, R. [Review of Paeffgen exhibition at Städtisches Museum Abteiberg, Mönchengladbach.] *Kunstwerk* (February 1984): 41.

TAZZI, Pier Luigi. [Review of Paeffgen exhibition at Galerie Dietmar Werle, Cologne.] *Artforum* (January 1988): 130-31.

A. R. Penck

1939 Born Ralf Winkler in Dresden (now GDR).

1945 Witnesses the destruction of Dresden.

1949 Begins to paint in oil.

1955 Takes various odd jobs: paperboy, packer in a margarine factory, nightwatchman, theater extra and boilerman. Penck repeatedly applies to the art academies of Berlin (GDR) and Dresden but is turned down.

1960 Assumes different pseudonyms in his work (A. R. Penck, T. M., Mike Hammer, Alpha Ypsilon). The pseudonym Penck is derived from the geologist Albrecht Penck (1858-1945), who studied the Ice Age.

1961 Meets Baselitz. Penck applies to be an army officer and is rejected because he has no educational or professional qualifications. In addition, the authorities suspect him of "being 'anti-social' and 'associating with criminal elements'" (Walter Grasskamp, "Biographies of the Artists," in Joachimides, Rosenthal and Schmied, 1985: 496).

1965 Meets Michael Werner, who becomes Penck's most important link to the West. Because of Werner's support and patronage, Penck's work is included in numerous exhibitions outside the GDR – more than fifteen years before the artist himself is able to leave East Germany.

1973-74 Is drafted into the army. In 1974, Penck wins the International Prize of the Swiss Triennale. After discharge from the army he paints new series of works, produces films, publishes several texts and makes a group of felt sculptures.

1976 Receives the Will Grohmann Prize. Penck publishes *Ich bin ein Buch, kaufe micht jetzt* (I Am a Book, Buy Me Now). After an extended stay in Budapest, he moves back to Dresden.

1977 Meets Immendorff in East Berlin. With him writes a manifesto on their collaborative art activity. Forms an action coalition with Immendorff which results in various joint activities and exhibitions.

1979 Releases his first record album. Further individual and collaborative record albums follow in subsequent years. Immendorff visits him in his Dresden studio. Publishes *Sanfte Theorie über Arsch, Asche und Vegetation* (Gentle Theory of Ass, Ash and Vegetation).

1980 Obtains an exit visa, leaves East Germany and moves to Cologne. Receives the Rembrandt Prize from the Goethe Foundation, Basel. In a 1982 interview Penck says: "You musn't forget that the GDR is a dictatorship, and a state which is also an avowed enemy of modernism, a state which has done everything in its power to prevent the growth of modern art" (quoted in Dietrich, 1983: 92).

1982 Publishes the first issue of his magazine *Krater und Wolke* (Crater and Cloud). Makes the record "Die Rache der Erinnerung" (The Revenge of Memory) with Immendorff, Büttner, Kippenberger and Markus and Albert Oehlen. See Albert Oehlen biography, p. 275.

1983 "[I] keep my message unspecific and at times ambiguous. Only the structure of the painting has to be logical. The sequence of signs has to be accessible so that the viewer can work somehow with the information. You know the famous saying that one can't remember more than seven things at a time. There is something to that" (quoted in Dietrich, 1983: 95). Penck also communicates his message in the form of words and music. His written work often accompanies his exhibitions.

1983-84 Takes frequent trips to Israel and moves to London. In 1984, he participates in the Venice Biennale. Penck plays jazz and rock music with musicians from New York, London and Germany. He receives the Art Prize of the city of Aachen.

1984 "Quo vadis Germania? Quo vadis Germania? Do I really care? What business is the German problem of mine? Thrown back on myself I can begin to discover others again. When your opponent is strong, even small victories count. Bourgeois culture brings out the ape, antibourgeois culture the tiger. The view from here is that people [in the East and West] are duplicates of the same fictitious desire" (translation of A. R. Penck, "Quo Vadis Germania? Quo Vadis Germania?" in *von hier aus*. Cologne: 1984, p. 205).

1987 Professor at the Kunstakademie, Dusseldorf. Buys a house in northwest Ireland. Wins the Art Prize of the NORD/LB.

current Lives and works in Dublin, London, Dusseldorf and Cologne.

Selected Exhibitions

1974 Cologne, Galerie Werner. *A. R. Penck.*

1975 Bern, Kunsthalle. *A. R. Penck.* Organized by Johannes Gachnang.

1977 Basel, Galerie Rolf Preising. *Y (A. R. Penck).* Kassel. *Documenta 6: Malerei, Plastik und Performance.* Penck was represented by one painting.

1978 Basel, Kunstmuseum, and Berlin, Nationalgalerie. *a. r. penck, Y: Zeichnungen bis 1975.* Catalogue includes essay by Dieter Koepplin.

1979 Cologne, Museum Ludwig. *A. R. Penck: Zeichnungen bis 1975.*
Leverkusen, Städtisches Museum Leverkusen, Schloss Morsbroich. *A. R. Penck: Zeichnungen und Aquarelle.*

1980 Bordeaux, Centre d'arts plastiques contemporains. *Baselitz, Beuys, Penck: 300 dessins 1945-1978.*

1981 Basel, Kunstmuseum. *A. R. Penck.*
Bern, Kunsthalle. *A. R. Penck.*
Cologne, Josef-Haubrich-Kunsthalle. *A. R. Penck: Gemälde, Handzeichnungen.*
Cologne, Michael Werner Gallery. *A. R. Penck.*
New York, Sonnabend Gallery. *A. R. Penck: Paintings.* Penck's first one-man exhibition in New York.

1982 Chicago, Young Hoffman Gallery. *A. R. Penck.*
London, Waddington Galleries. *A. R. Penck.*
Milan, Studio Cannaviello-Toselli. *A. R. Penck.*
New York, Sonnabend Gallery. *A. R. Penck.*
Paris, Galerie Gillespie-Laage-Salomon. *A. R. Penck à Paris. Je suis un livre. Achète-moi maintenant.*

1983 Berlin, Galerie Springer. *A. R. Penck: "Welt des Adlers (Problem)" und Zeichnungen 1982/83.*
Cologne, Galerie Michael Werner. *A. R. Penck: Skulpturen.*
New York, Sonnabend Gallery. *A. R. Penck.*
Paris, Galerie Gillespie-Laage-Salomon. *A. R. Penck.*
Toronto, Yarlow-Salzman Gallery. *A. R. Penck.*

1984 Boston, The Alpha Gallery. *A. R. Penck: Paintings and Works on Paper.*
London, Tate Gallery. *A. R. Penck.*
Milan, Studio d'Arte Cannaviello. *A. R. Penck: Recent Works.*
New York, Martina Hamilton Gallery. *A. R. Penck: Prints.*
New York, Mary Boone & Michael Werner Gallery. *A. R. Penck: 1963-1983.*
Tokyo, Akira Ikeda Gallery. *A. R. Penck.*
Venice, *XXXXI Esposizione Biennale Internazionale d'Arte Venezia*, West German Pavilion.

1985 Cologne, Galerie Michael Werner. *A. R. Penck: tskrie.*
Frankfurt, Galerie Herbert Meyer-Ellinger. *A. R. Penck: Gouachen, Zeichnungen.*
Mönchengladbach, Städtisches Museum Abteiberg. *A. R. Penck; Mike Hammer: Konsequenzen.*
New York, Mary Boone & Michael Werner Gallery. *A. R. Penck.*
Saint-Etienne, Musée d'Art et d'Industrie. *A. R. Penck.*
Zurich, Galerie & Edition Stähli. *Ralf Winkler (a.r. penck): 100 frühe Zeichnungen (1956-1964).*

1986 Geneva, Cabinet des Estampes, and Mönchengladbach, Städtisches Museum Abteilberg. *A. R. Penck: Dessins et gravures du Kupferstichkabinett de Bâle.*
London, Waddington Galleries. *A. R. Penck: Sculptures in Bronze.*
Munich, Sabine Knust. *A. R. Penck: Radierungen.*
New York, Barbara Toll Fine Arts. *Ralf Winkler [a.r. penck]: Drawings 1956-1964.*
Paris, Galerie Gillespie-Laage-Salomon. *A. R. Penck: Peintures des annes 80.*
Zurich, Galerie Maeght-Lelong. *A. R. Penck: Sculptures.*
Zurich, Galerie Maeght-Lelong. *A. R. Penck: Graphik Ost/West.*
Zwevegem-Otegem, Belgium, Deweer Art Gallery. *A. R. Penck.*

1987 Cologne, Galerie Jule Kewenig. *Was einem Emigranten durch den Kopf geht.*
Derry, Orchard Gallery. *A. R. Penck: The Northern Darkness, Recent Sculpture/New Painting.* Catalogue includes interview with A. R. Penck.
Salzburg, Galerie Thaddäus Ropac. *A. R. Penck: Skulpturen und Zeichnungen 1985-87.*

1988 Berlin, Galerie Springer. *A. R. Penck.*
Berlin, Nationalgalerie, and Zurich, Kunsthaus Zurich. *A. R. Penck.* Catalogue includes "Ich sehe meine Arbeit nach wie vor als Bildforschung" by Lucius Griesbach and "A. R. Penck: Kann Kunst noch Wissenschaft sein?" by Thomas Kirchner. Munich: Prestel Verlag.
Hannover, Kestner-Gesellschaft. *A. R. Penck: Skulpturen und Zeichungen 1971-1987.* Catalogue, Carl Haenlein, ed., includes texts by Remo Guidieri, Carl Haenlein and A. R. Penck.
Paris. Galerie Lelong. *A. R. Penck: Sculptures.* Catalogue includes text by Remo Guidieri.

Selected Bibliography

ANON. "Penck e Immendorff," *Domus* (April 1982): 70-71.

——. "Première pour Penck." *Connaissance des Arts* (April 1985): 20. Review of Penck exhibition at Musée d'Art et d'Industrie, Saint-Etienne.

BECKER, Wolfgang. *New German Painting from the Ludwig Collection.* Catalogue of exhibition at Provinciaal Museum, Hasselt, Belgium, 1985.

BISMARCK, Beatrice von. [Review of Penck exhibition at Galerie Springer Berlin.] *Noema: Art Magazine* 18-19 (1988): 98.

BLUM, Peter. "Penck Übergang." *Du* (November 1980): 14-20.

CATOIR, Barbara. [Review of Penck exhibition at Galerie Werner, Cologne.] *Kunstwerk* (July 1974): 43-44.

CELANT, Germano, ed. "A Project by A.R. Penck." *Artforum* (November 1981): 55-62.

COLLIER, Caroline. "The Codes of an Outsider." *Studio International*, no. 1007 (1984): 58. Review of Penck exhibition at Tate Gallery, London.

DIETRICH, Dorothea. "A Talk with A.R. Penck." *The Print Collector's Newsletter* (July-August 1983): 91-95.

FELLENBERG, W. von. "Eine Quersumme neuer Erfahrungen." *Weltkunst* (September 15, 1981): 2552. Review of Penck exhibition at Kunsthalle, Bern.

FISHER, J. [Review of Penck exhibition at Mary Boone & Michael Werner Gallery, New York.] *Artforum* (March 1986): 115-16.

GALLIGAN, G. [Review of Penck exhibition at Mary Boone & Michael Werner Gallery, New York.] *Arts Magazine* (January 1986): 138-39.

GAMBRELL, J. [Review of Penck exhibition at Mary Boone & Michael Werner Gallery, New York.] *Art in America* (January 1986): 138-39.

GARCIA-HERRAIZ, Enrique. [Review of Penck exhibition at Sonnabend Gallery, New York.] *Goya* (January-February 1983): 251.

GIRLING, O. [Review of Penck exhibition at Yarlow-Salzman Gallery, Toronto.] *Artmagazine* (Summer 1983): 26.

GOHR, Siegfried. "A.R. Penck: Expedition to the Holy Land." *Flash Art* (November 1983): 56-58.

GRÜTERICH, Marlies. [Review of Penck exhibition at Kunsthalle, Bern] *Studio International* (September-October 1975): 158-59.

HAPGOOD, Susan. "Irrationality in the Age of Technology." *Flash Art* (January 1983): 41-43.

HEINRICH, Theodore Allen. "Documenta 6, Part III: Painting." *Artscanada* (April-May 1978): 60-62.

KOEPPLIN, Dieter. "Experience in Reality: The Art of A.R. Penck." *Studio International* (March 1974): 112-16.

KONTOVA, Helena. [Review of Penck exhibition at Studio d'Arte Cannaviello-Toselli, Milan.] *Flash Art* (May 1982): 54.

KUSPIT, Donald B. [Review of Penck exhibition at Sonnabend Gallery, New York.] *Art in America* (February 1982): 139.

———. [Review of Penck exhibition at Mary Boone & Michael Werner Gallery and Martina Hamilton Gallery, New York.] *Artforum* (April 1984): 81.

LAWSON, Thomas. [Review of Penck exhibition at Sonnabend Gallery, New York.] *Artforum* (March 1982): 72.

PENCK, A.R. "Insert by A.R. Penck: The Secret Battle 1977." *Parkett*, 10 (1986): 120-37.

———, and Klaus Gallwitz, ed. *Mein Denken.* Frankfurt: Suhrkamp, 1987.

PILLER, Mickey. [Review of Penck exhibition at Galerie Michael Werner, Cologne.] *Artforum* (March 1981): 91-92.

PINCUS-WITTEN, Robert. "Entries: I: Baselitzmus: II: Borstal Boy Goes Mystic." *Arts Magazine* (June 1984): 96-98.

POHLEN, Annelie. [Review of Penck exhibition at Museum Ludwig, Cologne.] *Flash Art/Heute Kunst* (January-February 1980): 67.

POIRIER, M. [Review of Penck exhibition at Mary Boone & Michael Werner Gallery, New York.] *Artnews* (January 1986): 128.

PREVOST, Jean Marc. [Review of Penck exhibition at Galerie Gillespie-Laage-Salomon, Paris] *Flash Art* (May 1982): 54.

SCHWEINEBRADEN, Jürgen. "A.R. Penck: Malerei als Revolution." In *1945-1985: Kunst in der Bundesrepublik Deutschland:* 259-65. Catalogue of exhibition at Nationalgalerie, Berlin, 1985.

STICH, Sidra. "Pictorial, Personal and Political Expression in the Art of A.R. Penck." *Arts Magazine* (June 1984): 121-25.

VIELHABER, Christiane. [Review of Penck exhibitions at Galerie Jule Kewenig, Cologne, and Galerie Thaddäus Ropac, Salzburg.] *Art in America* (December 1987): 167.

WECHSLER, Max. [Review of Penck exhibition at Galerie Maeght-Lelong, Zurich.] *Artforum* (November 1986): 147-48.

WINTER, Paul. [Review of Penck exhibition at Josef-Haubrich-Kunsthalle, Cologne.] *Kunstwerk,* (April 1981): 82-84.

Sigmar Polke

1941 Born in Oels (now Olesnica, Poland).

1953 Moves with family to West Germany.

1959-60 Learns technique of stained glass in Dusseldorf.

1961-67 Studies painting at the Kunstakademie, Dusseldorf, under Gerhard Hoehme and Karl Otto Götz. While at the Kunstakademie Polke becomes acquainted with Richter. "Their [Polke's and Richter's] tabula rasa was designed to rid painting of its stifling 'ich,' the gesture, the subjectivity; Polke decided that all dots were his friends (another quote), and polka-dotted his paintings to simulate the raster of the printed page" (Barbara Flynn, [Review of Richter exhibition at Sperone Westwater Fischer Gallery, New York], *Artforum* [April 1978]: 62).

1963 With Konrad Fischer (alias Lueg) and Richter, he founds Kapitalistischer Realismus.

1966 Receives the West German Young Talent Award, Baden-Baden, in the same year as Krieg.

1970-77 Visiting professor at the Hochschule für Bildende Künste, Hamburg. Is appointed professor in 1977.

1974 Travels to Afghanistan and Pakistan.

1975 Polke receives the São Paulo Bienal Grand Prize.

1979-80 The artist travels to Southeast Asia, New Guinea and Australia.

1982 "[Polke] has developed a painting style that brings together a sophisticated taste for popular culture and kitsch with a spacey transcendentalism. For years Polke has luxuriated in the delirious appropriation of material, images, and styles favored by so many artists today. He has mimicked banal forms of photography and high-Modernist abstraction, he has lifted images from wallpaper design and comic books, he has used all sorts of untraditional and unstable materials, he has used thick paint and thin, large scale and small. In short, much more than painters like Georg Baselitz and Markus Lüpertz, for example, he is an artist who is still vitally connected to the world and to the problem of dealing with it effectively in contemporary terms" (Lawson, 1982: 67).

1982-86 Receives the following prizes: Will Grohmann Prize, Berlin (1982), Kurt Schwitters Prize, Hannover (1984), Lichtwark Prize of Hamburg (1985), Golden Lion Art Prize of the Venice Biennale (1986).

current Lives and works in Hamburg and Cologne.

Selected Exhibitions

1973 Frankfurt, Galerie Loehr. *Sigmar Polke.*

1976 Dusseldorf, Kunsthalle; Eindhoven, Stedelijk Van Abbemuseum; and Tubingen, Kunsthalle. *Sigmar Polke: Bilder, Tücher, Objekte: Werkauswahl 1962-1971.* Catalogue includes essays by Sigmar Polke, Friedrich W. Heubach, Benjamin H.D. Buchloch and Joseph Beuys.

1982 New York, Holly Solomon Gallery. *Sigmar Polke: Works 1972-1981.* First one-man exhibition in New York.

1983 Bonn, Galerie Klein. *Sigmar Polke.* Cologne, Galerie Michael Werner. *Sigmar Polke.* Sketchbook sheets from the 1960s. Milan, Studio d'Arte Cannaviello. *Sigmar Polke.*

1984 Bonn, Galerie Klein. *Sigmar Polke.* Bonn, Städtisches Kunstmuseum. *Sigmar Polke.* New York, Marian Goodman Gallery. *Sigmar Polke: Paintings.* Rotterdam, Boymans-van Beuningen Museum, and Zurich, Kunsthaus. *Sigmar Polke.* Catalogue includes "Halonen am Firmament der Bilder" by Harald Szeemann, "29. Februar: zu Polke" by Dietrich Helms and "Okkulte Intelligenz" by Reiner Speck.

1985 London, Anthony d'Offay Gallery. *Sigmar Polke.* New York, Marian Goodman Gallery. *Sigmar Polke.* New York, Mary Boone & Michael Werner Gallery. *Sigmar Polke.* Paris, Galerie Bama. *Sigmar Polke.*

1986 Cologne, Thomas Borgmann Kunsthandel. *Sigmar Polke: Bilder und Aquarelle der 6oer Jahre.* Dusseldorf, Galerie Schmela. *Sigmar Polke: Titel gibt's nicht.* New York, Mary Boone Gallery. *Sigmar Polke.* Venice, *XLII Esposizione Biennale Internazionale d'Arte Venezia,* West German Pavilion. *Sigmar Polke: Athanor.* Catalogue includes essay by Dierk Stemmler.

1987 New York, David Nolan Gallery. *Sigmar Polke: Drawings from the 1960's.* Catalogue includes text by Prudence Carlson.

1988 Bonn, Kunstmuseum. *Sigmar Polke: Zeichnungen, Aquarelle, Skizzenbücher 1962-1988.* Catalogue includes "Pfeile ins Gewitter" by Katharina Schmidt and "Zeichnungen von Sigmar Polke" by Gunter Schweikhart. New York, Mary Boone & Michael Werner Gallery. *Sigmar Polke.*

Selected Bibliography

AMMANN, Jean-Christophe. "Schweizer Brief." *Art International* (October 1969): 68. Review of *Düsseldorfer Szene* exhibition at Kunstmuseum, Lucerne, in which Immendorff, Polke and Richter were included.

BERLIND, R. [Review of Polke exhibition at Mary Boone & Michael Werner Gallery, New York.] *Art in America* (April 1985): 201-2.

BEYER, Lucie. [Review of Polke exhibition at Galerie Klein, Bonn.] *Flash Art* (April-May 1984): 41-42.

BISCHOFF, Ulrich, and J. C. Jensen. *Medium Photographie, 8: Künstlerarbeiten mit Fotos.* Catalogue of exhibition at Kunsthalle, Kiel, 1982, in which Polke was included.

BRENSON, Michael. "Art: Sigmar Polke, A Master of Elusion." *The New York Times* (January 11, 1985): C21. Review of Polke exhibition at Mary Boone & Michael Werner Gallery, New York.

BUCHLOCH, Benjamin H.D. "Parody and Appropriation in Francis Picabia, Pop, and Sigmar Polke." *Artforum* (March 1982): 28-34.

CURIGER, B., interviewer. "Sigmar Polke: La Peinture est une ignominie." *Art Press* (April 1985): 4-10.

DIMITRIJEVIC, Nena. "Alice in Culturescapes." *Flash Art* (Summer 1986): 52 ff.

FISHER, J. [Review of Polke exhibition at Mary Boone & Michael Werner Gallery, New York.] *Artforum* (May 1985): 102-3.

FLEISCHER, A. "Polke: Peintre de la surimpression." *Art Press* (April 1985): 10-12.

FRAILEY, S. "Sigmar Polke: Photographic Obstruction." *Print Collector's Newsletter* (July-August 1985): 78-80. Review of Polke exhibition at Alfred Kren Gallery, New York.

FREY, Patrick. "Sigmar Polke." *Flash Art* (Summer 1984): 44-47.

FUCHS, Rudi. "Sigmar Polke." In *Art of Our Time: The Saatchi Collection:* 22-24. London: Lund Humphries in association with Rizzoli, 1985.

GACHNANG, Johannes, ed. *Zeichnungen 1963-1969.* Bern: Verlag Gachnang & Springer AG, 1987.

GINTZ, Claude. "Polke's Slow Dissolve." *Art in America* (December 1985): 102-9.

GODFREY, Tony. [Review of Polke exhibition at Anthony d'Offay Gallery, London.] *Burlington Magazine* (April 1985): 251.

GRIMES, Nancy. [Review of Polke exhibition at Mary Boone & Michael Werner Gallery, New York.] *Artnews* (April 1985): 136-37.

GROOT, Paul. "To Describe the Wonders. . . . [Arte e Scienza at the 42nd Venice Biennale.]" *Artforum* (September 1986): 118-19.

——. "Sigmar Polke." *Flash Art* (May-June 1988): 66-67.

HONNEF, Klaus "Malerei als Abenteuer oder Kunst und Leben." *Kunstforum International* (April-May 1984): 132-207.

——. "Sigmar Polke." In *1945-1985: Kunst in der Bundesrepublik Deutschland:* 253-58. Catalogue of exhibition at Nationalgalerie, Berlin, 1985.

——, ed. "Die Welt als Imagination – Die Imagination als Welt." *Kunstforum International* (June-August 1986): 150-81.

KLEIN, Michael. [Review of Polke exhibition at Holly Solomon Gallery, New York.] *Artnews* (September 1982): 156.

KUSPIT, Donald B. [Review of Polke exhibition at Mary Boone Gallery, New York.] *Artforum* (February 1987): 111-12.

——. [Review of Polke exhibition at David Nolan Gallery, New York.] *Art in America* (January 1988): 130-1.

——. "At the Tomb of the Unknown Picture: The Art of Sigmar Polke." *Artscribe* (March-April 1988): 38-45.

LAWSON, Thomas. "Sigmar Polke." *Artforum* (October 1982): 67. Review of Polke exhibition at Holly Solomon Gallery, New York.

MASHEK, Joseph. "Art: Polke on Display." *The New York Times* (November 14, 1986): C30. Review of Polke exhibition at Mary Boone & Michael Werner Gallery, New York.

POHLEN, Annelie. "Sigmar Polke." *Artforum* (November 1983): 90-91. Review of Polke exhibition at Galerie Michael Werner, Cologne.

——. "Achtung vor der Falle des Genies." *Du* (April 1984): 68. Review of Polke exhibitions at Städtisches Kunstmuseum and Galerie Klein, Bonn.

POIRIER, M. [Review of Polke exhibition at Mary Boone Gallery, New York.] *Artnews* (February 1987): 127-28.

POLKE, Sigmar. [Photographs.] *Interfunktionen* (January 1972): 2-13.

——. "A Project by Sigmar Polke." *Artforum* (December 1983): 51-55.

——. [Photographs.] *Parkett*, 13 (1987): 105-17.

——. "What Interests Me is the Unforeseeable: Sigmar Polke Talks About His Work." *Flash Art* (May-June 1988): 68-70.

——. "'Registro.'" *Interfunktionen*, 10 (n.d.): 15-24.

PUVOGEL, Renate. [Review of Polke exhibition at Museum Boymans-van Beuningen, Rotterdam.] *Kunstwerk* (June 1984): 59-60.

REISE, Barbara M. "Who, What is 'Sigmar Polke'... And Where Can He Be Found?" *Studio* (July 1976): 83-86. Parts I and II.

——. "Who, What is 'Sigmar Polke'?" *Studio* (September 1976): 207-10. Part III.

——. "Who, What is 'Sigmar Polke'?" *Studio* (January-February 1977): 38-40. Part IV.

SAINZ, Simeon. "A Polke le cuesta ir a Nueva York." *Figura* (April 1985): 21.

SCHWARTZ, S. "The Saatchi Collection, or a Generation Comes into Focus." *The New Criterion* (March 1986): 22-37.

SMITH, Roberta. [Review of Polke exhibition at Holly Solomon Gallery, New York.] *The Village Voice* (May 25, 1982): 88.

——. "Material Concerns." *The Village Voice* (May 29, 1984): 85. Review of Polke exhibition at Marian Goodman Gallery, New York.

STACHELHAUS, Heiner. "Der Verwandlungskünstler: Sigmar Polke auf der Biennale in Venedig." *Kultur Chronik* (April 1986): 5.

STEMMLER, Dierk. "Pavillion BRD: Sigmar Polke." *Kunstforum International* (October 1986): 182-87.

WECHSLER, Max. [Review of West German Pavilion at Venice Biennale.] *Artforum* (October 1986): 142.

WINTER, Peter. "Titel gibt's nicht." *Kunstwerk* (June 1986): 67-68. Review of Polke exhibition at Galerie Schmela, Dusseldorf.

WIRTH, G. [Review of Polke exhibition at Kunsthalle, Tubingen.] *Kunstwerk* (June 1976): 32, 69.

WORSEL, T. "Notes om tsck kunst." *Louisiana Revy* (February 1977): 32.

Gerhard Richter

1932 Born in Dresden.

1949-52 Works as an assistant in a photography laboratory. (Richter maintains that this experience did not have a major impact on his work.) Also paints scenery at a theater in Zittau and works as a poster and billboard painter in a factory.

1952-57 Studies at the Hochschule für Bildende Künste, Dresden. Receives a traditional painter's training. Learns about modern art, although everything from Impressionism onward is officially considered "decadent," and books on the subject are not available in the library (Bruggen, 1985: 83).

1961 Moves to Dusseldorf in March, just two months before the Berlin Wall is erected to stop the East-West emigration.

1961-63 Studies at the Kunstakademie, Dusseldorf, under Karl Otto Götz. Admires the work of Francis Bacon, Alberto Giacometti and Jean Dubuffet. While at the Kunstakademie, Richter becomes acquainted with Polke. "Their [Richter's and Polke's] tabula rasa was designed to rid painting of its stifling 'ich,' the gesture, the subjectivity" (Flynn, 1978: 62).

1962 Is interested in the ideas of the Fluxus artists, who give their first concert at the Kunstakademie, Dusseldorf. Richter describes the event: "It was all very cynical and destructive. It was a signal for us, and we became cynical and cocky and told ourselves that art is bull and Cézanne is stupid." This attitude provoked Richter to "paint a photo!" (Bruggen, 1985: 83). Richter makes paintings that look like photographs. He begins by enlarging and projecting actual photographic images on canvas. Some of the photographs he takes himself, while others he finds in newspapers, magazines and family albums. The paintings are done in gray tones and shades of black and white. Later, using "defects in the photographic method, such as blurring due to camera movement, combinations of in and out of focus, simplification due to sharp black and white contrast, grainy quality, smudges and specks due to sloppy development technique, and so on, he created 'flaws' that mediate between the two mediums [of painting and photography]" (Bruggen, 1985: 86).

1963 Cofounds Kapitalistischer Realismus with Konrad Fischer (alias Lueg) and Polke. In October Richter and Fischer (now a prominent gallery owner) stage "A Demonstration for Capitalist Realism," which consists of showing a Dusseldorf furniture warehouse in the form of an exhibition. In one room, the artists reconstruct an ordinary living room. It is decorated with furniture, food, drinks, books and housewares. Separate pieces of furniture are placed on pedestals, like sculptures, to distance the common objects from the viewers. Richter and Fischer, dressed in suits and ties, are also on display.

1966 Receives the West German Young Talent Award, Recklinghausen.

1967 Visiting professor at the Hochschule für Bildende Künste, Hamburg.

1968-69 Teaches art at a Dusseldorf high school.

1971 Professor at the Kunstakademie, Dusseldorf.

1972 Represents West Germany at the Venice Biennale.

1978 Visiting professor at Nova Scotia College of Art and Design, Halifax.

1981 Receives the Arnold Bode Award of the City of Kassel.

1982 Statement on the occasion of *Documenta*: "Abstract paintings are fictive models because they show a reality that we neither can see nor describe, but whose existence we can surmise. This reality we characterize in negative terms: The unknown, the incomprehensible, the infinite, and for thousands of years we have described it with ersatz pictures, with heaven, hell, gods, devils. – With abstract painting we created a better possibility to approach that which cannot be grasped or understood, because in the most concrete form it shows 'nothing.' Accustomed to recognizing something real in pictures, we rightly refuse to recognize only color in all of its variety as the represented and instead allow ourselves to see the ungraspable, that which was never seen before and which is not visible. This is not artful play but a necessity because everything unknown frightens us and makes us hopeful at the same time" (translation of Gerhard Richter, in catalogue of *Documenta 7* exhibition, Kassel, 1982: 83-85).

1985 Simultaneously pursues two or more dissimilar bodies of work, whose development runs parallel to each other. Richter explains: "There is the notion that it's actually appropriate for an artist to develop a specific type of expression and that's it. This is seen as the high point. But then again you'll always find arguments for making two or more different kinds" (quoted in Bruggen, 1985: 91).
Receives the Oskar Kokoschka Prize.

current Lives and works in Cologne.

Selected Exhibitions

1964 Berlin, Galerie René Block. *Gerd Richter: Bilder des Kapitalistischen Realismus.* Catalogue includes "Gerd Richter oder der Kapitale 'Kapitalistische Realismus'" by Manfred de la Motte.
Dusseldorf, Galerie Alfred Schmela. *Gerd Richter.*

1966 Berlin, Galerie René Block. *Gerhard Richter.*
Rome, Galleria La Tartaruga. *Gerd Richter.*
San Marco, Galleria del Leone. *Gerhard Richter.*
Zurich, Galerie Bruno Bischofberger. *Gerhard Richter.*

1968 Cologne, Galerie Rudolf Zwirner. *Gerhard Richter: Ölbilder.*
Kassel, Galerie Rolf Ricke. *Gerhard Richter: Bilder.*

1969 Berlin, Galerie René Block. *Gerhard Richter.*
Essen, Museum Folkwang. *Gerhard Richter: Graphik 1965-70.* Catalogue includes "Die 'Graphik' Gerhard Richters" by Dieter Honisch.
New York, Solomon R. Guggenheim Museum. *Nine Young Artists: Theodoron Awards.* With catalogue. This was Richter's first exhibition in New York; he was the only German included.

1970 Dusseldorf, Galerie Konrad Fischer. *Gerhard Richter.*

1971 Dusseldorf, Grabbeplatz Kunsthalle, Kunstverein für die Rheinlande und Westfalen. *Gerhard Richter: Arbeiten 1962 bis 1971.* Catalogue includes "Über Gerhard Richter" by Dietrich Helms.

1972 Kassel, *Documenta 5.*
Venice, *XXXVI Esposizione Biennale Internazionale d'Arte Venezia,* West German Pavilion. *Gerhard Richter.* Forty-eight portraits based on encyclopedia photographs of eminent scholars of the nineteenth and twentieth centuries. Catalogue includes "Zu den Arbeiten Gerhard Richters" by Dieter Honisch, "Über Gerhard Richter" by Dietrich Helms, "Schwierigkeiten beim Beschreiben der Realität: Richters Malerei zwischen Kunst und Wirklichkeit" by Klaus Honnef, "Über Gerhard Richter" by Heinz Ohff, interviews by Rolf Gunter Dienst and Rolf Schön and essay by Sigmar Polke and Gerhard Richter.

1973 Lucerne, Kunstmuseum. *Gerhard Richter.*
Munich, Städtische Galerie im Lenbachhaus. *Gerhard Richter.* Catalogue includes essay by Jean-Christophe Ammann.
New York, Reinhard Onnasch Gallery. *Gerhard Richter: Paintings 1962-1973.*

1974 Mönchengladbach, Städtisches Museum. *Gerhard Richter.* Catalogue includes "Gerhard Richter Graue Bilder" by Johannes Cladders.
Munich, Galerie Heiner Friedrich. *Gerhard Richter, Atlas: Entwürfe, Fotografien, Skizzen, 295 Blätter von 1962-1973.*

1975 Bremen, Kunsthalle, and Brussels, Palais des Beaux-Arts. *Gerhard Richter: Bilder aus den Jahren 1962-1974.* Catalogue includes "Gerhard Richter, oder ein Weg weiterzumalen" by Manfred Schneckenburger and "Gerhard Richters Phänomenologie der Illusion: Eine gemalte Ästhetik gegen die reine Malerei" by Marlis Grüterich.
Dusseldorf, Galerie Konrad Fischer. *Gerhard Richter.*

1976 Florence, Renzo Spagnoli. *Gerhard Richter: Dipinti dal 1966 al 1976.*
Paris, Galerie Liliane et Michel Durand-Dessert. *Gerhard Richter.*

1977 Dusseldorf, Galerie Konrad Fischer. *Gerhard Richter.*
Kassel, *Documenta 6: Malerei, Plastik und Performance.* Catalogue includes essay by Klaus Honnef.
Paris, Galerie Expérimentale, Musée National d'Art Moderne, Centre Georges Pompidou. *Gerhard Richter.* Catalogue includes "Ready-Made photographie et peinture dans la peinture de Gerhard Richter" by Benjamin H.D. Buchloch.

1978 Cincinnati, Contemporary Arts Center; Chicago, The Art Institute of Chicago; Fort Worth, Fort Worth Art Museum; San Francisco Museum of Modern Art; and Washington, D. C., Joseph H. Hirshhorn Museum and Sculpture Garden. *Europe in the Seventies.*
Eindhoven, Stedelijk Van Abbemuseum, and London, Whitechapel Art Gallery (1979). *Gerhard Richter: Abstract Paintings.* Catalogue includes "Artificial Miracles" by Rudi H. Fuchs and "Ready-made, photography and painting in the painting of Gerhard Richter" by Benjamin H. D. Buchloch.
Milan, Galleria Massimo Valsecchi. *Gerhard Richter: Opere scelte 1966-1972.*
New York, Sperone Westwater Fischer Gallery. *Gerhard Richter: Abstract Paintings.*

1980 Essen, Museum Folkwang. *Gerhard Richter: Zwei Gelbe Striche.* Catalogue includes "'Zwei gelbe Striche' von Gerhard Richter" by Zdenek Felix.
New York, Sperone Westwater Fischer Gallery. *Gerhard Richter: Abstract Paintings, Candles.*

1981 Dusseldorf, Städtische Kunsthalle. *Georg Baselitz; Gerhard Richter.* Catalogue includes essays by Jürgen Harten and Ulrich Krempel.
Milan, Galleria d'Arte Moderna, Padiglione d'Arte Contemporanea. *Gerhard Richter.* Catalogue includes "Osservazioni dei percorsi interni, mutevoli e alti della pittura" by Bruno Corà.

1982 Bielefeld, Kunsthalle Bielefeld, and Mannheim, Mannheimer Kunstverein. *Gerhard Richter: Abstrakte Bilder 1976 bis 1981.* Catalogue includes "Artificial Miracles" by R.H. Fuchs (reprinted from 1978 Eindhoven catalogue) and "Gerhard Richter: Die abstrakten Bilder zur Frage des Inhalts" by Heribert Heere.
Munich, Galerie Fred Jahn. *Gerhard Richter: Abstrakte Bilder 1975-1981.*
Kassel, *Documenta 7.* Catalogue includes statement by Gerhard Richter.
Zurich, Galerie Konrad Fischer. *Gerhard Richter.*

1983 Naples, Galleria Lucio Amelio. *Gerhard Richter: Terrae Motus.*
New York, Sperone Westwater Fischer Gallery. *Gerhard Richter.*

1984 Cologne, Galerie Holtmann. *Gerhard Richter: Aquarelle.*
Cologne, Galerie Wilkens/Jacobs. *Gerhard Richter.*
Munich, Galerie Fred Jahn, and Stuttgart, Staatsgalerie. *Gerhard Richter: 77 Aquarelle 1983/84.*
Paris, Galerie Liliane et Michel Durand-Dessert, and Saint-Etienne, Musée d'Art et d'Industrie. *Gerhard Richter.* Catalogue includes "Gerhard Richter ou l'exercice du soupçon."

1985 Munich, Galerie Fred Jahn. *Gerhard Richter: Abstrakte Bilder.*
New York, Marian Goodman Gallery/Sperone Westwater Gallery. *Gerhard Richter.* Catalogue includes "Richter's Facture Between the Synedoche and the Spectacle" by Benjamin H.D. Buchloh.

1986 Berlin, Nationalgalerie; Bern, Kunsthalle; Dusseldorf, Städtische Kunsthalle; and Vienna, Museum Moderner Kunst/Museum des 20. Jahrhunderts. *Gerhard Richter: Bilder 1962-1985.*
New York, Barbara Gladstone Gallery, and Cologne, Galerie Rudolf Zwirner. *Gerhard Richter: Selected Early Works.* Catalogue includes essay by Wilfried Dickhoff.

1987 Amsterdam, Museum Overholland. *Gerhard Richter: Werken op papier, 1983-1986.*
London, Karsten Schubert Ltd. *Gerhard Richter: Works on Paper, 1984-1986.*
New York, Marian Goodman Gallery/Sperone Westwater Fischer Gallery. *Gerhard Richter: Paintings.* Catalogue includes "Gerhard Richter: The Illusion and Reality of Painting" by Anne Rorimer and "Abstract Painting" by Denys Zacharopoulos.
Rome, Galleria Pieroni. *Gerhard Richter e Isa Genzken.* Catalogue includes "Die Selbstporträts von I.G.G.R." by Paul Groot.

1988 Chicago, Museum of Contemporary Art, and Toronto, Art Gallery of Ontario. *Gerhard Richter: Paintings.* Organized by Roald Nasgaard. Catalogue includes essay by I. Michael Danoff and interview with Richter by Benjamin H.D. Buchloh.
London, Anthony d'Offay Gallery. *Gerhard Richter: The London Paintings.* Catalogue includes "Gerhard Richter: The London Paintings" by Jill Lloyd.
New York, David Nolan Gallery. *Gerhard Richter: Multiples and Complete Prints.*
Paris, Galerie Liliane & Michel Durand-Dessert. *Gerhard Richter.* Catalogue includes "L'Atelier de Richter: La Peinture" by Denys Zacharopoulos.

Selected Bibliography

AMMANN, Jean-Christophe. "Schweizer Brief." *Art International* (October 1969): 68. Review of *Düsseldorfer Szene* exhibition at Kunstmuseum, Lucerne, in which Immendorff, Polke and Richter were included.

ANON. "Atlas." [Review of Richter exhibition at Galerie Heiner Friedrich, Munich.] *Domus* (August 1974): 59.

——. [Review of Richter exhibition at Galerie Expérimentale, Musée National d'Art Moderne, Centre Georges Pompidou.] *Connaissance des Arts* (February 1977): 17.

——. "Gerhard Richter. Abstrakte Bilder." *Domus* (March 1982): 70-71.

——. Richter, tout peindre." *Connaissance des Arts* (March 1984): 27. Review of Richter exhibition at Galerie Durand-Dessert, Paris.

BATTCOCK, Gregory. "Reports: Venice and Documenta." *Arts Magazine* (September-October 1972): 52.

BELL, Jane. [Review of Richter exhibitions at Marian Goodman Gallery and Sperone Westwater Gallery, New York.] *Artnews* (Summer 1985): 117.

BLISTENE, Bernard. "Gerhard Richter." *Galeries Magazine* (April-May 1988): 90-95, 141.

BRUGGEN, Coosje van. "Gerhard Richter: Painting as a Moral Act." *Artforum* (May 1985): 82-91.

CALEY, S. [Review of Richter exhibition at Barbara Gladstone Gallery, New York.] *Flash Art* (April 1987): 90.

CAMERON, Dan. "Seven Types of Criticality." *Arts Magazine* (May 1987): 16-17

DANOFF, I. Michael. "Report from Chicago: Review of the exhibition *Europe in the Seventies.*" *Art in America* (January - February 1978): 97.

——. [Review of Richter exhibition at Sperone Westwater Fischer Gallery, New York.] *Artnews* (April 1978): 151.

——. "Gerhard Richter: Multiple Styles." *Arts Magazine* (June 1978): 150-51.

DAY, Peter. "On the Richter Scale." *Canadian Art* (Spring 1988): 80-85.

DERFNER, P. [Review of Richter exhibitions at Marian Goodman Gallery and Sperone Westwater Gallery, New York.] *Art in America* (September 1985): 138.

DIETRICH, Dorothea, interviewer. "Gerhard Richter: An Interview." *The Print Collector's Newsletter* (September - October 1985): 128-32.

——. "Retrospectiva de Gerhard Richter." *Goya* (March - April 1986): 298-99. Review of Richter exhibition at Städtische Kunsthalle, Dusseldorf.

DIMITRIJEVIC, Nena. "Alice in Culturescapes." *Flash Art* (Summer 1986): 52 ff.

ELLIS, Steven. "The Elusive Gerhard Richter." *Art in America* (November 1986): 130-39. Review of Richter exhibition at Städtische Kunsthalle, Dusseldorf.

FLYNN, Barbara. [Review of Richter exhibition at Sperone Westwater Fischer Gallery, New York.] *Artforum* (April 1978): 62.

FRIEDRICHS, Yvonne. [Review of Richter exhibition at Kunsthalle, Dusseldorf.] *Kunstwerk* (April 1981): 80.

FRY, Edward F. "Gerhard Richter: German Illusionist." *Art in America* (November 1969): 126-27.

GRAEVENITZ, Antje van. "Het maatschappelijk gezicht." *Openbaar Kunstbezit: De Foto in de Beeldende Kunst* (February 1979): 15-17.

GRASSKAMP, Walter. "Gerhard Richter: an Angel Vanishes." *Flash Art* (May - June 1986). 30 35.

HARTEN, Jürgen. "Der romantische Wille zur Abstraktion." In *Gerhard Richter*, Bilingual ed., Cologne: DuMont Buchverlag, 1986, 9-62.

HONISCH, Dieter. "Gerhard Richter." In *1945-1985: Kunst in der Bundesrepublik Deutschland:* 248-52. Catalogue of exhibition at Nationalgalerie, Berlin, 1985.

HONNEF, Klaus. "Richter's New Realism." *Art and Artists* (September 1973): 34-37.

——. *Gerhard Richter.* Monographien zur rheinisch-westfälischen Kunst der Gegenwart, vol. 50. Recklinghausen: Verlag Aurel Bongers, 1976.

KIFFEL, E. *Künstler in ihrem Atelier.* Foreword by J. Krichbaum. Munich: Mahnert-Lueg, 1979.

KUSPIT, Donald B. [Review of Richter exhibition at Marian Goodman Gallery/Sperone Westwater Fischer Gallery, New York.] *Artforum* (Summer 1987): 115-16.

LAWSON, Thomas. [Review of Richter exhibition at Sperone Westwater Fischer Gallery, New York.] *Flash Art* (March-April 1980): 18.

LIMKER, Kate. [Review of Richter exhibition at Sperone Westwater Fischer Gallery, New York.] *Artforum* (April 1983): 71-72.

LLOYD, Jill. [Review of Richter exhibition at Karsten Schubert Ltd., London.] *Burlington Magazine* (September 1987): 612.

OHFF, Heinz. [Review of Richter exhibition at Galerie René Block, Berlin.] *Kunstwerk* (February 1969): 79.

PFEIFFER, Günter. [Review of Richter exhibition at Kunstverein für die Rheinlande und Westfalen, Dusseldorf.] *Kunstwerk* (September 1971): 80-81.

PICKSHAUS, Peter Moritz. [Review of Richter exhibition at Kunsthalle, Bielefeld.] *Kunstforum International* (April - May 1982): 220-21.

PILLER, Micky. [Review of Richter exhibition at Museum Folkwang, Essen.] *Artforum* (November 1980): 95-96.

POHLEN, Annelie. [Review of Richter exhibition at Städtische Kunsthalle, Dusseldorf.] *Artforum* (May 1986): 148.

PRINCENTHAL, Nancy. [Review of Richter exhibition at Sperone Westwater Fischer Gallery, New York.] *Artnews* (March 1983): 160.

PUVOGEL, Renate. [Review of Richter exhibition at Städtische Kunsthalle, Dusseldorf.] *Kunstwerk* (April 1986): 60-61.

REASON, Rex. [Review of Richter exhibition at Sperone Westwater Fischer Gallery, New York.] *Flash Art* (May 1983): 64.

SAGER, Peter. "Gespräch mit Gerhard Richter." *Kunstwerk* (July 1972): 16-27.

SCHMIDT-WULFFEN, Stephan. [Review of Richter exhibition at Galerie Wilkens/Jacobs, Cologne.] *Flash Art* (January 1985): 48-49.

SCHWABSKY, Barry. [Review of Richter exhibitions at Marian Goodman Gallery/Sperone Westwater Gallery, New York.] *Arts Magazine* (May 1985): 41.

SMITH, Roberta. "Art: 17 Early Paintings by Gerhard Richter." *The New York Times* (January 2, 1987): 33. Review of Richter exhibition at Barbara Gladstone Gallery, New York.

——. "Art: At Two Galleries, Gerhard Richter Works." *The New York Times* (March 13, 1987): C31. Review of Richter exhibitions at Marian Goodman Gallery/Sperone Westwater Fischer Gallery, New York.

SOFER, K. [Review of Richter exhibitions at Marian Goodman Gallery/Sperone Westwater Fischer Gallery, New York.] *Art News* (Summer 1987): 201.

STACHELHAUS, Heiner, "Doubts in the Face of Reality: The Paintings of Gerhard Richter." *Studio International* (September 1972): 76-80.

TATRANSKY, Valentin. [Review of Richter exhibition at Sperone Westwater Fischer Gallery, New York.] *Arts Magazine* (April 1978): 29.

THWAITES, John Anthony. "Germany: Prophets without Honor." *Art in America* (December 1965-January 1966): 110 15.

VIELHABER, Christiane. "Interview mit Gerhard Richter." *Kunstwerk* (April 1986): 41-43.

WARREN, Ron. [Review of Richter exhibitions at Marian Goodman Gallery/Sperone Westwater Gallery, New York.] *Arts Magazine* (May 1985): 43.

WEDEWER, Rolf. "Zum Landschaftstypus Gerhard Richters." *Pantheon* (January - March 1975): 41-49.

WELISH, Marjorie. [Review of Richter exhibition at Sperone Westwater Fischer Gallery, New York.] *Art in America* (May - June 1978): 118.

WINTER, Peter. "Bildräume mit Fragezeichen." *Kunstwerk* (July 1975): 3-7.

——. [Review of Richter exhibition at Kunsthalle, Bremen.] *Kunstwerk* (January 1976): 62-63.

——. [Review of Richter exhibition at Kunsthalle, Bremen.] *Pantheon* (April - June 1976): 141-42.

——. [Review of Richter exhibition at Kunsthalle, Bielefeld.] *Kunstwerk* (April 1982): 64-65.

WORSEL, T. "Notes om tsek Kunst." *Louisiana Revy* (February 1977): 32.

ZACHAROPOULOS, Denys. [Review of Richter exhibition at Musée d'Art et d'Industrie, Saint Etienne.] *Artforum* (June 1984): 43.

Salomé

1954 Born Wolfgang Cilarz in Karlsruhe.

1973 Moves to Berlin.

1974-80 Studies at the Hochschule für Bildende Künste, Berlin, under Hödicke.

1977 Cofounds Galerie am Moritzplatz in Berlin with Fetting, Middendorf and Zimmer. See Fetting biography, p. 261.

1977-81 Active as a performer and musician. Salomé appears in films by Fetting, Robert van Ackeren, Jo Schablowsky, Knut Hoffmeister and Christof Eichborn, and sings in Berlin nightclubs with the rock group Geile Tiere (Horny Animals). In his performances and self-portraits, Salomé often appears with rouged cheeks and eyes hidden behind dark glasses. Salomé plays "the role of the 'Wicked Old Lady,' of Marilyn Monroe, or of an ephebic androgynous figure in an exhibitionist vein" (Busche, "Violent Painting," 1981: 28).

1980 Takes part in a performance with Nina Hagen. He also records and produces an album of his own compositions. Participates with Zimmer, Fetting and Middendorf in "Heftige Malerei," a painting exhibition at Haus am Waldsee, Berlin. Shortly thereafter these artists are referred to as "Heftige Maler" (Violent Painters) or "Die neuen Wilden" (The New Wild Ones or Neo-Fauves). At times Salomé exhibits not only his works but also himself. In a display window of a Berlin gallery he poses for twelve hours wrapped in barbed wire. In Salomé's assessment, a homosexual must, even today, live in a concentration camp. Salomé uses self-representation to confront his viewer directly and to provoke a reaction.

1981 Receives a scholarship from the Deutscher Akademischer Austauschdienst (DAAD) to work at P.S. 1, New York.

current Lives and works in Berlin and New York.

Selected Exhibitions

1981 Berlin, Galerie Lietzow. *Salomé.*
New York, Annina Nosei Gallery. *Salomé: Recent Paintings.*
1982 Cologne, Galerie Zwirner. *Salomé.*
New York, Annina Nosei Gallery. *Salomé.*
1983 Bordeaux, Centre d'arts plastiques contemporains de Bordeaux. *Salomé, Luciano Castelli, Rainer Fetting: Peintures 1979-1982.* Catalogue includes essay by Catherine Strassler.
Zurich, Gallery Bruno Bischofberger. *Salomé: Neue Werke.*
1984 Berlin, Raab Galerie. *Salomé.*
Munich, Galerie Thomas. *Salomé.*
1985 Los Angeles, Davies Long Gallery. *Salomé.*
1986 Berlin, Raab Galerie. *Salomé: Frauen in Deutschland.* Catalogue includes short statements by each of the women depicted and a poem by Wolf Wondratchek.
1988 Chicago, Walter Bischoff Gallery. *Salomé: New Paintings.*
San Francisco, Rena Bransten Gallery. *Salomé.*

Selected Bibliography

AGALIDES, S. "Irony and Quotation." *Artweek* (July 13, 1985): 4. Review of Salomé exhibition at Davies Long Gallery, Los Angeles.

BEHM, Harald. "Salomé." *Connaissance des Arts* (November 1984): 80-83.

BIENEK, H. "Dann kommt wieder die Schärfe." *Art: Das Kunstmagazin* (March 1983): 84-95.

BRUNSON, J. "Questions of Skill and Intent." *Artweek* (October 18, 1986): 1. Review of Salomé exhibition at Artspace, San Francisco.

CASADEMONT, Joan. [Review of Salomé exhibition at Annina Nosei Gallery, New York.] *Artforum* (March 1982): 72.

COLLINS, James. [Review of Salomé exhibition at Galerie Thomas, Munich.] *Flash Art* (March 1985): 64.

FAUST, Wolfgang Max, and Max Raphael. "Gemeinschaftsbilder: Ein Aspekt der neuen Malerei; Salomé, Luciano Castelli und Rainer Fetting: Bild Erotismen." *Kunstforum International* (November 1983): 70-85.

FROHNE, Ursula. [Review of Salomé exhibition at Raab Galerie, Berlin.] *Flash Art* (April-May 1984): 41.

HEGEWISCH, K. [Review of Salomé exhibition at Galerie Thomas, Munich.] *Kunstwerk* (February 1985): 64.

LAWSON, Thomas. [Review of Salomé exhibition at Annina Nosei Gallery, New York.] *Artforum* (September 1981): 78-79.

OHFF, Heinz. [Review of Salomé exhibition at Raab Galerie, Berlin.] *Kunstwerk* (April 1984): 72.

———. "Salomé" *Kunstwerk* (September 1985): 106-7.

OTTMANN, Klaus. "Who's Afraid of Salomé." *Flash Art* (December 1985-January 1986): 70-72.

RENARD, Delphine. [Review of Salomé, Castelli and Fetting exhibition at Centre d'arts plastiques contemporains, Bordeaux.] *Flash Art* (May 1983): 76.

SCHWERFEL, H.-P. "Salomé: Wild Boy." *Art Press* (May 1982): 28-29.

SKOGGARD, Ross. [Review of Salomé exhibition at Annina Nosei Gallery, New York.] *Art in America* (February 1982): 140.

Eugen Schönebeck

1936 Born in Dresden.

1954 Attends the Fachschule für Kunsthandwerk, Berlin (GDR); there he does wall painting and is trained in the technique and ideology of Social Realism.

1955 Moves to West Berlin where he studies at the Hochschule für Bildende Künste from 1955 to 1961 under Hans Jaenisch and Hans Kuhn and is exposed to *Art Informel* and *Tachisme*.

1957 Meets fellow-student Georg Baselitz.

1961 Joint exhibition, *Erstes Pandämonium*, with Baselitz. The two artists draw up the first *Pandämonium* manifesto for this exhibition. Does abstract works with an emphasis on gesture.

1962 Writes second *Pandämonium* manifesto with Baselitz. Figurative elements begin to emerge in his work, and in 1962-63 Schönebeck begins a new series of paintings executed in subdued tones and featuring dramatic characters that suggest the flayed human spirit. The "expressive-monumental" works that develop are influenced by Jean Fautrier. First one-man show, at Hilton-Kolonnaden, Berlin.

1965-66 Subjective, expressive elements are reduced. Begins to develop a figurative style influenced by Fernand Léger, the Mexican muralists and the Russian realist painter Alexander Deineka. He refers to this style as "Social Realist," in contrast to the naturalism of the official art of East Germany. Depicts revolutionary themes and portraits. Portrays the heroic, monumental figure in the guise of important Communist leaders such as Mao, Trotsky and Lenin.

1966 Stops working as a painter and withdraws from the public eye.

Selected Exhibitions

1961 Berlin, *Erstes Pandämonium*. Manifesto and exhibition with Georg Baselitz.

1962 Berlin, Hilton-Kolonnaden.
Berlin, *Zweites Pandämonium*. Manifesto and exhibition with Georg Baselitz.

1965 Berlin, Galerie Benjamin Katz.

1973 Berlin, Galerie Abis. *Eugen Schönebeck: Bilder, Skizzen, Zeichnungen, 1962-1973*. Catalogue includes essay by Gunther Gercken, "Wer ist Eugen Schönebeck?" by Christos Joachimides and "Gedanken über Eugen Schönebeck" by Klaus Gallwitz. Dusseldorf, Internationaler Kunst- und Informationsmarkt.

1988 Berlin, Galerie Silvia Menzel. *Schönebeck: Zeichnungen 1959-1963*. Accompanied by catalogue.

Selected Bibliography

FAUST, Wolfgang Max. "Die exemplarische Biographie – Eugen Schönebeck." *Wolkenkratzer* (February 1987): 66-73.

GACHNANG, Johannes, and Ursula Prinz. *Der gekrümmte Horizont – Kunst in Berlin 1945-1967*. Catalogue of exhibition at IBK Akademie der Künste, Berlin, 1981.

GALLWITZ, Klaus. *14 x 14*. Catalogue of exhibition at Staatliche Kunsthalle, Baden-Baden, 1973.

OHFF, Heinz. "Seiner Zeit weit voraus." *Der Tagesspiegel* (December 7, 1986): 5. Review of Schönebeck exhibition at Galerie Silvia Menzel, Berlin.

PIENE, N. R. "Report from Berlin." *Artforum* (January 1967): 109.

STRELOW, Hans, and Jürgen Wissmann. *Sammlung Ströher*. Catalogue of exhibition at Nationalgalerie, Berlin; Kunsthalle, Düsseldorf; and Kunsthalle, Bern, 1968.

WEDEWER, Rolf. *Zeichnungen 2*. Catalogue of exhibition at Städtisches Museum, Schloss Morsbroich, Leverkusen, 1972.

Andreas Schulze

1955 Born in Hannover.

1976-78 Studies painting at the Gesamthochschule, Kassel.

1978-83 Studies painting under Krieg at the Kunstakademie, Dusseldorf.

1985 "It is very important that the painting and sculpture look alike, producing confusion about which was there first, which illustrates the other. In some way they cancel each other out. One could think that the painting shows a sculpture, and that suggests another content. But the sculpture is already an art object, and therefore it isn't the subject of the painting. The painting that looks as if it were an illustration of a cupboard, has nothing to do with the cupboard; it is merely the illustration of a painting. Almost a trap" (quoted in Schmidt-Wulffen, 1985: 27).

current Lives and works in Cologne.

Selected Exhibitions

1982 Munich, Galerie Six Friedrich. *Andreas Schulze.*

1983 Cologne, Monika Sprüth Galerie. *Andreas Schulze.*
Ghent, Museum van Hedendaagse Kunst. *Andreas Schulze.*
Stuttgart, Galerie Max Hetzler. *Andreas Schulze.*

1984 Cologne, Monika Sprüth Galerie. *Andreas Schulze.*
Hamburg, Galerie Ascan Crone. *Andreas Schulze.*

1985 Frankfurt, Galerie Bärbel Grässlin. *Andreas Schulze.*
Munich, Galerie Six Friedrich. *Andreas Schulze.*
New York, Barbara Gladstone Gallery. *Andreas Schulze.*

1986 Cologne, Monika Sprüth Galerie. *Andreas Schulze.*
Hamburg, Galerie Ascan Crone. *Andreas Schulze.*

1987 Barcelona, Galerie Prats. *Andreas Schulze.*
Milan, Le Case d'Arte. *Andreas Schulze.*
Rome, Galeria Pio Mouti. *Andreas Schulze.*

Selected Bibliography

DICKHOFF, Wilfried. [Interview with Andreas Schulze.] *Flash Art* (Summer 1986): 42-45.

ROH, Julianne. [Review of *Rundschau Deutschland* exhibition at Fabrik, Munich.] *Kunstwerk* (March 1981): 88.

SCHMIDT-WULFFEN, Stephan. "Andreas Schulze." *Flash Art* (January 1985): 26-27.

Norbert Tadeusz

1940 Born in Dortmund.

1960-61 Studies painting under Gustav Deppe at the Werkkunstschule, Dortmund.

1961-66 Studies at the Kunstakademie, Dusseldorf, under Gerhard Hoehme, Joseph Fassbender and Joseph Beuys.

1962 Paints beach scenes, interiors, still lifes and nudes which already suggest a close connection to the symbolism of the Crucifixion.

1971 Paints his first picture on the theme of butchered meat. Tadeusz asserts that, "it's only with meat that you have the possibility of really painting red" (quoted in Beyer, 1984: 45). Receives a grant from the Cultural Group of the Federal Association of German Industry.

1973-88 Visiting professor of painting at the Institut für Kunsterzieher, Munster, a branch of the Kunstakademie, Dusseldorf. Full professor since 1981.

1983 Receives the Villa Romana Prize, Florence. While in Florence, Tadeusz expands upon the slaughtered livestock theme. The Italian shopkeepers' custom of displaying carcasses of animals in store windows provides him with ample subject matter.

1984 "I just can't stand perspective – although of course you can't do without it altogether, you can't just line everything up side by side – but I'm always trying to destroy it. For a time I made the perspective diverge again towards the back so that it looks as if it'd been wrongly drawn, or put in two horizons, or rearranged the lines so that they don't converge at one point; and I looked for views seen from above, flat – not a bird's eye view, but not a human perspective either; something in between, a bit higher than the normal view, so that I could avoid these converging lines and more top view comes about, which isn't so usual and makes everything seem odder. After all, we don't share Giotto's happy situation when perspective hadn't been mastered yet or perhaps wasn't even wanted, and when not everything in the pictures was so worked out and tallied" (quoted in Walter Grasskamp, in catalogue of Tadeusz exhibition at Galerie Gmyrek, Dusseldorf, 1984: n. p.).

1988 Visiting professor at the Akademie der Bildenden Künste, Karlsruhe. Professor at the Hochschule für Bildende Künste, Berlin.

current Lives and works in Dusseldorf, Karlsruhe and Berlin.

Selected Exhibitions

1966 Dusseldorf, Galerie Gunar. *Tadeusz.*

1970 Dusseldorf, Kunstmuseum. *Norbert Tadeusz: Zeichnungen, Gouachen.*

1973 Cologne, Galerie Onnasch. *Norbert Tadeusz.* Dusseldorf, Kunstverein für die Rheinlande und Westfalen. *Norbert Tadeusz: Werke 1963-1973.* Catalogue includes "Norbert Tadeusz" by Werner Schmalenbach.

1974 Berlin, Galerie Poll. *Norbert Tadeusz: Bilder 1963 bis 1974.*

1976 Freiburg, Galerie Kröner. *Norbert Tadeusz.*

1978 Cologne, Galerie Axiom. *Norbert Tadeusz. Bilder und Gouachen.*

1980 Aachen, Neue Galerie – Sammlung Ludwig. *Tadeusz: Gemälde 1975-1980.* Braunschweig, Kunstverein. *Tadeusz: Bilder 1962-1980.* Catalogue includes "Der Einzelgänger Norbert Tadeusz" by Eugen Thiemann and "Notiz zu Norbert Tadeusz" by Jürgen Schilling.

1981 Dortmund, Museum am Ostwall. *Tadeusz: Gemälde 1960-1980.* Dusseldorf, Galerie Gmyrek. *Norbert Tadeusz: Neue Bilder und Gouachen.* Nordhorn, Städtische Galerie. *Norbert Tadeusz: Bilder und Blätter.* Catalogue includes "Norbert Tadeusz: Die Dauer des Augenblicks, Konstruktion und Sinnlichkeit" by Eckhard Schneider.

1983 Brussels, Galerie Fred Lanzenberg. *Tadeusz.*

1984 Berlin, Galerie Poll. *Norbert Tadeusz: locus solus, Fleisch – Variationen. Bilder und Zeichnungen 1970-1984.* Dusseldorf, Galerie Gmyrek. *Norbert Tadeusz: Vorhölle, Carni.* Catalogue includes "Begegnung mit Tadeusz" by Philipp Kuhn, "Carni" by Joachim Peter Kastner and interview with Tadeusz by Walter Grasskamp. Wiesbaden, Rabanus Maurus-Akademie. *Norbert Tadeusz: Menschenbild - Christushild.* Catalogue includes "Norbert Tadeusz" by Friedhelm Mennekes.

1985 Oslo, Kunstnernes Hus and Copenhagen, Charlottenborg. *Norbert Tadeusz.*

1986 Dortmund, Galerie J. Friedrich. *Norbert Tadeusz: Zeichnungen.* Hamburg, Galerie Hans Barlach. *Norbert Tadeusz.* Ludwigshafen, BASF-Feierabendhaus. *Norbert Tadeusz: Bilder 1963-1985.* Munich, Galerie Hermeyer. *Norbert Tadeusz: Bilder 1971-1985.*

1988 Dusseldorf, Galerie Gmyrek. *Norbert Tadeusz: Akte – mtransitu.* Catalogue includes "Akte in transitu" by Joachim Peter Kastner and "Bilder als Konstruktion neuer Wirklichkeit" by Hans Albert Peters.

Selected Bibliography

ADOLPHS, Volker. [Review of Tadeusz exhibition at Galerie Gmyrek, Dusseldorf.] *Artefactum* (April-May 1988): 35-37.

BAUERMEISTER, Volker. [Review of Tadeusz exhibitions at Kunstverein Braunschweig, Neue Galerie – Sammlung Ludwig, Aachen, and Museum am Ostwall, Dortmund.] *Kunstwerk* (January 1981): 67, 76.

BEYER, Lucie. [Review of Tadeusz exhibition at Galerie Gmyrek, Dusseldorf.] *Flash Art* (November 1984): 45.

FRIEDRICHS, Yvonne. [Review of Tadeusz exhibitions at Galerie Poll, Berlin, and Galerie Gmyrek, Dusseldorf.] *Kunstwerk* (August 1984): 64.

KIFFEL, E. *Künstler in ihrem Atelier.* Foreword by J. Krichbaum. Munich: Mahnert-Lueg, 1979.

KUHN, P. [Review of *Akte – in transitu* exhibition at Galerie Gmyrek, Dusseldorf.] *Kunstwerk* (May 1988): 75.

MAI, Ekkehard. "Künstlerateliers als Kunstprogramm: Werkstatt Heute." *Kunstwerk* (June 1984): 38.

PETERS, Hans Albert. "Triptychon für Norbert Tadeusz." *Die Kunst* 6 (1988): 467-73.

PUVOGEL, Renate. "Norbert Tadeusz: Akte in transitu." *Kunstforum International* 94 (1988): 294-95.

ROST, Kerstin. "Norbert Tadeusz: Looking for life in death." *New Art Examiner* (February 1985): 28-30.

TADEUSZ, Norbert. [Three drawings.] *Interfunktionen* 10 (n.d.): 101-3.

WINTER, Peter. "Der Maler Norbert Tadeusz." *Kunstforum International* 2 (1982): 96-113.

——. "Vorhölle-Carni." *Weltkunst* 13 (1984): 1830-31.

Volker Tannert

1955 Born in the Ruhr district, an industrial area of West Germany.

1975-79 Studies painting at the Kunstakademie, Dusseldorf, under Klaus Rinke and Richter.

1979-80 Travels to New York. Tannert stays for six months in Paris as grant recipient from the Cité Internationale des Arts in that city.

1980 Receives Max Ernst Grant from the city of Brühl.

1982-84 Receives stipend from the Karl Schmidt-Rottluff Foundation.

1984 "My paintings certainly do not express approval of the times we live in. But they don't mourn a loss or represent a naive call for a 'return to nature.' I don't want people to admire paintings. I want the will visible in them to contribute to a livable culture. In this conception the painting is a device to be gotten rid of eventually, and I think this is essentially what interests me most about romanticism – it's a longing for a condition of culture that won't need material artifacts anymore. Somebody who builds a generator does it because he wants the electricity, and not the machine. And it is in this built-in utopian notion of dissolving painting into culture that German Romanticism still provides us with points of departure into the future of painting, rather than offering a comfortable indulgence in 'old values,' as the term 'nostalgia' suggests to me" (quoted in Kontova, 1984: 30).

current Lives and works in Cologne and Italy.

Selected Exhibitions

1981 Cologne, Galerie Rolf Ricke. *Volker Tannert.* Dortmund, Museum am Ostwall. *Volker Tannert: Dusseldorf.*

1983 Ghent, Galerie Baronian-Lambert. *Volker Tannert.*

1984 Basel, Galerie Buchmann. *Volker Tannert.* Dusseldorf, Galerie Gmyrek. *Volker Tannert: Vorhölle-Carni.* Catalogue includes texts by Walter Grasskamp, Bernd Jansen, Joachim Peter Kastner and P. Kuhn.

1985 Bremen, Kunsthalle, and Karlsruhe, Badischer Kunstverein. *Volker Tannert: Bilder und Zeichnungen 1981-1985.* Darmstadt, Ausstellungshallen Mathildenhöhe. *Volker Tannert.* Catalogue includes "Weltwunder und Naturschauspiele" by Klaus Heinrich Kohrs. Munich, Galerie Schellmann & Klüser. *Volker Tannert.* New York, Sonnabend Gallery. *Volker Tannert: New Paintings.*

1986 Bremen, Kunstverein. *Volker Tannert: Bilder und Zeichnungen 1981-1985.* Munich, Galerie Bernd Klüser. *Volker Tannert: Das Gute, das Wahre und das Schöne.* New York, Sonnabend Gallery. *Volker Tannert.* Paris, Galerie Daniel Templon. *Volker Tannert.*

Selected Bibliography

EDELMANN, R. G. [Review of Tannert exhibition at Sonnabend Gallery, New York.] *Art in America* (May 1985): 171-72.

GIRARD, X. "Volker Tannert: le peintre dans le terrier." *Art Press* (September 1983): 28.

HALDER, J. "Bilder und Zeichnungen 1981 bis 1985." *Kunstwerk* (June 1985): 78-79. Review of Tannert exhibition at Badischer Kunstverein, Karlsruhe, and Kunsthalle, Bremen.

HEGEWISCH, K. [Review of Tannert exhibition at Galerie Schellmann & Klüser, Munich.] *Flash Art* (April-May 1985): 43.

KONTOVA, Helena, interviewer. "Volker Tannert." *Flash Art* (Summer 1984): 27-31.

KUSPIT, Donald B. [Review of Tannert exhibition at Sonnabend Gallery, New York.] *Artforum* (May 1985): 106-8.

POHLEN, Annelie. [Review of Tannert exhibition at Badischer Kunstverein, Karlsruhe.] *Artforum* (September 1985): 136-37.

SCHÜTZ, Sabine. "Volker Tannert." *Kunstforum International* (December 1983): 198-207.

VECCHI, L. de. [Review of Tannert exhibition at Galerie Daniel Templon, Paris.] *L'Oeil* (March 1986): 76.

Rosemarie Trockel

1952 Born in Schwerte.

1970-78 Studies anthropology, sociology, theology and mathematics in order to qualify for a teaching degree. Later, she switches to art and studies under W. Schreifers at the Werkkunstschule, Cologne.

1985 Trockel begins a series of works that she calls "knitted paintings." The "paintings," made of stretched wool, feature patterned designs of recognizable logos or symbols: a series of Playboy bunnies, a repetition of a famous wool manufacturer's logo or a continuous line of text that reads "Made in Western Germany." The pieces are woven together by a computerized knitting machine, according to Trockel's own designs and instructions. She deliberately chooses to work in materials, such as wool, to

which relatively little cultural value is attached and in processes traditionally associated with women's work, such as knitting.

1987 "Art works are focuses of time. They provide information about the relation between art, culture and the state. And the question of the meaning of art is bound up with this. But works of art only achieve this through their being objects of desire, through their beauty" (quoted in Koether, 1987: 41).

current Lives and works in Cologne.

Selected Exhibitions

1983 Bonn, Galerie Philomena Magers. *Rosemarie Trockel.* Cologne, Monika Sprüth Galerie. *Rosemarie Trockel: Plastiken 1982-1983.* Catalogue includes text by Wilfried A. Dickhoff.

1984 Basel, Stampa. *Rosemarie Trockel.* Cologne, Monika Sprüth Galerie. *Rosemarie Trockel.* Hamburg, Galerie Ascan Crone. *Rosemarie Trockel: Skulpturen und Bilder.* Catalogue includes "La Belle et la Bête" by Reiner Speck.

1985 Berlin, Galerie Folker Skulima. *Rosemarie Trockel.* Bonn, Rheinisches Landesmuseum. *Rosemarie Trockel: Bilder – Skulpturen – Zeichnungen.* Catalogue includes texts by Wilfried Dickhoff, Klaus Honnef, Jutta Koether et al.

1986 Bern, Galerie Friedrich. *Rosemarie Trockel.* Cologne, Monika Sprüth Galerie. *Rosemarie Trockel.*

1987 Hamburg, Galerie Ascan Crone. *Rosemarie Trockel.* Munich, Galerie Tanit. *Rosemarie Trockel.* Seville, La Máquina Española. *Jutta Koether, Bettina Semmer & Rosemarie Trockel.* Catalogue includes "Three, Three by Three" by Diedrich Diederichsen.

1988 Basel, Kunsthalle. *Rosemarie Trockel.* Bonn, Galerie Philomene Magers. *Walter Dahn und Rosemarie Trockel.* London, Institute of Contemporary Arts. *Rosemarie Trockel.* New York, The Museum of Modern Art. *Rosemarie Trockel.*

Selected Bibliography

ANON. "Rosemarie Trockel: Wie aus Menschen Vasen Werden." *Art: das Kunstmagazin* (February 1984): 94-95.

CAMERON, Dan. "In the Realm of the Hyper-Abstract." *Arts Magazine* (November 1986): 40.

HAAS, Bruno. [Review of Dahn/Trockel exhibition at Galerie Philomene Magers, Bonn.] *Noema: Art Magazine* 18-19 (1988): 102.

KOETHER, Jutta. "Pure Invention." *Flash Art* (April 1986): 51.

———. "Interview with Rosemarie Trockel." *Flash Art* (May 1987): 40-42.

LEIGH, Christian. [Review of Trockel exhibition at The Museum of Modern Art, New York.] *Artforum* (Summer 1988): 135-36.

MALEN, Lenore. [Review of Trockel exhibition at The Museum of Modern Art, New York.] *Art in America* (June 1988): 179.

NYFFELER, Nona. "Rosemarie Trockels Strickbilder." *Wolkenkratzer* (January 1986).

POHLEN, Annelie. "Rosemarie Trockel." *Kunstforum* 81 (1985): 260-61.

REIN, Ingrid. "Knitting, Stretching, Drawing Out." *Artforum* (Summer 1987): 110.

SMITH, Roberta. "Sly, Sardonic Feminism from a West German." *The New York Times* (March 11, 1988): 24. Review of Trockel exhibition at The Museum of Modern Art, New York.

SCHMIDT-WULFFEN, Stephen. [Review of Trockel exhibition at Monika Sprüth Galerie, Cologne.] *Flash Art* (February-March 1987): 111.

Bernd Zimmer

1948 Born in Planegg, near Munich.

1968 Completes apprenticeships in business and publishing.

1970 Works as a graphic artist at several publishing houses.

1972 Spends six months in Southeast Asia (Malaysia, Burma, Thailand, Laos and Hong Kong).

1973-79 Studies philosophy and religion at the Freie Universität, Berlin.

1975 Spends seven months in Mexico and the United States. Zimmer uses "Diego Rivera's huge public murals and Mexican and Califor-

nian wall painting" as models for his own large-format works (Busche, "Violent Painting," 1981: 29).

1977 Cofounds Galerie am Moritzplatz in Berlin with Fetting, Middendorf and Salomé. See Fetting biography, p. 261.

1979 Designs stage sets and murals with Fetting and Middendorf.

1979-80 Receives stipend from the Karl Schmidt-Rottluff Foundation.

1980 Participates with Fetting, Middendorf and Salomé in *Heftige Malerei,* a painting exhibition at the Haus am Waldsee, Berlin. Shortly thereafter these artists are referred to as "Heftige Maler" (Violent Painters) and "Die neuen Wilden" (The New Wild Ones or Neo-Fauves).

1981 Does not paint directly from nature. As Zimmer explains, "I don't paint outdoors, direct from nature. I paint the things around my studio – a barn, maybe, or a little enclosure – whatever is close at hand. . . . I go out, look at things, get a visual impression; then come back to the studio and paint from memory. I think sketches really do limit you, that when you work from them, some kind of realism or other always results. Basing pictures on drawings always has something second-hand about it for me. It cramps my spontaneity too much, and it always turns out looking like an enlarged drawing. But when I do my drawings at night, after spending the whole day outdoors, everything takes on a degree of abstraction because it's passed through my mind into my hand. I mean, from eye to mind to hand. But when it only goes from eye to hand, I bypass those four hours of thinking I have during my walks, which are very important to me " (Trans-lation of quote in catalogue of Zimmer exhibition at Galerie Thomas in Munich, 1985: n.p.).

1982-83 Wins the Villa Massimo Prize, Rome.

1983-84 Lives in Rome.

current Lives and works in Polling and Rapallo.

Selected Exhibitions

1977 Berlin, Galerie am Moritzplatz. *Bernd Zimmer: FLUT.*

1978 Berlin, Galerie am Moritzplatz. *Stadtbilder: Hochbahn.*
Berlin, Musikhalle SO 36. *Stadtbild 3/28.*

1979 Berlin, Galerie Interni. *Bernd Zimmer.*
Berlin, Musikhalle SO 36. *Kulissenbild New York.* With Rainer Fetting.

1980 Dusseldorf, Galerie Gmyrek. *Bernd Zimmer: Bilder – Landschaften.*

1981 Berlin, Galerie Georg Nothelfer. *Bernd Zimmer: Bilder – Landschaften 1981.*
Darmstadt, Ausstellungshallen Mathildenhöhe. *Bernd Zimmer: Bilder.*
Dusseldorf, Galerie Heiner Hepper. *Bernd Zimmer: Bilder.*
Freiburg, Kunstverein Freiburg, Schwarzes Kloster. *Bernd Zimmer: 28 Tage in Freiburg.*
New York, Barbara Gladstone Gallery. *Bernd Zimmer.*

1982 Brussels, Galerie Albert Baronian. *Bernd Zimmer.*
Groningen, Groninger Museum. *Bernd Zimmer: Bilder.* Catalogue includes "Variationen zu einem Thema: Farbe als Abstraktion von Sinnesempfin-dungen" by Franz Boas and interview with Zimmer by Ernst Busche.
Milan, Studio d'Arte Cannaviello. *Bernd Zimmer.*
St. Gallen, Galerie Buchmann. *Bernd Zimmer.*

1983 Dusseldorf, Galerie Gmyrek. *Bernd Zimmer: Abgründe. Ihr Berge, tanzt!* Catalogue includes "Notiz zu Bernd Zimmer" by Jürgen Schilling and "Villa Massimo: Unverhofftes Wiedersehen" by Michael Krüger.
Genoa, Chisel Arte Contemporanea. *Bernd Zimmer.*
Paris, Galerie Yvon Lambert. *Bernd Zimmer.*

1984 Hamburg, Farbbad Galerie. *Bernd Zimmer.* Catalogue includes "Der Berg nach Hodler gehört mir" by Jürgen Schilling.
Lyon, Saint Pierre Art Contemporain. *Bernd Zimmer.*
Milan, Studio d'Arte Cannaviello. *Bernd Zimmer.*

1985 Dusseldorf, Galerie Gmyrek. *Bernd Zimmer: Unter Null.*
Liège, Musée d'Art Moderne. *Bernd Zimmer.*
Munich, Galerie Hermeyer. *Bernd Zimmer.*
Munich, Galerie Thomas. *Bernd Zimmer.*

1986 Braunschweig, Kunstverein, and Ulm, Ulmer Museum (1987). *Bernd Zimmer: Bilder-Landschaften 1983-1985.* Catalogue includes texts by Dorothée Bauerle, Wilhelm Bojescul, Roland Simon-Schaefer and Beat Wyss.
Paris, Galerie Yvon Lambert. *Bernd Zimmer.*

1987 Milan, Studio d'Arte Cannaviello. *Bernd Zimmer: Made in Italy.*

1988 London, Raab Gallery. *Bernd Zimmer: Paintings of the Sea.* Catalogue includes "Il mare dei giganti" by Giovanni Testori.
Pforzheim, Kunstverein. *Bernd Zimmer.*

Selected Bibliography

FRIEDRICHS, Yvonne. [Review of Zimmer exhibition at Galerie Gmyrek, Dusseldorf.] *Kunstwerk* (April 1984): 68.

KERBER, Bernhard. [Review of Zimmer exhibition at Galerie Nothelfer, Berlin.] *Art International* (May-June 1982): 49-50.

ROH, Julianne. [Review of Zimmer exhibition at Galerie Hermeyer, Munich.] *Kunstwerk* (October 1982): 78-79.

THAME, Gerard de. "Bernd Zimmer interviewed by Gerard de Thame." *Artscribe* 45 (1984): 28-31.

ZIMMER, William. "Puttin' on the Blitz." *The Soho News* (September 22, 1981): 45. Review of Zimmer exhibition at Barbara Gladstone Gallery, New York.

General Bibliography

Only artists included in the present exhibition are noted in the following entries.

Books and Catalogues

1969

AMMANN, Jean-Christophe. *Düsseldorfer Szene.* Catalogue of exhibition at Kunstmuseum, Lucerne. Includes discussion of Immendorff, Penck and Richter.

1972

KASSEL, Museum Fridericianum. *Documenta 5.* Includes discussion of Baselitz, Immendorff, Penck, Polke and Richter.

1975

EDINBURGH, Fruit Market Gallery, Scottish Art Council. *Eight from Berlin.* Includes discussion of Hödicke and Koberling.

1979

KIFFEL, E. *Künstler in ihrem Atelier.* Foreword by J. Krichbaum. Munich: Mahnert-Lueg. Includes discussion of Klapheck, Lüpertz, Richter and Tadeusz.

1980

AACHEN, Neue Galerie – Sammlung Ludwig. *Les nouveaux Fauves/Die neuen Wilden.* 2 vols. This exhibition focused on Neo-Expressionist artists in America, France and Germany. German artists represented include: Baselitz, Immendorff, Kiefer, Lüpertz and Penck. Includes text by Wolfgang Becker.

KEMPAS, Thomas. *Heftige Malerei: Rainer Fetting, Helmut Middendorf, Salomé, Bernd Zimmer.* Catalogue of exhibition at Haus am Waldsee, Berlin.

MOLDERINGS, H. *De la photographie 17 artistes allemands.* Catalogue of exhibition at Goethe Institute, Paris. Includes discussion of Dahn, Polke and Hacker.

VENICE. *XXXIX Esposizione Internazionale d'Arte Venezia. Settore Arti Visive 1980.* Includes discussion of Baselitz and Kiefer.

1981

BERLIN (BRD), Akademie der Künste. *Bildwechsel: Neue Malerei aus Deutschland.* Essays by Ernst Busche, Tibor Kneif and Michael Schwarz. Includes discussion of Bach, Büttner, Dokoupil, Fetting, Middendorf, Albert Oehlen and Zimmer.

BRUSSELS, Palais des Beaux-Arts. *Schilderkunst in Duitsland 1981.* Essays by Troels Andersen, Johannes Gachnang, Günther Gercken, Siegfried Gohr, Christos M. Joachimides, T. Kneubühler and D. Koepplin. Includes discussion of Baselitz, Immendorff, Kiefer, Lüpertz and Penck.

FREIBURG, Kunstverein. *Die heimliche Wahrheit: Mühlheimer Freiheit.* Includes discussion of Bömmels, Dahn and Dokoupil.

LONDON, Royal Academy of Arts and Arts Council of Great Britain. *A New Spirit in Painting.* Exhibition organized by Christos M. Joachimides, Norman Rosenthal and Nicholas Serota. German artists represented include: Baselitz, Fetting, Hacker, Hödicke, Kiefer, Koberling, Lüpertz, Penck, Polke and Richter.

LUCERNE, Kunstmuseum. *Im Westen nichts neues. Wir malen weiter.* Essays by Martin Kunz and Eberhard Roters. Includes discussion of Fetting, Middendorf, Salomé and Zimmer.

PFEFFERLE, Karl, ed. *Das Bilderbuch.* Introduction by Wolfgang Max Faust. Grünwald: Edition Pfefferle. Includes discussion of Barfuss, Bömmels, Dahn, Dokoupil, Markus Oehlen, Polke, Tannert and Zimmer.

1982

AMMANN, Jean-Christophe, and Christel Sauer. *Werke aus der Sammlung Crex.* Catalogue of exhibition at Kunsthalle, Basel. Includes discussion of Baselitz, Penck, Polke and Richter.

——, and Margrit Suter, eds. *Zwölf Künstler aus Deutschland: Adamski, Bömmels, Büttner, Castelli, Dahn, Dokoupil, Fetting, Kever, Naschberger, A. Oehlen, Salomé und Tannert.* Catalogue of exhibition at Kunsthalle, Basel, and Museum Boymans-van Beuningen, Rotterdam.

BILLETER, Erika, ed. *Les Oeuvres de Karl Heinz Hödicke, Bernd Koberling, Markus Lüpertz, Rainer Fetting, Helmut Middendorf et Salomé dans les collections de Peter Pohl et Hans Hermann Stober à Berlin.* Catalogue of exhibition at Musée Cantonal des Beaux-Arts, Lausanne.

DIETRICH-BOORSCH, Dorothea, and Alan Shestack. *German Drawings of the 60s.* New Haven: Yale University Press. Catalogue of exhibition at Yale University Art Gallery, New Haven. Includes discussion of Baselitz, Immendorff, Lüpertz, Penck, Polke and Richter.

FELIX, Zdenek, et al. *La Giovane Pittura in Germania: Die junge Malerei in Deutschland.* Catalogue of exhibition at Galleria d'Arte Moderna, Bologna. Includes discussion of Bömmels, Büttner, Dahn, Dokoupil, Fetting, Kippenberger, Middendorf, Albert Oehlen and Salomé.

——, ed. *10 junge Künstler aus Deutschland: Adamski, Bömmels, Dahn, Dokoupil, Fetting, Kever, Kunc, Middendorf, Naschberger, Salomé.* Catalogue of exhibition at Museum Folkwang, Essen.

GALLWITZ, Klaus, ed. *Zeitgenössische Kunst in der Deutschen Bank Frankfurt.* Stuttgart: Ernst Klett Verlag. Exhibition catalogue. Includes discussion of Bach, Baselitz, Bömmels, Chevalier, Dahn, Dokoupil, Fetting, Hahn, Hödicke, Immendorff,

Kiefer, Koberling, Krieg, Lange, Lüpertz, Middendorf, Markus Oehlen, Penck, Polke, Richter, Salomé Tannert and Zimmer.

KASSEL. *Documenta 7.* Includes discussion of Bach, Baselitz, Dahn, Dokoupil, Immendorff, Kiefer, Lüpertz, Penck, Polke, Richter, Salomé and Tannert.

OLIVA, Achille Bonito. *La giovane transavanguardia tedesca.* Catalogue of exhibition at ASART-Galleria Nazionale d'Arte Moderna, S. Marino. Includes discussion of Barfuss, Bömmels, Dahn, Dokoupil, Fetting, Middendorf, Albert Oehlen, Salomé, Tannert and Zimmer.

PRINZ, Ursula, and Wolfgang Jean Stock. *Gefühl und Härte: Neue Kunst aus Berlin.* Berlin: Fröhlich & Kaufmann. Catalogue of exhibition at Kunstverein, Munich, and Kulturhuset, Stockholm. Includes discussion of Fetting, Lange, Middendorf, Salomé and Zimmer.

1983

COWART, Jack, ed. *Expressions: New Art from Germany – Baselitz, Immendorff, Kiefer, Lüpertz, Penck.* Munich: Prestel-Verlag in association with St. Louis Art Museum. Catalogue of exhibition at St. Louis Art Museum.

EDINBURGH, Fruit Market Gallery, Scottish Art Council and the Institute of Contemporary Art, London. *Mülheimer Freiheit Proudly Presents the Second Bombing.* Preface by Donald Kuspit. Includes discussion of Bömmels, Dahn and Dokoupil.

GRAZ, Künstlerhaus. *Eros, Mythos, Ironie: Europäische Kunst heute.* Bach and Barfuss were the only Germans included in this exhibition of twenty-seven artists from seven countries.

HAMBURG, Kunsthalle. Organized by Kulturkreis im Bundesverband der deutschen Industrie. *Absprünge: Ars Viva 1983 – Bilder junger deutscher Maler.* Includes discussion of Albert Oehlen and Tannert.

JOACHIMIDES, Christos M., and Norman Rosenthal, eds. *International Art Exhibition Berlin 1982: ZEITGEIST.* New York: George Braziller. Catalogue of exhibition at Martin-Gropius-Bau, Berlin. Includes discussion of Baselitz, Bömmels, Büttner, Dahn, Dokoupil, Fetting, Hacker, Hödicke, Immendorff, Kiefer, Koberling, Lüpertz, Middendorf, Penck, Polke, Salomé and Tannert.

KUSPIT, Donald B. *New Figuration: Contemporary Art from Germany.* Catalogue of exhibition at Frederick S. Wight Art Gallery, University of California, Los Angeles. Includes discussion of Baselitz, Fetting, Hödicke, Kiefer, Koberling, Lüpertz, Middendorf, Penck and Salomé.

1984

JOACHIMIDES, Christos M., ed. *Ursprung und Vision: Neue Deutsche Malerei.* Berlin: Fröhlich &

Kaufmann Verlag. Catalogue of exhibition at Palacio Velázquez, Madrid. Includes discussion of Baselitz, Büttner, Chevalier, Dahn, Dokoupil, Fetting, Hacker, Hödicke, Immendorff, Kiefer, Koberling, Lüpertz, Middendorf, Albert Oehlen, Penck and Tannert.

——, ed. *Die Wiedergefundene Metropole: Neue Malerei in Berlin.* Berlin: Fröhlich & Kaufmann Verlag. Catalogue of exhibition at Palais des Beaux-Arts, Brussels, and Kulturabteilung der Bayer AG, Leverkusen. Includes discussion of Barfuss, Chevalier, Fetting, Hacker, Hödicke, Koberling, Lange, Middendorf, Salomé and Zimmer.

KÖNIG, Kaspar, ed. *Von hier aus: Zwei Monate neue deutsche Kunst in Düsseldorf.* Cologne: DuMont Buchverlag. Includes discussion of Barfuss, Baselitz, Büttner, Dahn, Dokoupil, Fetting, Immendorff, Kiefer, Kippenberger, Lüpertz, Näher, Albert Oehlen, Markus Oehlen, Penck, Polke, Richter, Salomé and Tadeusz.

LONDON, Goethe Insitute. *Cross-Section: Galerie Poll, Berlin.* Foreword by Günter Coenen. This exhibition, which focused on the figurative artists represented by Galerie Poll, Berlin, included Albert, Hödicke and Tadeusz. Includes essays by Heinz Ohff, Lucie Schauer, Jeannot Simmen, Eberhard Roters, Eugen Thiemann and Jürgen Schilling.

McSHINE, Kynaston. *A Recent Survey of International Painting and Sculpture.* Catalogue of exhibition at The Museum of Modern Art, New York. Includes discussion of Baselitz, Bömmels, Dahn, Dokoupil, Fetting, Hödicke, Immendorff, Kiefer, Koberling, Lüpertz, Middendorf, Penck, Polke, Richter, Salomé and Zimmer.

SCHRENK, Klaus, ed. *Upheavals: Manifestos, Manifestations – Conceptions in the Arts at the Beginning of the Sixties.* Cologne: DuMont Buchverlag. Catalogue of exhibition at Städtische Kunsthalle, Dusseldorf. Includes discussion of Baselitz, Hödicke, Koberling, Lüpertz, Polke, Richter and Zimmer.

VESTER, Karl-Egon. *Bella Figura.* Catalogue of exhibition at Wilhelm-Lehmbruck-Museum, Duisburg. This exhibition focused on developments in sculpture since the return to figuration in the late 1970s. Includes discussion of Baselitz, Immendorff, Lüpertz, Penck and Trockel.

1985

BECKER, Wolfgang. *New German Painting from the Ludwig Collection.* Catalogue of exhibition at Provinciaal Museum, Hasselt, Belgium.

CELANT, Germano. *The European Iceberg: Creativity in Germany and Italy Today.* Catalogue of exhibition at Art Gallery of Ontario, Toronto.

DARMSTADT, Hessisches Landesmuseum. *Tiefe Blicke: Kunst der achtziger Jahre aus der Bundesrepublik Deutschland, der DDR, Österreich und der Schweiz.* Cologne: DuMont Buchverlag.

JOACHIMIDES, Christos, Norman Rosenthal and Wieland Schmied, eds. *German Art in the 20th Century: Painting and Sculpture 1905-1985.* Munich: Prestel-Verlag. Catalogue of exhibition at Royal Academy of Arts, London.

BERLIN, Nationalgalerie. *1945-1985: Kunst in der Bundesrepublik Deutschland.* Foreword by Dieter Honisch.

THOMAS, Karin. *Zweimal deutsche Kunst nach 1945: 40 Jahre Nähe und Ferne.* Cologne: DuMont Buchverlag.

1986

LONDON, Hayward Gallery. *"Falls the Shadow": Recent British and European Art.* Catalogue of annual exhibition. Includes discussion of Baselitz, Lüpertz and Polke.

FAUST, Wolfgang Max, Ron Radford and Karl Ruhrberg. *Wild Visionary Spectral: New German Art.* Catalogue of exhibition at Art Gallery of South Australia, Adelaide. Includes discussion of Baselitz, Bömmels, Dokoupil, Fetting, Hödicke, Immendorff, Kiefer, Penck, Polke and Richter.

PORTLAND, Portland School of Art. *Aggression, Subversion, Seduction: Young German Painters.* Exhibition catalogue. Includes discussion of Bömmels, Büttner, Chevalier, Dahn, Dokoupil, Fetting and Albert Oehlen.

1987

CLADDERS, Johannes, and Margarethe Cladders. *Wechselströme: Kontemplation – Expression – Konstruktion; Deutsche Kunst Heute.* Catalogue of exhibition at Kunstverein, Bonn.

BERLIN, Haus am Waldsee. *Auf der Spur: Sammlung Stoher – Eine Auswahl aus der Sammlung zeitgenössischer Kunst sowie von Skulpturen, Masken, Gefässen aus Afrika, Mexiko, Asien.* Includes discussion of Baselitz, Büttner, Chevalier, Fetting, Hödicke, Koberling, Lüpertz, Middendorf, Penck, Polke and Richter.

DUSSELDORF, Kunstmuseum. *Brennpunkt Düsseldorf 1962-1987.* Includes discussion of Immendorff, Polke and Richter.

GERCKEN, Günther, et al. *Neue Kunst in Hamburg 1987.* Catalogue of exhibition at Kampagnegelände, Hamburg. Includes discussion of Büttner and Markus Oehlen.

JOACHIMIDES, Christos M., Wieland Schmied and Nicolaas Teuwisse. *Der unverbrauchte Blick: Kunst unserer Zeit in Berliner Sicht – Eine Ausstellung aus Privatsammlungen in Berlin.* Catalogue of exhibition at Martin-Gropius-Bau, Berlin.

KLOTZ, Heinrich. *Der Hang zur Architektur in der Malerei der Gegenwart: Büttner, Chevalier, Fetting, Hacker, Hödicke, Kippenberger, Lüpertz, Middendorf, Näher, A. Oehlen, Richter, Tadeusz, Tannert und Zimmer.* Catalogue of exhibition at Architekturmuseum, Frankfurt.

McSHINE, Kynaston, ed. *BERLINART 1961-1987.* New York: The Museum of Modern Art, and Munich: Prestel-Verlag. Catalogue of exhibition at The Museum of Modern Art, New York. Includes discussion of Barfuss, Baselitz, Chevalier, Fetting, Hacker, Hödicke, Kippenberger, Koberling, Lüpertz, Middendorf, Salomé and Zimmer.

MUNICH, Sammlung Thomas. *Kunst aus den achtziger Jahren: Art Forum 11.* Includes discussion of Fetting, Hacker, Middendorf, Näher, Salomé, Tannert and Zimmer.

NICE, Villa Arson. *Le Radius Kronenbourg: W. Büttner, M. Kippenberger, A. Oehlen and M. Oehlen.* Includes texts by C. Besson et al.

Articles

1975

WINTER, Peter. "Bildräume mit Fragezeichen." *Kunstwerk* 28 (1975): 3-37. Includes discussion of Hödicke, Krieg and Richter.

1976

FISCHER, Klaus-Jürgen. "Aspekte des Realismus in Deutschland." *Kunstwerk* (July 1976): 3-58. Includes discussion of Albert, Baselitz, Hahn, Lüpertz, Richter and Tadeusz.

1977

WINTER, Peter. "Karrig, alvorlig og koelig." *Louisiana Revy* (February 1977): 18-23. Review of *Pejling af tysk Kunst – 21 Kunstnere fra Tyskland* exhibition at Louisiana Museum of Modern Art, Humlebaek, Denmark. Includes discussion of Albert, Kiefer, Krieg, Polke and Richter. Also contains the catalogue of the exhibition.

1978

DEECKE, Thomas. "Art is No Luxury: Art Has its Social Uses." *Artnews* (October 1978): 88-91.

DRAHT, Viola Herms. "A Low Profile in the U.S.: High prices for German art in the wake of the dollar plunge and a resurgence of nationalism on the American art scene are the reasons most frequently cited by dealers." *Artnews* (October 1978): 83-87.

HERCHENRÖDER, Christian. "The West German Art Market: High rolling for a lost artistic heritage." *Artnews* (October 1978): 78-81.

HONISCH, Dieter. "What is admired in Cologne may not be accepted in Munich." *Artnews* (October 1978): 62-67.

ZUTTER, J. "Drei Vertegenwoordigers van een nieuwe duitse Schilderkunst." *Museumjournaal* (April 1978): 52-61. Includes discussion of Baselitz, Kiefer and Lüpertz.

1980

BROCK, Bazon. "Avantgarde und Mythos." *Kunstforum International* 4 (1980): 86-103. Review of 1980 Venice Biennale.

FISCHER, Klaus-Jürgen. "Come-back der Malerei?" *Kunstwerk* (March 1980): 3-57. Includes discussion of Baselitz, Fetting, Hahn, Koberling, Krieg, Richter and Salomé.

OHFF, Heinz. [Review of *Heftige Malerei* exhibition at Haus am Waldsee, Berlin.] *Kunstwerk* (March 1980): 77.

POHLEN, Annelie. "Irony, Rejection and Concealed Dreams: Some Aspects of 'Painting' in Germany." *Flash Art* (January-February 1980): 17-18. Includes discussion of Baselitz, Lüpertz and Penck.

——. [Review of *Die neuen Wilden/Les nouveaux Fauves* exhibition at Neue Galerie – Sammlung Ludwig, Aachen.] *Flash Art* (March-April 1980): 55.

1981

AMMANN, Jean-Christophe. "Im Gespräch: Die jungen Deutschen." *Kunstforum International* (December 1981-January 1982): 41-47.

BANN, Stephen. [Review of *A New Spirit in Painting* exhibition at Royal Academy of Arts, London.] *Connaissance des Arts* (October 1981): 98-105.

BROCK, Bazon. "The End of the Avant-Garde? And So the End of Tradition: Notes on the Present 'Kul-

turkampf' in West Germany." *Artforum* (June 1981): 62-67. Includes discussion of Baselitz, Immendorff, Kiefer, Lüpertz and Penck.

———. "Special Germania: Avanguardia e Mito." *D'Ars* (December 1981): 28-45. Includes discussion of Kiefer and Baselitz.

BUSCHE, Ernst. "Van Gogh an der Mauer: Die neue Malerei in Berlin – Tradition und Gegenwart." *Kunstforum International* (December 1981-January 1982): 108-16. Includes discussion of Chevalier, Fetting, Lange, Middendorf, Salomé and Zimmer.

———. "Violent Painting." *Flash Art* (January-February 1981): 27-31.

COLLINS, James. "The Rise of Europe." *Flash Art* (October-November 1981): 64-67.

FAUST, Wolfgang Max. "'Du hast keine Chance, Nutze sie!'" *Artforum* (September 1981): 33-39.

———. "Deutsche Kunst, Hier, Heute." *Kunstforum International* (December 1981-January 1982): 24-40.

———. "Mühlheimer Freiheit: Eine Interviewmontage." *Kunstforum International* (December 1981-January 1982): 117-22. Interview with Bömmels, Dahn and Dokoupil.

———, and B. Passel. "Worüber zu sprechen ist: Ein Florilegium aus Kritiken und Rezensionen zum Zeitschnitt 30 Deutsche." *Kunstforum International* (December 1981-January 1982): 160-84. Includes discussion of Baselitz, Hödicke, Immendorff, Kiefer, Lüpertz, Penck, Polke and Richter.

FEAVER, William. "A 'New Spirit' – Or Just a Tired Ghost?" *Artnews* (May 1981): 114-18. Review of *A New Spirit in Painting* exhibition at Royal Academy of Arts, London.

FRANCBLIN, C. "La Peinture dans les chaînes." *Art Press International* [France] (July-August 1981): 23-25.

GEHREN, Georg von. [Review of *A New Spirit in Painting* exhibition at Royal Academy of Arts, London.] *Kunstwerk* (February 1981): 67-68.

GRÜTERICH, Marlis. "Natuurlijke Gevoelens voor Kunstmatige Werelden." *Museumjournaal* (1981): 221-35. Includes discussion of Baselitz and Kiefer.

HAASE, A. "Wechselnd wild und schön hässlich: Die paradoxe junge deutsche Malerei und ihre expressionistischen Stiefväter." *Kunstforum International* (December 1981-January 1982): 125-28.

IDEN, Peter. "Die hochgemuten Nichtskönner." *Kunstwerk* (May 1981): 3-5.

KAGENECK, Christian von. [Review of *Die heimliche Wahrheit: Mühlheimer Freiheit* exhibition at Kunstverein, Freiburg.] *Kunstwerk* (May 1981): 91.

KUSPIT, Donald B. "The New (?) Expressionism: Art as Damaged Goods." *Artforum* (November 1981): 47-56.

MARCELIS, Bernard. "German Painters." *Domus* (April 1981): 54-55. Includes discussion of Baselitz, Kiefer, Lüpertz and Penck.

MÜLLER, Hans-Joachim. "Ausstellungs-Rückschau: Biennale Venedig 1980." *Kunstwerk* (April 1981): 58-69. Review of Venice Biennale. Includes discussion of Baselitz and Kiefer.

PHILLIPS, D. C. "No Island is an Island: New York Discovers the Europeans." *Artnews* (October 1981): 66-71.

RUSSELL, John. "Art: The News is All from West Germany." *The New York Times* (December 11,

1981). Reviews of Baselitz, Fetting and Penck exhibitions.

SIMMEN, Jeannot L. "Im Westen nichts neues." *Du* 11 (1981): 14-17. Review of exhibition of the same title at Kunstmuseum, Lucerne. Includes discussion of Fetting, Middendorf, Salomé and Zimmer.

SMITH, Roberta. "Fresh Paint?" *Art in America* (Summer 1981): 70-79. Review of *A New Spirit in Painting* exhibition at Royal Academy of Arts, London.

WINTER, P. "Das Picabia-Syndrom oder die Lust an 'schlechter' Malerei: Notizen zu einem speziellen Aspekt der *Westkunst.*" *Kunstwerk* 6 (1981): 34-36. Refers to *Westkunst* exhibition at Rheinhallen, Cologne. Includes discussion of Polke and Penck.

ZIMMER, William. "Blitzkrieg Bopped." *The Soho News* (December 22, 1981): 61. Reviews of Baselitz, Fetting, Lüpertz, Penck and Salomé exhibitions.

1982

ANON. "*Zeitgeist:* An Interview with Christos Joachimides." *Flash Art* (November 1982): 26-27, 30-31.

FRACKMAN, N., and R. Kaufmann. "*Documenta 7:* the Dialogue and a Few Asides." *Arts Magazine* (October 1982): 95.

FUCHS, Rudi, Alfred Hecht and Alfred Nemeczek. "Die Avantgarde ist tot." *Art: Das Kunstmagazin* (June 1982): 2-53. Report on *Documenta 7* exhibition in Kassel.

GACHNANG, Johannes. "New German Painting." *Flash Art* (February-March 1982): 33-37. Includes discussion of Baselitz, Immendorff, Kiefer and Lüpertz.

GOHR, Siegfried. "The Situation and the Artists." *Flash Art* (February-March 1982): 38-46. Includes discussion of Baselitz, Immendorff, Kiefer and Lüpertz.

GRAEVENITZ, Antje von. [Review of *Zwölf Künstler aus Deutschland* exhibition at Museum Boymans-van Beuningen, Rotterdam.] *Pantheon* (July-September 1982): 257-58.

GRAZIOLI, Elio. [Review of *New German Painting* exhibition at Studio Marconi, Milan.] *Flash Art* (Summer 1982): 68-69.

GROOT, Paul, interviewer. "The Spirit of *Documenta 7:* Rudi Fuchs Talks about the Forthcoming Exhibition." *Flash Art* (Summer 1982): 20-25.

HASSELL, C. von. "Teutonischer Einfall." *Weltkunst* (March 1982): 544-45.

HUGHES, Robert. "Upending the New German Chic." *Time Magazine* (January 11, 1982): 84-87.

JANUSZCZAK, W. "*Zeitgeist* Exhibition, Berlin." *Studio International* (November-December 1982): 78-79.

KUSPIT, Donald B. "Report from Berlin 'Bildwechsel': Taking Liberties." *Art in America* (February 1982): 43-49. Review of *Bildwechsel: Neue Malerei aus Deutschland* exhibition at Akademie der Künste, Berlin.

———. "Acts of Aggression: German Painting Today, Part I." *Art in America* (September 1982): 140-51.

———. "The Night Mind." *Artforum* (September 1982): 64-67. Review of *Documenta 7* exhibition in Kassel.

MEREGALLI, Marta, and B. Mats [Review of *Gefühl und Härte* exhibition at Kulturhuset, Stockholm.] *Flash Art* (Summer 1982): 70.

MILLET, C. "*Zeitgeist:* La Beauté des ruines." *Art Press* (December 1982): 22-23. Review of *Zeitgeist* exhibition at Martin-Gropius-Bau, Berlin.

MOORE, J.M. "Le Retour de l'émotion." *Connaissance des Arts* (March 1982): 62-69.

OHFF, Heinz. [Review of *Zeitgeist* exhibition at Martin-Gropius-Bau, Berlin.] *Kunstwerk* (December 1982): 73-74.

PICARD, L. "Brief aus New York: Schweres Geschütz – Der neue Expressionismus, die Invasionisten." *Kunstforum International* (February-March 1982): 149-52.

POHLEN, Annelie. "Premieren-Blicke durch Köln." *Kunstforum International* (August 1982): 140-45. Reviews of Kiefer, Lüpertz and Salomé exhibitions.

PRINZ, U. "Haftigt Maleri fran Berlin." *Paletten* 1 (1982): 36-39. Includes discussion of Fetting, Middendorf, Salomé and Zimmer.

ROBBINS, Corinne. "Nationalism, Art, Morality, and Money: Which Side Are We, They or You On?" *Arts Magazine* (January 1982): 107-11.

ROH, Juliane. [Review of *Gefühl und Härte: Neue Kunst aus Berlin* exhibition at Kunstverein, Munich.] *Kunstwerk* (December 1982): 95.

SIMMEN, Jeannot L. "New Painting in Germany." *Flash Art* (November 1982): 54-58.

ZELLWEGER, Harry. [Review of *Im Westen nichts Neues* exhibition at Kunstmuseum, Lucerne.] *Kunstwerk* (January 1982): 27-28.

1983

BILLETER, Erika. "Kreuzberg: Das Soho von Berlin." *Du* (January 1983): 18-23, 93. Includes discussion of Fetting, Hödicke, Lüpertz and Middendorf.

COWART, Jack, and Jean Louis Froment. "Nouvelle art allemand: succès mérite?" *Connaissance des Arts* (July-August 1983): 52-57.

DICKHOFF, W. W. "Schein des Scheines – Oder Was?" *Kunstforum International* (December 1983): 43-53. Includes discussion of Büttner, Dahn, Dokoupil, Albert Oehlen and Trockel.

FABO, A. "New Expressionism." *C* (Winter 1983-84): 30-31. Review of *New Expressionism* exhibition at Art Gallery of Ontario.

FAUST, Wolfgang Max. "The Appearance of the *Zeitgeist.*" *Artforum* (January 1983): 86-93. Review of *Zeitgeist* exhibition at Martin-Gropius-Bau, Berlin.

———, and Max Raphael. "Gemeinschaftsbilder: Ein Aspekt der Neuen Malerei." *Kunstforum International* (November 1983): 25-87.

HICKS, Emily. [Review of *New Figuration: Contemporary Art from Germany* exhibition at Frederick S. Wight Art Gallery, University of California, Los Angeles. *Artweek* (February 5, 1983): 5.

KUSPIT, Donald B. "Acts of Aggression: German Painting Today, Part II." *Art in America* (January 1983): 90-101, 131-35.

———. "*Zeitgeist:* Art's Attempt to Give A Spirit to the Times." *Vanguard* (May 1983): 20-23.

LARSEN, Susan C. [Review of *New Figuration: Contemporary Art from Germany* exhibition at Frederick S. Wight Art Gallery, University of California, Los Angeles.] *Artnews* (April 1983): 120, 123.

OWENS, Craig. "Honor, Power and the Love of Women." *Art in America* (January 1983): 7-13.

PINCUS-WITTEN, Robert. "Entries: Vaulting Ambition." *Arts Magazine* (February 1983): 70-75. Review of *Documenta 7* exhibition in Kassel and *Zeitgeist* exhibition at Martin-Gropius-Bau, Berlin.

POHLEN, Annelie. "The Beautiful and the Ugly Pictures: Some Aspects of German Art – The Found and the Constructed Pictures." *Art & Text* (Summer 1983-Autumn 1984): 60-73. Includes discussion of Immendorff, Polke and Richter.

REIN, Ingrid. [Review of *Zwischenbilanz: Neue deutsche Malerei* exhibition at Landesmuseum, Bonn, and Museum Villa Stuck, Munich.] *Artforum* (October 1984): 100. Artists represented: Bach, Barfuss, Bömmels, Büttner, Dahn, Dokoupil, Fetting, Kippenberger, Middendorf, Albert Oehlen, Markus Oehlen and Tannert.

ROPOHL, Udo, and Barbara Straka. "Kleine Phänographie subversiver Ausstellungspraxis: Das Realismusstudio der NGBK." *Kunstforum International* (November 1983): 88-105. Includes discussion of Barfuss, Büttner, Kippenberger, Albert Oehlen, Salomé and Tannert.

RUSSELL, John. "The New European Painters." *The New York Times* (April 24, 1983): 28-33.

SOKOLOV, M. "Chelovek i Priroda v Sovremennoi Zhivopisi I Grafike: Khudozhniki FRG i Zapadnogo Berlina." *Dekorativnde Iskusstvo* 8 (1983): 54-60.

——, "Ekologischeskie Problemy v Iskusstve Zapada." *Dekorativnde Iskusstvo* 9 (1983): 35-37. Review of West German exhibition *Man and Nature in Contemporary Art* in Moscow, Leningrad and Novosibirsk.

1984

ASHTON, Dore. [Review of *A Recent Survey of International Painting and Sculpture* exhibition at The Museum of Modern Art, New York.] *Arts Magazine* (September 1984): 108-11.

BELL, Jane. "What is German about the New German Art?" *Artnews* (March 1984): 96-101. Review of *Expressions: New Art from Germany* exhibition at St. Louis Art Museum. Includes discussion of Baselitz, Immendorff, Kiefer and Lüpertz.

COLEMAN, John. [Review of *Mühlheimer Freiheit Proudly Presents the Second Bombing* exhibition at Institute of Contemporary Arts, London.] *Flash Art* (March 1984): 41-42.

COLLINS, James. "The Rise of Europe." *Flash Art* (April-May 1984): 48-53.

GLUECK, Grace. "Expressions: New Art from Germany." *The New York Times* (October 7, 1983): C22. Review of exhibition of same title at Institute for Art and Urban Resources, Queens, New York.

HANSON, Henry. "Five Horsemen of the Apocalypse: German Artists Bring Up Dark Visions from a Divided Homeland." *Chicago* (March 1984): 170. Review of *Expressions: New Art from Germany* exhibition at Museum of Contemporary Art,

Chicago. Includes discussion of Baselitz, Immendorff, Kiefer, Lüpertz and Penck.

IANCO-STARRELS, Josine. "Five Expressionistic German Artists." *The Los Angeles Times* (April 15, 1984): 101. Review of *Expressions: New Art from Germany* exhibition at Newport Harbor Art Museum, Newport Beach, California.

KOHN, Michael, Kim Levin and Klaus Ottmann. "MOMA: An International Survey." *Flash Art* (Summer 1984): 62-64.

LICHTENSTEIN, Therese. [Review of *European Expressions* exhibition at Annina Nosei Gallery, New York.] *Arts Magazine* (February 1984): 37. Artists represented: Chevalier, Hödicke and Middendorf.

MUCHNIC, Suzanne. "New Expressions from the Big Bottle. *The Los Angeles Times* (May 13, 1984): 92. Review of *Expressions: New Art from Germany* exhibition at Newport Harbor Art Museum, Newport Beach, California.

RELYEA, Lane. "Attempting to Elude History." *Artweek* (June 9, 1984): 1. Review of *Expressions: New Art from Germany* exhibition at Newport Harbor Art Museum Newport Beach, California.

SIMMEN, Jeannot L. "Paraphrases or Key Pictures." *Flash Art* (Summer 1984): 20-24.

TULLY, J. "A New Expression." *Horizon* (January-February 1984): 38-47. Includes discussion of Baselitz, Fetting, Hödicke, Koberling and Middendorf.

WILDERMUTH, Armin. "The Crisis of Interpretation." *Flash Art* (March 1984): 8-18. Includes discussion of Bömmels, Dahn, Dokoupil, Fetting, Middendorf, Salomé and Zimmer.

1985

BEYER, Lucie. [Review of *von hier aus* exhibition at Kunsthalle, Dusseldorf.] *Flash Art* (January 1985): 33-34.

BROCKMANN, J. "Noen Tanker om Vesttysk Maleri Idag." *Kunst og Kultur* 68 (1985): 2-19.

DIENST, Rolf-Gunter. "20 Jahre Kunst in Berlin." *Kunstwerk* (September 1985): 8-34. Includes discussion of Albert, Hödicke, Koberling, Lüpertz and Zimmer.

GALLOWAY, David. "Report from Germany." *Art in America* (March 1985): 23-29. Review of *von hier aus* exhibition at Kunsthalle, Dusseldorf.

SCHULZ, Bernhard. "La Métropole retrouvée." *Flash Art* (January 1985): 53-54. Review of exhibition at Palais des Beaux-Arts, Brussels.

STEPAN, P. "Germany." *Artnews* (February 1985): 52-56.

WILKEN, Karen. "The Iceberg Show." *Artnews* (May 1985): 112-13. Review of *The European Iceberg* exhibition at Art Gallery of Ontario, Toronto.

1986

CATOIR, Barbara. "The New German Collectors." *Artnews* (April 1986): 77-82.

COPPEL, S. "*Zeitgeist* Art: Neo-Expressionist Prints from Germany and Italy." *Art in Australia* (Winter 1986): 501-6. Includes discussion of Baselitz, Immendorff and Penck.

DIMITRIJEVIC, Nena. [Review of *German Art in the 20th Century: Painting and Sculpture 1905-1985* exhibition at Royal Academy of Arts, London.] *Flash Art* (March 1986): 54.

GALLOWAY, David. "Taking Stock." *Art in America* (May 1986): 29-39. Review of *German Art in the 20th Century: Painting and Sculpture 1905-1985* exhibition at Royal Academy of Arts, London, and *1945-1985*; *Kunst in der Bundesrepublik Deutschland* exhibition at Nationalgalerie, Berlin.

MARCK, Jan van der. "Report from Pittsburgh: the Triennial Revisited." *Art in America* (May 1986): 51-52.

PINCUS-WITTEN, Robert. "Georg Baselitz: From Nolde to Kandinsky to Matisse – A Speculative History of Recent German Painting." *Arts Magazine* (June 1986): 30-34.

TAYLOR, Paul. "Café Deutschland." *Artnews* (April 1986): 68-76. Discussion of post-Neo-Expressionism in Germany."

1987

BRENSON, Michael. "A New Show Chronicles Resurgence of Berlin Art." *The New York Times* (June 5, 1987): C1, C22. Review of *BERLINART 1961-1987* exhibition at The Museum of Modern Art, New York.

COTTER, H. "Art from the Exiled City." *Art in America* (October 1987): 43-49. Review of *BERLINART 1961-1987* exhibition at The Museum of Modern Art, New York.

HIGH, Stephen S. "Young German Painting: Towards the Hyperreal." *Art Criticism* 2 (1988): 26-37.

KOETHER, Jutta. "Under the Influence." *Flash Art* (April 1987): 46-50.

NEMECZEK, Alfred. "Aufstieg und Erbe der 'Wilden.'" *Art: Das Kunstmagazin* (July 1988): 54-57.

PROYEN, Mark van. "Voices from within the Cage." *Artweek* (December 5, 1987): 1, 4. Review of *BERLINART 1961-1987* exhibition at San Francisco Museum of Modern Art.

ROGOFF, Irit. [Review of *BERLINART 1961-1987* exhibition at The Museum of Modern Art, New York.] *Burlington Magazine* (September 1987): 623-25.

ROUSTAYI, Mina. "Crossover Tendencies: An Interview with Wolfgang Max Faust." *Arts Magazine* (February 1988): 62-65.

Photographic Credits